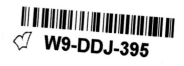
Van Gogh to Picasso

The Berggruen Collection at The National Gallery

Van Gogh to Picasso

The Berggruen Collection at The National Gallery

Catalogue by Richard Kendall

Essays by Lizzie Barker and Camilla Cazalet

The National Gallery, London

© National Gallery Publications Limited 1991

First published in Great Britain in 1991 by
National Gallery Publications Limited
5/6 Pall Mall East, London SW1Y 5BA

British Library Cataloguing in Publication Data
Kendall, Richard
 Van Gogh to Picasso: the Berggruen Collection at
 the National Gallery.
 1. European visual arts, 1800 – – Catalogues, indexes
 I. Title II. Barker, Lizzie III. Cazalet,
 Camilla IV. National Gallery, Great Britain
 709.0346

 ISBN 0–947645–83–7 (hardback)
 ISBN 0–947645–82–9 (paperback)

Printed and bound in Italy by
Amilcare Pizzi, S.p.a., Milan

Designed by Peter Guy

Provenance and bibliography are based on the work of
Jean M. Marquis, with additions by Richard Kendall.
African art entries compiled by Jean Paul Barbier (J.P.B.),
Henry John Drewal (H.J.D.), and Louis Perrois (L.P.).

Cover: Picasso, *Seated Nude drying her Foot*, 1921; Cat. no. 49.

Contents

List of Exhibits

Vincent van Gogh

 1 *An Autumn Garden*, 1888
 2 *Arles, View from the Wheat Fields*, 1888

Georges Seurat

 3 *Crouching Boy, c.* 1882
 4 *The Lady in Black, c.* 1882
 5 *The Nanny, c.* 1882
 6 *Woman Reading, c.* 1883
 7 *The Rainbow, c.* 1883
 8 *Man in a Bowler Hat*, 1883–4
 9 *A Seated Man reading on a Terrace, c.* 1884
 10 *Study for 'La Grande Jatte'*, 1884–5
 11 *The Morning Walk*, 1884–5
 12 *Family Group (Condolences), c.* 1886
 13 *The Bridge at Courbevoie*, 1886
 14 *The Seine seen from La Grande Jatte*, 1888
 15 *Les Poseuses (The Artist's Models)*, 1888
 16 *The Channel of Gravelines, Grand Fort-Philippe*, 1890

Paul Cézanne

 17 *Portrait of Madame Cézanne, c.* 1885
 18 *Path in Chantilly*, 1888
 19 *Mont Sainte-Victoire*, 1888–90
 20 *Study for the 'Cardplayers'*, 1890–2
 21 *Jug and Fruit*, 1893–4
 22 *Girl with a Doll, c.* 1899
 23 *Young Girl with a Doll*, 1902–4
 24 *A Letter to his Son*, 1906
 25 *Portrait of the Gardener Vallier, c.* 1906

Georges Braque

 26 *Still Life with Pipe (Le Quotidien du Midi)*, 1913–14
 27 *Still Life with Glass and Newspaper (Le Guéridon)*, 1913

Pablo Picasso

 28 *At the Café-Concert*, 1902
 29 *Head of a Young Man*, 1906
 30 *Two Female Nudes*, 1906

Acknowledgements

Many people have helped in the preparation of this catalogue and the exhibition that it accompanies. Above all, the Gallery is grateful to Heinz Berggruen and to Olivier Berggruen for their untiring support and advice. We are also indebted to the author of the catalogue, Richard Kendall, for his enthusiasm, hard work and scholarship. Jean Marquis generously allowed us to use material that he prepared for an exhibition of the Berggruen Collection in Geneva in 1988, and also supplied updated references for several works.

Tim Clark of the Department of Japanese Antiquities at the British Museum, London, helped to catalogue Picasso's *Head of a Young Man* (Cat. no. 29).

Within the National Gallery the assistance of the following is gratefully acknowledged: Astrid Athen, Lizzie Barker, Karen Bath, Peter Brett and the Working Party, Jill Dunkerton, John England, Herb Gillman, Patricia Goddard, Eric Harding, Sara Hattrick, Mary Hersov, Jo Kent, Caroline Macready, Margaret Stewart, Joe Swift, June Wallis, Michael Wilson, Louise Woodroff and Martin Wyld. Felicity Luard, Sue Curnow and Emma Shackleton worked with patience and skill to prepare this catalogue for publication.

John Leighton
Curator of Nineteenth-Century Painting

Foreword

This catalogue marks not just an exhibition, but one of the most generous loans made to the National Gallery in its entire history. For the next few months the Berggruen Collection will be shown on its own in Rooms 44, 45 and 46; for the following five years the paintings, and a rotating selection of the works on paper, will hang alongside paintings belonging to the National Gallery. The Berggruen study for Seurat's *Bathers at Asnières* will be near the painting itself; and two versions of Cézanne's *Avenue at Chantilly* will hang side by side. Joined together, the two collections will offer one of the most distinguished showings of Cézanne and Seurat anywhere in the world. The British public will thus be able to study first the achievement of a collector of rare discernment, and later to see those same works, hung with our own paintings, to form the closing chapter of that part of the story of Western painting which is told at Trafalgar Square.

And a little bit more – the great run of works by Picasso carries the Berggruen Collection past the middle of this century, and well beyond the point at which the Tate Gallery takes up the tale. Nonetheless, visitors will, I believe, see at once why Heinz Berggruen wanted the Picassos to remain together, spanning as they do the whole career of this century's greatest artist. And the temporary trespass on the territory of Millbank will for these five years allow Picasso to be viewed not as a pioneer modern, but as the last – and among the greatest – of the Old Masters.

The Berggruen Collection would have been welcomed by any city; but it can truly be said that it is doubly welcome in London. British collections, extravagantly rich in Old Master paintings, are – unlike their equivalents in France and the United States – poor in the works of the Post-Impressionists, and effectively unable to show the heroic Cubist endeavours of Braque and Picasso. By his generous loan, Heinz Berggruen has made this failing good, and the British public will now be able to get to know these pictures at a level quite impossible through a temporary exhibition or a brief visit to Paris.

Throughout the preparation of this exhibition, and the inevitable mass of arrangements and details, the Berggruen family have been unfailingly generous of time and help. I must particularly express my gratitude to Olivier Berggruen, who has devoted much energy to bringing this venture to so happy a conclusion.

To Heinz Berggruen our debt is of an unusual order. He has put all his knowledge and enthusiasm at our disposal in the compiling of this catalogue. He has contributed to every discussion about the transport and presentation of the Collection. Above all, he is sharing his pictures for five years with the British public. On behalf of the National Gallery, and of that wider public, I should like to express to him our affectionate thanks.

<div align="right">

Neil MacGregor
Director

</div>

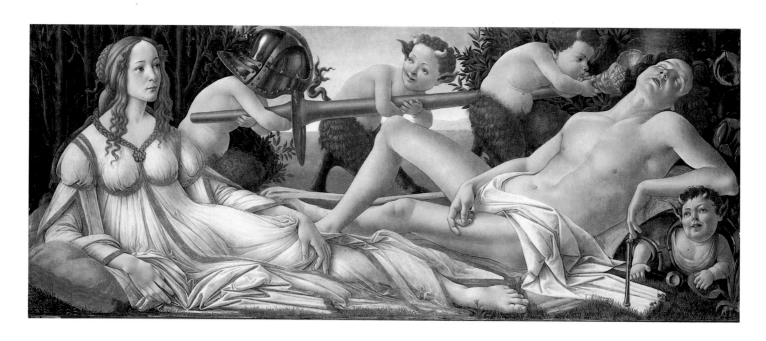

Plate 1 *Above* Botticelli (about 1445–1510), *Venus and Mars*. Wood, painted area 69.2 × 173.4 cm. The National Gallery, London.

Cat. no. 66 *Left* Picasso, *Man Sleeping*, 1942.

Modern Old Masters
The Berggruen Collection at The National Gallery

Lizzie Barker

Throughout his mercurial career, Picasso remained determined to keep art open-ended, 'alive' and 'dangerous'. He believed that to finish a work was to kill it and made a practice of re-enacting his own and other artists' works. He once referred jokingly to himself as a collector who created his collection by repainting other peoples' pictures that he admired.

Picasso was critical of tasteful but unimaginative museum and gallery displays, which he felt destroyed the essential life force of art: 'If you want to kill a picture all you have to do is hang it beautifully on a nail and soon you will see nothing of it but the frame. When it's out of place you see it better.'[1] Yet he would surely have relished seeing the Berggruen Collection lodged in the National Gallery, not only for the opportunity of testing so many of his own works against famous Old Master paintings but also for the chance to see how both modern and Old Master collections appear to take on new life and change in response to each other. Picasso told the writer Christian Zervos in 1935: 'A picture lives a life like a living creature, undergoing changes imposed on us by our life from day to day. This is natural enough, as the picture lives only through the man who is looking at it.'[2]

When Picasso saw a number of his works hung beside paintings in a temporary exhibition at the Louvre in 1946 he was at first very anxious to see if his art could hold its own against famous Old Masters, but he soon overcame his nervousness and exclaimed to George Salles, Director of the Louvre: 'You see it's the same thing, it's the same thing!'[3] It is easy to understand Picasso's enthusiasm about 'the same thing' when considering his drawing *Man Sleeping*, 1942 (Cat. no. 66), which makes an excellent companion to Botticelli's *Venus and Mars* (Plate 1). They share the subject of a watched sleeper, which has been a recurring theme in mythological painting, although more commonly in the form of males watching over sleeping female nudes. Both artists create a mood of poetic reverie, contrasting the serene, reflecting but also questing expression of the vigilant female with the oblivion of the sleeping male.

This new liaison makes familiar aspects of Picasso and Botticelli's work seem fresh and provocative. One can appreciate how both artists successfully used anatomical distortion to heighten the descriptive, expressive and formal potency of their figures without destroying a sense of their idealised classical beauty. The comparison also augments the spectator's appreciation of these works' unique qualities and individual power. Picasso, for example, is less reticent about the relationship between the male and female characters. He places them close together on a bed and attends to such details as tufts of body hair and the woman's fleshy belly, which help to suggest the physicality and sensuality of their relationship. By contrast with Botticelli's polished and rather limp young man, Picasso's rugged male is in active slumber. Although his feet are splayed, the muscles in his upper body are taut with his arms locked firmly behind his head. The spectator is witnessing only a momentary pause in this couple's lovemaking.

Modern works in the Berggruen Collection seem to engage, fraternise and cultivate links with National Gallery paintings in several different ways. Direct kinship exists, for example, where a number of the works are studies for or

1 R. Penrose, *Picasso: His Life and Work*, London 1958, p. 71.
2 Conversation with Christian Zervos, at Boisgeloup in 1935, in Dore Ashton, *Picasso on Art: A Selection of Views*, London 1972, p. 8.
3 Penrose, op. cit., p. 395.

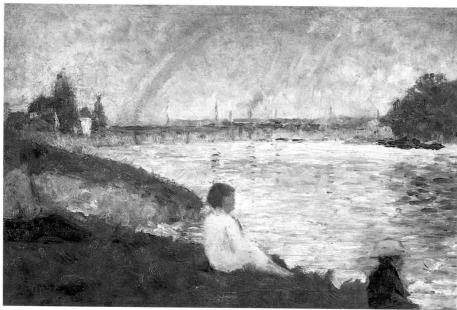

Plate 2 *Above* Seurat, *Bathers at Asnières*, 1883–4. Oil on canvas, 201 × 300 cm. The National Gallery, London.

Cat. no. 7 *Left* Seurat, *The Rainbow*, c. 1883.

variations on National Gallery paintings. Other relationships are established by default, where Berggruen works fill gaps in the National Gallery Collection and assist in providing a more comprehensive display of an artist's work. Many of the modern works of the Berggruen Collection, far from representing a break with the art of the past, extend and manipulate established traditions and genres of painting and can be linked to companion works in the National Gallery. Finally, other works in the Berggruen Collection, which have no historical links with the National Gallery Collection, appear to forge new relationships through a mysterious sense of affinity, like Picasso's drawing *Man Sleeping*, and Botticelli's *Venus and Mars*.

Several works by Seurat and Cézanne in the Berggruen Collection are directly related to National Gallery paintings. There are, for example, oil sketches and conté crayon drawings that are studies for the monumental National Gallery painting by Seurat, *Bathers at Asnières* (Plate 2). These studies indicate something of the extent and range of Seurat's preparatory work for *Bathers at Asnières*, which represented his first grand bid for recognition at the Salon des Indépendants in 1884. He painted many small rapid sketches in oil, such as *The Rainbow* (Cat. no. 7), directly in front of his subject on the banks of the Seine, in order to record the movements of boats and people and to capture the particular effects of weather and reflections on the water. He also made highly finished studies in conté crayon, such as the *Man in a Bowler Hat* (Cat. no. 8), which he

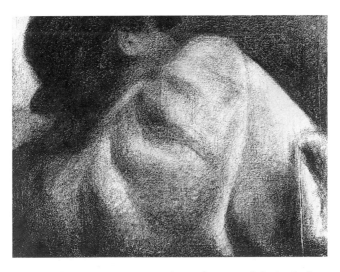

Cat. no. 8 Seurat, *Man in a Bowler Hat*, 1883–4.

drew from models posed in his studio, suggesting the volumes of their clothes and bodies solely through contrasts of tone.

The Rainbow study is very close in many ways to the final painting in terms of the artist's viewpoint and the character and disposition of the figures. Even the cropped figure of a man in a straw hat at the bottom of the study appears, from the angle of his shoulder, to be reclining. He may well be the prototype for the large reclining figure wearing a bowler hat in the finished painting, which Seurat developed in his studio in the conté drawing *Man in a Bowler Hat*.

There are, however, fascinating differences in the atmospheric effects of *The Rainbow* study and the finished painting. In contrast to the stability and sense of classical order in the *Bathers at Asnières*, the study has a raw immediacy, suggesting a very particular and transient state in the weather. The turbulent strokes loaded with blue pigment used for the sky and the presence of the rainbow give the impression that there has been a recent downpour of summer rain and that the air is heavy with moisture.

The reunification of these studies with the *Bathers at Asnières* gives new insight into the artist's creative process: the way he transformed and re-created his direct experience of nature in the studio. A similar metamorphosis can be detected in two Cézanne paintings of Chantilly. The *Path in Chantilly* (Cat. no. 18) is not a study but an independent variation on the *Avenue at Chantilly* (Plate 3) in the National Gallery Collection. Both were probably painted in 1888 when Cézanne stayed at Chantilly and explored the tree-lined avenues in the grounds of the Château. The paintings share a similar composition: the deep perspective of a leafy avenue played off against strong horizontal bands of light and shadow. The exact location, atmospheric effects and Cézanne's formal experiments are, however, quite different. The *Avenue at Chantilly* reveals a distant view of houses, the receding path broken by low barriers or gates. By contrast, the *Path in Chantilly* bears no trace of human presence and conveys a much wilder atmosphere. The foliage seems denser and Cézanne's brushstrokes are more evident in the flickering patches of colour that unify the surface of the painting.

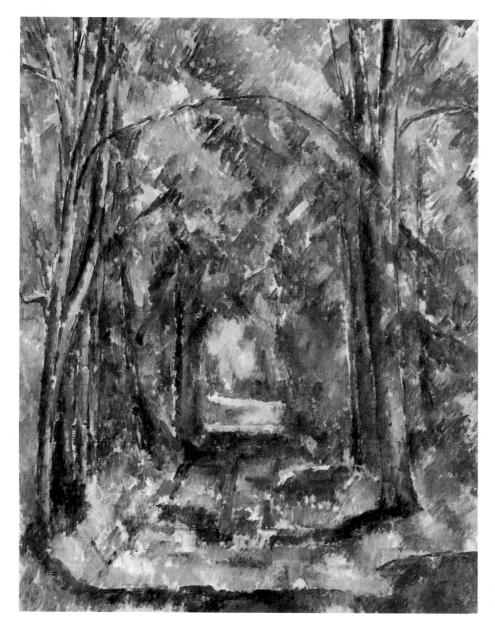

Cat. no. 18 *Left* Cézanne, *Path in Chantilly*, 1888.

Plate 3 *Opposite* Cézanne, *Avenue at Chantilly*, 1888. Oil on canvas, 82 × 66 cm. The National Gallery, London.

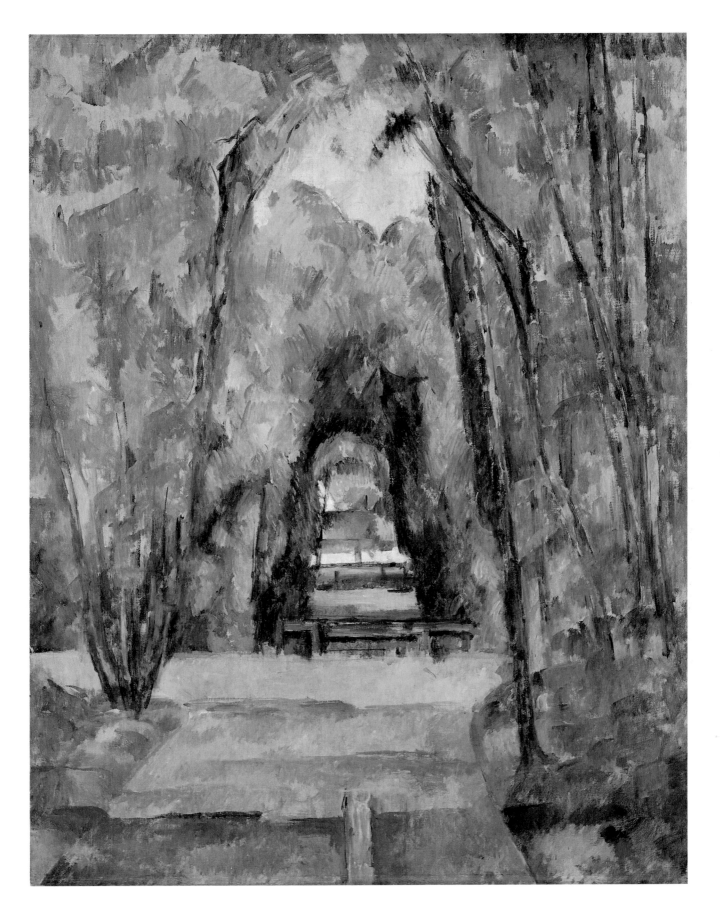

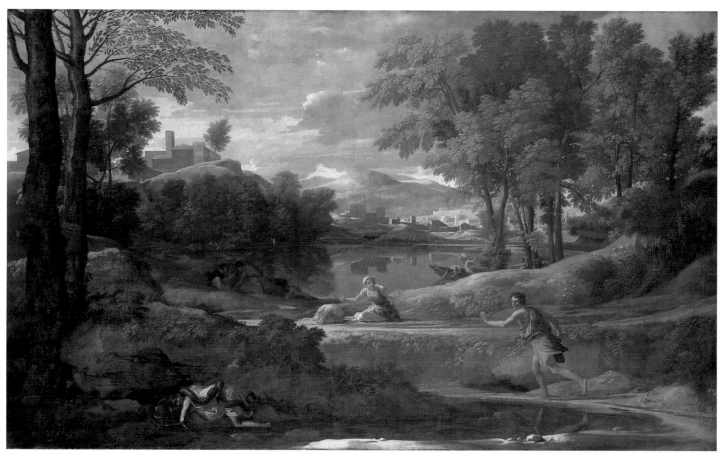

Plate 4 Poussin, *Landscape with a Man killed by a Snake*, *c*. 1648. Oil on canvas, 119.4 × 198.8 cm. The National Gallery, London.

Two other Cézanne paintings in the Berggruen Collection are linked to National Gallery works by default and help to create a more complete picture of his artistic career. The National Gallery has, until now, offered no example of Cézanne's famous series of paintings of Mont Sainte-Victoire and has never possessed a Cézanne still life. This latter is, perhaps, a more serious omission considering the significance still life had for Cézanne's other work. He once complained when painting a portrait of the dealer Vollard that he wished his sitter could pose more like an apple!

The monumental and architectonic qualities of Cézanne's *Mont Sainte-Victoire* (Cat. no. 19) bring to mind his recorded ambition of 'revivifying Poussin in front of nature'.[4] A comparison with Poussin's *Landscape with a Man killed by a Snake* (Plate 4) testifies to his success in this endeavour. Despite differences in the

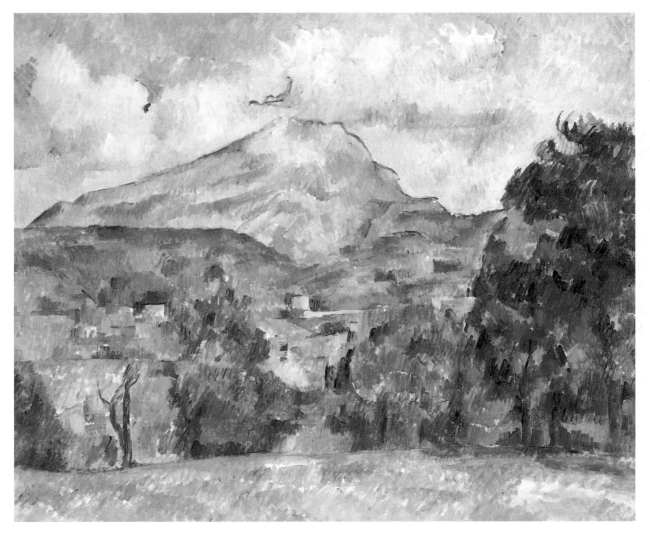

distance and scale of his mountain, Cézanne, like Poussin, used the simple geometry of the buildings to anchor and structure the centre of the composition. He also perfected Poussin's planar organisation of space, stressing the measured rhythm of horizontal bands in the landscape. The Cézanne painting is brimming with life and movement and conveys a direct experience of nature which is lacking in the more abstract and generalised vision of Poussin's landscape. Cézanne's rich touches of colour animate the foliage and create the sense of shifting light and air circulating in the picture.

Cat. no. 19 Cézanne, *Mont Sainte-Victoire*, 1888–90.

4 This remark was first published, during Cézanne's lifetime, by Charles Camoin in *Mercure de France*, 1.8.1905, p. 353.

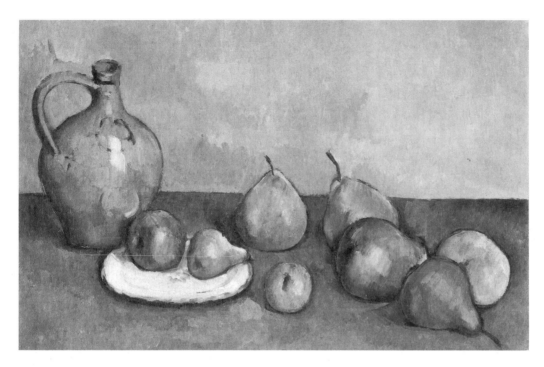

Cat. no. 21 Cézanne,
Jug and Fruit, 1893–4.

There is a similar tangible sense of reality in Cézanne's painting *Jug and Fruit* (Cat. no. 21), which is conveyed through the monumental presence of the objects and the emphasis on paint and canvas surface. Rejecting conventional devices for recording the purely visual appearance of these objects, Cézanne re-creates them as pictorial characters. The apples, pears, plate and jug appear to respond to each other, subtly changing their shape and colour to create a new harmonious ensemble across the surface of the canvas. Just as Cézanne wished his human subjects could behave more like still lifes, he also imagined his still-life objects acting out dramas like human beings: 'People think that a sugar basin has no face, no soul. But even that changes day by day. You have to know how to catch and cajole those fellows. . . . These glasses and plates talk among themselves. Endless confidences.'[5]

The presence together in the National Gallery of Cézanne's *Jug and Fruit* and Picasso's *Fruit-bowl with Pears and Apples*, 1908 (Cat. no. 33), offers an opportunity to examine how Cézanne's work inspired Picasso's early Cubist experiments. Picasso, like Cézanne, forced a change in the appearance of the bowl of fruit on the table to conform to the surface of the picture. The apples and pears take on geometrical edges echoing the angle of the table which has been tipped up to correspond to the real wooden surface of the panel.

The National Gallery possesses only one Cubist painting, a much later work by Picasso, but the Berggruen Collection offers a very comprehensive picture of Picasso's Cubism between 1908 and 1916, in drawing, painting, collage and sculpture. These works amplify and enrich the Gallery's modern collection and will radically alter visitors' awareness of Old Master paintings.

A distant precedent for Picasso's early Cubist experiments with form and space can be found in the detail of the Virgin's vase of lilies in Duccio's predella panel *The Annunciation* (Plate 5, Fig. 1). The vase appears to be standing flat on a shallow step but Duccio distorts it so that the spectator can simultaneously peep inside and appreciate its pure profile. Both Duccio and Picasso appeal to the spectator's conceptual knowledge of objects, showing different aspects of reality rather than limiting themselves to a single visual impression.

5 From Joachim Gasquet, *Cézanne*, reprinted in Richard Kendall, *Cézanne by Himself*, London 1988, p. 310.

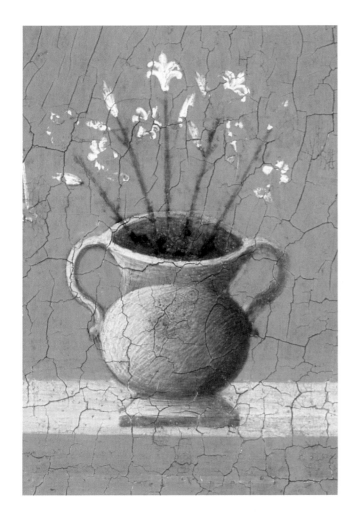

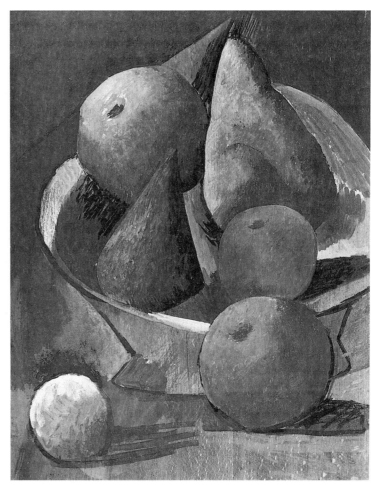

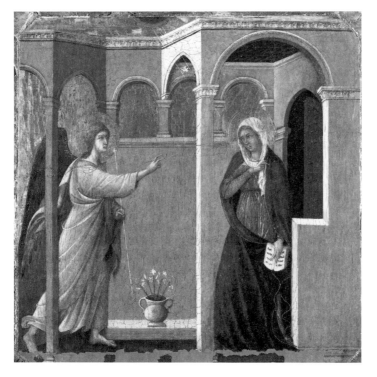

Cat. no. 33 *Above* Picasso, *Fruit-bowl with Pears and Apples*, 1908.

Plate 5 *Above Left* Detail from *The Annunciation* (Fig. 1).

Fig. 1 *Left* Duccio, *The Annunciation*, 1308–11. Predella panel from an altarpiece, wood, painted area 43.2 × 43.8 cm. The National Gallery, London.

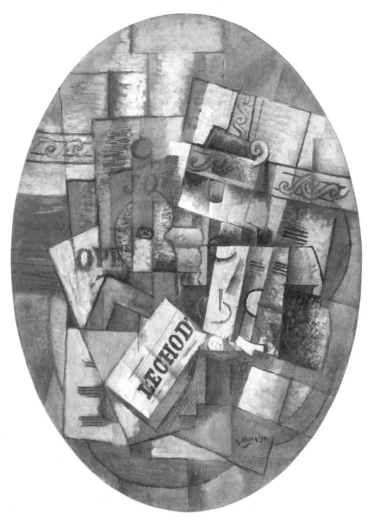

Cat. no. 27 Braque, *Still Life with Glass and Newspaper*, 1913.

It is refreshing to discover how many of the more radical works in the Berggruen Collection continue and extend traditions of painting exemplified in the National Gallery Collection. A large number of Cubist works, for instance, manipulate and rework the conventions of still-life painting.

Still lifes, by their very nature, rely on a paradoxical play between nature and art. While they are in a sense pictorial substitutes for real objects, closely echoing them in scale and visual appearance, they also involve the artist in rearranging elements of reality. Moreover, many still-life paintings have been given symbolic meanings through the associations of certain objects. So, by no means a simple record of appearances, still-life painting offers a complex interplay of different meanings.

By contrast with the clarity of image and the superbly crafted finish of Holbein's *'The Ambassadors'* (Plate 6, Fig. 2), Braque's *Still Life with Glass and Newspaper* (Cat. no. 27) may initially seem abrasive, with its confusing mass of unrecognisable shapes. Braque's painting does, however, share many features with Holbein's monumental painting.

There are close visual correspondences between Braque's still life and the arrangement of objects on the lower shelf in *'The Ambassadors'*. Both artists laid out their objects to suggest a casual clutter on a wooden surface and both took a long-distance view down onto the table-top, increasing the spectator's sense of deep space by including a glimpse of the floor below. This can be detected as the area of grey on the lower left-hand side of Braque's painting. Just as Holbein

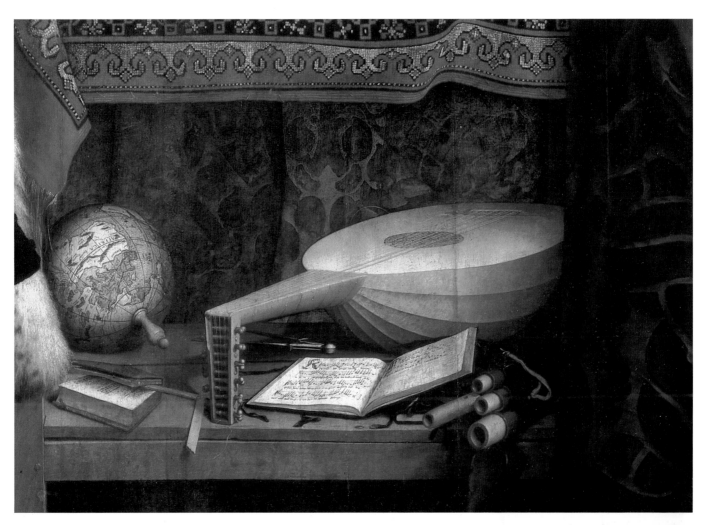

made decorative use of the patterns in curtain, carpet and marble floor, so Braque played with lively scroll designs, which were fashionable in interior design, to enliven the surface of his painting.

Both artists rejected single-point perspective and made use of different viewpoints in their work. Holbein not only used different viewpoints for the figures, the shelf and the floor but also painted the skull in the foreground in a completely different system of perspective. He suggested the projection of objects beyond the surface of the shelf by means of foreshortening. Braque produced a similar illusion by imitating the effects of collage, creating a sense that fragments of paper are interleaved and built outwards beyond the surface of the canvas.

Music – stringed instruments and sheet music – constitutes the leitmotif of both paintings. Holbein carefully recorded the appearance of a lute but also used it to convey deeper intellectual meaning by painting a broken string, which was understood in the sixteenth century as a symbol of discord. Holbein offered the spectator a chance actually to read the music and lyrics in the open hymn book. Braque also wrote references to sound in his picture by cropping the title of a newspaper to frame the word *L'ECHO D'*. Both artists played with the legibility of their paintings, confounding areas that can be read literally with areas of hidden meaning. Braque offered tantalising clues to the presence of objects such as a guitar, drinking glasses and sheet music, only to obscure them with inexplicable abstract shapes. Both paintings are, in this sense, hermetic. They suggest intellectual meanings to the spectator but remain elusive.

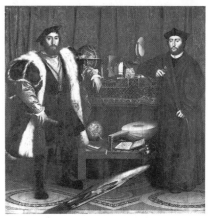

Plate 6 *Top* Detail from '*The Ambassadors*' (Fig. 2).

Fig. 2 *Above* Holbein, '*The Ambassadors*', 1533. Wood, painted area 207 × 209.5 cm. The National Gallery, London.

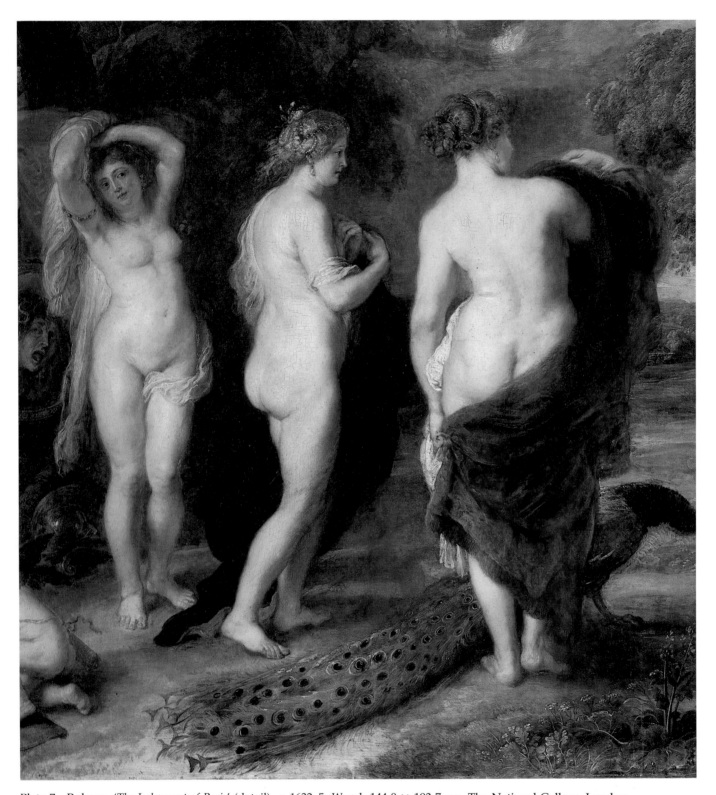

Plate 7 Rubens, *'The Judgement of Paris'* (detail), *c.* 1632–5. Wood, 144.8 × 193.7 cm. The National Gallery, London.

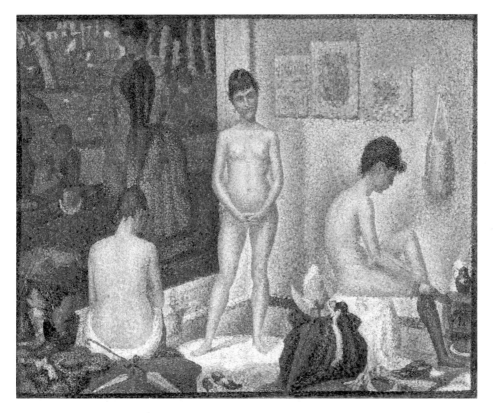

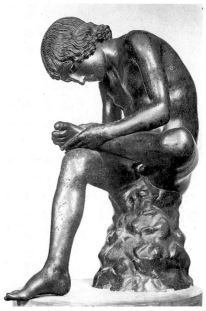

Cat. no. 15 *Above Left* Seurat, *Les Poseuses*, 1888.

Fig. 3 *Above* The *Spinario* ('The Thorn-puller'), Roman copy of the imperial period. Bronze, height 70 cm, Museo Capitolino, Rome.

Despite the modest scale and respectful air of Seurat's *Les Poseuses* (Cat. no. 15) it represents, like Braque's Cubism, a radical restatement of tradition. The trio of nudes arranged to present back, front and profile views, recalls the Three Graces, an archetype of the classical figurative tradition. Each of these fashionable nineteenth-century models appears to pose naturally as a famous classical nude from the past. There is a hint of Ingres's *Valpinçon Bather* (Louvre, Paris) in the figure on the left, a suggestion of the antique sculpture the *'Capitoline' Venus* in the central figure, while the woman on the right is seated in the same position as the antique bronze the *Spinario* (Fig. 3). Another look at the central figure, however, and the experience of real life breaks through the classical mould. Her pose, hardly befitting the archetypal role, is graceless, with her belly thrust forward and legs splayed. Seurat emphasised the interplay of art and life by setting his models in these equivocal poses, which are natural since they are physically comfortable and yet are resonant with artistic quotations. He also set up correspondences between the naked models in his studio and their clothed counterparts 'outside' on the banks of the Seine – seen in the background in the representation of Seurat's 1886 painting *Sunday Afternoon on the Island of La Grande Jatte*.

Rubens made an earlier attempt to revitalise classical figuration in his painting *'The Judgement of Paris'* (Plate 7) in which he recast the Three Graces as buxom Flemish beauties. Rubens and Seurat are also linked across time by their interest in colour relationships. Seurat, in the nineteenth century, is renowned for applying colour theories and the science of optics to his painting, while Rubens, in the seventeenth, is also recorded as having made notes on colour theory and was by Seurat's time heralded as the founder of a colourist tradition of painting. The tapestry of colour points Seurat used to suggest the translucence of the models' skin in *Les Poseuses* is matched by the vibrant touches of colour employed by Rubens for the warm, pliant flesh of his goddesses.

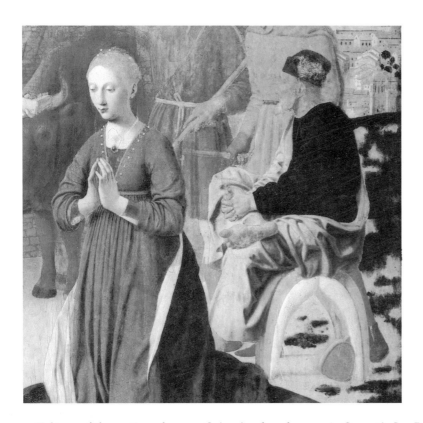 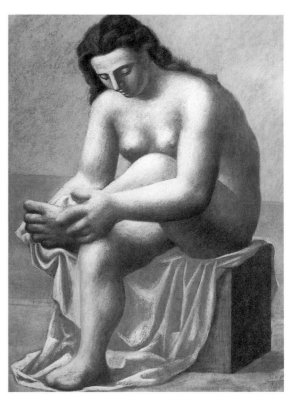

Echoes of the antique bronze *Spinario*, already seen in Seurat's *Les Poseuses*, are also present in Picasso's beautiful pastel of a *Seated Nude drying her Foot* (Cat. no. 49). This reference to a famous antique statue was frequently used by artists to draw attention to their classical pedigree. Piero della Francesa, for example, cast his figure of Joseph seated on a saddle in *The Nativity* (Fig. 4) in the same form as the pagan sculpture.

When Picasso drew the pastel in 1921, he was steeped in classical antiquity. Like other avant-garde artists in Paris after the First World War, he reaffirmed his faith in traditional values, returning to classical figuration and Arcadian subject matter. Picasso reworked the classical repertoire of artists such as Poussin and Ingres as well as evoking more ancient prototypes. His interest in Roman paintings, such as the figure of Arcadia (Fig. 5) which inspired Ingres's portrait of *Madame Moitessier* (Fig. 6), was aroused by a visit to Pompeii and Herculaneum when he travelled to Italy with the Diaghilev ballet in 1917.

Picasso's nude finds a relative in the National Gallery *Allegorical Figure of Grammar* by Laurent de la Hire (Plate 8). These women share the same monumental, sculptural form and appear to move their large hands with ponderous grace. There is a strong family resemblance in their faces, with heavy-lidded eyes, broad noses and full cheeks.

Laurent de la Hire was recognised as a leader of a French classical revival, known as 'Parisian Atticism', in the mid-seventeenth century. He made allusions to the antique past in his painting of Grammar through the vast fluted columns and urn in the background and the fragmented block of classical architecture that acts as a ledge for the flower pots. La Hire contrasted these relics of civilisation with untamed nature seen beyond the wall and the little flowers being nurtured by Grammar. Nature and the antique past also coexist as attributes of Picasso's woman, but in their most primitive and essential forms. The ample body of his bather is associated here with the purest monolithic block and an elemental sea.

Fig. 4 *Above Left* Piero della Francesca (active 1439; died 1492), *The Nativity* (detail). Wood, painted area 124.4 × 122.6 cm. The National Gallery, London.

Cat. no. 49 *Above* Picasso, *Seated Nude drying her Foot*, 1921.

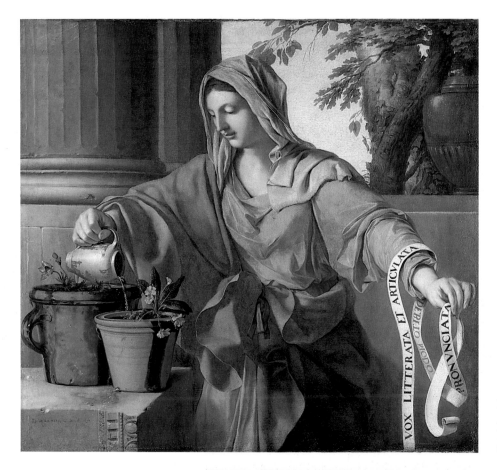

Plate 8 Laurent de la Hire, *Allegorical Figure of Grammar*, 1650. Oil on canvas, 102.9 × 113 cm. The National Gallery, London.

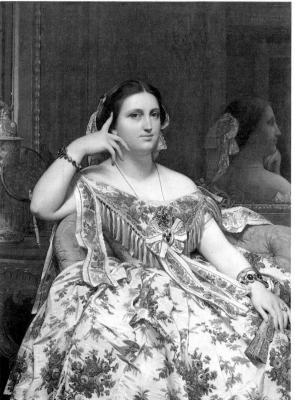

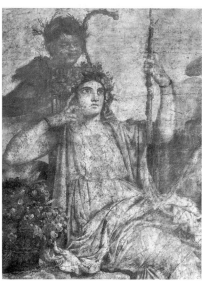

Fig. 5 *Above* Fresco from Herculaneum showing the figure of Arcadia, before AD 79. Museo Nazionale, Naples.

Fig. 6 *Left* Ingres, *Madame Moitessier*, 1844–56. Oil on canvas, 120 × 92.1 cm. The National Gallery, London.

Many Berggruen works appear ideal partners for National Gallery paintings even when there are no direct historical links between them. It is often difficult to pinpoint the factors which draw modern and Old Master works together. In some cases affinities are purely fortuitous, but in others the correspondences seem to arise from the ways artists tackled similar challenges in the picture-making process.

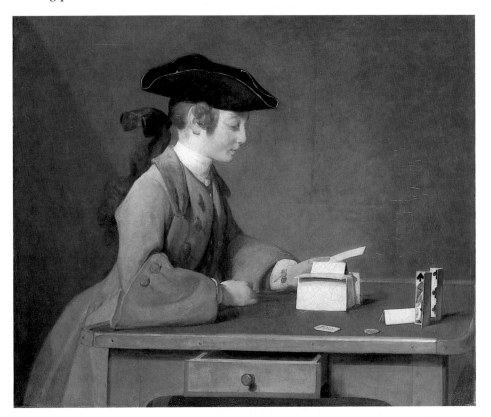

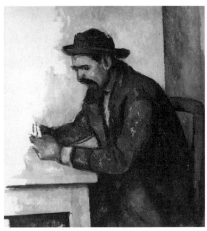

Cat. no. 20 *Above* Cézanne, *Study for the 'Cardplayers'*, 1890–2.
Plate 9 *Left* Chardin, *The House of Cards*, *c*. 1741. Oil on canvas, 60.3 × 71.8 cm. The National Gallery, London.

Compelling formal links make Cézanne's *Study for the 'Cardplayers'* (Cat. no. 20) an ideal pendant for Chardin's *The House of Cards* (Plate 9). Mirrored across time, their figures both sit at tables, engrossed in the cards they are holding. The lack of any distracting detail focuses attention on the players, joining the spectator and cardplayers in absorbed acts of perception. Both artists frame their subjects with the horizontal and vertical lines of table and wall, but create spatial tensions by setting these lines at odds with the right-angles of the picture frame. The stark compositions are offset by the softer lines of costume, and the subtle harmonies of brown, which Chardin enlivens with green and touches of red and Cézanne with blue and touches of green. Both artists made variations on these cardplayer paintings and it is possible that Cézanne may have responded to one of Chardin's works. He certainly identified with Chardin, who was hailed by many critics as a pioneer of modern painting in France because he had 'honestly' declared the pigment and surface of his pictures.

It is unlikely, in 1907, that Picasso identified in this way with the fifteenth-century Italian painter Baldovinetti. At first glance, his *Female Nude* (Cat. no. 32) appears to be the antithesis of Baldovinetti's lyrical Renaissance image, *Portrait of a Lady in Yellow* (Plate 10). Surprisingly, Picasso's barbaric female and Baldovinetti's elegant lady have a lot in common. Like his Renaissance predecessor, Picasso created a new representation of femininity which alluded to a distant sculptural source. The Renaissance cult of classical antiquity stimulated Baldovinetti to cast his sitter in the form of a Roman relief portrait. A passionate

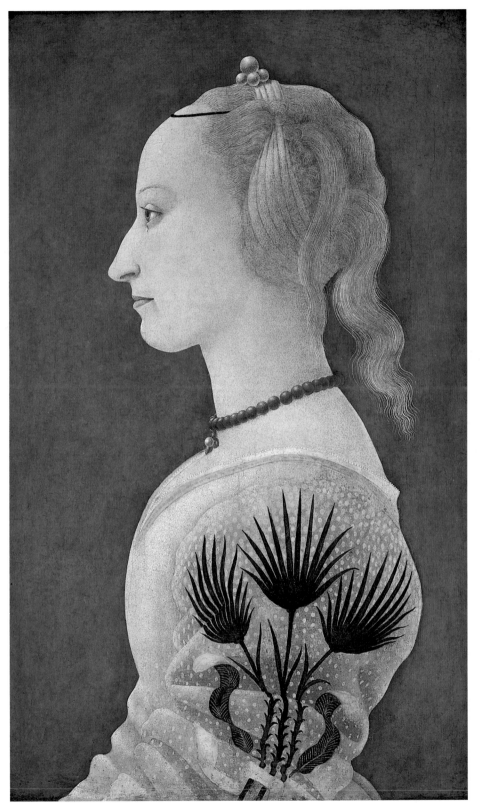

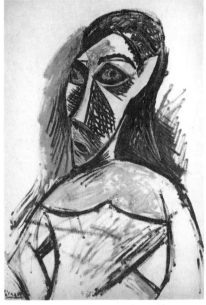

Cat. no. 32 *Above* Picasso, *Female Nude (Study for 'Les Demoiselles d'Avignon'),* 1907.

Plate 10 *Left* Baldovinetti, *Portrait of a Lady in Yellow, c.* 1465. Wood, painted area 62.9 × 40.6 cm. The National Gallery, London.

interest in tribal art fired Picasso and other avant-garde artists during the first decade of the twentieth century. Picasso's *Female Nude* is an imaginative re-creation of forms found in tribal sculpture, especially the metallic reliefs of the African Kota reliquary figures (Cat. no. 72), which were commonly found for sale in Paris at this time.

Both artists endowed their women with volume, carving out their faces with incisive black outlines and using the warmth and light of yellow skin tones to lift the faces from deep blue backgrounds. Initially the Picasso painting appears more volumetric. The figure is turned in three-quarter pose and the nose is hewn out of the face by rough hatching strokes. However, a closer look at the Renaissance painting reveals volume in the cluster of spherical pearls on the woman's head and in the deep folds of material on her sleeve. Both artists even used a similar technique of scratching through paint to suggest the texture of individual strands of hair falling loose down the necks of their models.

These comparisons between modern and Old Master paintings also offer fresh insights into the different intentions of the artists. Picasso, for example, deliberately subverted conventions of Western figurative art, rejecting the idealisation epitomised by Baldovinetti's portrait and brutalising the technique of oil painting. Baldovinetti's painting proclaims the values of fine craftsmanship, demonstrating his methodical, intellectual control over his medium. Picasso, by contrast, attempted to convey, through his reckless handling, the raw energy and instinctive forces which generated his 'primitive' woman.

'The beauties of the Parthenon, Venuses, Nymphs, Narcissuses, are so many lies. Art is not the application of a canon of beauty but what the instinct and the brain can conceive beyond any canon.'[6] While this statement by Picasso pertains to the iconoclastic study for *Les Demoiselles d'Avignon* (Cat. no. 32), his recurring celebration of classical beauty in other drawings and paintings (Cat. nos. 66 and 49) indicates that he did not reject the classical tradition or any other canon of art but demanded the freedom to re-create and combine different types of representation. His painting *The Yellow Sweater* (Cat. no. 63) demonstrates this ambivalent response to and provocative play with tradition.

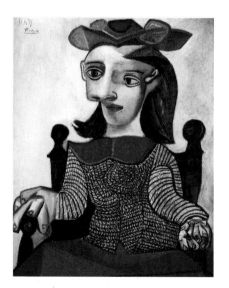

Extreme deformities characterise many of Picasso's portraits after the Second World War, especially the paintings of his beautiful mistress Dora Maar. At first glance, the displacement of Dora Maar's features and distortion of her hands in *The Yellow Sweater* appear monstrous. There is a suggestion that Picasso's model has become a victim, her beauty perverted and destroyed in a session of artistic torture. Picasso's motives appear less destructive, however, when the painting is compared to a seventeenth-century portrait by Rubens in the National Gallery. Picasso's Dora Maar in *The Yellow Sweater* has a companion from the past in the alluring woman of '*Le Chapeau de Paille*' (Plate 11), thought to be the artist's sister-in-law Susanna Lunden.

Long before Picasso, Rubens made use of distortion for expressive purposes in his portraits. The exaggeration of this woman's eyes, breasts and hands intensifies the spectator's experience of her most characteristic features or 'best points'. Vivid colour contrasts of red and green, the agitated patterns and textures of costume and the wind-blown wisps of hair also help to animate the painting and suggest, perhaps, the model's vivacious personality. Picasso used similar devices of flamboyant hat, fussy top, strident colour contrasts and wayward hair to endow his sitter with a sense of life and character. The spontaneous technique of both artists also creates energy and movement in the paintings. Rubens used rapid, sketchy strokes for the stormy sky and for the woman's sleeve in the bottom right section of the picture, which was a later addition. There are traces of reworking in Picasso's painting and the fluent dashes of green in Dora Maar's hat indicate that he also developed the image in an impromptu way.

Cat. no. 63 *Above* Picasso, *The Yellow Sweater*, 1939.

Plate 11 *Opposite* Rubens, '*Le Chapeau de Paille*', c. 1622–5. Wood, approximately 79 × 54 cm. The National Gallery, London.

6 Picasso statement to Christian Zervos, 1935, in Ashton, op. cit., p. 73.

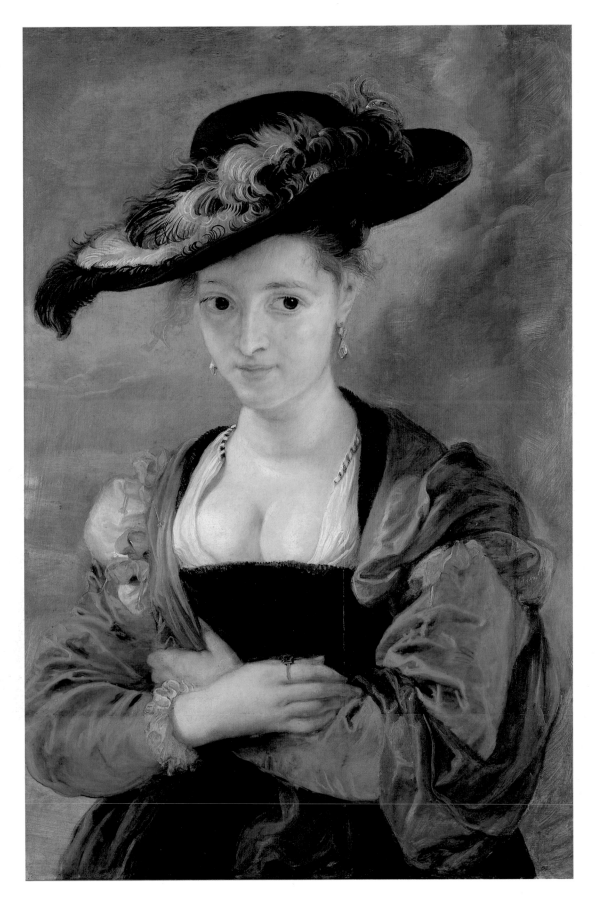

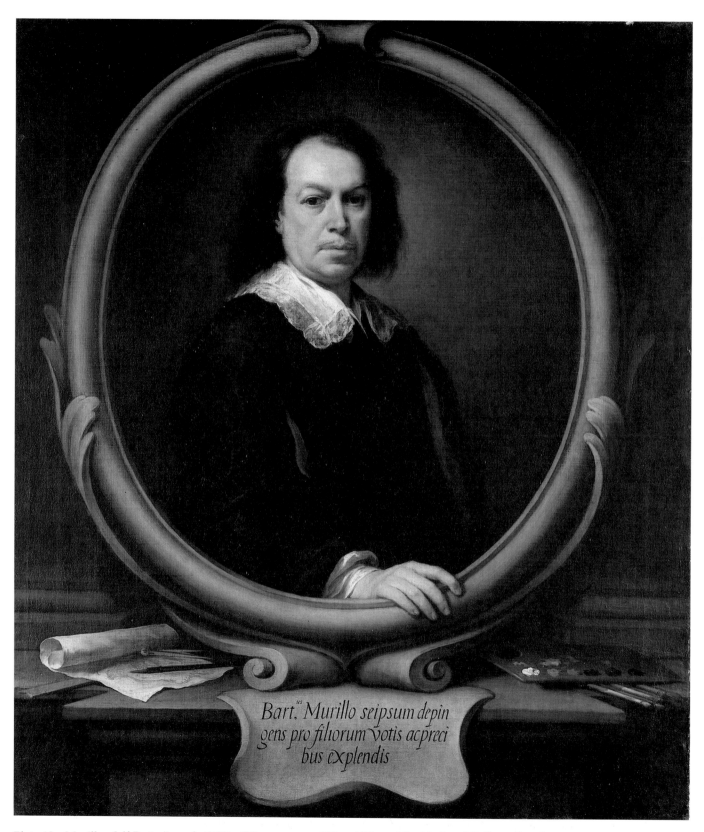

Plate 12 Murillo, *Self Portrait*, early 1670s. Oil on canvas, 122 × 107 cm. The National Gallery, London.

'We all know that art is not truth. Art is a lie that make us realise truth.'[7] Throughout his career, Picasso returned to the teasing spirit and visual conundrums of Cubism which expressed his belief in the freedom and autonomy of art, independent of any model in nature. This self-referential aspect of Picasso's art and his practice of inverting real and fictive elements in a picture, also characterises much Spanish painting of the past. Murillo's *Self Portrait* (Plate 12), for instance, is a manifesto of the artist's power to imitate and then reinvent nature in a painting. The artist used spatial games to confuse boundaries between real and painted life. His self portrait, for example, is represented as a painting within the painting, but the hand projects as though there were a real man behind the frame.

Picasso's humorous little relief *Woman Seated* (Cat. no. 64), constructed on a box that had contained *Gitanes* cigarettes, plays similar games but pushes them

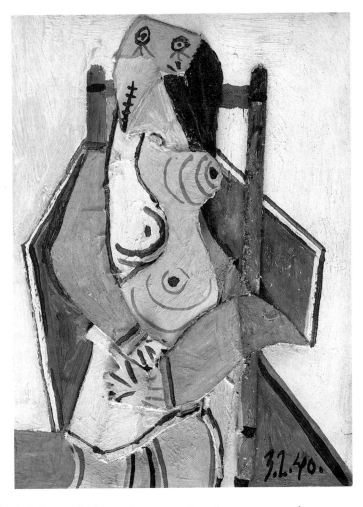

Cat. no. 64 Picasso, *Woman Seated*, 1940.

further than Murillo did. Instead of merely suggesting the presence of a convex form such as the oval frame in Murillo's painting, Picasso literally made one by glueing a section of a paintbrush onto the surface of the box to represent the frame of the chair. This 'real' element paradoxically throws a painted shadow, which Picasso sketched in down its left side. Whereas Murillo left a 'real' blob of white paint on the image of his palette, Picasso combined painting and relief sculpture, giving his paint 'real' three-dimensional substance.

Perhaps the most beguiling and enigmatic relationship that can be established between a modern work in the Berggruen Collection and an Old Master painting

7 Picasso statement to Marius de Zayas, 1923, in Ashton, op. cit. p. 3.

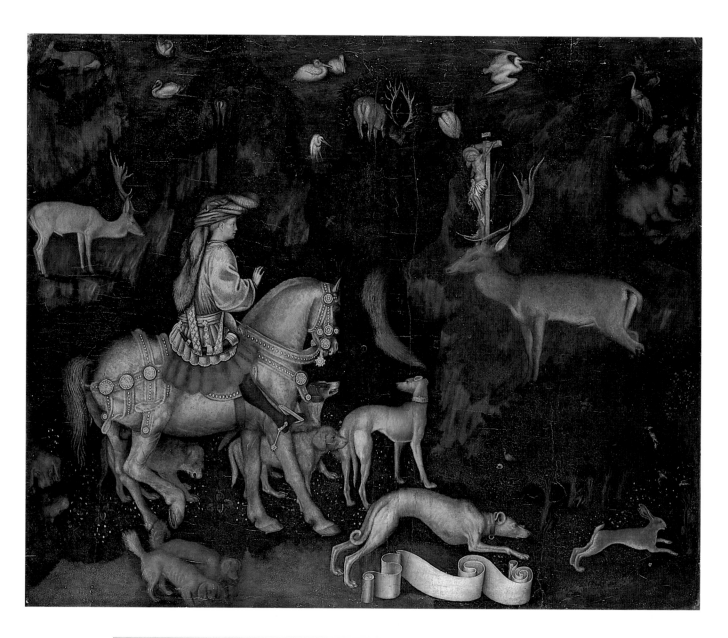

Plate 13 *Above* Pisanello (living 1395; died 1455?), *The Vision of Saint Eustace*. Wood, painted area, 54.5 × 65.5 cm. The National Gallery, London.

Cat. no. 69 *Left* Miró, *Dialogue of Insects*, 1924–5.

in the National Gallery is that between Miró's *Dialogue of Insects* (Cat. no. 69) and Pisanello's *Vision of Saint Eustace* (Plate 13). They are poetic, visionary paintings which hover between dream and reality. Charming, delicate, whimsical, they have an air of childish innocence and Eden-like purity, but at the heart of each painting are indications of violence and cruelty.

Pisanello and Miró created microcosms of the natural world, filling their paintings with lovingly observed details of animal, bird and insect life. Neither artist was concerned, however, to transcribe these details directly from nature. Pisanello adapted and recombined flora and fauna drawn from pattern books, creating new environments and dramas for these specimens in his imagination. Encouraged by his involvement with the Surrealists, Miró searched his subconscious for the characters of his paintings. Following the example of Eskimo and North American Indian art, he then simplified and stylised these creatures into effective pictographic symbols which evoked forms in the natural world but had their own fantastic life.

Pisanello's painting depicts the Christian legend of the conversion of Saint Eustace, who was an officer in Trajan's army. Dressed in courtly costume, accompanied by a bizarre retinue of cuddly domestic pets and lean hunting dogs, Pisanello's Eustace confronts his prey. His killing instincts are, however, quelled and he is converted to Christianity by the vision of a radiant crucifix between the antlers of the stag. The appearance of Christ, torn and bleeding on the cross, in the midst of this virgin forest, suggests the constant threat to God's universe posed by man's cruelty and sinfulness.

Imminent death is a reality in Miró's painting, but there is no hope of redemption. The painting shows a finely balanced ecosystem where organisms prey off one another and watch the death of other creatures with equanimity. The flying organism in the top left corner pursues its centipede-like prey with tentacle arms waving. Little black droplets falling from a bladder-shaped sac at the end of its body perhaps suggest that this creature has just digested a similar meal. On the other side of the painting, two delicate insects fly hazardously within reach of a thin spidery creature, while below a ravenous little worm, with flickering tongue, takes a break from gorging on a plant to survey the scene. An excruciating accident has taken place in the right foreground of the painting where a moustachioed crawlie loses a leg and continues its journey without it. Miró painted the remaining limb red, which might suggest the blood or burning pain that resulted from this amputation.

The presence of the Berggruen Collection in the National Gallery emphasises the marvellous vitality of modern and Old Master traditions. Far from being a mausoleum for Western art, the National Gallery is a space for living paintings which are constantly open to new interpretations. Associations will inevitably form between works in the Berggruen Collection and National Gallery paintings and the experience of comparing and contrasting these will generate new identities. Picasso was convinced of this powerful life force and denied any division between old and modern art: 'To me there is no past or future in art. If a work of art cannot always live in the present it must not be considered at all.'[8]

8 Ibid, p. 4.

Vincent van Gogh

1853–1890

Vincent van Gogh

1 An Autumn Garden
1888

Oil on canvas, 71.7 × 91.5 cm

In a number of letters to his brother Theo, written in October 1888, van Gogh described a group of paintings of the public garden at Arles that were currently occupying him. Writing of the present picture he announced: 'I have done another size 30 canvas, "An Autumn Garden", with two cypresses, bottle green, shaped like bottles, and three little chestnut trees with tobacco and orange-coloured leaves. And a little yew tree with pale citron foliage and a violet trunk, and two little bushes, blood-red and scarlet purple leaves. And some sand, some grass, and some blue sky.' Before long the subject had taken on wider associations, and van Gogh had begun to refer to it as 'the poet's garden', anticipating a time when he could use his canvases to decorate a room for his fellow painter Paul Gauguin, 'the new poet living here'. In a letter to Gauguin, who had promised to join him in Arles later that month, van Gogh wrote: 'I have expressly made a decoration for the room you will be staying in, a poet's garden . . . the ordinary public garden contains plants and shrubs that make one dream of landscapes in which one likes to imagine the presence of Botticelli, Giotto, Petrarch, Dante and Boccaccio.'

Like his other pictures of the park, *An Autumn Garden* contrasts the broad, pale sweep of the footpath with the colourful mass of trees, and a spacious foreground with the dense foliage beyond. Small figures are used to establish scale, while glimpses of distant buildings and sky suggest sunlight and the life beyond the park. Within this carefully considered structure van Gogh has responded to the autumnal scene with exceptional directness, applying his paint in thick strokes, dabs and bars of paint. Many of the Arles paintings were generously and sensuously painted, but few approach the sheer physicality of this picture. Not only do streaks and flourishes of paint stand proud of the canvas surface, but many are agitated into networks or textures that further describe their subjects and give direction to spaces and forms. While there are those who prefer to see such brushwork as evidence of frenzy, a close scrutiny of these pictures shows the ingenuity and control of van Gogh's technique. Vertical accents are set against horizontal thrusts, spatial recession is balanced by surface incident, and the ebb and flow of brushstrokes underscores the rhythm of the subject. Though van Gogh was his own most severe critic, and occasionally destroyed or reworked his canvases (some evidence of scraping down is visible in the right-hand corner of this picture), the bottle-green trees and tobacco-coloured leaves of *An Autumn Garden* are the work of an unusually precise, deliberate artist.

PROVENANCE: Mrs J. van Gogh-Bonger, Amsterdam; Jenny Basch, Berlin; Paul Cassirer, Berlin; Paul von Mendelssohn-Bartholdy, Berlin; Mrs Kesselstadt; Rosenberg and Stiebel, New York; Henry Ford II; private collection, Venezuela; Acquavella Galleries, New York.

EXHIBITIONS: Amsterdam 1905, no. 126; Munich 1909, no. 37; Berlin 1913, no. 28; Berlin 1921; Basle 1924, no. 45 or 47; Amsterdam 1930, no. 58 bis; London 1979–80, no. 101.

LITERATURE: De la Faille 1928, vol. II, no. 472, pl. CXXXI; Sherjon and De Gruyter 1937, no. 106, p. 135, ill.; De la Faille 1939, no. 495, ill. p. 352; Letters 1958, vol. III, no. 551; De la Faille 1970, no. 472, ill. p. 214; Lecaldano 1971, no. 591, pp. 215–16, ill.; Hulsker 1974, pp. 22–32; Hulsker 1980, no. 1598, ill. p. 368; Pickvance 1984, p. 182 and p. 264; Dorn 1988, p. 375; Feilchenfeldt 1988, p. 97, ill. p. 28; Wentinck 1989, ill. p. 50; Walther-Metzger 1990, t. 11, ill. p. 435.

Vincent van Gogh

2 Arles, View from the Wheat Fields
1888

Reed pen and sepia ink on paper, 31.2 × 24.2 cm. Signed lower right: *Vincent*

Apart from drawings made for their own sake, or in preparation for other works of art, van Gogh executed a number of pen-and-ink variants or replicas of his oil paintings to give to friends. It has been suggested that *Arles, View from the Wheat Fields* is one of three such studies of the same picture, *The Reapers* (Fig. 7), that van Gogh made in early August 1888; two were given to fellow painters, and this drawing to his brother Theo. Despite the great vigour of the drawing there are signs that it has been carefully composed and executed. A few light pencil marks were first made to indicate its dominant forms, followed by a careful sequence of pen strokes of varying intensity. This technique allows no subsequent erasures or alterations, and areas such as the distant train and the factory smoke have evidently been defined before the build-up of surrounding detail. Using a range of dots, stipples and curving strokes, van Gogh has then summarised the tones and textures of the landscape, from the fine detail of the distant town to the roughness of the foreground stubble. The reed pen, an instrument often used by Rembrandt, one of van Gogh's favourite artists, is ideally suited to such blunt, rhythmic marks, and is here ingeniously handled to echo the brushstrokes of the original painting.

This view of Arles was the subject of other drawings and paintings by van Gogh, notably the large horizontal canvas *Wheat Field with Setting Sun* (Kunstmuseum, Winterthur). In all his studies, the buildings of the town, including its Roman amphitheatre, churches and factories, have been carefully described, and the close proximity of rural and urban life stressed. For van Gogh such subjects were fraught with private significance, and the prominent image of the train, the centrally placed sun and the figures of the reapers were all open to literary, biblical and perhaps morbid interpretation. An avid reader of Emile Zola's novels of contemporary life, which included tales of the Provençal countryside and of the new industrial towns, van Gogh was also erudite in matters of art. In letters of this period he mentions with admiration Vermeer and Delacroix, Rembrandt and Degas, Monticelli and Cézanne, and was soon to execute some copies after Millet, including one of a reaper in a cornfield.

PROVENANCE: Theo Van Gogh, Amsterdam; Mrs J. van Gogh-Bonger, Amsterdam; Paul Cassirer, Berlin; Gustav Engelbrecht, Hamburg; J. Freund, Berlin; Robert von Hirsch, Basle; Goulandris, London; Thomas Gibson Fine Art, London.

EXHIBITIONS: Amsterdam 1905, no. 374; Berlin 1907, no. 123; Berlin 1914, no. 87a; Berlin 1927; Basle 1943, no. 162; Basle 1945, no. 24; Basle 1947, no. 161; New York 1984, no. 82, ill. p. 146; London 1987, pp. 46–7, ill.

LITERATURE: De la Faille 1928, no. F 1492, ill.; Hans von Marées-Gesellschaft 1928, pl. XI; Letters 1958, vol. II no. 498 and vol. III no. 519; Lecaldano 1971, no. 565c, ill.; De la Faille 1970, no. F 1492; Hulsker 1980, no. 1544; Walker 1981, p. 35; Thomson 1983, ill. p. 162; Bonafoux 1987, p. 82, ill.; Feilchenfeldt 1988, p. 135; Van der Wolk-Pickvance 1990, p. 233.

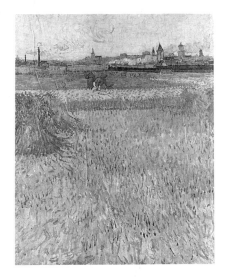

Fig. 7 Van Gogh, *The Reapers*, 1888. Oil on canvas, 73 × 54 cm. Musée Rodin, Paris.

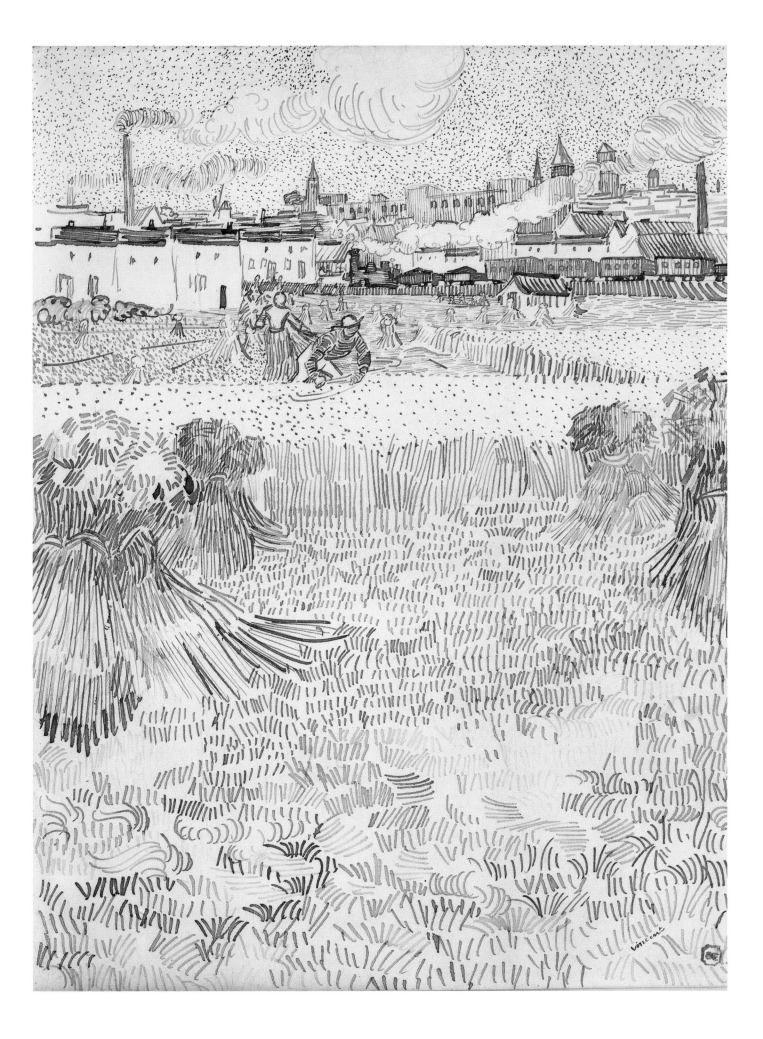

Georges Seurat

1859–1891

Georges Seurat

3 Crouching Boy

c. 1882

Conté crayon on paper, 32 × 25 cm

This drawing was made by Seurat during the crucial transition from his youthful to his mature career. In the late 1870s Seurat had studied at the Ecole des Beaux-Arts under Henri Lehmann, a follower of Ingres who instructed his pupils in the virtues of classicism and the pre-eminence of draughtsmanship. Like generations of young artists before him, Seurat had learnt to draw by studying antique sculpture and the nude model, rendering each nuance of tone and every shift of contour with careful touches of pencil or charcoal. In 1879, as he approached the age of 20, Seurat began a year of military training, and it was during this period that his own preoccupations and technical concerns began to emerge. Still relying on his skills as a draughtsman, he began to record the soldiers, labourers and everyday subjects that he encountered, evolving a looser and more personal manner appropriate to his new subject matter. Towards the end of 1881 Seurat signed and dated a number of drawings of single figures, each one dramatically poised between deep shadow and pools of light. As in *Crouching Boy*, the legacy of his training is evident in the disciplined parallel hatching and symmetrical composition of these drawings, but they are also recognisable as the work of an artist who has begun to define, and partly fulfil, his own pictorial ambitions.

Crouching Boy is executed in Seurat's most distinctive materials – black conté crayon applied freely and inventively to finely textured laid paper. The subject may have been suggested by a figure seen in the street, or perhaps posed in his studio, although it does not correspond to any known painting by the artist. At this stage in his career Seurat was making his first tentative experiments with oil painting, but drawing continued to play a central role in his creative processes. Many sheets of studies, such as *Crouching Boy*, appear to have been made for their own sake and were exhibited by Seurat as independent works of art, while a number of later drawings, for example, *Man in a Bowler Hat* (Cat. no. 8), were clearly produced in the preparation of larger paintings.

PROVENANCE: Edmond Cousturier, Paris; Dikran Khan Kelekian; D. K. Kelekian sale, New York 1922; René Bardey, R. Bardey sale, Paris 1927; Mme Lucien Milinaire, Paris; Edouard Loeb, Paris; César de Hauke, Paris; Hector Brame, Paris; Reid & Lefèvre, London; Philipp Goldberg, London (1962).

EXHIBITIONS: Paris 1900, no. 45; Paris 1908–9, no. 122; Paris 1920, no. 60; Paris 1926, no. 128 (not exhibited); London 1957, no. 18, ill. p. 14; Geneva 1988, no. 13, ill. p. 49.

LITERATURE: Sale, Dikran Khan Kelekian collection, New York, Hotel Plaza, 30 January 1922, no. 19; sale, Paris Hôtel Drouot, 'Tableaux Modernes, Aquarelles', 29 April 1927, no. 79; *Burlington Magazine*, vol. XCVIII, no. 645, December 1956, pl. XX; *The Illustrated London News*, 16 March 1957, p. 439; De Hauke 1961, vol. II, no. 490, p. 94, ill. p. 95; Chastel 1973, no. D 188, p. 113, ill.; Goldberg sale, Christie's, London 1986, no. 160, ill. p. 104; Madeleine-Perdrillat 1990, ill. p. 152.

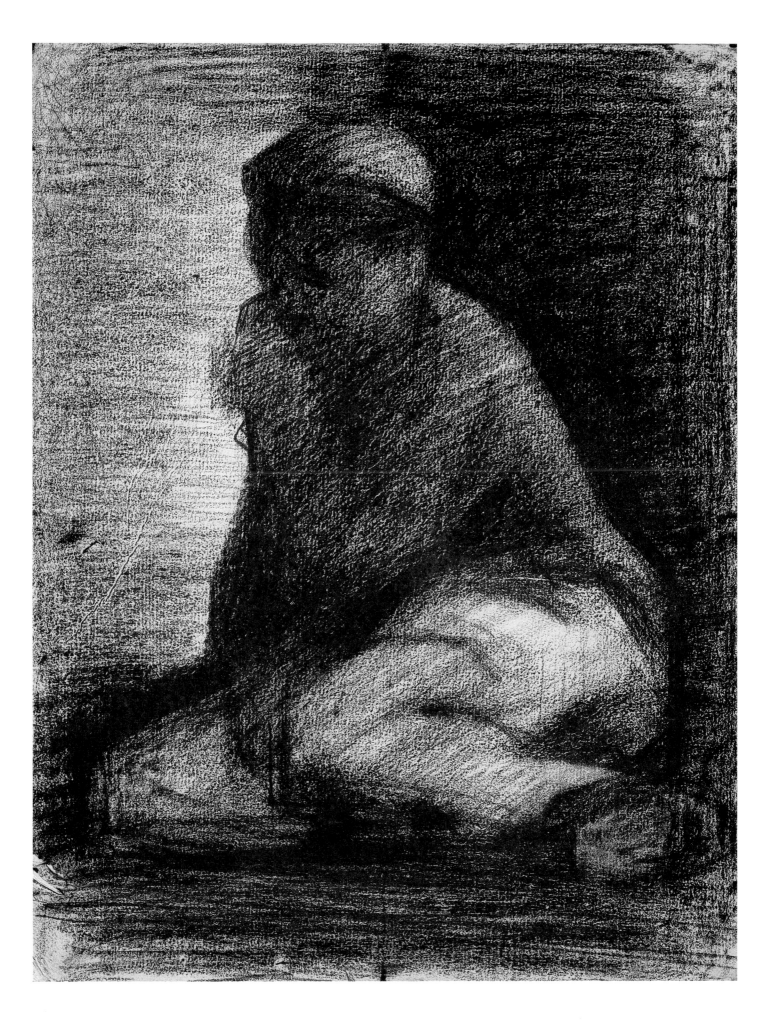

Georges Seurat

4 The Lady in Black

c. 1882

Conté crayon on paper, 30.7 × 23 cm

The Lady in Black is one of a remarkable series of standing male and female figures drawn by Seurat in the early 1880s. Often placed in the centre of the composition, and occupying the full height of the sheet, these figures are made to dominate their surroundings with the minimum of means. Details of faces, hands and even backgrounds are suppressed, and it is only the subtle modulations of Seurat's crayon that animate and inform the scene. Using a variety of horizontal and vertical hatching strokes, he built up an extraordinary range of tones and textures, from the palest of warm greys to the darkest of waxy blacks. In *The Lady in Black*, a new and highly distinctive crayon stroke has also appeared: to the left of the figure, Seurat has used the sharpened point of the conté crayon in a meandering, almost arbitrary line that curves and weaves over the surface of the paper. This line – which is also much in evidence in *The Bridge at Courbevoie* (Cat. no. 13) – signals Seurat's final progression beyond his academic past, a replacement of the rigid tonal systems of convention with an anarchic, improvised alternative. From this point onwards, outline and hatching virtually disappeared from his repertoire, and the uninhibited interplay of light and shadow dominated Seurat's art.

The radical simplicity of *The Lady in Black* does not, however, obscure its subject. As in so many of this group of drawings Seurat has retained precisely those indicators of costume, posture and activity that allow us to identify the type, if not the individual, represented. Here, the haughty bearing and full-length, high-collared coat mark out the model as a fashionably dressed and socially elevated lady, perhaps walking along a boulevard or waiting for a companion. Despite their economy of form and technical similarity, this drawing and *Crouching Boy* (Cat. no. 3) could scarcely be more contrasted. Light-effects, body language and incidental detail all describe representatives of two quite different social classes, and leave us in little doubt where Seurat's own sympathies lay. Following the example of Manet, Degas, Pissarro and others, Seurat increasingly regarded his art as having both a documentary and a polemical role in contemporary society. His drawings of street vendors, idlers, entertainers and labourers make up a catalogue of urban experience, and were soon to be ambitiously juxtaposed in his painted panoramas of modern life.

PROVENANCE: Theo van Rysselberghe, Brussels; Charles Vignier, Paris; Charles Gillet, Lyon; César de Hauke, Paris; Paul Brame, Paris.

EXHIBITIONS: Paris 1908–9, no. 179; Bielefeld et al. 1983–4, cat. no. 37, ill. p. 185; Geneva 1988, no. 14, ill. p. 51.

LITERATURE: De Hauke 1961, vol. II, no. 508, p. 102, ill. p. 103; Herbert 1962, no. 89, p. 98, ill. p. 97; Madeleine-Perdrillat 1990, ill. p. 145.

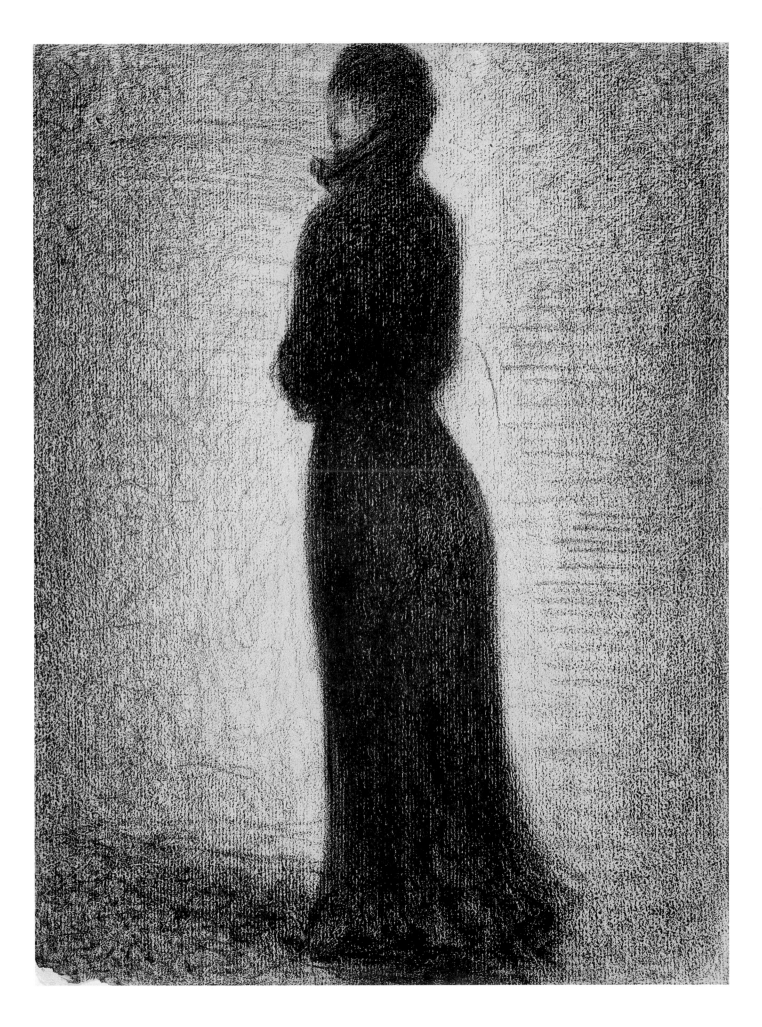

Georges Seurat

5 The Nanny
c. 1882

Conté crayon on paper, 32 × 25 cm

The nanny, wet nurse or *nourrice* was a familiar figure in late-nineteenth-century France and featured in several drawings and paintings by Seurat (Fig. 8). Distinguished by her long cape and extravagant headgear, the nanny also appears in a number of Impressionist canvases, often in an incidental role as she tends the children of her superiors. In this drawing she becomes the central subject of the composition, the severe geometry of her cloak dominating the sheet and only her headdress and the spectral figure of the child breaking its symmetry. In a slightly later study Seurat reversed these tonal relationships, contrasting a dark headdress with a pale cloak, and setting his model against a shadowy landscape. This later drawing was clearly a study for the seated nurse (by now dressed in red and pink) at the left of *La Grande Jatte* (see Fig. 11), and it appears that *The Nanny* is one of several figures that anticipated the dramatis personae of this painting by two or three years.

The intense velvety black of the cloak in *The Nanny* was built up through repeated applications of conté crayon, the artist avoiding the linear strokes of traditional crosshatching and producing an almost directionless area of tone. Working on a fine-grained Ingres paper (the watermark of the maker, Michallet, can be seen on the left), Seurat has allowed its texture and colour to play a prominent part in the final image. In places, the grid-like pattern of the surface is accentuated by the superimposed conté, while in other areas, such as the cloak, the texture of the paper has almost been filled in. This combination of materials, which is now inseparably linked with Seurat, provided him with a graphic equivalent for the subtle range of highlights and shadows more usually associated with painting. In a drawing such as *The Nanny*, it enabled the artist to make the central figure both austere and radiant, while the surrounding space seems to glow with the warmth of the half-concealed paper. In spite of its simplicity the drawing combines considerable grandeur with fine touches of detail, the sombre regularity of its composition enlivened by minute inflections in the nurse's bonnet and her charge's face.

PROVENANCE: Léon Keller, Paris; Paul Rosenberg, New York.

EXHIBITIONS: Paris 1936[2], no. 104; New York 1949, no. 57; Bielefeld et al. 1983–4, no. 35, ill. p. 185; Geneva 1988, no. 15, ill. p. 53.

LITERATURE: Rich 1935, no. 3, p. 59; Frost 1942, p. 33; Laprade 1945, mentioned p. IX; De Hauke 1961, vol. II, no. 486, p. 92, ill. p. 93; Russell 1965, no. 142, ill. p. 155; Chastel 1973, no. D 115, ill. p. 113; Nochlin 1989, ill. p. 146; Madeleine-Perdrillat 1990, ill. p. 120.

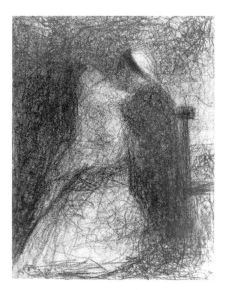

Fig. 8 Seurat, *Seated Nanny holding a Child*, *c.* 1882. Conté crayon, 30 × 24 cm. Musée du Louvre, Paris.

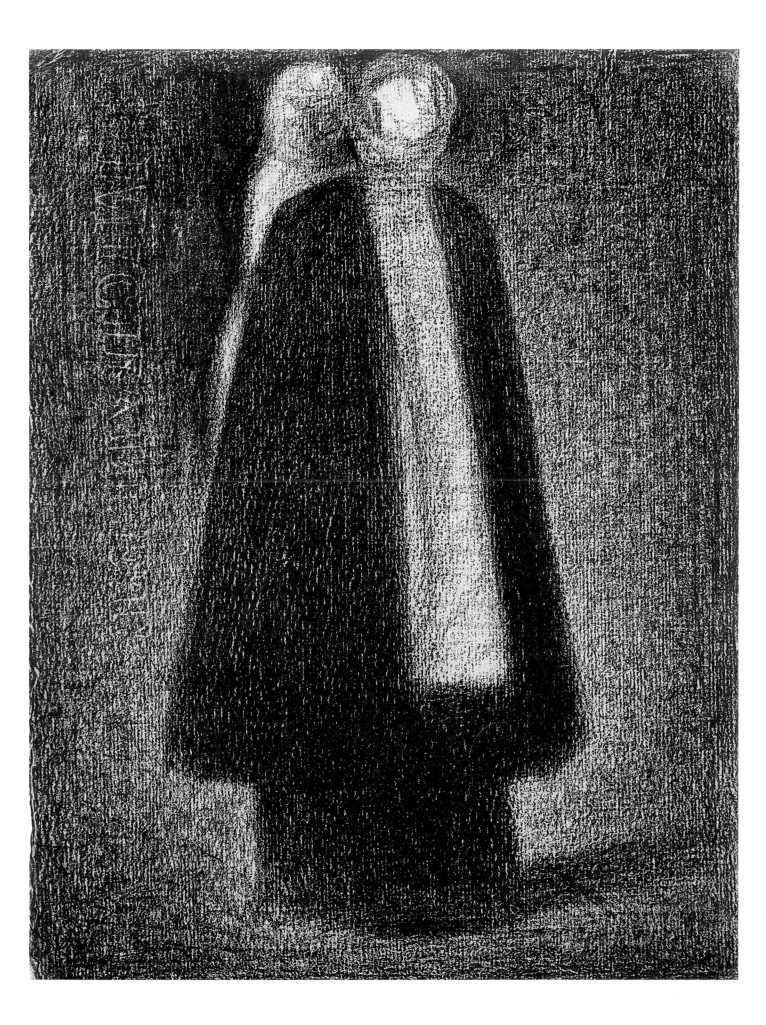

Georges Seurat

6 Woman Reading
c. 1883

Conté crayon on paper, 30 × 23 cm

For all its radical topicality, Seurat's work was deeply informed by the art of the past and by the example of his older and younger contemporaries. Like Degas, he was trained by a follower of Ingres, and committed to the tradition which separated drawing and tonal construction from the rival demands of colour. A study such as *Woman Reading* shows his indebtedness to another tradition, that of Rembrandt and seventeenth-century Dutch painting, which had already influenced the Impressionist generation. Artists as varied as Manet, Fantin-Latour, Cézanne and Whistler had turned to the commonplace subject matter and brilliant effects of light in Rembrandt's etchings and the recently rediscovered paintings of Vermeer, finding in them a model for their own aggressive modernity. Following their example, Seurat and the friends of his student days – such as Edmond Aman-Jean and Ernest Laurent – developed a similar responsiveness to deep shadows and finely judged highlights, using black chalk or crayon in a way that often recalls the most crepuscular examples of Dutch painting.

Like Rembrandt, Seurat based much of his early graphic work on his own family or on models taken from his immediate surroundings. *Woman Reading* probably depicts his mother, posing for her son while working by the light of an oil lamp. In contrast to other drawings of the same model (Fig. 9), Seurat has almost entirely omitted details of her costume, physiognomy and background, to the extent that his mother's activity remains indeterminate. While the subdued lighting and the demands of a long sitting may partly explain his approach, in *Woman Reading* Seurat has chosen to emphasise the fundamental components of pictorial experience. Summarising the information presented to his senses in a few near-geometric forms, in a way that vividly recalls the contemporary work of Cézanne (Cat. no. 17), Seurat has created graphic equivalents for light and space, volume and mass, texture and palpability. Though simple in structure, the composition artfully balances paler and darker greys, angular and rounded forms, and Seurat's characteristic manipulation of contrasts ensures that a shadowed profile falls against a light wall and that the darkened table is accentuated by a bright highlight.

PROVENANCE: Theo van Rysselberghe, Brussels; Charles Vignier, Paris; Eduard von der Heydt, Wuppertal; Alfred Flechtheim, Berlin; N. F. Tollenaar, London; C. F. Stoop, London (1932); Reid & Lefèvre, London.

EXHIBITIONS: Paris 1908–9, no. 178; Paris 1926, no. 46; New York 1929, no. 70; Bielefeld et al. 1983–4, no. 54, ill. p. 188; Geneva 1988, no. 16, ill. p. 55.

LITERATURE: Kahn 1928, no. 33; Hope Johnstone 1932, p. 201, fig. 24; Laprade 1945, p. 69; De Hauke 1961, vol. II, no. 581, p. 158, ill. p. 159; Herbert 1962, no. 74, ill. p. 79; Chastel 1973, no. D 148, ill. p. 115.

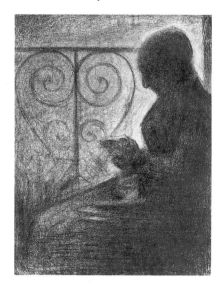

Fig. 9 Seurat, *In front of the Balcony*, 1883–4. Conté crayon, 31 × 24 cm. Musée du Louvre, Paris.

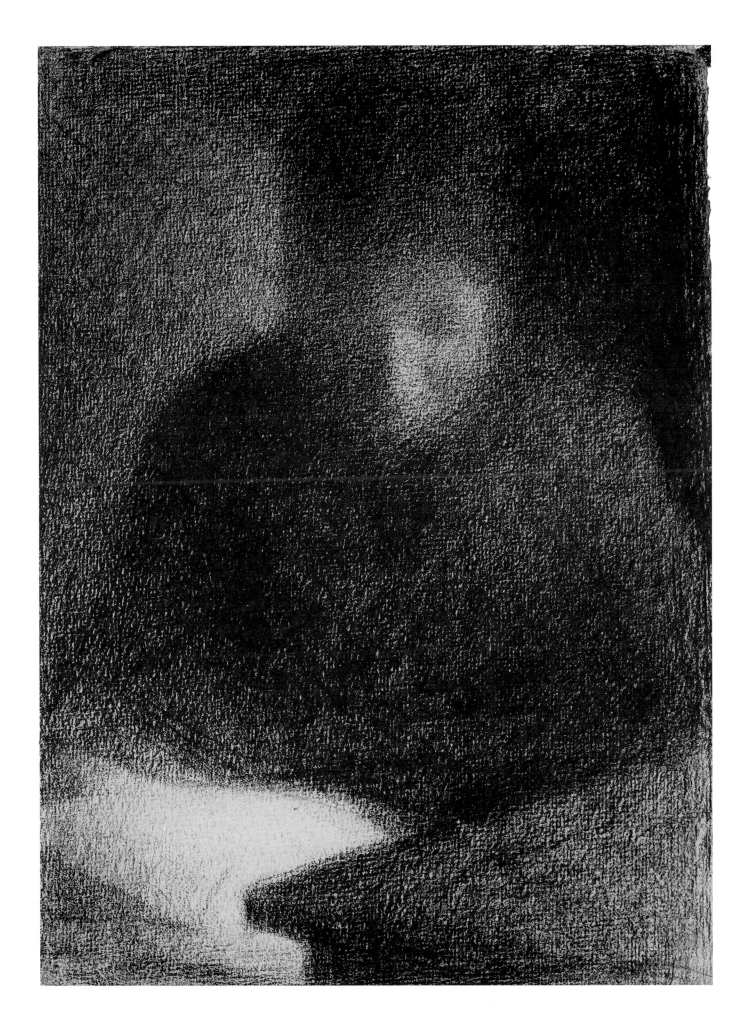

Georges Seurat

7 The Rainbow
c. 1883

Oil on panel, 15.5 × 24.5 cm. Signed lower left: *Seurat*

After the self-imposed apprenticeship of his early career, during which he produced only drawings and small painted studies, Seurat launched himself in earnest as a public artist by embarking on two large-scale canvases. The first of these, which now belongs to the National Gallery, was *Bathers at Asnières* (Fig. 10), exhibited at the Salon des Indépendants in 1884 and apparently evolved through a series of drawings and small oil paintings in the previous year. *The Rainbow* is one of more than a dozen such preparatory paintings, executed briskly and directly onto a small wooden panel of a size much favoured by Seurat. The earliest of these panels were probably painted outdoors, in front of the chosen scene, and include a number of experiments with different viewpoints and various permutations of figures, boats and horses. As Seurat's intentions became more defined, the panels began to look increasingly like studio studies, and it is noticeable that certain landscape features, such as the curving riverbank and the industrial skyline, were repeated with little variation. In *The Rainbow*, the essential structure of the final composition has been resolved, though a few remaining hints of the *plein-air* sketch, and of course the rainbow itself, have yet to disappear.

The setting of *The Rainbow*, and of Seurat's second large-scale picture, *Sunday Afternoon on the Island of La Grande Jatte* (see Fig. 11), is a stretch of the River Seine in northwest Paris, between the bridges at Asnières and Courbevoie (Cat. no. 13). In the distance can be seen the large factories at Clichy, while in the foreground a scattering of male figures relax in the sunshine. In the final stages of *Bathers at Asnières*, and following such studies as *Man in a Bowler Hat* (Cat. no. 8), these figures were to increase in both number and significance, until they ultimately dominated the landscape that forms the basis of *The Rainbow*.

PROVENANCE: Félix Fénéon, Paris; Etienne Bignou, Paris; D.W.T. Cargill, Lanark (Scotland); Reid & Lefèvre, London; Mrs Dwight F. Davis, Washington; Acquavella Galleries, New York.

EXHIBITIONS: New York 1885, no. 133; Paris 1887, no. 447; Brussels 1892, no. 1; Paris 1908–9, no. 22; Paris 1919–20; London 1926; London 1932, no. 5544; New York 1940, no. 14; New York 1942, no. 24; New York 1949, no. 5, ill. On extended loan to the Los Angeles County Museum (January 1972–October 1984); Geneva 1988, no. 17, ill. p. 57.

LITERATURE: *Illustrated London News*, 2 January 1932, ill.; Nicolson 1941, ill. p. 141, pl. II B; *Art News*, March 1942, ill.; Cooper 1946, no. 9, p. 13, ill. no. 6, p. 8; Dorra-Rewald 1959, no. 92, ill. p. 91; De Hauke 1961, vol. I, no. 89, p. 52, ill. pp. 53, 198; Chastel 1973, no. 89, ill. p. 96; Madeleine-Perdrillat 1990, p. 49, ill. p. 48; Rewald 1990, ill. p. 60.

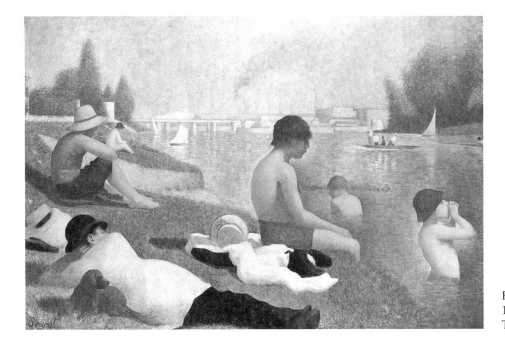

Fig. 10 Seurat, *Bathers at Asnières*, 1883–4. Oil on canvas, 201 × 300 cm. The National Gallery, London.

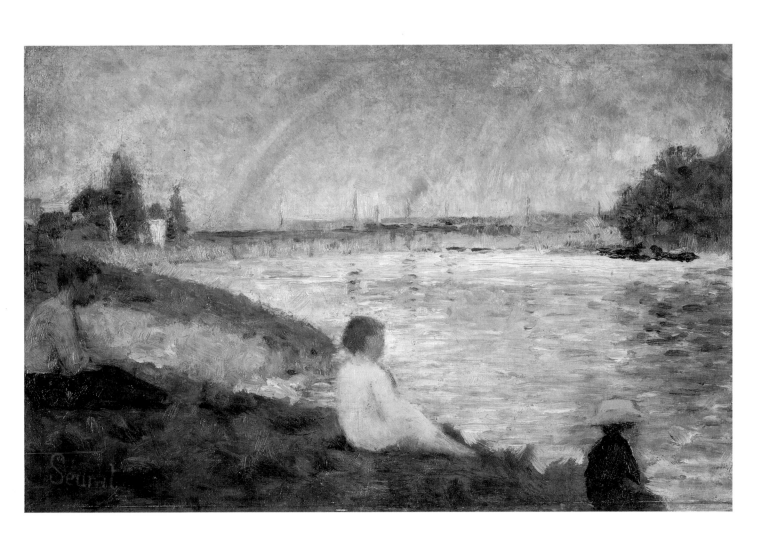

Georges Seurat

8 Man in a Bowler Hat
1883–4

Conté crayon on paper, 24 × 30 cm. Inscribed on verso: *G. Seurat; La baignade, 320*

Seurat's preparatory studies for *Bathers at Asnières* (see Fig. 10) included more than 20 drawings and small paintings. The paintings (see Cat. no. 7) were used principally to explore the picture's composition, while the works on paper, such as *Man in a Bowler Hat*, concentrated on individual figures, and on details of pose or clothing. Such meticulous preparation was partly the legacy of Seurat's academic training, but was also a response to the demands and ambitions of his first large-scale canvas. By determining in advance the dominant features, the tonal and chromatic relationships, and even the precise gestures of certain of the protagonists, Seurat was able to proceed with confidence towards the final resolution of his image. *Man in a Bowler Hat* is one of the most intense and specific of these studies, an unusual close-up of a single figure in which the folds of the clothing are patiently analysed. The drawing reminds us of the distinctive meeting of the traditional and the contemporary in Seurat's work: on the one hand it recalls the drapery studies of the artists of the past, such as Leonardo da Vinci, and on the other it insists upon the modernity of its present subject. This is an ordinary Parisian workman, not a biblical or historical character, who is here celebrated in a fresco-sized public image. Like the other figures in *Bathers at Asnières* the bowler-hatted man is a paradigm of the industrial populace, dressed in quotidian clothing and painted within sight of the factory where he works.

This drawing is informative in a number of other respects. It is one of three surviving studies for the same figure, and appears to have been the first in a developing sequence. As the figure evolved, Seurat gradually simplified its outline and suppressed the delicate folds of the drapery that are so much in evidence in the present drawing. In moving from the particularity of his first observations towards a more general and monumental simplicity, Seurat encapsulated the progress of the painting itself. In the final canvas a subtle geometry pervades both figures and landscape, and incidental details are subsumed in broader rhythms. The silhouette of the reclining man echoes the diagonal of the riverbank, while its tonal character has been adjusted to the dominant scheme of the composition. In *Man in a Bowler Hat* Seurat's distinctive control of tones can be clearly seen; the technique of 'irradiation', in which lighter forms are contrasted with darker in order to enhance their intensity, is evident in the profiles of both the bowler hat and the raised shoulder.

PROVENANCE: Emile Seurat, Paris; Félix Fénéon, Paris; César de Hauke, New York; Germain Seligman, New York; E. V. Thaw, New York.

EXHIBITIONS: Paris 1922, no. 11; Paris 1926, no. 102; Chicago 1935, no. 9; Paris 1946, no. 154, pp. 57–8; Newark 1961, no. 59; New York 1977, no. 24; London 1978[2], no. 17; Bielefeld et al. 1983–4, no. 51, pp. 19, 62, 190; Geneva 1988, no. 18, ill. p. 59.

LITERATURE: For literature before 1961 (if not mentioned) see De Hauke (below); Nicolson 1941, pp. 139–46, ill.; Dorra-Rewald 1959, no. 97 f; Herbert 1960, p. 368, no. 3; De Hauke 1961, no. 591, p. 168, ill. p. 169; Russell 1965, no. 125, ill. p. 134; Sérullaz 1968, no. 99; Chastel 1973, no. D 5, p. 97, ill.; Richardson 1979, no. 72, ill.

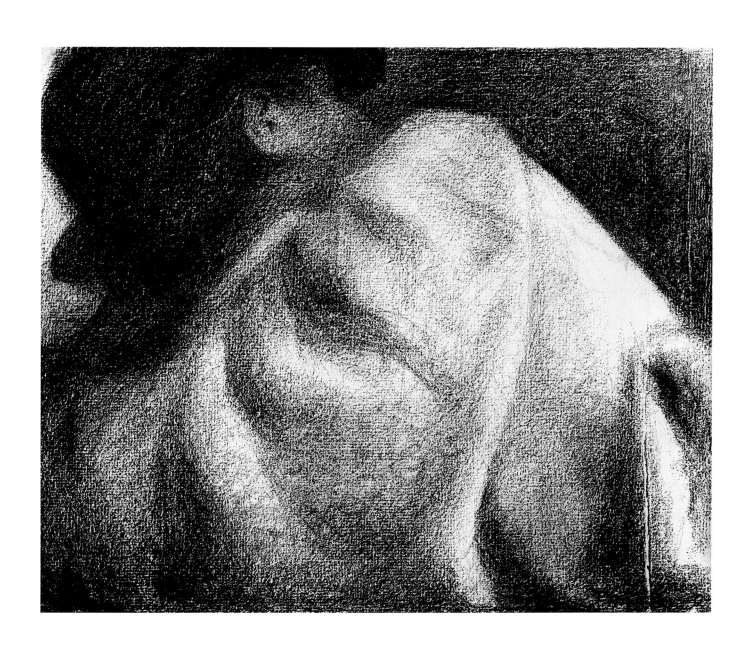

Georges Seurat

9 A Seated Man reading on a Terrace
c. 1884

Conté crayon on paper, 30.7 × 23.3 cm

Several of the Seurat drawings in the Berggruen Collection were originally owned by the artist's close friends and supporters. *The Lady in Black* and *Woman Reading* (Cat. nos. 4 and 6) belonged to the painter Theo van Rysselberghe, *The Rainbow, The Bridge at Courbevoie* and *Man in a Bowler Hat* (Cat. nos. 7, 13 and 8) to the critic Félix Fénéon, and *Family Group (Condolences)* (Cat. no. 12) to the novelist Joris-Karl Huysmans. Such contemporary appreciation of his drawings was partly a reflection of Seurat's own emphasis on his graphic work, and partly of his continued practice of showing finished and self-contained studies in public exhibitions. *A Seated Man reading on a Terrace*, found in Seurat's studio after his untimely death, was acquired by the artist Maximilien Luce and subsequently added to the collection of Félix Fénéon. Unrelated to any known painting by Seurat, the drawing appears to be an independent composition that has similarities with the single-figure studies of the early 1880s.

By tradition this drawing represents Seurat's father, Antoine, whose successful career as a government official provided the financial support for his son's activities. Antoine Seurat was an eccentric and remote parent, who lived apart from the family, visiting only occasionally and featuring little in his son's work. Another drawing (private collection, Paris) shows him seated at the dining table, his domed head inclined over his meal and, like *Seated Man reading on a Terrace*, his gaze averted from the viewer. In both studies much of his individuality is lost and he has become a generalised and distanced representative of his gender and times. Distinguishing features are avoided or concealed (Seurat's father had lost a hand in a riding accident), and emphasis is placed on the resonant ovoid of the head, the expressive silhouette of the body, and the subtle interplay between figure and setting. A few light strokes indicate a chair, an untouched strip of paper suggests sunlight, and a distant building, which may represent the façade of the Cathedral of Notre Dame (Seurat's father was an ardent, if unconventional, Catholic), completes the composition.

PROVENANCE: Atelier of the artist, inv. succession no. 143; Maximilien Luce, Paris; Félix Fénéon, Paris; Louis Rosen, Los Angeles; Jacques Seligmann, Paris–New York; Georges Seligmann, Paris; Robert Eichholz, Washington.

EXHIBITIONS: Rome 1950, no. 4, ill.; Venice 1950, no. 4, ill.; New York 1958, unnumbered; Geneva 1988, no. 19, ill. p. 61.

LITERATURE: Mabille 1938, pp. 2–9, ill. p. 9; Apollonio 1945, pl. IV, p. 12; Seligman 1947, pp. 21–3, pl. XXXIII, p. 73; De Hauke 1961, vol. II, no. 599, p. 180, ill. p. 181; Russell 1965, p. 16, ill. p. 17; Courthion 1969, ill. p. 12; Chastel 1973, no. D 162, ill. p. 115; *Le grand livre des ventes aux enchères*, Paris 1988, p. 155, no. 118, ill.; Madeleine-Perdrillat 1990, ill. p. 13; Rewald 1990, ill. p. 140.

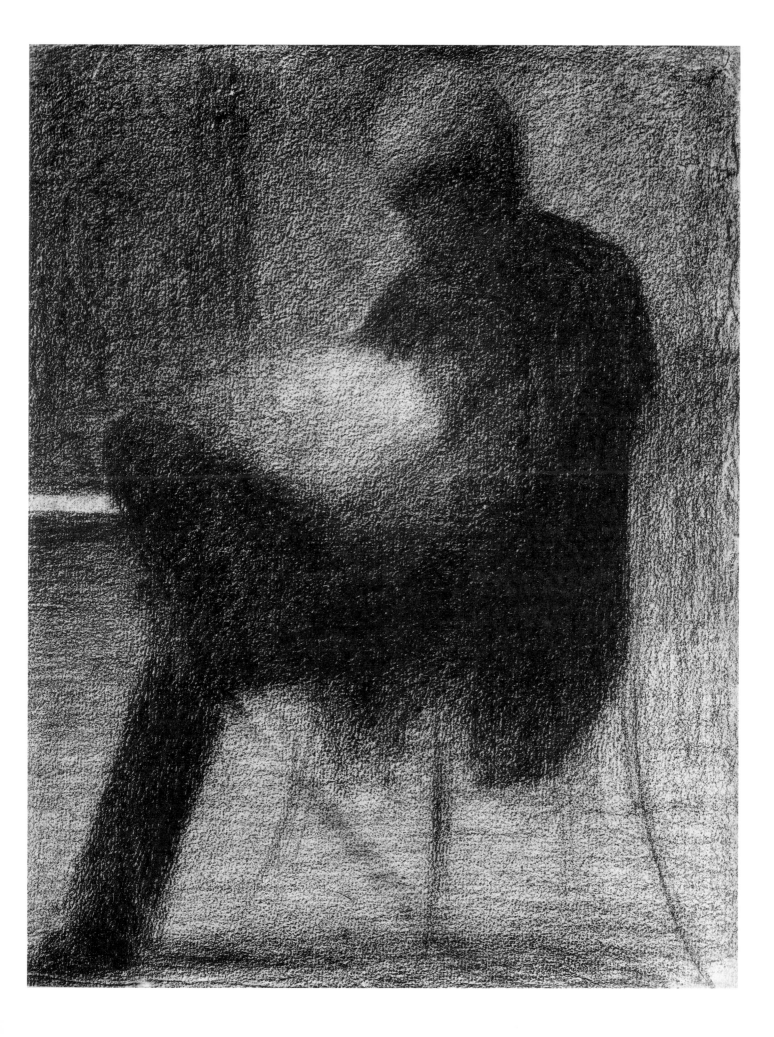

Georges Seurat

10 Study for 'La Grande Jatte'
1884–5

Oil on cradled panel, 16 × 25 cm

This vibrant little oil painting appears to have been executed in the open air, in a series of flickering, unrehearsed brushstrokes that capture the freshness of a spring morning. While working on his second large-scale canvas, *Sunday Afternoon on the Island of La Grande Jatte* (Fig. 11), Seurat made regular visits to the site depicted in the picture, observing the Parisians who gathered there and making small oil sketches of the landscape setting. La Grande Jatte was a long, narrow island in the Seine immediately opposite the riverbank depicted in *Bathers at Asnières* (see Fig. 10). At this time it was famous for the leisure and boating activities which form the subject of Seurat's finished picture, but which are omitted, presumably for practical reasons, in most of his open-air studies. As in *Bathers at Asnières*, but on an even more ambitious scale, Seurat's aim in *La Grande Jatte* was to create a panorama of urban experience, a precisely observed but tightly orchestrated tableau of modern Paris. Beginning with the site itself, he made more than 50 studies in oil paint or conté crayon of the trees, shadows and human and animal participants in his intricate composition, gradually refining their forms and clarifying their pictorial relationships.

The evidence of style, technique and subject matter all suggest that *Study for 'La Grande Jatte'* was one of the earliest of these preparatory works. Not only is the scene generalised and virtually unpopulated, but the scarcity of leaves on the trees indicates that it was begun in late spring, in contrast to the dense summer foliage of most of the other studies. The brushwork, too, seems exploratory rather than formalised: though there are touches of red and blue amongst the energetic brushstrokes in the grass, there is little sign of the systematic application of colour for which the artist was soon to become celebrated.

PROVENANCE: Van Wisselingh, Amsterdam; Appert Family collection; Etienne Bignou, Paris; Reid & Lefèvre, London; Knoedler, New York; Joseph Hessel, Paris (until 1933); Georges Renand, Paris (until 1966); Wildenstein, Paris; Florence Gould, Cannes.

EXHIBITIONS: Amsterdam 1931, no. 48, ill.; Paris 1933–4, no. 77; Paris 1936², no. 30; Paris 1937, no. 411; Paris 1942, no. 160; Amsterdam-Otterlo 1953, no. 60; Paris 1957, no. 10; Chicago-New York 1958, no. 88; Paris 1960–1, no. 658; Geneva 1988, no. 20, ill. p. 63.

LITERATURE: For literature before 1961 (if not mentioned), see De Hauke (below); Zervos 1928, p. 364, ill.; Dorra-Rewald 1959, no. 110, p. 117; De Hauke 1961, vol. I, no. 112, p. 68, ill. p. 71 (with the title: *Paysage et personnages*); Russell 1965, no, 135, ill. pp. 148–9; Courthion 1969, p. 102, ill. p. 103; Hautecoeur 1974, p. 85, fig. 4; Gould sale, Sotheby's, New York, 24 April 1985, no. 29, ill.

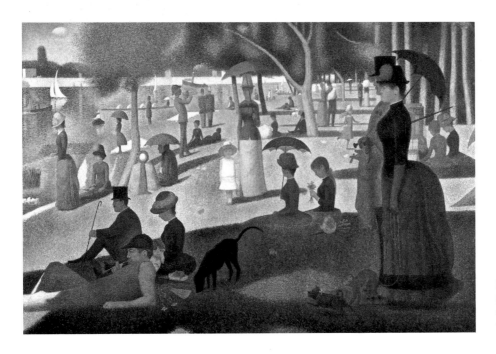

Fig. 11 Seurat, *Sunday Afternoon on the Island of La Grande Jatte*, 1884–6. Oil on canvas, 207.6 × 308 cm. The Art Institute of Chicago.

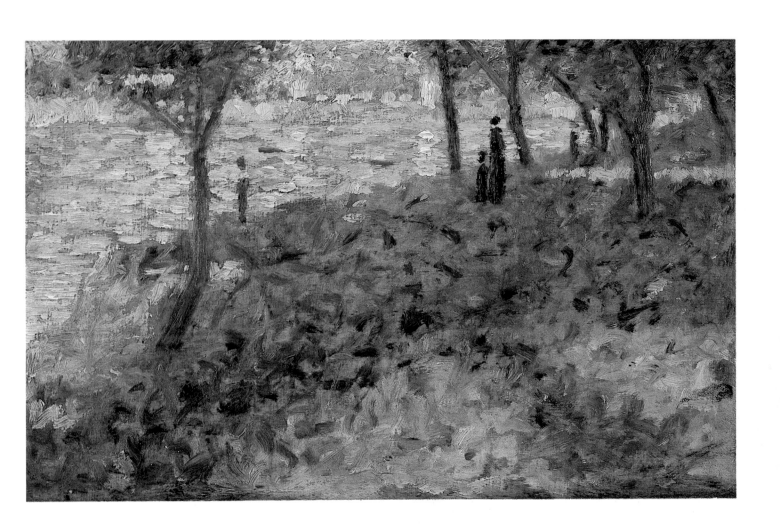

Georges Seurat

11 The Morning Walk
1884–5

Oil on panel, 24.9 × 15.7 cm. Inscribed on verso: *G. Seurat L*[uce] *89*

Though its vertical format is untypical, *The Morning Walk* belongs to a group of more than a hundred identically sized landscape studies made by Seurat between 1882 and 1886. Painted on small wooden panels, these miniature images contain some of the most dazzling brushwork and frank experimentation of the artist's career. Following the long-established tradition of the open-air oil sketch, or *pochade*, Seurat painted rapidly and directly onto his panels, often leaving glimpses of bare wood to contribute to the final image. Almost every brushmark in this sketch can be counted and characterised, from the horizontal wave-like strokes of the river to the opposing verticals of the houses, and from the animation of the grass to the transparency of the tree. Using clean, often unmixed colours, Seurat has responded in a remarkably sensuous way to the freshness of the morning light, contrasting it with the cool shadows of the foliage, the tree trunk and the promenading figure. While his use of the *pochade* may be conventional, Seurat's responsiveness to natural light and colour is clearly indebted to the achievements of his Impressionist colleagues. Such fresh tones and improvised composition can be found in earlier pictures by Monet, Pissarro and others, though the directional strokes of paint, the rectilinear grid of the composition and the calculated use of complementary colours all point to Seurat's developing refinement.

Many of Seurat's earliest paintings on panel were self-contained, independent works, and he thought highly enough of them to add his signature and exhibit some of them in public. *The Rainbow* and *Study for 'La Grande Jatte'* (Cat. nos. 7 and 10) both formed part of his preparation for large-scale compositions, while *A Morning Walk* was evidently the starting point for a medium-size canvas of 1885, *The Seine at Courbevoie* (private collection). Following his usual practice Seurat refined and intensified his technique in the finished picture, introducing considerably more detail and underlining the formal relationships within the composition. Less typically, he made subtle alterations in his viewpoint, stepping back from his subject and including a greater area of sky and a second tree trunk at the right.

PROVENANCE: Atelier of the artist, inv. succession no. 89; Léon Gausson, Paris; Georges Tardif, Paris; Mme G. Tardif, Paris; Mlle Alice Tardif, Paris; Wildenstein, New York; Henry Ittleson, Jr., New York; Acquavella Galleries, New York.

EXHIBITIONS: Geneva 1988, no. 21, ill. p. 65.

LITERATURE: Cogniat 1959, p. 124, ill.; Dorra-Rewald 1959, no. 160, ill. p. 188; De Hauke 1961, vol. I, no. 133, p. 84, ill. p. 85; Courthion 1969, p. 110, ill. p. 111; Chastel 1973, no. 162, p. 104, pl. XXX.

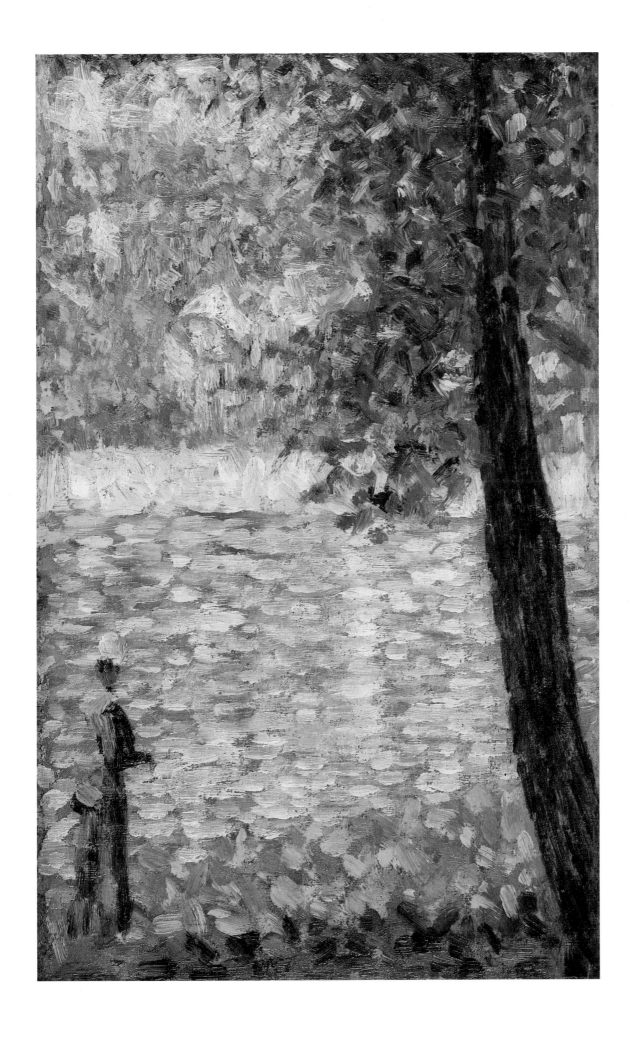

Georges Seurat

12 Family Group (Condolences)
c. 1886

Conté crayon on paper, 24 × 31.7 cm

Seurat's reputation as a theoretical artist, with an interest in mathematics, systems of proportion and colour harmony, has tended to obscure the great poignancy of some of his work. While he is rarely sentimental or anecdotal, a number of his paintings – and certain remarkable drawings – appear to retreat from the rhetoric of the public statement and engage with more private emotions and sympathies. A dry sense of humour, which has been related to his admiration for caricaturists such as Daumier, is evident in many of Seurat's figure studies, and his drawings of close friends suggest both intimacy and affection. The radical politics of his associates (which are thought to have been shared by the artist) also find personal expression in his work. Depictions of the labouring poor, both urban and rural, appear throughout his career and images of the industrial landscape and its alienated population can be found – both literally and metaphorically – behind many of his well-known compositions.

Family Group (Condolences) is an unusually well-documented drawing by Seurat and an unusually explicit example of this kind of subject matter. It was exhibited at the eighth and last Impressionist exhibition of 1886, where it was listed as belonging to the novelist and critic Joris-Karl Huysmans. The original title, *Condoléances*, which was presumably given to the drawing by Seurat himself, encourages us to identify the scene as a funeral and to see the participants as mourners. The details of the event are not known, but it seems reasonable to assume that Seurat was both present and involved, and that the exceptional delicacy of the drawing reflects this involvement. Using his conté crayon with great resourcefulness, Seurat evokes both the constrained tonalities and melancholy gestures of the occasion. A wide range of strokes, inflections and textures has been used throughout the sheet, leaving the white of the paper to illuminate only faces and accessories. In comparison with one of Seurat's few other group portraits (Fig. 12), where the industrial context provides an alternative narrative, this drawing is intense, brooding and confessional.

PROVENANCE: Joris-Karl Huysmans, Paris; Lucien Descaves, Paris; César de Hauke, Paris; Brame & Lorenceau, Paris; Hazlitt, Gooden & Fox, London; E. V. Thaw, New York.

EXHIBITIONS: Paris 1886, no. 182; Paris 1908–9, no. 128; Paris 1954, no. 198; Chicago-New York 1958, no. 112; London 1978[1], fig. 79; Bielefeld et al. 1983–4, no. 74, ill. pp. 84, 192; Washington-San Francisco 1986, no. 153, p. 466; Geneva 1988, no. 22, ill. p. 67.

LITERATURE: Geffroy 1886; auction sale, Paris, Galerie Charpentier, 6 April 1954, no. 22, pl. IV; De Hauke 1961, vol. II, no. 655, ill. p. 233; Herbert 1962, no. 54, pp. 60–1; Russell 1965, no. 177, ill. p. 199; Courthion 1969, p. 64, ill.; Chastel 1973, no. D 165, ill. p. 115; Thomson 1985, p. 74, pl. 79; Wotte 1988, pl. 44; Madeleine-Perdrillat 1990, p. 72, ill. p. 198.

Fig. 12 Seurat, *Group of Figures in front of a Factory, c.* 1883. Conté crayon, 24 × 31 cm. Musée du Louvre, Paris.

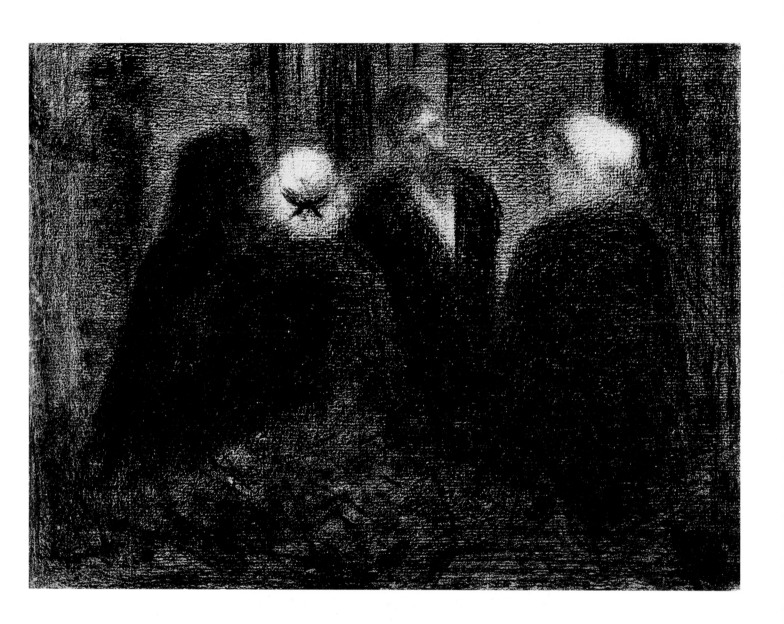

Georges Seurat

13 The Bridge at Courbevoie
1886

Conté crayon on paper, 23.2 × 30 cm

In Seurat's day, Courbevoie was one of a cluster of small towns and villages lying just beyond the northwest perimeter of Paris that had yet to be absorbed into the city. Situated along the banks of the Seine and easily accessible by railway, their restaurants and swimming and boating facilities were immensely popular with the urban population, as well as with artists in search of topical subject matter. Monet had spent much of the 1870s at Argenteuil (a few miles downstream from Courbevoie), where he had been joined on occasions by Manet, Renoir and others, while Seurat had already based a number of major paintings on sites between Courbevoie and Asnières. The area was also growing in importance as an industrial centre, and many paintings by the Impressionists and their followers make reference to its modern bridges, railway lines and factory architecture. Seurat's *Bathers at Asnières* (see Fig. 10), which depicts a scene only a short distance from the Courbevoie bridge, is pointedly set against the factories at Clichy, and a number of his drawings move even closer to such urban motifs. In *The Bridge at Courbevoie* we see the gaunt and rectilinear forms of the river embankment, the surrounding buildings and the bridge itself, their scale emphasised by the dramatic light and the absence of distracting detail. The effect is both monumental and spare, as if Seurat wished to celebrate the grandeur of these new structures while registering their inhuman implications.

This drawing is also a *tour de force* of Seurat's mature graphic style. Using the sharpened point of a piece of hard conté crayon, and a light, almost feathery stroke, he has progressively conjured up a pattern of lines and textures that correspond to the tones of his subject. From the fantastic lacework of the sky to the flickering strokes of the foreground, and from barely touched highlights to dense black shadows, Seurat has exploited the full expressive range of his medium. Literal description plays only the most modest role, as the silhouettes of buildings become softened and individual structures generalised. Though it evokes a particular location and a specific subject matter, *The Bridge at Courbevoie* is also a study of light and a self-consciously constructed work of art. In both these respects, and in his extensive use of monochrome, Seurat comes close to one of his most immediate mentors, Edgar Degas. The Parisian streets, cabarets and public places which Degas had depicted in the previous decade, and which are often shown by night or by artificial light, were the inspiration for an important group of Seurat's drawings and painted studies in the late 1880s.

PROVENANCE: Félix Fénéon, Paris; De Hauke & Co., New York; Mrs Margaret H. Drey, London; Samuel Courtauld, London; Arthur Kaufmann, London.

EXHIBITIONS: Chicago 1935, no. 11; New York 1947, no. 10; Bielefeld et al. 1983–4, no. 77, ill. p. 193; Geneva 1988, no. 23, ill. p. 69.

LITERATURE: Seligman 1947, no. 17, pp. 32, 56, pl. XIV; sale, Sotheby's, London, 10 July 1957, lot no. 43; De Hauke 1961, vol. II, no. 650, ill. p. 227; Madeleine-Perdrillat 1990, ill. p. 105.

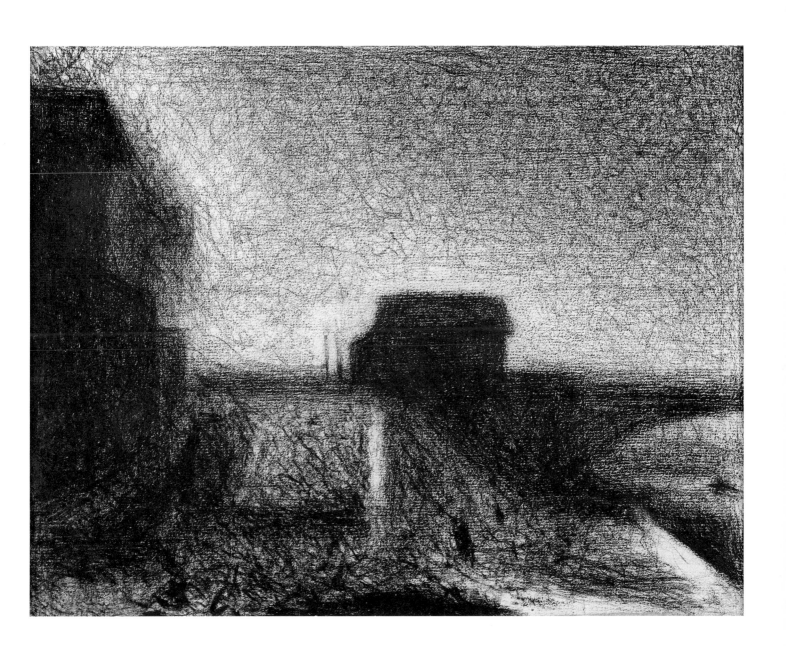

Georges Seurat

14 The Seine seen from La Grande Jatte
1888

Oil on panel, 15.7 × 25 cm. On verso: *P/13754*; and old exhibition labels

Unusually for Seurat, this brilliantly coloured study represents a picture in transition – a composition caught midway between its first and final stages. Like many of his other oil paintings on panel it was probably executed outdoors, in front of the chosen subject and in direct response to its light and colour. Such panels would typically be regarded as finished works, or as first statements in a sequence leading to an intricate and large-scale composition. With *The Seine seen from La Grande Jatte*, it is evident that Seurat had a more ambitious picture in mind, and had already begun to manipulate the scene in front of him. Establishing a pronounced and characteristic horizontal in the distant embankment, which is counterbalanced by the vertical of the tree, he has introduced a diagonal riverbank and the curving form of a second tree trunk. In an attempt to offset these elements, Seurat originally placed a large, white-sailed yacht at the left of the picture, but subsequently changed his mind. Painting over the yacht, and over parts of the base of the tree, he readjusted the composition, allowing these earlier forms to survive as vestigial, ghost-like presences. Curiously, in the canvas that followed this experiment (Fig. 13), both features were reinstated, the tree emphatically anchored to the riverbank and the boat more modestly dispatched to the middle distance.

The setting for this study is a stretch of the Seine much depicted in Seurat's pictures – and related to at least six of the artist's works in the Berggruen Collection. In some of these studies Seurat was clearly drawn to the site by the pictorial challenge of the swimmers, boating parties and strollers for which it was celebrated. Many of his canvases, however, are remarkably free of figures, and it can be argued that other factors were predominant. The banks of the Seine offered a perfect vocabulary of forms for many of his experiments: river and trees provided the rectilinear grid for his composition, branches and sails became curves and ellipses, while shadows, boats and foliage could be arranged at will. Seurat's interest in the expressive potential of line flourished in this context, allowing him to echo or rhyme the curve of the branch with that of the yacht in both versions of *The Seine seen from La Grande Jatte*. Similarly, his involvement with colour theory had considerable licence in such a setting. By moving his vantage point or choosing a certain time of day, Seurat could create contrasts of tone and hue that suited his current preoccupations. In this small panel he has chosen to paint on a simple white ground rather than on the natural colour of wood, and to accentuate the interplay between the warm and cool colours of the scene. Just visible at the upper edge of the picture is a line of coloured dots (unusually, this line does not continue round all four sides of the picture), the beginnings of the coloured border that is so pronounced in the final canvas.

PROVENANCE: Atelier of the artist, inv. succession no. 93; Charles Angrand, Paris; Pierre Angrand, Paris; E. V. Thaw, New York.

EXHIBITIONS: Paris 1936[2], no. 35; Paris 1938; Paris 1942–3, no. 6; Venice 1952, no. 14; Amsterdam-Otterlo 1953, no. 59; Paris 1957, no. 3; London 1979–80, no. 200, ill. p. 133; Geneva 1988, no. 24, ill. p. 71.

LITERATURE: Coquiot 1924, p. 40; *Lettre d'Angrand à L. Cousturier* (4 July 1912), in *La Vie*, 1 October 1936, p. 248; Dorra-Rewald 1959, p. 228, no. 182, ill.; De Hauke 1961, vol. I, no. 175, p. 128, ill. p. 129; Sutter 1970, p. 36, ill.; Chastel 1973, no. 176, ill. p. 105; Rewald 1990, ill. p. 174.

Fig. 13 Seurat, *The Seine from La Grande Jatte*, *c.* 1888. Oil on canvas, 65 × 81 cm. Musée des Beaux-Arts, Brussels.

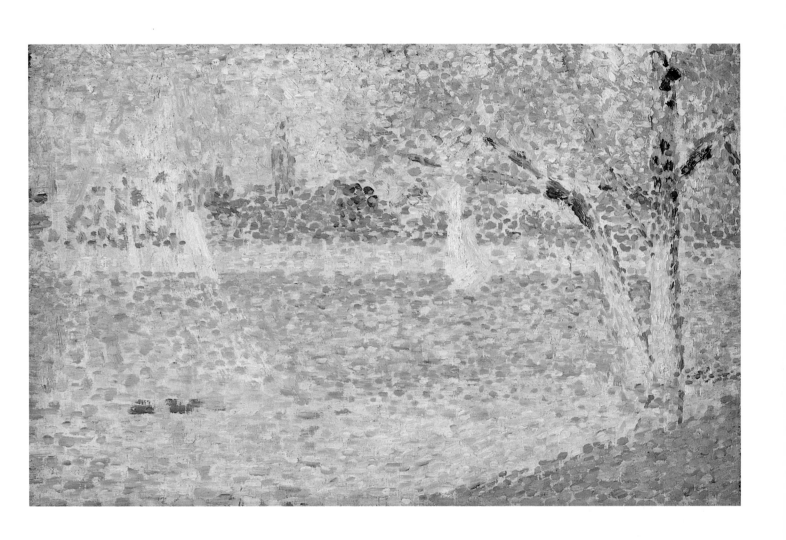

Georges Seurat

15 Les Poseuses (The Artist's Models)
1888

Oil on canvas, 39.5 × 49 cm

Seurat was a notably taciturn individual, and little record has survived of his conversations or of his stated ambitions for his pictures. Partly as a consequence, paintings such as *Les Poseuses* have proved susceptible to a wide variety of interpretations, ranging from the formal and technical to the abstruse and metaphorical. Its history, on the other hand, is straightforward. In about 1887 Seurat embarked on his third major canvas, producing a number of drawn and painted studies and exhibiting the finished picture at the Salon des Indépendants in 1888. This large painting, now in the Barnes Foundation in Merion, Pennsylvania, is also called *Les Poseuses*, and is identical in almost every feature of its composition to the present version. Surviving documents show that Seurat was dissatisfied with the quality of the paint used in the Barnes Foundation canvas, and it is now widely accepted that the smaller version was made to demonstrate the colours that he had intended for the original.

In many important respects *Les Poseuses* is a simple painting, perhaps provocatively so. By contrast with the public settings and rhetorical language of his two previous large-scale canvases – *Bathers at Asnières* and *Sunday Afternoon on the Island of La Grande Jatte* (see Figs. 10 and 11), *Les Poseuses* is intimate, almost domestic. The scene is a corner of the artist's studio, where a number of drawings hang on one wall and the enormous canvas of *La Grande Jatte* (recently returned unsold from exhibition) leans against another. Three professional models are posed in varying states of undress, while their discarded clothing clutters both floor and furniture. They are slender by the standards of the day, and each poses simply and even awkwardly, as if to stress the ordinariness of their activity. Beyond this point, however, the naturalistic reading of the scene begins to fail. The sheer improbability of three models posing together, the artificiality of their triangular disposition, and the textbook variations of their poses (seen from back, front and side respectively) all draw attention to the artfulness of the composition. Each figure also echoes a well-known classical or academic prototype (see page 23), as well as reflecting their clothed counterparts in the painting of *La Grande Jatte* behind them. Within the modest confines of *Les Poseuses*, these oppositions between the traditional and the modern, the natural and the artificial, the leisured and the labouring, provide a virtual summary of Seurat's artistic preoccupations.

Les Poseuses is also a crucial and spectacular document of Seurat's working practice. Among the first canvases to be executed entirely in the pointillist technique, it has retained much of the sparkle of its original colour and the freshness of its paint surface. In this version of the scene, oil paint has been applied in unusually fine touches, the size and direction of each mark varied according to its function. As in the small studies for the individual models, Seurat first built up his figures with diagonal strokes, which were then overpainted in dots and streaks of controlled colour. Though the extent to which Seurat applied his pigments in scientific or systematic fashion has often been exaggerated, in *Les Poseuses* something of the intensity of his original contrasts of tone and oppositions of colour can still be appreciated.

PROVENANCE: Jules F. Christophe, Paris; B. A. Edynski-Max Hochschiller, Paris; Galerie Bernheim-Jeune, Paris, (inv. no. 17565 R); Alphonse Kann, Paris (*c.* 1913); Marius de Zayas, New York; John Quinn, New York; Julia Quinn Anderson, New York; Mary Anderson Conroy, New York; Henry P. McIlhenny, Philadelphia; auction sale, London 1970; Artemis, Luxembourg; on loan to the Alte Pinakothek, Munich.

EXHIBITIONS: Paris 1892, no. 1083; Paris 1908–9, no. 70; Paris 1910, no. 105; New York et al. 1913, no. 455; Chicago 1913, no. 371; Boston 1913, no. 198; Copenhagen 1914, no. 192; New York 1924, no. 17; Cambridge (Mass.) 1936, no. 190; Philadelphia 1937; Paris 1937, no. 414, ill.; New York 1939, no. 75, ill.; Baltimore 1940; Detroit 1940, no. 38; Worcester 1941, no. 17, ill.; Los Angeles 1941, no. 126; Philadelphia 1947, no. 27; New York 1948, no. 51, ill.; New York 1949, no. 19, ill.; Philadelphia 1949 (no catalogue); Philadelphia 1950–1, no. 81, ill.; Paris 1955[1], no. 52, ill.; Chicago-New York 1958, no. 136, ill. p. 68; San Francisco 1962, no. 38, ill.; New York 1963, no. 455, ill.; London 1978[2]; Bielefeld et al. 1983–4, pl. no. 11, ill. p. 71; Geneva 1988, no. 25, ill. p. 73.

LITERATURE: Cousturier 1921, pl. 22; Langaard 1921, no. 9, p. 34, ill.; Lhote 1922, p. 9, ill.; Pach 1923[1], pp. 160–4, ill.; Pach 1923[2], pl. 4; Coquiot 1924, p. 233, ill.; Anon 1926, no. 125, ill.; Cousturier 1926, pl. 27; Sitwell 1926, p. 345, ill. p. 344; Rey 1931, p. 142; Roger-Marx 1931, pl. 14; Edouard-Joseph 1934, vol. III, p. 293, ill.; Renard 1938, vol. IV, p. 72, ill.; Fry 1939, pl. 5; Goldwater 1941, p. 119; Rewald 1943, p. 106, pl. 83; Huyghe 1947, p. 12, ill.; Rewald 1948, p. 129, pl. 89; Cogniat 1951, pl. 40; Rewald 1952, note 8, p. 271; Rewald 1956, p. 107, ill.; Bernier 1957, p. 22, ill.; Schapiro 1958, p. 23; Herbert 1958, p. 152; Canaday 1959, p. 336, pl. 410; Dorra-Rewald 1959, no. 179, pp. 220–1; De Hauke 1961, vol. I, p. 144, no. 184, ill.; Herbert 1962, p. 111, pl. VII; Brown 1963, pp. 51–93, ill. p. 175; Russell 1965, pp. 208–9, pl. 186; Reid 1968, p. 557; Courthion 1969, p. 136, ill.; Russell 1970, pp. 117–18; sale, Christie's, London, 30 June 1970, ill.; Chastel 1973, pp. 105–6, ill. p. 105, pl. XLIII; Hautecoeur 1974, p. 43, ill.; Haacke 1975; Broude 1978; House 1979, p. 17, ill.; House 1980, pl. 56; Georgel 1982, p. 150, fig. 171; Greenspan 1985, p. 109, ill.; Thomson 1985, p. 143, pl. 147; Courthion 1988, pp. 104–5, ill.; Wotte 1988, pl. 63; Clayson 1989, ill. p. 169; Rasponi 1989, ill. no. 27; Madeleine-Perdrillat 1990, p. 102, ill. pp. 94–5, 103; Rewald 1990, ill. p. 155.

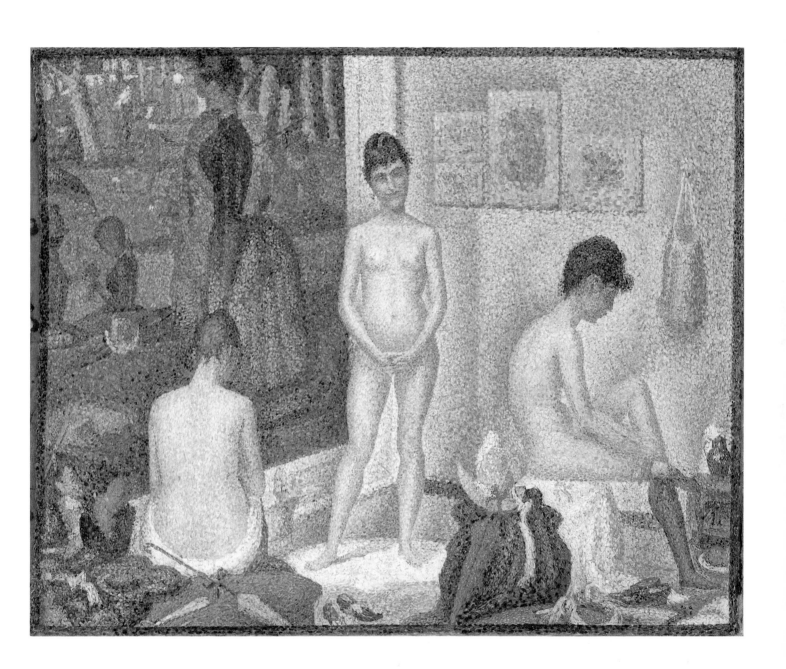

Georges Seurat

16 The Channel of Gravelines, Grand Fort-Philippe
1890

Oil on canvas, 65 × 81 cm. Signed lower right in painted border: *Seurat*

In the years immediately preceding his premature death in 1891 at the age of 31, Seurat spent several summers on the Channel coast, producing more than 20 substantial canvases of its harbours and marine landscapes. Unlike Monet, who often painted in the same area during these years, and who seems to have been attracted by its cliffs and turbulent seas, Seurat was instinctively drawn to the most tranquil of subjects. It is also significant that Seurat chose man-made sites, where harbour walls, masts and jetties frame the irregularity of the landscape. In this respect, Seurat followed the practice of his own urban imagery, using a grid of horizontals and verticals to contain the profusion of the scene and to suggest the balance between the natural and the artificial. After the summers spent in Honfleur, Port-en-Bessin and Le Crotoy, this tendency towards rationalisation and simplification became even more pronounced. Narrative is suppressed, and the marine traffic of the waterways and the human traffic of the harbour are almost entirely absent in a picture like *The Channel of Gravelines, Grand Fort-Philippe*.

This canvas must rank among the most spare and audacious of Seurat's completed pictures. The almost horizontal line of the harbour and the solitary row of buildings divide the composition into two equal parts, both sky and foreground empty but for incidental features. Shadow and modelling are reduced to a minimum, leaving large areas of uninterrupted and barely inflected colour. Applying the oil paint in his most disciplined manner, Seurat has covered the canvas with a regular mosaic of strokes and dots, allowing the colours to retain their freshness while contributing to the overall luminance. In some passages, such as that to the left of the boat, touches of red, yellow, blue, green and violet can be seen in close proximity, while other areas are dominated by blond and pastel hues. The brushwork, too, is highly controlled – horizontal, vertical and diagonal strokes make up the intense fabric of the sky, pinpricks of colour evoke the detail of the houses, and a broad sweep of marks gives form and direction to the foreground. Most conspicuously, a dramatic border of coloured dots has been added to the canvas edge, each band of dots adjusted to the adjacent area of picture and calculated to heighten its chromatic impact. Seurat had been adding such borders to his paintings for several years, and even colouring appropriate frames to isolate the internal relationships of the pictures. Here, as in *Les Poseuses* (Cat. no. 15), the coloured border appears to have been painted in the last stages of the work, defining and containing its meticulous harmonies.

PROVENANCE: Mme Antoine Seurat, née Faivre; Léon Appert, Paris; E. Bignou, Paris; Reid & Lefèvre, London; Samuel Courtauld, London; Lord Butler of Saffron Walden; London (by 1953).

EXHIBITIONS: Brussels 1891, no. 4; Paris 1891, no. 1103; Paris 1900, no. 36 (wrong title); Paris 1905, no. 3; Paris 1908–9, no. 79; London 1926, no. 3 (wrong title); London 1936, no. 122; London 1937, no. 32; London 1948, no. 73; London 1949–50, no. 298, pl. 67; Paris 1955[2], no. 56, pl. 76; London 1979–80, no. 205, ill. pp. 135–6; Geneva 1988, no. 26, ill. p. 75; Indianapolis 1990, no. 1, ill. p. 17.

LITERATURE: For literature before 1961 (if not mentioned), see De Hauke (below); Wilenski 1951, p. 21, ill.; Venturi 1953, pp. 203–4, ill.; Cooper 1954, no. 71, p. 118, ill.; Dorra-Rewald 1959, no. 206, p. 268, ill.; De Hauke 1961, no. 205, p. 182, ill. p. 183; Russell 1965, pp. 249, 254, 257, ill. p. 261; Chastel 1973, no. 210, ill. p. 110, pl. LX; Lee 1983, p. 62; Thomson 1985, pp. 171, 173, 177, 181, fig. 197, ill.; Madeleine-Perdrillat 1990, pp. 180–2, ill.; Rewald 1990, ill. p. 194.

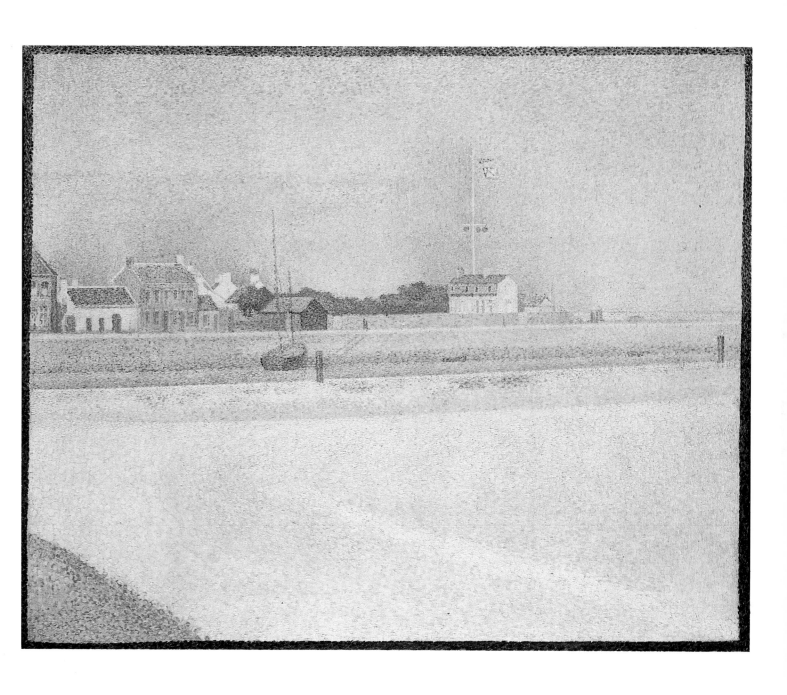

Paul Cézanne

1839–1906

Paul Cézanne

17 Portrait of Madame Cézanne
c. 1885

Oil on canvas, 46 × 38 cm

This portrait represents Hortense Fiquet, who married Paul Cézanne in 1886 after a bizarre and turbulent cohabitation of more than a decade. Despite its remarkable symmetry and containment, the portrait was painted at a time of continued domestic stress, when Cézanne's worries about health, money and family sometimes brought his work to a standstill. He had met Hortense in the late 1860s in Paris, where she had been working as an artists' model. A son, also called Paul, was born to the couple in 1872, but Cézanne had kept the existence of both child and mistress from his own family at Aix-en-Provence for many years. Moving frequently between Paris and Aix, Cézanne showed his pictures in two of the first Impressionist exhibitions, but found little sympathy amongst critics and public for these abrasive early canvases. Financially dependent on his parents, Cézanne persisted in his studies of the landscape, the portrait and the still life, earning the respect of his fellow artists and the support of one or two collectors. Writing to one of these collectors, Victor Chocquet, in 1886, Cézanne admired his 'intellectual equilibrium', noting of himself that 'Fate has not endowed me with an equal stability'. In the same year, Cézanne's circumstances changed dramatically: his mistress and child were acknowledged by his parents, Hortense and he were married, and the death of Cézanne's father left him financially secure for the rest of his days.

The *Portrait of Madame Cézanne* is one of almost 20 canvases of Hortense painted in the decade between 1885 and 1895 (Fig. 14). Cézanne was a notoriously demanding portrait painter, insisting on numerous sittings and complete immobility in his models: on one occasion he is said to have compared his sitter unfavourably to a still life, exclaiming 'Do *apples* move?' Though we know little of the relations between Cézanne and Hortense, she appears to have been a patient and accommodating model, and her rather severe features appear in drawings, watercolours and sketchbook studies. Something of this severity may be due to the rigours of posing, but equally to Cézanne's disdain for the transient and anecdotal. In *Portrait of Madame Cézanne*, the artist has chosen a characteristically frontal, symmetrical pose, allowing neither background incident nor costume detail to distract from his monumental subject. Having drawn in the principal forms with thinned blue and green paint, Cézanne then used delicate strokes of colour to build up the essential volumes and structures of Hortense's face. By setting the fresh pinks of the skin against the coldness of the background wall, and by introducing touches of cool greens and blues into the warmth of the face, a pronounced sense of projection and relief has been achieved. Most remarkably, this portrait shows Cézanne's use of the underlying rhythms of the subject to emphasise its vitality; the parabola of Hortense's hair is echoed in the line of her chin, and almost precisely repeated in the curve of her collar. Other curves, circles and ellipses reverberate throughout the picture, unifying and galvanising its deceptive simplicity.

PROVENANCE: Stephan Bourgeois Gallery, New York; William Van Horne, Montreal; Van Horne sale, New York, 1946; George Garde da Sylva, Los Angeles; Max Moos, Geneva.

EXHIBITIONS: New York et al. 1913, no. 1072 (Chicago, no. 51); Montreal 1933, no. 146 a; Zurich 1956, no. 54, pl. 24; Geneva 1988, no. 4, ill. p. 29.

LITERATURE: Archives Vollard, photo no. 4 (note by Cézanne's son: 1886); Rivière 1923, p. 213; Venturi 1936, no. 520, pl. 160 (dated: *c.* 1885; revised: 1883–6); sale, New York, Parke Bernet, 24 January 1946, no. 12, ill.; *Art News* 1946, ill. p. 28; Taillandier 1961, p. 63, ill.; Van Buren 1966, fig. 8 (dated: 1886–8); Orienti 1972, no. 518; Rewald 1986, p. 156, ill. (dated: *c.* 1885); *Du* 1989, ill. p. 39. ·

Fig. 14 Cézanne, *Madame Cézanne*, *c.* 1886–7. Oil on canvas, 48 × 39 cm. Philadelphia Museum of Art.

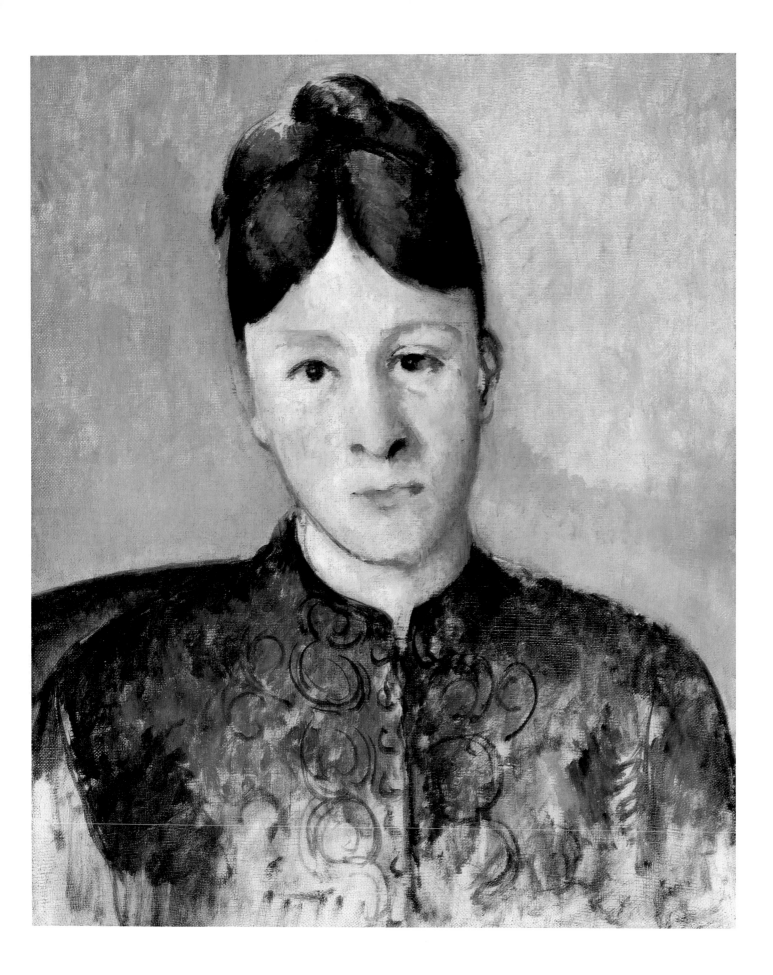

Paul Cézanne

18 Path in Chantilly
1888

Oil on canvas, 82 × 66 cm

According to the artist's son, Cézanne spent several months at Chantilly in 1888 and it was presumably at this time that *Path in Chantilly*, and two closely related canvases (Fig. 15), were painted. In choosing to depict a roadway through the Chantilly forest, Cézanne may have recalled a favourite motif of his earlier years – the parallel avenue of chestnut trees at the family home, the Jas de Bouffan, in Aix-en-Provence. Both subjects provided Cézanne with one of the great challenges of his art: a clearly defined and resonant structure that presented itself to the eye as a series of volumes and depths, but which the artist must express through patterns of paint on a canvas. In *Path in Chantilly*, Cézanne tackled this problem head-on, choosing a symmetrical viewpoint and directly confronting its receding intervals and spaces. Conventional perspective lines would have created a tunnel-like recession at the centre of the canvas, but it is notable that the artist has avoided or suppressed such devices. Always suspicious of illusions and meretricious effects, Cézanne has attempted to represent the scene in his own terms, using the orientation of his brushstrokes, the limpidity of his colours and the contrasts of his tones to summarise his visual experience.

Recent research has demonstrated that Cézanne had little interest in conventional systems of perspective, preferring a direct, improvised approach to the subject and apparently having little familiarity with standard textbook practice. His much misquoted and misunderstood claim that we should 'treat nature by means of the cylinder, the sphere, the cone', which has often been used as a facile link with abstraction, comes from a letter that deals principally with the representation of depth in landscape painting. In this letter, and in many other remarks and recorded conversations, Cézanne insisted that colour was the basis of his visual perception, and thus the means by which the artist should express depth, substance and light in his paintings. More than the work of any previous artist, a painting such as *Path in Chantilly* can be seen as a mosaic of coloured patches, each patch judged in relation to its neighbours, to the picture as a whole and to the original subject. Slight shifts of tone and hue are recorded in adjacent strokes, while something of the animation of the scene is captured in their flickering, nervous intensity.

A group of small watercolours made by Cézanne at Chantilly, which were probably once part of a sketchbook, includes one study that is very close to *Path in Chantilly*. In this study the framing effect of the most prominent trees, the foreground shadow and the delicately linked branches is conspicuous, and is emphatically echoed in the distant arch of sunlight. It is possible that such small watercolours were produced while Cézanne was searching for subjects or 'motifs', though this practice was by no means invariable. By this stage in his career, however, his oil-painting technique had demonstrably been informed by his mastery of watercolour, and such preliminary studies may even have suggested the transparent washes and overlapping planes of colour in a work such as *Path in Chantilly*.

PROVENANCE: Ambroise Vollard, Paris; Paul Cassirer, Berlin; Mme L. Katzenellenbogen, Berlin; Meirowsky, Berlin; Baronne Myriam von Rothschild, Vienna; André Weil, Paris; private collection, Chicago; E. V. Thaw, New York.

EXHIBITIONS: Oslo 1918 (?); Washington et al. 1971, no. 16 (exhibited only in Chicago); New York-Houston 1977–8, p. 47, ill. (see Reff, below); Geneva 1988, no. 5, ill. p. 31.

LITERATURE: Archives Vollard, photo no. 124 (note by Cézanne's son: Chantilly 1888); Vollard 1914, pl. 22 (with the title: *La Forêt de Chantilly*, dated: 1888); Wedderkop 1922, ill.; Rivière 1923, p. 216 (dated: 1888); Arishima 1926, pl. 4; Mauny 1927, p. 17, ill.; Pfister 1927, fig. 94 (with the title: *Parklandschaft*); Bertram 1928, pl. 18; Venturi 1936, no. 628, pl. 201 (wrong dimensions; dated: 1888); Jedlicka 1948, fig. 37; Elderfield 1971, p. 54, ill.; Orienti 1972, no. 666; Reff 1977, p. 47, ill.; Rewald 1986, p. 193, ill. (dated: 1888); Du 1989, ill. p. 66.

Fig. 15 Cézanne, *Avenue at Chantilly*, 1888. Oil on canvas, 82 × 66 cm. The National Gallery, London.

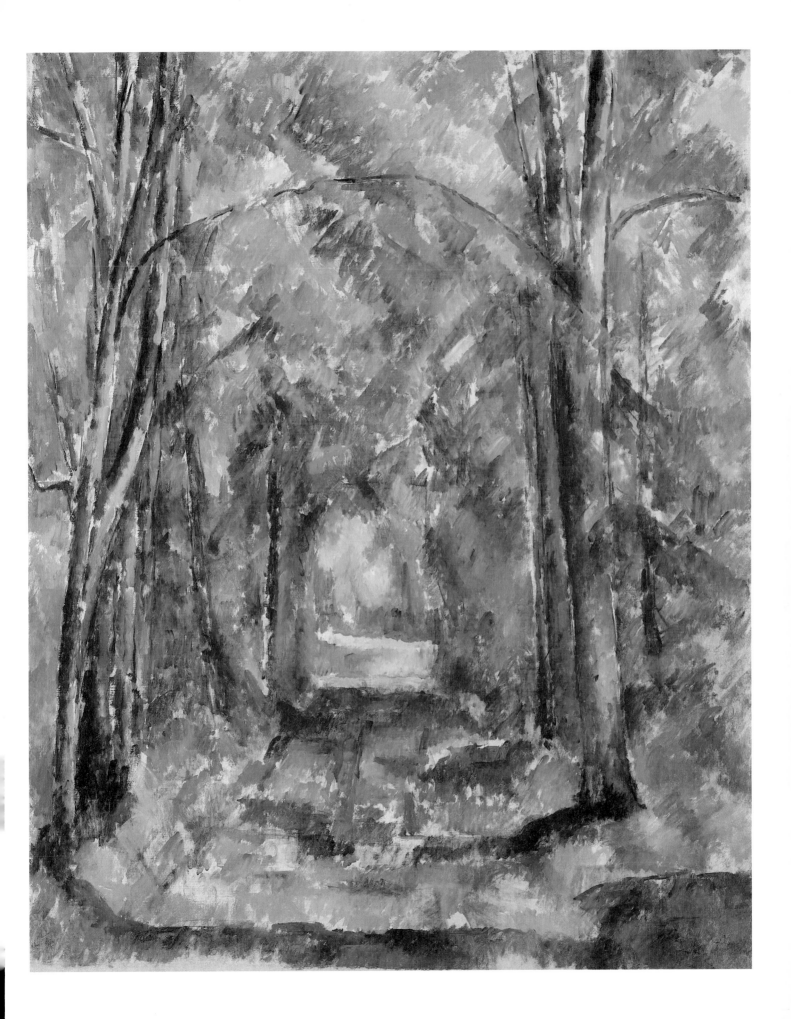

Paul Cézanne

19 Mont Sainte-Victoire
1888–90

Oil on canvas, 65 × 81 cm

This canvas is one of the most brilliantly and variously coloured of all Cézanne's studies of Mont Sainte-Victoire. In an excellent state of preservation, the picture surface shows the vibrancy of Cézanne's original brushwork and the tense, mobile application of paint that characterises much of his later work. In many parts of the picture, patches of uncovered canvas can be seen, where the artist has chosen to leave small areas of cream-coloured priming as part of the final image. Close examination of the brushstrokes shows that many were applied while neighbouring areas were still wet, resulting in the spontaneous mixing and blending of colours on the canvas surface. Throughout the picture Cézanne has used his distinctive parallel strokes of paint, in some places with great finesse and in others, such as the mountain, with considerable freedom. In general the paint is thin and partially transparent, allowing Cézanne's rudimentary pencil drawing of the subject to be seen beneath the final painted surface.

The image of Mont Sainte-Victoire appears in the background of certain of Cézanne's earliest oil paintings, and became the subject of many of his last canvases. In his maturity, the mountain increasingly dominated the centre of a series of oil paintings and watercolour studies, sometimes to the exclusion of other landscape features. For Cézanne, who was intensely loyal to his native region and to his birthplace of Aix-en-Provence, the mountain appears to have taken on both a private and a symbolic significance. Rising to the east of Aix and visible from many of its streets and squares, Mont Sainte-Victoire is an abrupt, assertive mass of grey rock that contrasts sharply with the surrounding land-scape. This contrast lies behind many of Cézanne's paintings of the mountain, where the cool greyness of the rock opposes the greens and ochres of the farm-land, and the rising curves of its profile counterbalance the horizontals of the foreground terrain.

In all probability, *Mont Sainte-Victoire* was painted outdoors directly in front of the subject. Accounts by his friends and fellow artists of Cézanne at work des-cribe his nervous concentration and the sudden, darting movements of his brush as a touch of colour was seized upon and added to the canvas. Cézanne was one of the most self-critical of artists, continually frustrated by his ambition to find equivalents in colour and paint for his perceptual experience. In *Mont Sainte-Victoire* the proliferation and intensity of his colours reaches an unusual pitch of resolution. At the centre of the composition, cool acid greens are laid against the hottest of red-browns, lilacs and pinks against blues and yellows, while in the foreground and sky a single dominant tone provides relief and contrast. Every feature of the scene appears animated by colour, from the hum-blest bush and farm building to the gaunt mass of Mont Sainte-Victoire itself.

PROVENANCE: Ambroise Vollard, Paris (inv. no. 3834?); Auguste Pellerin, Paris; Jean-Victor Pellerin, Paris; George A. Embiricos, Lausanne.

EXHIBITIONS: Geneva 1988, no. 6, ill. p. 33.

LITERATURE: Archives Vollard, photos nos. 123, 410 (notes by Cézanne's son: 1885–90 and Sainte-Victoire 1885); Venturi 1936, no. 662, pl. 212 (dated: 1890–4; revised: 1890–5); Rewald 1939, fig. 65; Loran 1943, p. 100, pl. XXIII; Rewald 1948, fig. 86; Orienti 1972, no. 751; Rewald 1986, p. 177, ill. (dated: 1888–90); Du 1989, ill. p. 57; Coutagne 1990, p. 147, ill.

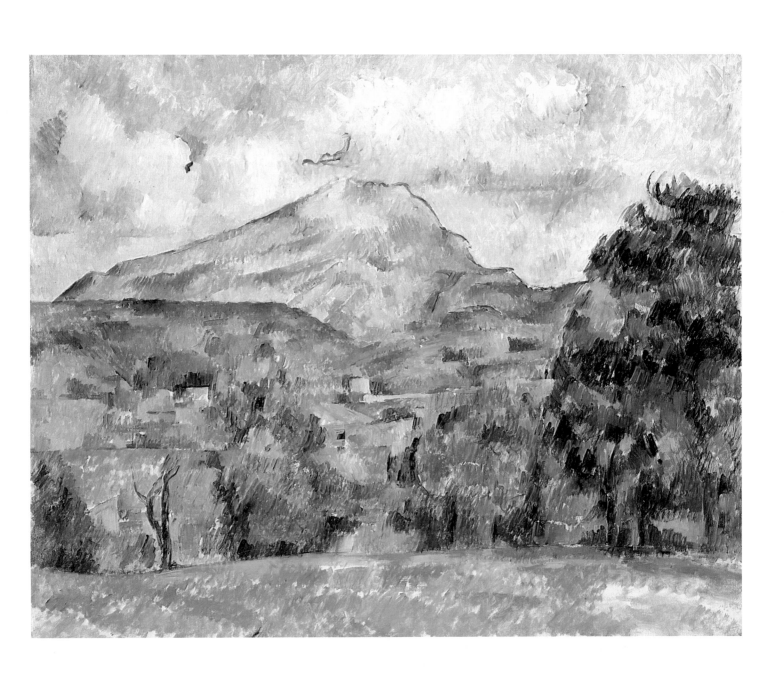

Paul Cézanne

20 Study for the 'Cardplayers'
1890–2

Oil on canvas, 50 × 46 cm

In the early 1890s Cézanne embarked on one of the most important figure subjects of his career. Taking as his theme a group of men playing cards at a table, the artist produced five completed canvases, as well as a number of drawings, watercolours and oil studies of individual figures. Documentation of the works is sparse, and even the sequence of the variations is a matter of conjecture, but it is clear that *Study for the 'Cardplayers'* is related to the two most populated compositions, one now in the Barnes Foundation (Merion, Pennsylvania), the other in the Metropolitan Museum of Art, New York (Fig. 16). Curiously, the figure in this study is a mirror image of its counterpart in the finished pictures, suggesting that it was intended for yet another variant of the scene, or perhaps that it had been superseded at an earlier stage. It is a measure of the seriousness with which Cézanne approached this project, however, that he should have committed himself to so many versions of the subject and to such substantial exploratory studies.

The subject of cardplayers has both an ancient and a colourful pedigree. Often associated with the Dutch low-life painters of the seventeenth century, it could also be transformed by an artist like Chardin into a pretext for elegance and subtle social allusion. Cézanne was well versed in both these precedents, as well as in the dignified imagery of the Le Nain brothers in the seventeenth century and the caricatures of Daumier and Gavarni in his own day, and it seems that his *Cardplayers* were a self-conscious attempt to extend the same tradition. The younger painters who increasingly visited him in his last years were often exhorted to attend to the Old Masters, and Cézanne made clear his own wish to emulate and develop the achievements of his favourite painters, such as Veronese, Rubens and Delacroix. Cézanne's sketchbooks from the period of the *Cardplayers* contain numerous drawings from works in the Louvre, while the other great themes of his maturity, such as the bathers and portraits, illustrate his ambition to create figure compositions in the grand manner.

The subject of *Study for the 'Cardplayers'* – traditionally thought to have been a workman from the family estate – is both modest and enormously dignified. The sombrely suited figure has become part of a taut, considered composition, the bulk of his body poised between the horizontal thrust of the table and the vertical emphasis of chair and wall. Several areas of the painted surface have been reworked or left unfinished, allowing an unusual access to the artist's technique. Beneath the figure itself a preliminary brush drawing can be seen, in which Cézanne has used thinned deep-blue oil paint (and perhaps some violet) to establish both the contours and the principal areas of tone in the composition. Once this underpainting had dried, Cézanne could superimpose his delicate strokes of colour, leaving passages of the original blue paint and untouched canvas where appropriate. Around the edges of the figure a complex dialogue has ensued between the light tones of the wall and the darker tones of hat, jacket and face, resulting in numerous adjustments and redefinitions of this powerfully expressive silhouette.

PROVENANCE: Ambroise Vollard, Paris; Paul Cassirer, Berlin; Jakob Goldschmidt, Berlin; Jakob Goldschmidt sale, Berlin 1941 (see below); C. A. Zapp, Düsseldorf; Jakob Goldschmidt, New York; Alfred Goldschmidt, New York; Alfred Goldschmidt sale, New York 1970 (see below); Sidney R. Barlow, Beverly Hills; Sidney R. Barlow sale, New York 1977 (see below); Sotheby's sale, London 1979 (see below).

EXHIBITIONS: Minneapolis, Institute of Arts (on loan from 4 December 1970 to 8 March 1971); Tokyo et al. 1974, no. 46, ill.; Geneva 1988, no. 7, ill. p. 35.

LITERATURE: Venturi 1936 (dated: 1890–2); sale, Berlin, Goldschmidt collection, Hans W. Lange, 25 September 1941, no. 33; sale, New York, Goldschmidt collection, Parke Bernet, 28 October 1970, no. 17, ill.; Sutton 1974, p. 99, fig. 3; sale, Christie's, New York, Barlow collection, 16 May 1977, no. 7, ill.; sale, Sotheby's, London, Barlow collection, 2 April 1979, no. 8, ill.; Rewald 1986; *Du* 1989, ill. p. 45.

Fig. 16 Cézanne, *The Card Players*, *c*. 1892. Oil on canvas, 65 × 81 cm. Metropolitan Museum of Art, New York.

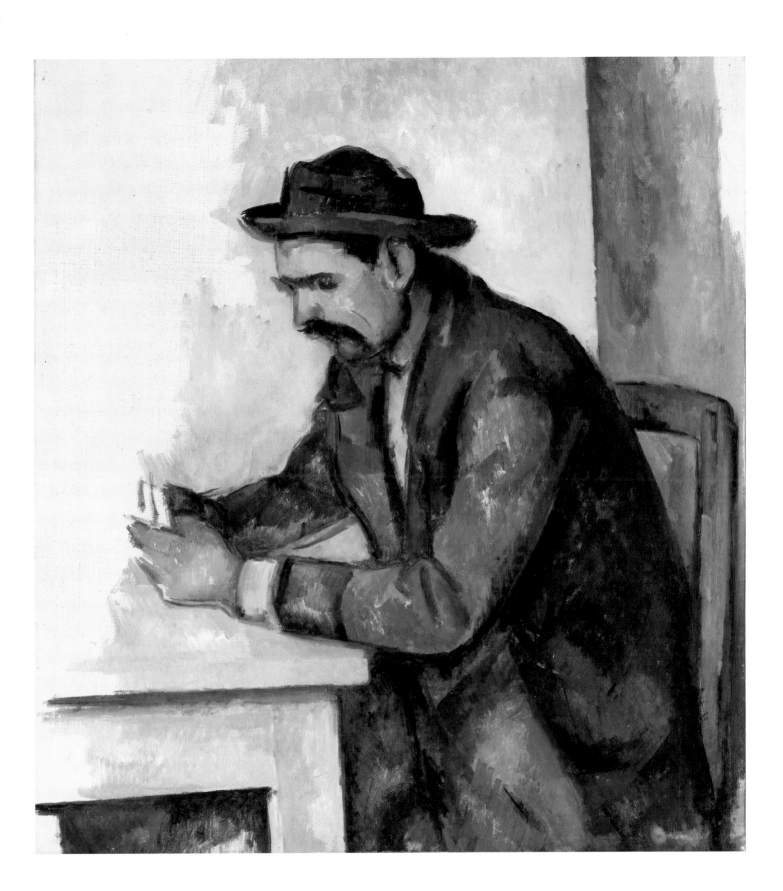

Paul Cézanne

21 Jug and Fruit

1893–4

Oil on canvas, 43.2 × 62.8 cm

By the time Cézanne painted *Jug and Fruit* the still life had been one of the principal themes of his art for more than three decades. Like much of his subject matter the still life was essentially commonplace, allowing Cézanne to exalt ordinary perceptions and experiences; and again, like his landscapes, portraits and bathing scenes, it was resonant with historical associations, recalling the work of Vermeer and Chardin, Manet and Monticelli. However, unlike his other subjects, the still life was almost infinitely flexible, inviting the artist to invent and arrange, to juxtapose colours and to construct relationships of form. However casual the appearance of the objects in *Jug and Fruit* might be, it is known that Cézanne took infinite pains over such arrangements. Over the years, he accumulated a bizarre collection of plates, jugs, bottles and other domestic objects – such as spirit stoves and funnels – from which he could choose the forms and colours demanded by his composition (Fig. 17). Cézanne's contemporaries have recorded how he would spend several hours selecting and positioning his fruit, tilting up an apple or a pear on a small pile of coins until it reached the required angle. In this sense Cézanne's still lifes are both the most innocent-seeming and most artificial of all his works – a self-conscious convergence of nature and art.

A pronounced horizontal format was often used by Cézanne in his still-life compositions, though the spareness and simplicity of this canvas has few precedents on a comparable scale. Other still lifes of the period, including a number that feature the same earthenware jug, incorporate elaborate drapery and background detail, as well as larger groups of fruit and domestic utensils. Here, Cézanne has ruthlessly divided his canvas into two bands of colour, allowing nothing to distract from the precise disposition of his chosen objects and the intervals between them. The eight pieces of fruit are subtly contrasted with each other in size, orientation and hue, while discreet echoes and rhymes – such as that between the central pear and the water jug – establish unity within the group. Arranging his subject matter across the surface of the canvas, as if to stress its pattern-like character, Cézanne has at the same time gone to unusual lengths to accentuate the three-dimensional nature of the objects. By overlapping many of the forms, by modelling their surfaces from deep shadow to bright highlight, and by intensifying their colours with saturated warm and cool hues, he has created a dramatic tension between illusionism and flatness. Even the exaggerated scale of some of the fruit, and the dense blue line drawn around their profiles, seem to contribute to this palpable, almost disruptive confrontation.

PROVENANCE: Ambroise Vollard, Paris; Cornelis Hoogendijk, Amsterdam (on loan to the Rijksmuseum, Amsterdam); Paul Rosenberg, Georges Wildenstein, Jos. Hessel and Durand-Ruel, Paris; Marcel Kapferer, Paris; Bernheim-Jeune, Paris; Nathan J. Miller, New Rochelle, N.Y.; Mr and Mrs Aaron W. Davis, New York; Sam Salz, New York; William Beadleston, New York.

EXHIBITIONS: Amsterdam 1911 (on loan to the Rijksmuseum, cat. no. 6880); New York 1942, no. 11, ill.; New York (Wildenstein) 1947, no. 36; Chicago-New York 1952, no. 59, ill.; London 1979, no. 3, pp. 10–11, ill.; Geneva 1988, no. 8, ill. p. 37.

LITERATURE: Bye 1921, ill. facing p. 134; Fontainas-Vauxcelles 1922, p. 232, ill.; Bertram 1929, pl. 23; Venturi 1936, no. 500, pl. 155 (dated: 1885–7); Raynal 1936, pl. XCIV; Venturi 1942, p. 16, ill. (dated: 1893–5); Orienti 1972, no. 481; Elgar 1975, fig. 74; Rewald 1986, p. 180, ill. (dated: 1893–4); Du 1989, ill. p. 25.

Fig. 17 Cézanne, *Spirit Stove and Jug*, 1885–1900. Graphite, 12.7 × 18.8 cm. Philadelphia Museum of Art.

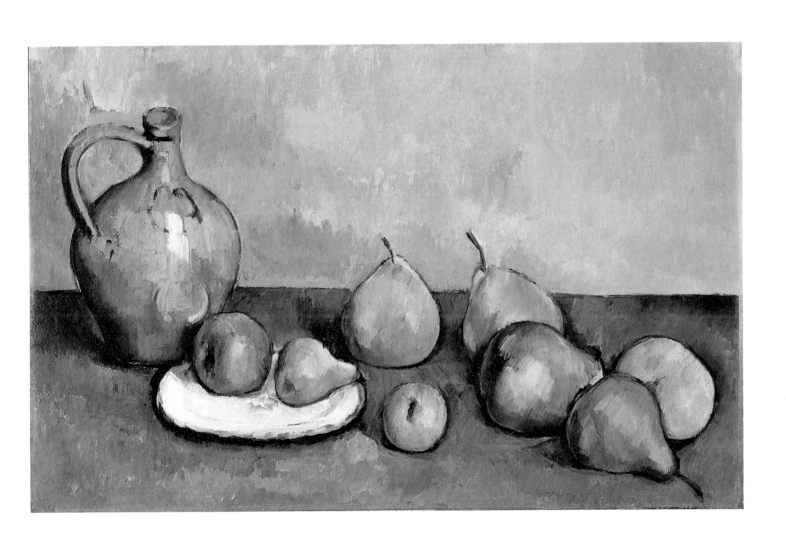

Paul Cézanne

22 Girl with a Doll
c. 1899

Oil on canvas, 92 × 73 cm

In the last decade of his life Cézanne committed himself to an ambitious programme of portrait painting, using as models his friends, family servants and local acquaintances. While some of his subjects are known to us, including the critic Gustave Geffroy, the art dealer Ambroise Vollard, the poet Joachim Gasquet and Cézanne's gardener Vallier, most are presumed to be neighbours, or workmen from the family estate at Aix. It is unlikely that any of the pictures were commissioned and in every case Cézanne has avoided the pretension and display associated with the fashionable portrait. *Girl with a Doll* is one of about a dozen canvases of identical size, each one featuring a single figure seated impassively at the centre of a vertical rectangle. As in so many of Cézanne's portraits, incident is reduced to a minimum and the gravity of the occasion is expressed in the simple geometry of its components. Here, the pronounced curve of the girl's shoulder and sleeve establishes a solemn rhythm within the scene, which is echoed in the rounded forms of dress and head, and reflected in the sweep of the chair-back. A horizontal line across the wall and the vertical accent along its edge only heighten the essential fullness and rotundity of the image.

One of the most remarkable features of *Girl with a Doll* is its colour: a warm, subdued grey is allowed to dominate both the girl and her background, interrupted only by the ochres of her hands and face and by touches of brown on the chair and wall. Within such severe constraints Cézanne's mastery of tone and his originality in the application of paint is particularly evident. However modest its role in the picture, every area of grey is made up of numerous subsidiary patches of colour, each warmer or colder than its neighbours or subtly tinted with different pigments. The corner of wall to the left of the girl's head, for example, includes green-greys, blue-greys, lilac-greys and even a touch of crimson-grey, as if the artist wished to breathe life into this most neutral of spaces. Cézanne's intense, almost nervous, clusters of brushstrokes are more restrained in the girl's face, but here again the dominant ochre is enlivened with strokes of violet, green and blue.

Although there is no external evidence of a programmatic intention in Cézanne's late portraits, the coincidence of size, scale and subject matter in *Girl with a Doll* and a number of his other late canvases might suggest such an approach. Consciously adopting the format of the grand portrait, Cézanne celebrated the children, working men and women, and elderly acquaintances of his late career and assembled a picture gallery of provincial types. Just as Pissarro and van Gogh had devoted major canvases to some of their humblest sitters, so Cézanne appears to see in the modest colouring, lugubrious pose and gentle gesture of *Girl with a Doll* the potential for great art.

PROVENANCE: Ambroise Vollard, Paris (inv. no. 3864, with the title: *Portrait de femme assise dans une chaise et tenant une poupée à la main*, without dimensions; or inv. no. 7027, with the title: *Jeune fille à la poupée*, 92×73 cm); Alphonse Kann, Saint-Germain-en-Laye; Paul Rosenberg, New York; Walter P. Chrysler, Jr., New York.

EXHIBITIONS: Paris 1895 (unnumbered); Zurich 1917, no. 12; Paris 1929, no. 29; Paris 1936, no. 92; Portland (Oregon) 1956, no. 86, pl. 130; Dayton 1960, no. 71; Geneva 1988, no. 9, ill. p. 39.

LITERATURE: Archives Vollard, photo no. 443; Vollard 1915, pl. 27 (dated: 1894); Fry 1917, pl. III; L. Vaillat, 'Cent ans de peinture française', in *L'Illustration*, 1 April 1922, no. 4126, ill. p. 292; Rivière 1923, p. 221; Arishima 1926, pl. 28; Venturi 1936, no. 675, ill. (dated: 1892–6; revised: *c.* 1897); Barnes-De Mazia, 1939, no. 146 (dated: *c.* 1895); Gimpel 1963, p. 274; Orienti 1972, no. 583; Taillandier 1979, p. 54, ill. p. 84; Rewald 1986, p. 214, ill. (dated: *c.* 1902); Du 1989, p. 48.

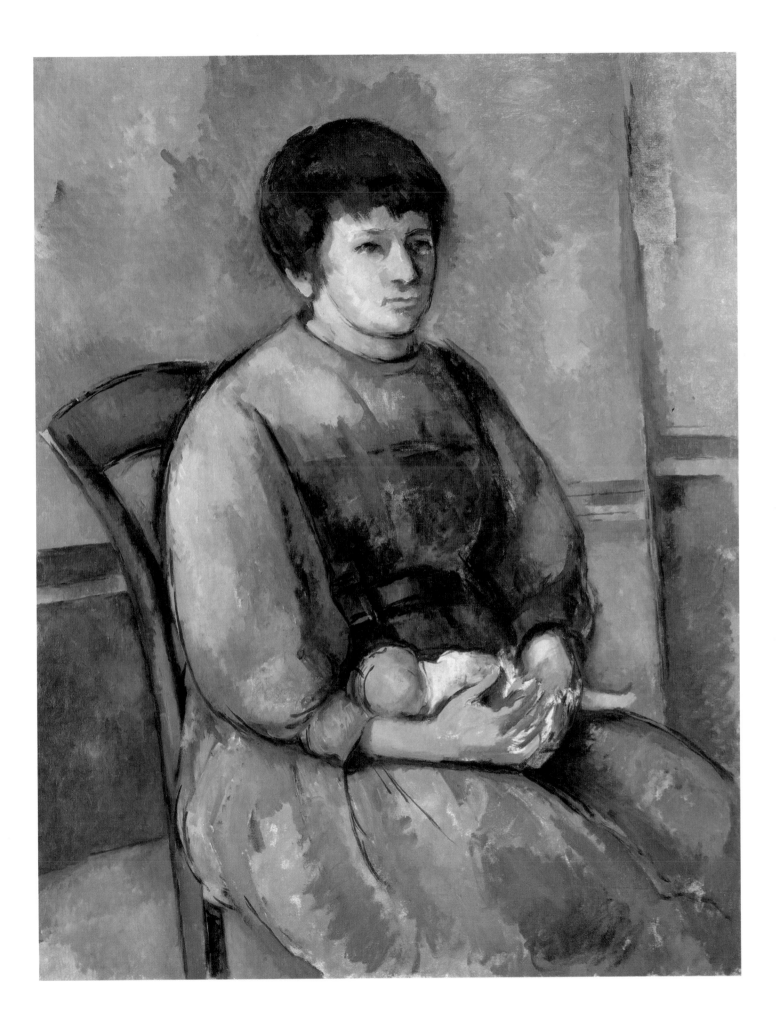

Paul Cézanne

23 Young Girl with a Doll
1902–4

Oil on canvas, 73 × 60 cm

The identity of the sitter in *Young Girl with a Doll* is unknown, and the reason why Cézanne should have painted two pictures with similar subjects (see Cat. no. 22) in his final years has never been explained. Despite his reputation as a reclusive and difficult individual, Cézanne showed a fondness for painting children at most stages of his career. Numerous drawings, watercolours and oil paintings exist of his own son, Paul, and in old age Cézanne used the local children and young people of Aix as his models. He was also a notoriously slow painter, and many of the poses adopted in his portraits were chosen for comfort rather than elegance. His sitters are typically shown in impassive or undemonstrative positions, while hands are concealed, used to support a head, or firmly clasped. The decision to include a doll in this picture and in its earlier companion may have had such a homely motive, though this feature will doubtless lend itself to more esoteric interpretation.

Cézanne's insistence on painting directly from nature, whether his subject was a still life, landscape or human model, led to practical inconvenience and daily frustration. Many of his portraits were left unfinished or abandoned, while others were reworked until the canvas became richly encrusted with paint. By the time *Young Girl with a Doll* was painted, Cézanne was using both colour and brushwork with exceptional licence, applying his paint in the broad patches or facet-like blocks that were soon to be adopted by the young Cubists. In this canvas, the earlier stages of the picture and the gradual emergence of the image can be traced. Thin washes of paint were used to fix the position of the figure and to establish the fundamental tones and colours of the image. In subsequent sittings Cézanne used thicker paint and more emphatic brushwork, exploiting both the direction of his strokes and the intensity of their colour to give form and substance to his subject. The rich yellow-orange of the girl's hat and the warm tones of her hands contrast with the blue of her tunic, while asserting themselves as symmetrical and curving forms within the composition. In contrast to the slightly earlier *Girl with a Doll*, the colour here seems more insistent, detaching itself from its purely descriptive role and energising the surface of the canvas. Even the more neutral areas of background and distant foliage are densely worked, and there is evidence that the broad band of shadow across the middle of the canvas was superimposed at a late stage.

PROVENANCE: Ambroise Vollard, Paris; Auguste Pellerin, Paris; Bernheim-Jeune, Paris; Alphonse Kann, Saint-Germain-en-Laye; Galerie E. Bignou, Paris; Galerie Barbazanges, Paris; Mme Lilli Lippmann-Wulf, Amsterdam; Dalzell Hatfield, Los Angeles; Honolulu Academy of Fine Arts, Honolulu; Knoedler Galleries, New York; Zannis L. Cambanis, London; George A. Embiricos, Lausanne.

EXHIBITIONS: London 1924 (unnumbered), ill.; San Francisco 1937, no. 36, ill.; Ottawa 1950, no. 5, ill.; Detroit 1954, no. 101, ill.; Tokyo et al. 1974, no. 54, ill; Geneva 1988, no. 10, ill. p. 41.

LITERATURE: Archives Vollard, photo no. 292 (dated, in *Cahiers d'Art*: c. 1895); *Bulletin of the Honolulu Academy of Arts*, 6 March 1917, p. 18; G. Burmann 1922, Leipzig, p. 52, ill.; Wedderkop 1922[1], p. 689, ill.; Wedderkop 1922[2], ill.; Rivière 1923, p. 221 (dated: 1897); Tatlock 1924; Venturi 1936, no. 699, pl. 228 (dated: 1900–2; revised: c. 1896); Raynal 1936, pl. LXXIV; Gaunt 1938, p. 144; Goldwater 1938, p. 138; *Art News*, 26 March 1938, ill.; Cogniat 1939, pl. 84; Frost 1942, p. 47; Jewell 1944, p. 24, ill.; Guerry 1966, pl. 55; Ramuz 1968, fig. 26; Orienti 1972, no. 609; Bourges 1984, p. 49; Rewald 1986, p. 215, ill. (dated: 1902–4); *Du* 1989, ill. p. 48.

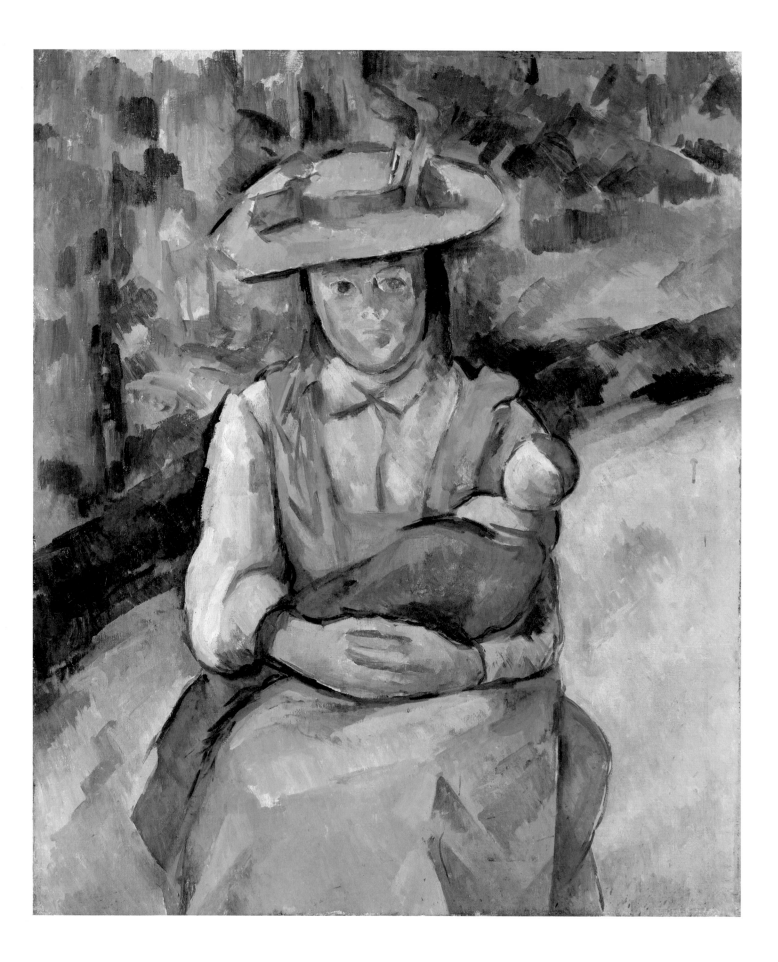

Paul Cézanne

24 A Letter to his Son
1906

Signed letter, 19.5 × 25.5 cm.
Envelope addressed to: *Monsieur Paul Cézanne/16 rue Duperré/Paris IX arron.* Postmark: *Aix* [en Provence] *26.7.06*

Aix, 25 July, 1906

My dear Paul,
Yesterday I received your wonderful letter giving me your news. I am really very grieved about your mother's condition, take care of her as much as you can, try to make her feel well, with the freshness and distractions which are appropriate to the circumstances. – Yesterday, on Thursday, I had to go and visit the ensoutané *Roux. I didn't go, and this will be so until the very end, and it will be the best thing to do. He's a sticky man. – Regarding Marthe, I went to visit Aunt Marie. – Another nuisance, at my age it is better to live isolated and paint.*

Vallier massages me, my kidneys feel a little better and Madame Brémond says that my foot is improving. – I am following Boissy's cure, it's terrible. It is very hot. – From eight o'clock on the weather is unbearable. – The two canvases, of which you sent me photographs, are not mine. I embrace you both with all my heart, your old father,

Paul Cézanne

Give my regards to Monsieur and Madame le Goupil, whose good greetings touch me greatly and who are so very kind to your poor mother. P. Céz.

PROVENANCE: Paul Cézanne, Jr., Paris.

EXHIBITIONS: Geneva 1988, no. 11, ill. p. 43.

LITERATURE: Mack 1935, p. 386; Rewald 1937, pp. 279–80; Lindsay 1969, p. 336; Rewald 1978, pp. 317–18.

In the last few months of his life, Cézanne wrote regularly to his son Paul, leaving us with an unusually detailed picture of his circumstances and daily routines. Unlike his letters to fellow artists such as Charles Camoin and Emile Bernard, Cézanne's family correspondence is largely taken up with domestic matters. He complains of his poor health and of the summer heatwave, and of the irritation of unwelcome calls. In his old age, and partly under the influence of his sister Marie, Cézanne had turned to the Church, though in this letter he expresses his dislike of the local *abbé*, the *ensoutané* Roux. Cared for by his house-keeper Madame Brémond and gardener Vallier (who also posed for several pictures; Cat. no. 25), Cézanne continued to paint until the end, while his son managed his father's affairs. The reference in this letter to photographs sent by Paul probably concerns imitations, or possibly forgeries, of Cézanne's paintings.

Monsieur
Paul Cézanne,
16 rue Duperré,
Paris

1

Aix, 25 juillet 1906.

Mon cher Paul.

Hier, j'ai reçu ta
bonne lettre qui me
donne de vos nouvelles,
je ne puis que déplorer
l'état dans lequel se
trouve ta mère, donne
lui le plus de soins
possible, cherche le
bien être, la fraîcheur et
des divertissements appro-
priés à leur constance. — Hier, je...

2

je devais aller trouver le
ensouffrant Rouse. Je
n'y puis pas aller et il en
sera ainsi, jusqu'à la
fin, ce sera ce qui s'il y a encore
de mieux à faire, c'est en
poésie. — à propos
de Marthe, je serais allé
voir ta tante Marie. —
c'est encore un têton, à mon
aya il convient de vivre
isolé et de peindre.
Vallier me frictionne, je m'en
vais un peu mieux, Madame
Brémond, et que le pied va
mieux. — Je suis le traite-
ment de Boissy, il est

3

atroce. Il fait très chaud. —
Dès huit heures, le temps est
insupportable. — Les
deux toiles, dont tu m'as
envoyé la photographie ne
sont pas de moi. —
Je vous embrasse tous deux
de tout mon cœur,
ton vieux père,

Paul Cézanne

Donne le bonjour à Monsieur
et à Madame le Gompel. —
dont le bon souvenir me
touche et qui sont si gentils
pour ta pauvre mère.

Paul Cézanne

25 Portrait of the Gardener Vallier
c. 1906

Watercolour on paper, 48 × 31.5 cm

Towards the end of his life Cézanne painted a number of portraits of his gardener Vallier, including the canvas in the Tate Gallery, London (Fig. 18), and a small group of watercolours. As with so many of his late portraits there is a wilful simplicity, almost an inelegance, about the gardener's posture and the matter-of-fact placing of his figure within the picture rectangle. In his still-life paintings, Cézanne had transmuted the most commonplace of domestic objects into the refined currency of art, and it is possible that his figure paintings shared a similar ambition. In the *Cardplayers* (Cat. no. 20), the studies of anonymous children (Cat. nos. 22 and 23) and the portraits of local acquaintances, Cézanne seems to elevate the mundane and the provincial. Always loyal to his Provençal roots and suspicious of Parisian delicacy, Cézanne himself appeared eccentric and uncouth to many of his visitors. In *Portrait of the Gardener Vallier*, no concessions are made to refinement – an unkempt corner of the garden, a rustic chair and the simplest of clothing provide all the materials necessary for the picture.

On many occasions in later life, Cézanne is said to have insisted on the central role of colour in his art. This portrait, on the other hand, shows the extent to which colour and line remained interdependent even in the most advanced work of his maturity. Following his normal procedure, line formed the starting point of this picture, a pencil being used to draw in the principal forms of figure, chair and background, and even to indicate areas of tone with simple hatching. Over this drawing were laid thin veils of watercolour, building up shadows with repeated applications of paint and leaving highlights almost untouched. Towards the end of this process another series of lines, this time applied with the tip of a brush and using bright blue paint, was added to the profiles of the figure and to the dominant shadows. As in the work of his contemporary Degas, who used pastel to define both colour and line in a single stroke, Cézanne has here unified the fundamental elements of his art. As he said to Larguier: 'Pure drawing is an abstraction. Drawing and colour are not distinct, everything in nature is coloured.'

PROVENANCE: Ambroise Vollard, Paris; Sir Victor Schuster, London; Edward Molyneux, London; O. Edler, London; auction sale, London 1958; Interart Ltd., Zug.

EXHIBITIONS: London 1939, no. 71 (wrongly identified as Venturi no. 1092, lent by Sir Victor Schuster); London 1942, no. 35; Vienna 1961, no. 82, pl. 46; Aix-en-Provence 1961, no. 39, pl. 23; New York 1963, no. 70, p. 60, pl. LXVI; Kassel 1964, no. 3, ill.; Paris 1971, no. 21; Newcastle-London 1973, no. 97, ill.; Tokyo et al. 1974, no. 87, ill.; Tübingen-Zurich 1982, no. 103, ill.; Liège-Aix-en-Provence 1982, p. 43, ill.; Geneva 1988, no. 12, ill. p. 45; Saint-Paul-de-Vence 1989, no. 8, ill.

LITERATURE: Venturi 1936, no. 1566, pl. 396 (dated: 1902–6); Venturi 1943, p. 42, pl. 29 (dated: 1906); sale, Sotheby's, London, 26 March 1958, no. 138, ill.; Sérullaz 1971, pl. 14; Hoog 1971, p. 63, ill.; Siblik 1972, pl. XIV; Wadley 1975, fig. 65; Rubin 1977, pl. 30; Venturi 1978, p. 129, ill.; Rewald 1984, no. 640, pp. 257–8, ill. (dated: *c.* 1906); Bourges 1989, p. 19, ill.

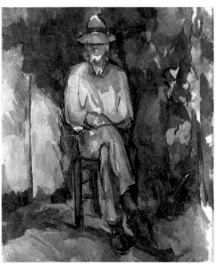

Fig. 18 Cézanne, *The Gardener*, *c.* 1906. Oil on canvas, 65.4 × 54.9 cm. Tate Gallery, London.

Georges Braque

1882–1963

Georges Braque

26 Still Life with Pipe (Le Quotidien du Midi)
1913–14

Oil on canvas, 33 × 41 cm. Signed on verso: *G. Braque*

Braque and Picasso first met in 1907, at about the time *Les Demoiselles d'Avignon* was painted. Though their backgrounds and temperaments were widely different, they soon established a mutually respectful and intimate working relationship that was famously described by Braque as 'like two mountaineers roped together'. Their collaboration was at its most intense during 1911 and 1912, each artist responding to the innovations of the other and at times working in a manner that only the most practised eye can tell apart. The formal devices in *Still Life with Pipe* all have their equivalents in Picasso's concurrent painting, though several originated in Braque's distinctive technique and sensibility. Braque, in 1911, had been the first to stencil letters and numbers onto his pictures, a procedure that had revolutionary consequences for the syntax of Cubism. The letters in *Still Life with Pipe* (which are painted rather than stencilled) refer to a newspaper and a bottle of spirits, and together locate the composition among everyday paraphernalia. Without this lettering, and the comically schematic clay pipe, the picture would lose not only its legibility but its relationship to the vocabulary of ordinary experience.

One of Braque's principal ambitions in his Cubist work was to find pictorial equivalents for the visual complexity of objects and for their textures and tactile qualities – to 'take full possession of them' in his own words. *Still Life with Pipe* is a rich and dynamic interplay of colours and simulated surface effects, each evoking a different sensuous response to the depicted object. Braque, who was the son of a house-painter, had initiated Picasso into the technique of wood graining, and uses it here to suggest the coarse surface of the table behind the still life. As often in Cubism, this procedure generates a number of complex, playful and sometimes wilfully contradictory responses. The wood grain, the newspaper lettering and the clay pipe all refer to commonplace objects; at the same time, each is manifestly contrived from the substance of paint, and any possibility of illusionism is denied by their stylised forms and painterly textures. As a further twist in the conundrum, the wood graining, a conventional illusionistic device, is here used in an anti-illusionistic context, while the different areas of shadow appear to describe volumes that are self-evidently flat.

Still Life with Pipe is one of a number of oil paintings by Braque which used papiers collés, or collages made from pasted paper, as their starting point. A piece of newspaper used in the large papier collé from which this picture is derived (Fig. 19) has been dated 15 November 1912, though the confidence and exuberance of the finished canvas suggest that it was executed some while later. A number of elements from this original study have been carried over into the final work, while others, such as the dark curve of the violin, survive in vestigial form. Both Braque and Picasso had by this date incorporated real pieces of paper and other material into their oil paintings, while conversely transforming their painted surfaces to look more like collages. In *Still Life with Pipe*, the result is a taut, witty and abrasive composition that reveals its own workings with unusual frankness.

PROVENANCE: Galerie Kahnweiler, Paris (photo no. 1192); Kahnweiler sale, Paris, 1925; Galerie Simon, Paris; César de Hauke, Paris (until 1947); Galerie Knoedler & Co., New York; The Hyde Collection, Glen Falls, N.Y. (until 1969); Hirschl and Adler, New York; Norton Simon, Los Angeles; E.V. Thaw, New York.

EXHIBITIONS: Los Angeles-New York 1970–1, p. 277, no. 28, pl. 51; New York 1985, p. 117, ill. p. 108; Geneva 1988, no. 29, ill. p. 85; New York 1989–90, ill. p. 305.

LITERATURE: 1st Kahnweiler sale, Paris, Hôtel Drouot, 13 June 1921 (with the title: *Pipe et tabac*); Isarlov 1932, no. 192, pp. 19–20 (with the title: *La Bouteille d'Eau-de-vie*); Krauss 1971, vol. IX, no. 6, p. 32 ff.; Descargues-Carrà 1973, p. 90, no. 92, ill.; Steadman 1976, vol. 193, no. 777, p. 220 ff.; Hermann 1980, p. 132, ill.; Worms de Romilly 1982, no. 235, ill. p. 196 (with the title: *La Bouteille d'Eau-de-vie*); Paris 1982, ill. p. 138; Pouillon 1982, p. 54, fig. 3.

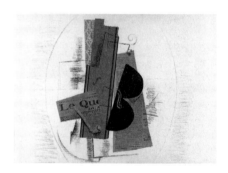

Fig. 19 Braque, *Violin and Pipe* (detail), *c.* 1912–14. Charcoal and papier collé, 74 × 106 cm. Musée National d'Art Moderne, Centre Georges Pompidou, Paris.

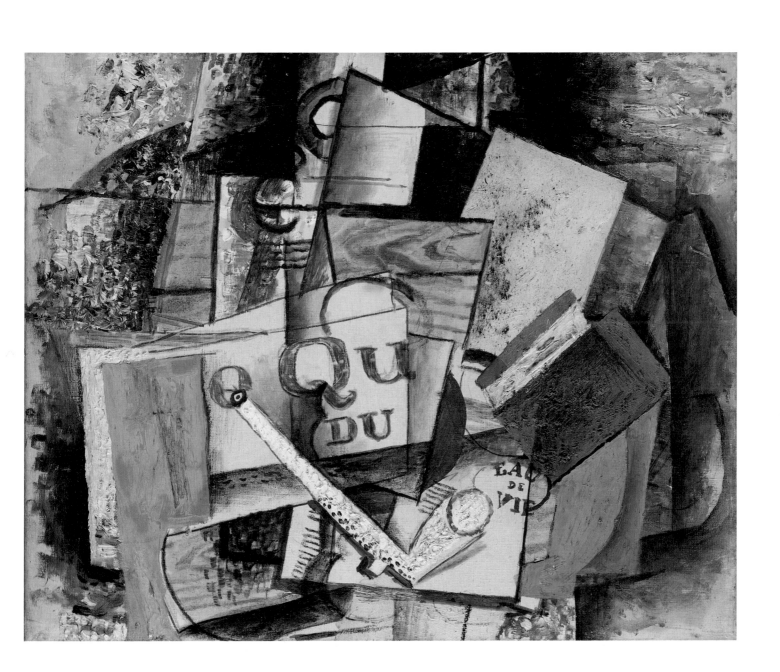

Georges Braque

27 Still Life with Glass and Newspaper (Le Guéridon)
1913

Black chalk, charcoal and oil on canvas, 98.7 × 72.5 cm. Signed lower right: *G. Braque*

This still life is principally constructed from a series of white, brown and grey rectangles, shadowed in darker paint to resemble overlapping planes or sheets of paper. Within this severe structure, a number of arcs and curves suggest a wineglass, a musical instrument and a scroll-like decorative border, while the ellipses at the lower edges of the canvas indicate a *guéridon*, or circular one-legged table, on which the still life is grouped. With characteristic finesse, and with the simplest of means, Braque has balanced the requirements of representation against the interplay of shape, and the planar surface of the canvas against the volumes and recessions of the still life. Whether or not such a composition originated in a group of real objects, the final priorities are those of the painting itself and its dialogue with the language of perception.

Like Picasso's *Still Life on a Piano* (Cat. no. 36), this picture was painted in the aftermath of an intense period of experimentation which brought the two artists to the brink of pure abstraction. Subsequently, both Braque and Picasso returned to the description of everyday objects in their pictures, using such items as wineglasses and newspapers to identify their subject matter, and often adding painted or stencilled words to enrich their range of references. In *Still Life with Glass and Newspaper*, the lower lettering refers to the newspaper *L'Echo d'Avignon*, which was also used in a closely related collage, while the word *JOU* belongs to a well-established Cubist vocabulary of puns. Derived from the title of another newspaper, the word *journal* is here abbreviated to *jou* and recalls the verb *jouer*, appropriate to the playing of the nearby musical instruments as well as to the playfulness of Braque's picture.

This painting also invites a close scrutiny of Braque's working procedures. Drawn directly with black chalk and charcoal onto a lightly primed canvas (which has probably darkened with age), the picture shows a wide variety of brushmarks and textural devices. Areas of thinly washed paint are contrasted with dense passages of impasto, while a blunt instrument (probably the handle of the paintbrush) has been used to scratch into the still-wet paint. Many of these devices emphasise the physical fabric of the picture and are in stark and deliberate contrast to the 'finish' of conventional painting. In this, as in so many respects, Cubism can be seen as an art of subversion, replacing dissimulation with frankness, mixing surface effects with spatial illusion, and daring to combine high seriousness with self-indulgent witticism.

Still Life with Glass and Newspaper has an unusually significant and well-documented history. It was reproduced in a Parisian periodical in 1914 and acquired by Kahnweiler, who was then Picasso's dealer. Subsequently bought by André Breton, the leading figure of the Surrealist movement, the painting was later acquired by the historian and collector of Cubist art, Douglas Cooper.

PROVENANCE: Galerie Kahnweiler, Paris (inv. no. 1468, photo no. 1152); Kahnweiler sale, Paris, 1922; André Breton, Paris; Mackenzie Sholto, London; Douglas Sholto, London; Comte Horter, Philadelphia (until 1926); Douglas Cooper, Argilliers (from 1937 to 1969); Acquavella Galleries, New York (1969–70).

EXHIBITIONS: Edinburgh-London 1956, no. 40, cat. pl. 21(i); Munich 1963, no. 46, pl. 42; New York 1981, no. 13, p. 30, ill. p. 31; London 1983, no. 30, ill. p. 95; Geneva 1988, no. 30, ill. p. 87; New York 1989–90, ill. p. 291.

LITERATURE: *Les Soirée de Paris*, no. 23, 15 April 1914, ill. facing p. 224 (with the title: *Nature morte*); 3rd Kahnweiler sale, Paris, Hôtel Drouot, 4 July 1922, no. 40 (with the title: *Nature morte*); *L'Effort Moderne*, November 1925, ill.; Isarlov 1932, no. 165, pl. 19 (with the title: *Le guéridon*); Richardson 1955, ill. p. 20; Descargues-Ponge-Malraux 1971, p. 116, ill.; Caizergues 1981, p. 87, no. 18, ill.; Worms de Romilly 1982, no. 182, ill. p. 197 (with the title: *Le guéridon*).

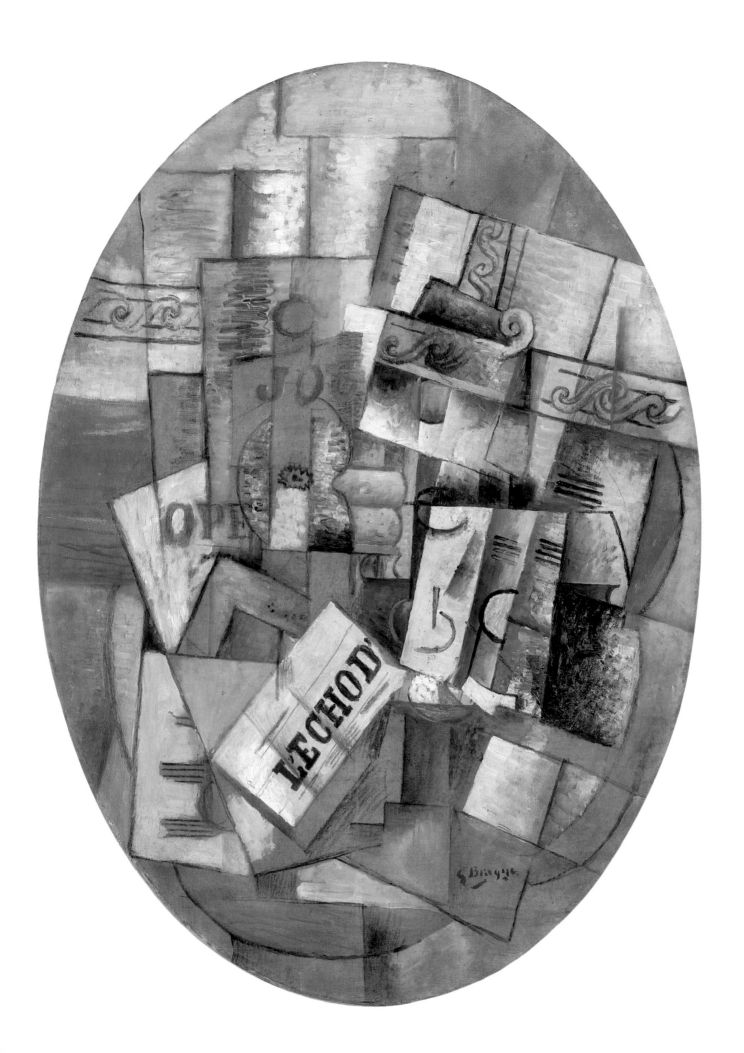

Pablo Picasso

1881–1973

Pablo Picasso

28 At the Café-Concert
1902

Pastel on paper, 31 × 40 cm. Signed lower right: *Picasso*

In the autumn of 1900, the 19-year-old Picasso made his first journey from Barcelona to Paris. Over the next two years he divided his time between these two cities, painting dexterous and brilliant scenes of bullfights, cabarets and local celebrities, as well as studies of his fellow bohemians. As the months passed, the bright colours of this urban subject matter were overtaken by the severity of the Blue Period, well exemplified in the tones and hues of *At the Café-Concert*. Despite the artist's tender years and the abrasiveness of his subject matter, however, Picasso had already begun to attract the attention of dealers and collectors.

Writing of *At the Café-Concert* in 1902, Charles Morice exclaimed: 'Such composition – at the theatre, two spectators, a man and a woman, in a box, turning away from the stage where the *danseuse* performs, far off, in bright light, – is as disturbing and provocative as a *Fleur du Mal*. Beings of hardly either sex, "ordinary demons", with despairing eyes, head bowed, brow blackened with desperate or criminal thoughts. . . .' The composition that so fascinated Morice is both severe and remarkably symmetrical. The two figures echo each other across a central void, while the harshly illuminated table-top is balanced along a diagonal axis by a distant view of the stage. No upholstery or ornament relieves the grimness of the cubicle, where the melancholy of the couple is contrasted with the gaiety of the remote dancing figure. As if to complete their isolation, Picasso has shown both figures from behind, highlighting the gaunt musculature of the man and the huddled, almost crouched position of his companion. These poses appear frequently in pictures of the Blue Period, often identified with scenes of poverty, withdrawal and despair (Fig. 20). Though Picasso was not above sentiment and theatricality, he had himself experienced real privation and may even have intended the forlorn figure on the right of *At the Café-Concert* as a self portrait – contemporary photographs of the artist show the same angular features, dark colouring and deeply recessed hair-parting.

According to his contemporaries, Picasso's extreme poverty at this period obliged him to abandon oil paints and produce only drawings and pastels on paper. Pastel was a medium he used only sporadically during his career, though here it is handled confidently in the modelling of the figures and in the description of the faces. Variants of this composition exist in the form of a small crayon drawing in a Barcelona private collection and a related oil painting, and each is dominated by the chalk-white mask of the woman. Picasso's choice of medium and subject matter suggests another historical parallel. The pastel was first shown at the Galerie Berthe Weill, 25 rue Victor Massé. A few doors away, at number 37, was the studio of the elderly Edgar Degas, an artist still famed for his pastels, his pictures of the Café-Concert and his studies of the female back. Could the young Spaniard's picture have been intended as a gesture of homage, or even of defiance, towards his predecessor and temporary neighbour?

PROVENANCE: Theodore Schempp, New York; Mr and Mrs Lee Ault, New York.

EXHIBITIONS: Paris 1902, no. 18 (?) (with the title: *Scène de concert*); New York 1962 (Knoedler & Co.), no. 12, ill.; New York 1985, p. 94, ill.; Tübingen-Düsseldorf 1986, no. 15 (see Spies 1986, below); Geneva 1988, no. 63, ill. p. 167.

LITERATURE: Zervos 1949–86, vol. XXI, no. 345, pl. 129; *Art in America* 1962, no. 1, p. 97; Daix-Boudaille 1966, cat. VII, no. 12, p. 210; *Life Magazine* 1968, Christmas Edition, ill.; Palau i Fabre 1981, no. 756, p. 302, ill.; Spies 1986, no. 15, ill.

Fig. 20 Picasso, *Two Women at a Bar*, 1902. Oil on canvas, 80 × 91.4 cm. Hiroshima Museum of Art.

Pablo Picasso

29 Head of a Young Man
1906

Gouache on paper, 40 × 26.7 cm. Signed lower right: *Picasso*

The terracotta, ochre and white of this portrait are characteristic of Picasso's work in the earlier part of 1906, as he turned away from the attenuated colour schemes of the Blue and Pink Periods towards an earthy and less emotive range of pigments. While there are dangers in assuming a direct relationship between colour and an artist's emotional life, the evidence shows that Picasso's first melancholy years in Paris had given way to a warmer and more confident phase of early manhood. At the time he painted *Head of a Young Man*, Picasso was spending the summer with his mistress Fernande Olivier in the remote village of Gosol, in the Spanish Pyrenees, attracted by the cheapness of the life and the rugged simplicity of the surroundings. Something of this ruggedness comes across in the pictures he made there, which are often broadly brushed, artlessly composed and loosely finished. Picasso drew the old men of the village with a wilful awkwardness, the women balancing loaves of bread squarely on their heads, and the massive local cattle led by solemn young boys. One of these boys became the subject of several drawings and paintings, appearing once in a traditional headdress and here in an orthodox full-face portrait. The boy's remote, wistful expression still recalls the work of the Blue and Pink periods, but here the face is altogether more substantial. The strong lines of the nose, chin and eyebrows suggest a vigorous interplay of volumes, while the deeply mod-elled features remind us of Picasso's well-documented interest in sculpture. Since his arrival in Paris, Picasso had studied classical, Egyptian and ancient Iberian artefacts in the city's museums and collections, and had already begun to make small sculptures, including some portraits.

Until recently it has been assumed that *Head of a Young Man* was part of a general response to ancient art that characterised much of Picasso's work at this period. While examining the picture for the present exhibition, however, it has been possible to identify Picasso's source of inspiration with some precision. Beneath the surface of the picture another image can be seen and further examination under infra-red light has shown that Picasso superimposed his painting onto a Japanese wood-block print (Fig. 21). The print, which has been provisionally identified as an early nineteenth-century work from the circle of Kunisada, shows an elaborately dressed Japanese actor, his ceremonial clothing billowing down towards the right-hand side of the composition as he struggles with an anchor against a background of waves. The circumstances in which Picasso chose to paint over this print must remain a matter of conjecture, but there is evidence that it was more than a casual or arbitrary act. At several points in this portrait, the features of Picasso's image coincide strikingly with those of the underlying print: the contour of the boy's neck follows a fold in the actor's clothing; the arch of his eyebrow is formed by lines which appear to belong to a boat; and the forms of his hair and ear are suggested by those of the print beneath. There seems little doubt that Picasso's unprecedented decision to impose an image on the print was stimulated by the print itself, placing *Head of a Young Man* among the first of the imaginative and serendipitous conjunctions of imagery that are usually associated with his mature career.

PROVENANCE: A. Saint, Paris; Valentine Dudensing, New York; Mr and Mrs Lee A. Ault, New York (1962); Acquavella Galleries, New York.

EXHIBITIONS: New York 1962 (Knoedler & Co.), no. 30, ill.; New York 1963[1]; Princeton 1981, p. 151, ill.; New York 1982, no. 26, ill. p. 24; New York 1984[1], no. 3, p. 8, ill. p. 9; New York 1984[2], no. 115, ill. p. 74; Tübingen-Düsseldorf 1986, no. 37 (see Spies 1986, below); Geneva 1988, no. 65, ill. p. 171.

LITERATURE: Zervos 1949–86, vol. I, no. 331, pl. 155, vol. VI, no. 781, pl. 95; Boeck-Sabartés 1955, no. 248, ill. p. 481; Blunt-Pool 1962, no. 126; Daix-Boudaille 1966, cat. XV, no. 17, ill. p. 297; Daix-Lecaldano 1980, no. 266, ill. p. 109; Palau i Fabre 1981, no. 1319, p. 552, ill. p. 464; Spies 1986, no. 37, ill.

Fig. 21 Picasso, *Head of a Young Man*, infra-red photograph.

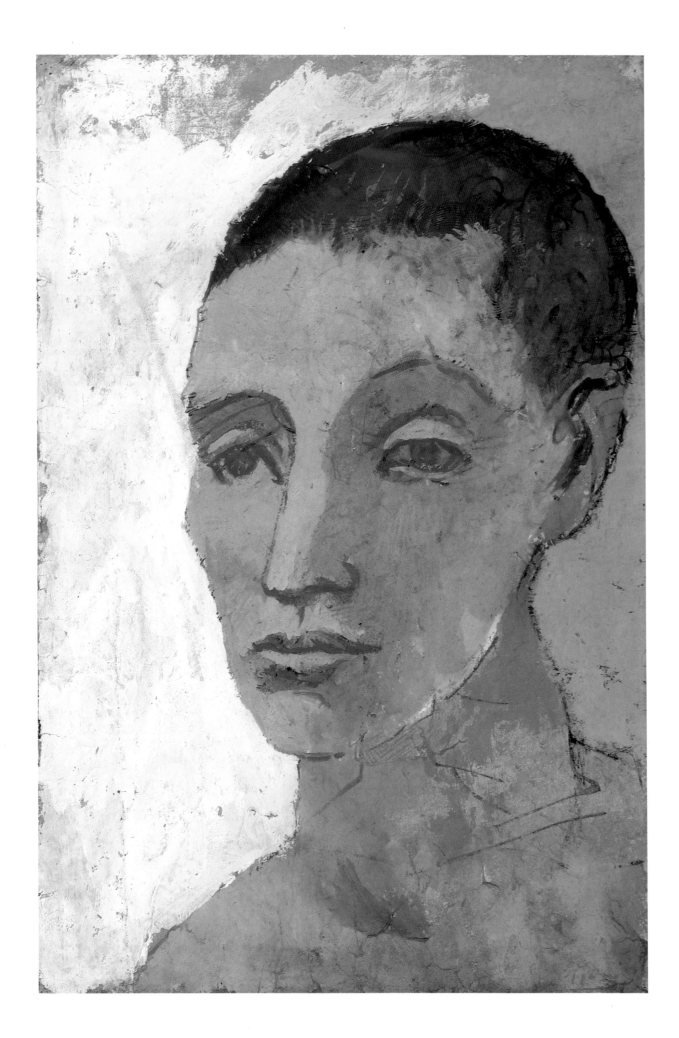

Pablo Picasso

30 Two Female Nudes
1906

Black ink and wash on paper, 48 × 31.5 cm. Signed lower right: *Picasso*

This spirited brush drawing is based on a theme that fascinated Picasso in his early years and persisted throughout the extraordinary shifts of style and technique that preceded Cubism. The subject of two women standing in close proximity, either naked or draped, sometimes embracing and sometimes apart, can be used as a measure of Picasso's changing and maturing preoccupations. In its earlier forms, such as *The Two Sisters*, 1902 (The Hermitage, Leningrad), it could suggest a tragic encounter, while later variants became scenes of prostitution, of the female toilet and of physical intimacy (Fig. 22). Picasso's interest in the theme has never been fully explained, but his pictures recall a diverse range of sources, from the biblical subject of the Visitation to the photographs of Eadweard Muybridge, and his sketchbooks provide vivid evidence of an interest in lesbianism. By the end of 1906, however, when *Two Female Nudes* was probably drawn, Picasso had suppressed many of these associations and had subdued the womens' gestures and accessories. Though their hands may still be intertwined, the dominant impression is of two nude models standing in a studio, posed according to the whim of the artist in a symmetrical, but strictly professional, relationship.

One of Picasso's ambitions in this composition was to describe the two figures as a series of closely related volumes, each occupying space and each subject to the pull of gravity. There is a marked tendency towards simplification of form and the use of geometry, often at the expense of detail and the models' individuality. The thighs of the left-hand figure are essentially cylindrical, her breasts have become modified spheres and a tube-like neck supports her nearly ovoid head. Her face is similarly schematic: a rectilinear nose extends into the semicircles of her eyebrows, while her almond eyes repeat the curves of mouth, forehead and ear. Many of these devices first appear in Picasso's work in the summer and autumn of 1906, and seem to derive from a recent encounter with the ancient sculpture of the Iberian peninsula. Picasso's Spanish origins always predisposed him towards the art associated with his native country – notably the paintings of El Greco, Goya and Velázquez – and may have initiated his interest in a new display of Iberian objects at the Louvre in the spring of 1906. The elemental forms of these Iberian figures offered Picasso an alternative visual vocabulary, a means of expression that was vivid but distanced from orthodox realism. In this energetic monochrome drawing, where the hatchings of pen and brush evoke the sculptor's chisel and the vigour of the drawing process, the tensions between three-dimensional form and the artifice of the picture plane take on a new and urgent dynamism.

PROVENANCE: Ambroise Vollard, Paris; John Richardson, New York.

EXHIBITIONS: Kassel 1964, no. 6, ill. p. 188; Frankfurt-Hamburg 1965, no. 31, ill.; New York 1980, p. 76, ill.; Tübingen-Düsseldorf 1986, no. 38 (see Spies 1986, below); Geneva 1988, no. 64, ill. p. 169.

LITERATURE: Zervos 1949–86, vol. I, no. 359, pl. 170; Daix-Rosselet 1966, no. D XVI, 21, ill. p. 332; Palau i Fabre 1981, no. 139, ill. p. 480; Spies 1986, no. 38, ill.

Fig. 22 Picasso, *Two Standing Women*, 1906. Gouache and black crayon, 63.5 × 48.6 cm. The Baltimore Museum of Art, Maryland.

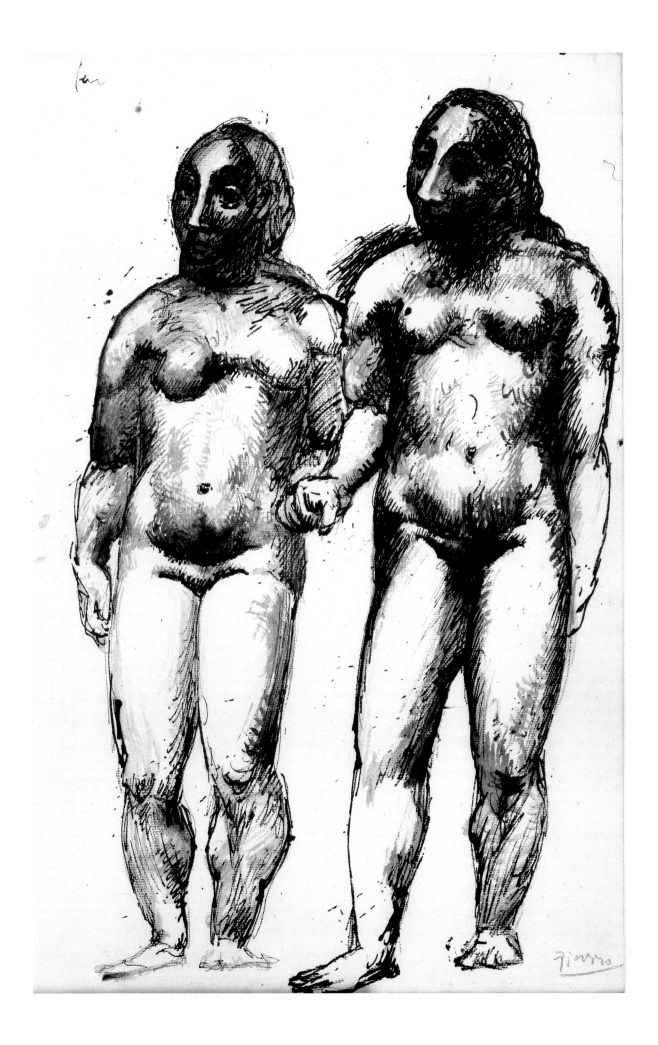

Pablo Picasso

31 Sailor rolling a Cigarette
1907

Brown ink and gouache on paper, 62.5 × 47 cm. Signed lower left: *Picasso*

Although this study of a figure intent on his mundane task might appear unassuming and self-sufficient, it once played a crucial role in the early history of Cubism. Executed on superior quality paper, brushed first in ink and subsequently revised with opaque white paint, *Sailor rolling a Cigarette* is one of almost a thousand drawings, sketchbook studies and preliminary paintings for Picasso's monumental canvas *Les Demoiselles d'Avignon* (see Fig. 24). In the last months of 1906 Picasso began to plan a large-scale composition based on an incident at a brothel, where a group of prostitutes display themselves in front of a male customer. As the studies accumulated, both the composition and the pictorial imperatives of the scene changed dramatically, and by the summer of 1907, when the canvas had reached its present state, many of the features of Picasso's first conception had been abandoned. Among these was the sailor, who is present at the centre of a number of early studies (Fig. 23), and was once clearly seated behind a table (the table is visible in the foreground of the present drawing and just survives as an obscure curved form in the finished canvas). In this sense, the sailor is a token of the changing fortunes of *Les Demoiselles d'Avignon*, whose exclusion marks a shift both of structure and of narrative intention.

The figure had already undergone several transformations before reaching its present form. In his sketchbooks Picasso had first drawn a more thick-set individual, with head tilted back, wearing the wide, V-necked collar and circular hat of a sailor. These studies overlap with a number of drawings executed at Gosol in the summer of 1906 and, like them, depend on a sculptural relationship between head and body and a rigorous geometry in the facial features. Many of these devices, such as the curving, shell-like ear, are employed here, though the sailor has now been divested of his costume and inclines his head forward. Unlike the studies associated with Gosol and with Picasso's response to Iberian sculpture, however, *Sailor rolling a Cigarette* is effectively devoid of modelling and asserts itself as a series of lines and flat shapes on the paper surface. In this respect, the drawing is related to the first phase of *Les Demoiselles d'Avignon*, as represented by the two central nudes, and predates the fundamental reworkings that were to take place as the canvas progressed.

The private significance for Picasso of the sailor figure has been much debated. In its earliest form, the figure bore a marked resemblance to Picasso himself, and it is now accepted that the first composition was intended as an allegory of his own sexual fantasies and uncertainties. Sailors were widely associated with the spread of venereal disease – a subject that greatly preoccupied Picasso at this time – and the figure at the centre of the scene may be understood as both client and victim of the sexual transaction. As the picture developed the sailor's roles became even more disparate. In a recently discovered study, found by X-raying a later picture, he sits with a prostitute on his knee; in another sketchbook drawing a woman has appropriated his sailor's hat; while in further studies the man's identity becomes confused with a neighbouring female figure. Finally, it has been argued that the sailor's diffident attitude in the present drawing may be based on Picasso's friend Max Jacob, whose own sexual equivocation briefly became the subject of the celebrated canvas.

PROVENANCE: Yvonne Zervos, Paris.

EXHIBITIONS: Paris 1956, pl. 3; Arles 1957, no. 15; Hamburg 1959, no. 241; Stuttgart 1960, no. 116; Frankfurt 1965, no. 33, ill.; Paris 1966, no. 30, ill.; Cambridge et al. 1981, no. 26 (see Tinterow 1981, below); Tübingen-Düsseldorf 1986, no. 49 (see Spies 1986, below); Paris 1988, no. 44, p. 52, ill. p. 53; Geneva 1988, no. 66, ill. p. 173.

LITERATURE: Zervos 1949–86, vol. II, no. 7, pl. 5; Eluard 1954, p. 132; Daix-Rosselet 1979, no. 14, ill. p. 193; Tinterow 1981, no. 26, ill. p. 83; Palau i Fabre 1981, no. 1447, ill. p. 490; Spies 1986, no. 49, ill.

Fig. 23 Picasso, *Study for 'Les Demoiselles d'Avignon'*, 1907. Ink, 8.2 × 9 cm. Musée Picasso, Paris.

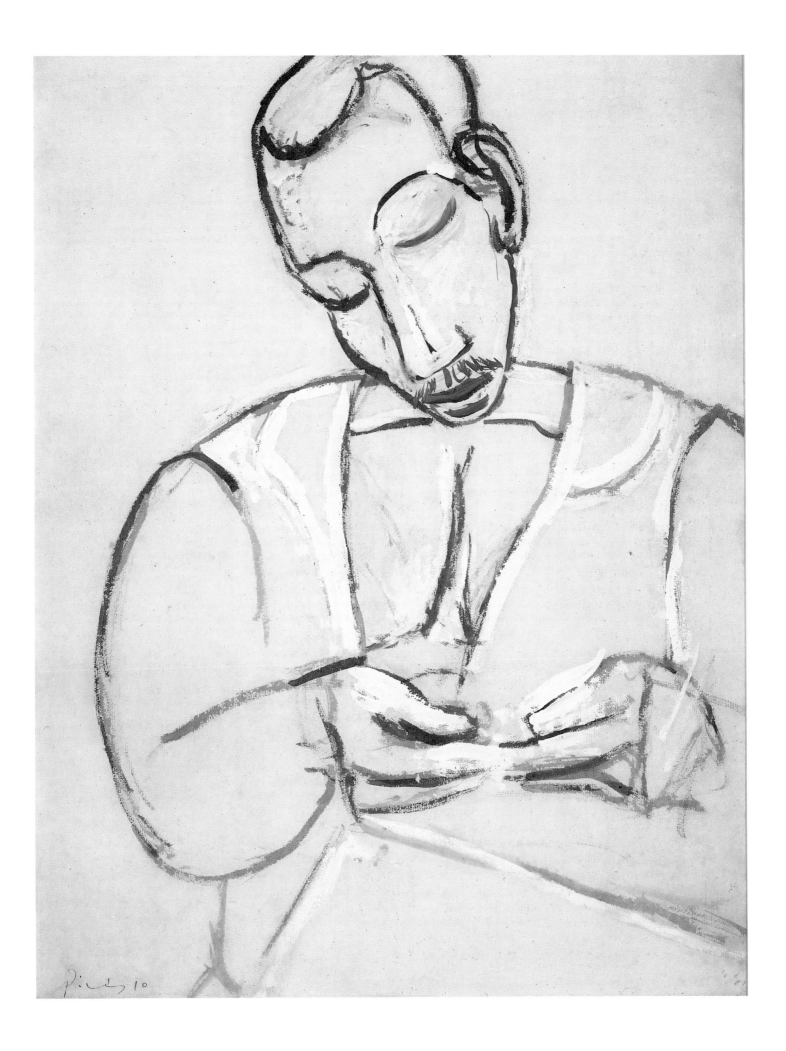

Pablo Picasso

32 Female Nude (Study for 'Les Demoiselles d'Avignon')
1907

Oil on canvas, 81 × 60 cm. Signed lower left: *Picasso*

Many of the caprices and innovations of Picasso's early years have continued to disconcert those who come into contact with his art. There is nothing that quite prepares us, however, for the unequivocal savagery of *Female Nude*, whose lurid colours and slashing, inelegant brushwork appear to defy every canon of taste and technical accomplishment. It remains a defiant painting, not least in its brash declaration of the means of its own making and in its remoteness from any orthodox notions of 'finish'. Perhaps the most startling feature of the picture, however, is the absence of conventional modelling and its replacement by striations and networks of crudely hatched lines. These lines, and the black contours of chin and eyes, appear almost gouged into the surface of the face and give it the appearance of a carved statue or wooden mask. Picasso himself remembered how he was mesmerised by an encounter with a group of tribal sculptures that he saw at about this time, and paintings such as *Female Nude* can be seen as his first excited response to these objects. The extent to which the tribal sculptors had taken liberties with perceived appearances, rearranging the human figure in an independent but highly suggestive manner, confirmed many of Picasso's more tentative experiments and gave him the confidence to reassess much of his own art.

The most dramatic evidence of Picasso's change of heart is to be found in the major canvas of his early career, *Les Demoiselles d'Avignon* (Fig. 24). Parts of this canvas, which was begun in early 1907, were drastically repainted later in the year and little attempt was made to integrate these areas with earlier phases of the picture. *Female Nude* was part of this transformation process, allowing Picasso to make a full-size restatement of the standing nude at the right-hand side of the painting (the dimensions of the figure correspond to those of the finished canvas). Surviving drawings show that the original figure was more clearly engaged in parting the curtains that surround her, and X-rays of the present canvas indicate that she once had a curvilinear, full-profile face in the style of the two central women. Despite the violent and improvised appearance of *Female Nude*, it forms part of a considered series of sketchbook studies and experimental paintings which preceded the final metamorphosis of the canvas. In the repainted figure, Picasso has incorporated the downward-sweeping nose, pinched mouth and facial scarifications of the preliminary study, while retaining the raised arms of the earlier variants.

When Picasso recalled his first encounters with tribal sculpture, he emphasised that it was the elements of 'magic' and 'exorcism' that most attracted him to these exotic objects. Though he immediately began to purchase examples for his own collection, his response to tribal art was remote from the scholarly or formalistic attitudes that surround these objects today. The bright colours and idiosyncratic features of *Female Nude* do not correspond to any known museum specimens, but seem to represent an original fusion of Oceanic, African and purely imaginary elements. For Picasso, formal innovation and autobiography were never far apart, and the 'exorcism' of these paintings represents both a private catharsis and an artistic liberation.

PROVENANCE: Paul Guillaume, Paris; Pierre Gaut, Paris.

EXHIBITIONS: Paris 1929 (?); New York 1936, no. 203, pl. 12; Paris 1955; Vallauris 1961, no. 2; Paris 1966–7[1], cat. no. 42; Tel Aviv 1966, no. 4, ill.; Amsterdam 1967, no. 15, ill.; Paris 1973, no. 2, ill.; Paris 1975, no. 54; Tokyo et al. 1977–8, cat. no. 8; Paris 1978, ill. p. 73; New York et al. 1984, p. 255, ill.; Venice 1986, ill. p. 54; Paris 1988, vol. I, no. 61, pl. III.3, p. 278; Geneva 1988, no. 67, ill. p. 175.

LITERATURE: Zervos 1949–86, vol. II, no. 24, pl. 13; Courthion 1966, ill. p. 80; Allen 1967, no. 199, p. 88, ill.; Goldwater 1967, p. 151, fig. 33; *Hommage à Picasso* 1971, ill. p. 19; Nash 1974, fig. 3; Warnod 1975, p. 88 b, ill.; Minervino-Cachin 1977, no. 26, ill. p. 89, pl. V; *Galerie des Arts* 1978, no. 178, ill.; Daix-Rosselet 1979, no. 41, p. 198, pl. IV, p. 31; Palau i Fabre 1981, no. 1550, ill.; Rubin 1984 (see above, New York 1984); Breerette 1988, p. 17, ill.

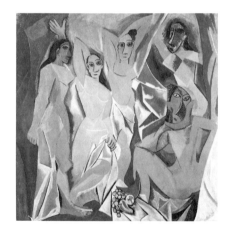

Fig. 24 Picasso, *Les Demoiselles d'Avignon*, 1907. Oil on canvas, 243.9 × 233.7 cm. The Museum of Modern Art, New York.

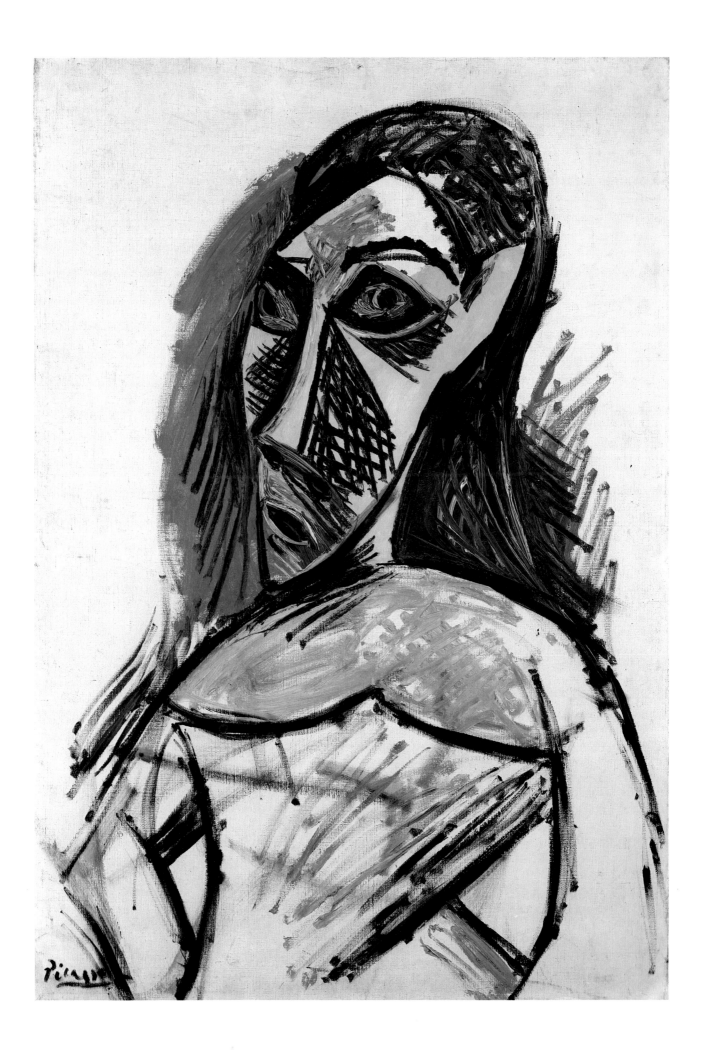

Pablo Picasso

33 Fruit-bowl with Pears and Apples
1908

Oil on panel, 27 × 21 cm. Inscribed on verso: *à mon ami Monsieur Arq* [?] *affectueusement Picasso*

Everything about this small but monumental still life suggests a painting executed swiftly and with great purposefulness. It belongs to a group of more than a dozen similar compositions on identical wooden panels, probably painted in rapid succession towards the end of 1908. Many of the pictures were composed from the same repertoire of objects – a bowl, a wineglass, a carafe and a selection of fruit – apparently chosen for their simplicity of form and their everyday associations. Often the paint is thinly applied and in several examples, including *Fruit-bowl with Pears and Apples*, the initial brush drawing and the grain of the panel are still visible. The shapes of the objects, as well as the intervals between them, are expressed with great vigour, while a strong light source is used to accentuate volume and shadow. Rigorous but inventive, these studies are like variations on a boldly stated theme, a set of problems and solutions resolved with exemplary clarity.

The choice of still life at this point in his career was significant in a number of ways for Picasso. A year earlier, the Salon d'Automne had included a memorial exhibition of the work of Cézanne, an artist who had used the still life for many of his most radical explorations of pictorial language. *Fruit-bowl with Pears and Apples* is a virtual homage to Cézanne, echoing the older artist's compositions of fruit and domestic objects and responding to a number of his strategic challenges. Like Cézanne, Picasso has manipulated the still life to his own advantage, arranging the chosen objects into rhythms and contrasts of tone, texture and rotundity. Contours and areas of shadow are artfully juxtaposed, broadly in keeping with a single light source but in places freely improvised. Again following Cézanne, Picasso has chosen a high viewpoint for the table-top and fruit-bowl rim, while the apples, pears and underside of the bowl are depicted from a lower angle. The result is a new kind of visual equilibrium, an animated dialogue between the roundness of the still-life elements and their evident distribution across the flat plane of the painting.

Unlike Cézanne, however, Picasso has chosen a sombre palette of greys, browns and dull greens, as if to accentuate the severity of his composition rather than its naturalistic qualities. He had also, by this time, adopted what was to be a lifelong preference for working at night under artificial lighting, and many of his subjects were painted from memory rather than from direct observation. The artifice of *Fruit-bowl with Pears and Apples* is further emphasised by the pronounced stippling and hatching of the brushwork, curiously reminiscent of the striations of African sculpture, which Picasso had recently introduced into his paintings. While acknowledging his debt to Cézanne, Picasso has taken liberties with procedure and with perceived appearances that go well beyond those of his revered predecessor.

PROVENANCE: Monsieur Arq(?); Emile Spaeth, New York; Galerie Perls, New York; Lee Ault, New York; Jacques Sarlie, New York; J. Sarlie sale, London; Sotheby's sale 1960 (see below); O'Hana Gallery; Galleria Toninelli, Milan.

EXHIBITIONS: London 1983, no. 116, ill. p. 243; Geneva 1988, no. 68, ill. p. 177; New York 1989–90, ill. p. 104.

LITERATURE: Zervos 1949–86, vol. XXVI, no. 424, pl. 158; sale, Sotheby's, London, 12 October 1960, no. 9; *World Collectors Annuary*, vol. XII, 1960, no. 4191, ill.; Minervino-Cachin 1977, no. 309, ill. p. 102; Daix-Rosselet 1979, no. 200, p. 228, ill.; McEwen 1983, p. 33, ill.

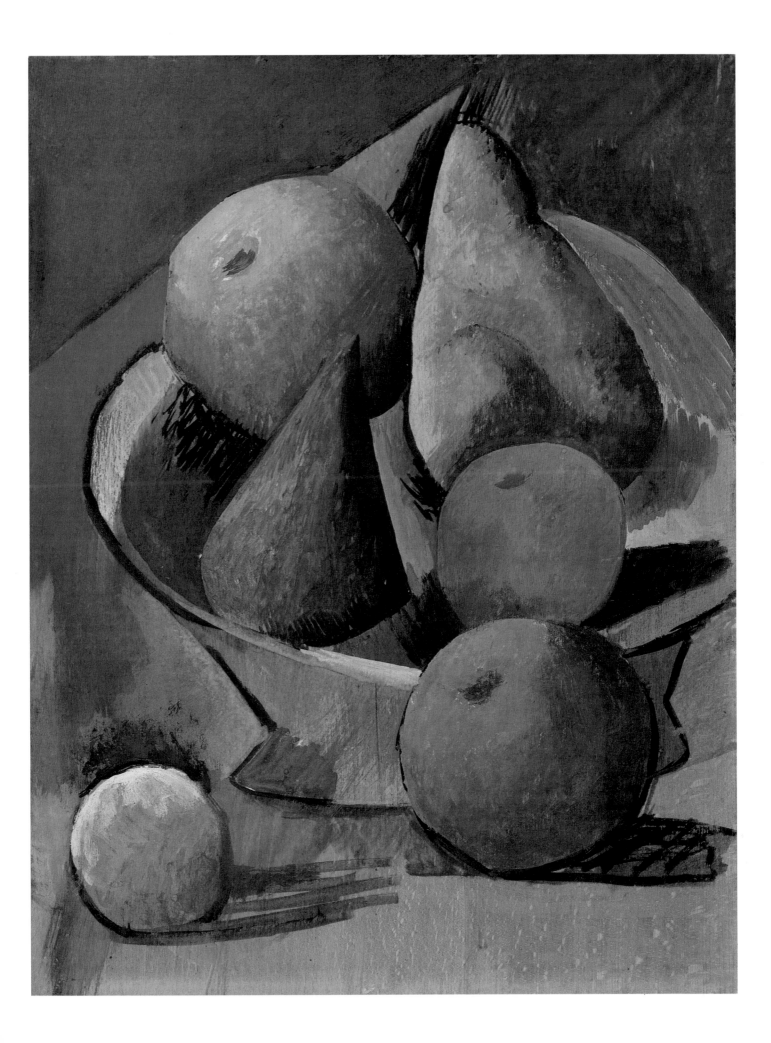

Pablo Picasso

34 Head of a Woman
1909

Bronze, 42 × 23 × 23 cm. Signed and numbered on the right: *Picasso 6/9*; founder's seal: *Cire perdue C. Valsuani*

Sculpture came naturally to Picasso and played a primary role in his creative thinking at many stages in his career. *Head of a Woman* is the most celebrated work of his early years, the culmination of his first experiments in modelling and carving, as well as a turning point in his grasp of the medium. His largest and technically most ambitious project to date, the head was preceded by a number of experimental models in clay, plaster and wood, many of them closely related to drawings and paintings. This dialogue between Picasso's work in two dimensions and his own sculpture, as well as the sculpture of other artists and other cultures, was to be a distinctive feature of his early career, and was to continue throughout much of the evolution of Cubism and the artist's later life.

Head of a Woman was completed in late 1909, in the Paris studio of Picasso's Spanish friend, the sculptor Julio González. Picasso had recently returned from a stay of several months at Horta da Ebro in Spain, bringing with him more than a dozen canvases and a number of drawings of his mistress Fernande Olivier. Like so many of Picasso's summer vacations, the months at Horta had been an intense and undistracted period of pictorial research, using new subject matter to develop and clarify his latest ideas. During this period, the lessons learnt from tribal sculpture and from Cézanne's painting had become more fully assimilated into his art and a recognisably Cubist syntax began to emerge. Stimulated partly by the recent work of Braque, Picasso evolved his own system for the 'facetting' of forms and spaces, translating the features of the landscape and the human body into sequences of independent, yet interconnected formal structures. In some of his studies of Fernande (Fig. 25) her face has become a pattern of slotted and overlapping planes, each of them suggested by some aspect of her physiognomy but few of them describing her in conventional terms. The result is an original restatement of the human head, a translation of a complex visual and tactile phenomenon into the simple language of lines and parabolas.

In choosing to complete his sequence of portraits of Fernande by making a life-size sculpture, Picasso was once again breaking new ground. The disembodied language of Cubism, which had been developed on the flat surface of paper and canvas, was now to be extended into three dimensions. *Head of a Woman* incorporates many of the devices of the Horta da Ebro pictures, such as the sweeping curve beneath the eye socket, the corrugated effect of the forehead and the deep indentations of the face, while Fernande's hair is rendered as a series of arcs or waves and the lines of her neck are made to echo the curves of nose and chin. Many of these structures break into, or stand out from, the sculpture surface, animating the bronze but denying a naturalistic reading of the portrait. It has been argued that such procedures were contradictory and that Picasso was attempting to use pictorial solutions in a sculptural context. While some of the features of the sculpture resemble the forms of his paintings, many plunge deep into the mass of the head and might have penetrated it completely were it not for the technical limitations of the modelling and casting processes. It was surely these limitations, rather than any inconsistencies of style, that brought Picasso's sculptural adventures to a halt for several years.

EDITIONS: A number cast for Ambroise Vollard, *c.* 1909; 9 cast for Heinz Berggruen, 1959, by Valsuani, of which 3 exclusively for the artist (7/9 to 9/9).

PROVENANCE: Edition Galerie Berggruen, Paris.

EXHIBITIONS: Paris 1966–7², cat. no. 215, ill.; Paris 1973, cat. no. 54, no. 4, ill.; London 1983, no. 190, p. 360, ill. p. 361; New York et al. 1984, cat. p. 304, ill.; Lugano 1988, no. 1, ill. p. 24; Geneva 1988, no. 69, ill. p. 179.

LITERATURE: Zervos 1949–86, vol. II, no. 573, pl. 266; Barr 1946, p. 69, ill. (different cast); Kahnweiler 1948, no. 8 (different cast); Boeck-Sabartés 1955, p. 462, no. 54, ill. (different cast); Penrose 1961, pl. 6, no. 4, ill. (different cast); Warnod 1975, p. 135, ill. (different cast); Johnson 1976, p. 101 ff., no. 23, p. 167, ill. p. 231 (different cast); Spies 1983, pp. 47, 51, cat. no. 24, p. 273, ill. pp. 48–9; Rubin 1984 (see above: New York et al. 1984).

Fig. 25 Picasso, *Head of Fernande*, 1909. Black chalk, 62.8 × 48 cm. Musée Picasso, Paris.

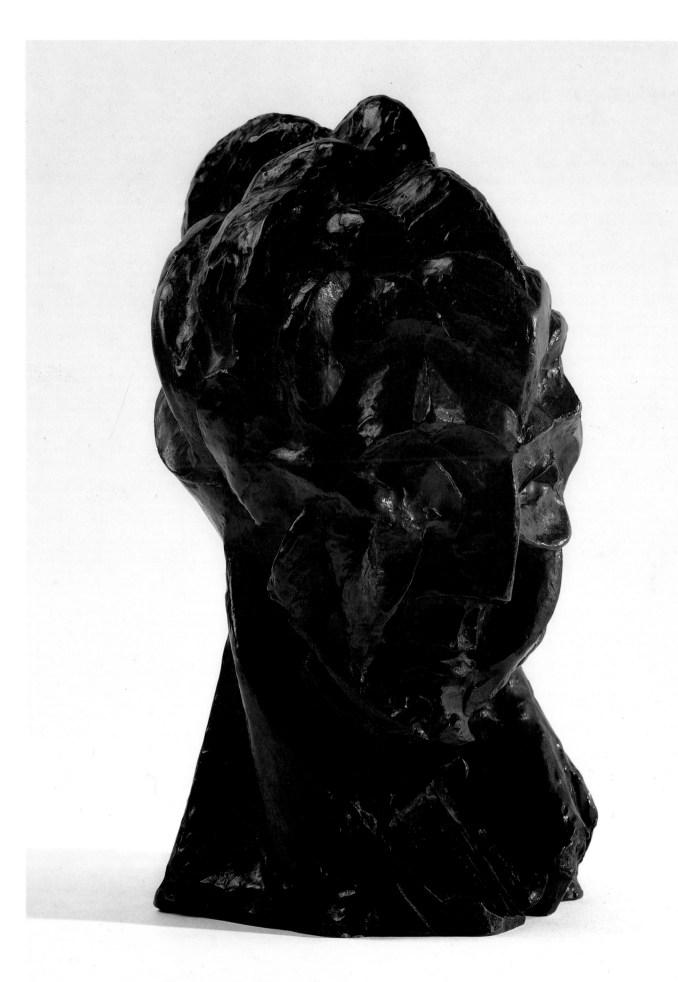

Pablo Picasso

35 Portrait of Georges Braque
1909–10

Oil on canvas, 61 × 50 cm. Signed upper right: *Picasso*

This portrait forms part of one of the most challenging series of pictures produced by Picasso in the early and formative years of Cubism. With the studies of Fernande Olivier executed in the summer of 1909 (see Fig. 25) and the sculpture *Head of a Woman* (Cat. no. 34) completed later in that year, Picasso had embarked on a progressive exploration of the human head and its transformation into a new language of form. One by one the established conventions of portraiture were examined and abandoned, while new solutions were proposed and put to the test. The austere colour scheme of browns and greys, and the severity of the geometric forms in *Portrait of Georges Braque* effectively convey the seriousness of this project, which was to culminate, towards the end of 1910, in the near-abstraction of pictures such as *Portrait of Kahnweiler* (Art Institute of Chicago). All these paintings confront one of the central issues of Cubism, that of the relationship between the language of art and the processes of representation, and confront it in an unusually acute way. As studies of the human head they also refer to the most represented of all pictorial subjects and, as portraits, to the age-old problem of resemblance.

The head in *Portrait of Georges Braque* is defined almost entirely by diagonal lines and segments of ellipses. The areas between these lines and curves have been roughly filled in with parallel strokes of paint, often graduated to suggest the effect of shadow or roundness of form. These planes or facets have a strong resemblance to chisel-marks cut into a piece of wood or stone, a resemblance encouraged by Picasso's use of earth-based pigments. More specifically, certain parts of the image recall a low-relief sculpture, as if the artist has carved into the surface of a shallow panel or built his forms onto a flat plane. Many of these devices can seem aggressively non-naturalistic, though the early apologists for Cubism insisted on its intimate relationship with reality. Then as now, it has often been convenient to present the forms and structures of a painting such as *Portrait of Georges Braque* as the record of different perceptions made from a number of viewpoints as the artist moved around the subject. A brief examination of such pictures shows the limitations of this approach. While Picasso has taken great liberties with the appearance of his model, redistributing and accentuating certain features while suppressing others, there is no evidence of him stalking his sitter or systematically reconstructing the front, side and back of the head.

Despite its apparent severity this portrait also shows traces of an underrated aspect of Picasso's Cubism: its sense of humour. It is difficult to take the tall, bizarrely brimmed hat with complete seriousness, and the sitter's tapering forearm, clutching a diminutive glass or tankard, reminds us of Picasso's lifelong delight in caricature. Even the title of the picture seems to have come about light-heartedly: later in life, the artist claimed that he had painted the portrait from imagination and had subsequently identified the model with Braque, but only because of a resemblance between their hats.

PROVENANCE: Frank Crowninshield, New York; F. Crowninshield sale, New York, 1943; Edward A. Bragaline, New York; E. V. Thaw, New York.

EXHIBITIONS: New York 1936, no. 209, pl. 21; New York et al. 1939–40, no. 89; New York 1962 (Knoedler & Co.), no. 44; New York 1963²; New York 1971, no. 11, p. 25, ill.; Geneva 1988, no. 70, ill. p. 181; New York 1989–90, ill. p. 146.

LITERATURE: Zervos 1949–86, vol. II, no. 177, pl. 89; Level 1928, pl. 26; Cassou 1937, pl. 21; auction sale, New York, 20–1 October 1943; Fels 1950, p. 229, ill.; Barr 1946, p. 69, ill.; Boeck-Sabartés 1955, no. 252, p. 482, ill.; Russell 1959, p. 13; Picasso 1967, p. 50, ill.; Leymarie 1971, p. 220, ill.; Descargues et al. 1971, p. 92, ill.; Minervino-Cachin 1977, no. 316, ill. p. 103; Daix-Rosselet 1979, no. 330, p. 252; Martin 1982, pp. 48–9, fig. 4 (English edition: p. 66, fig. 46); Greenspan 1985, p. 111, ill.

Pablo Picasso

36 Still Life on a Piano
1911–12

Oil on canvas, 50 × 130 cm. Signed lower left: *Picasso*

Begun only three years after *Fruit-bowl with Pears and Apples* (Cat. no. 33), this majestic still life is evidence of the early maturity and precocious development of Cubism. Gone are the respectful references to Cézanne and the tentative manipulations of form and space, to be replaced by a bravura display of the new pictorial idiom. It is a challenging painting, and intentionally so. The flatness of the canvas is both asserted and denied, while dark tones and violent contrasts disrupt the centre of its complex composition. A roughly textured surface demands to be seen as just that, and not as a series of accomplished effects or illusionistic devices. Most challengingly, the viewer is offered partial glimpses of a number of familiar-seeming objects – a wineglass, a candlestick, some musical instruments and a group of piano keys. Incoherent at first, the composition gradually resolves itself into an arrangement of objects on and around a piano: a familiarity with the Cubist vocabulary also reveals a pipe, a fan, a carafe, a metronome and even the vestiges of a figure (Fig. 26).

While the use of such visual clues may seem tantalising, their presence in this picture is of particular historical significance. Between 1910 and 1911 Picasso and Braque had produced some of their most radical and uncompromising pictures of the Cubist era. Following what appeared to be the logic of their earlier experiments, both artists reduced the new visual language to little more than straight lines and areas of textured monochrome. At its most extreme the subject matter of these pictures became illegible and could only be identified by reference to their titles, and contemporary accounts suggest that Picasso's friends – and possibly the artist himself – were ill at ease with the obscurity and near-abstraction of such works. At about the time *Still Life on a Piano* was painted, Picasso had begun to reintroduce allusions to everyday objects, providing enough information to anchor the subject in familiar space while reserving the right to subvert our experience of it.

This unusual horizontal canvas, which recalls a decorative frieze or a panel from a mural, is continuing evidence of Picasso's originality and ambition. He had by this date already exhibited his work in England, Germany, America and elsewhere, and was to sign an exclusive contract with the dealer Kahnweiler in 1912. Though he had become the acknowledged figurehead of a group of Parisian Cubists, he always distanced himself from their joint exhibitions and worked closely with only a few artist friends such as Gris and Braque. *Still Life on a Piano* comes from a period of intense collaboration with Braque and has many features in common with his work at this time. It was Braque who had pioneered the use of stencilled letters, which draw attention to the canvas surface while extending the range of allusion and pictorial reference of the image (the letters CORT in Picasso's painting refer to the pianist Cortot). Braque may also have encouraged a greater sensitivity to the picture surface, resulting in the extraordinary range of streaked, washed, feathered, dabbed and tessellated brushstrokes in this tensely animated canvas.

PROVENANCE: Carlo Frua de Angeli, Milan; Christian and Yvonne Zervos, Paris; Jane Wade, New York.

EXHIBITIONS: Milan 1953, no. 342; Paris 1955, no. 25; Tel Aviv-Jerusalem 1966, no. 11, ill.; Paris 1966–7[1], no. 72; Amsterdam 1967, no. 27; Los Angeles-New York 1970–1, no. 236, pl. 35; Paris 1973, no. 7, ill.; Berlin 1974, no. 91; Tokyo et al. 1977–8, no. 17, ill.; New York 1980, p. 156, ill.; Paris 1987–8, no. 4, p. 44, ill. p. 52; Madrid 1988, no. 4, p. 42, ill. p. 50; Geneva 1988, no. 71, ill. p. 183; New York 1989–90, ill. p. 215.

LITERATURE: Zervos 1949–86, vol. II, no. 728, pl. 319; Courthion 1966, vol. 26, p. 75 ff.; Cooper 1970, pl. 35; *Hommage à Picasso* 1971, no. 26, p. 76; Krauss 1971, ill. p. 34; Leymarie 1971, p. 223; Rosenberg 1975, p. 1; Minervino-Cachin 1977, no. 371, ill. p. 105, pl. XXIV–XXV; Daix-Rosselet 1979, no. 462, p. 278, pl. XXIX; McEwen 1983, p. 34, ill.

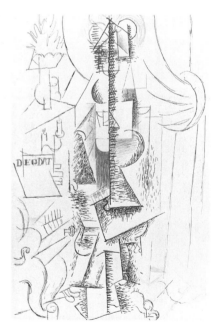

Fig. 26 Picasso, *Déodat de Séverac at the Piano*, 1912. Ink and pencil, 34.2 × 22.2 cm. Musée Picasso, Paris.

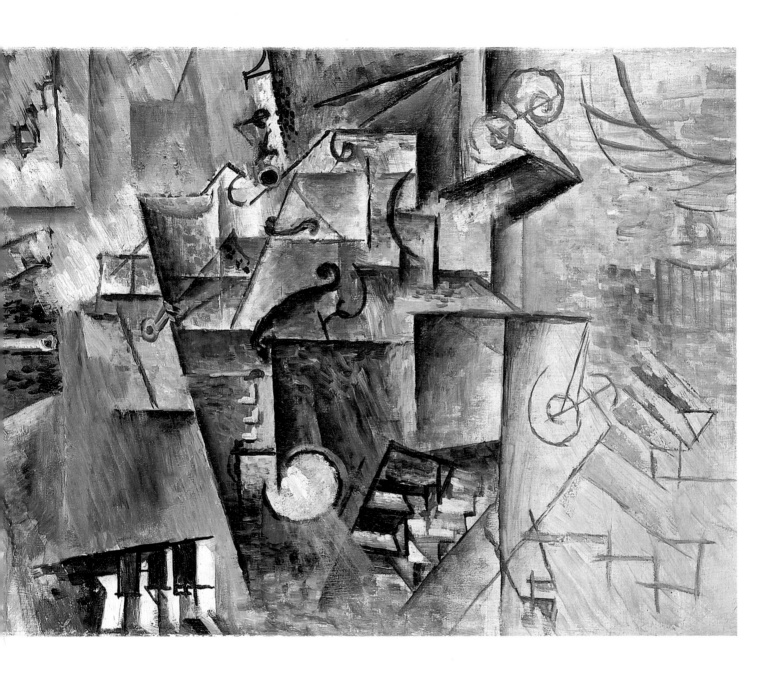

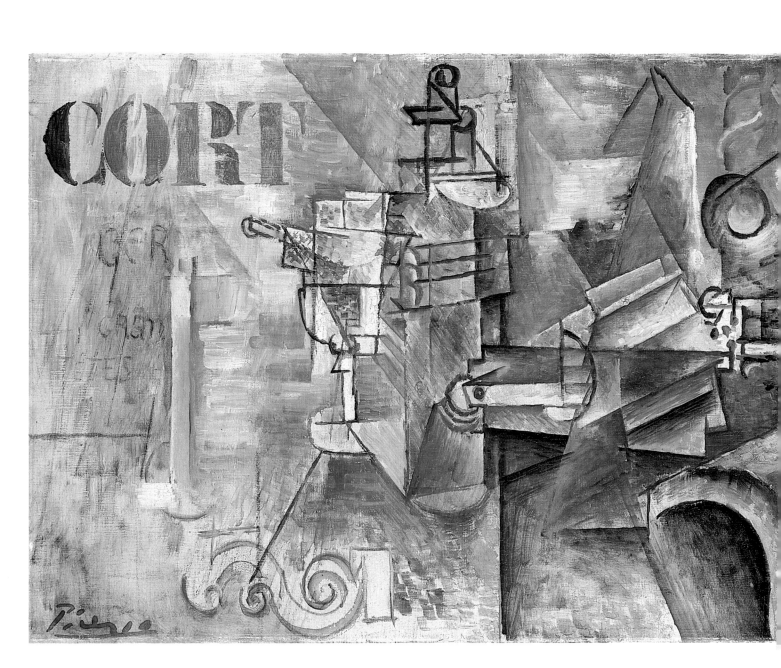

Pablo Picasso

37 Still Life with Glass and Deck of Cards
(Homage to Max Jacob)
1914

Graphite, gouache and papier collé on paper, 35 × 46 cm. Signed on verso: *Picasso*

Although the human figure remained the sovereign subject of his art, during the years of Cubism, and especially during his association with Braque, Picasso repeatedly chose the still life as the basis for his compositions. Objects in a still life can be chosen and manipulated at will, their colours and forms deliberately contrasted and their relationships adjusted, or imagined, to a nicety. The narrative implications of the figure study, the psychological demands of the portrait, and the spatial and atmospheric complexities of the landscape are all set aside, allowing the artist to delimit and control his own pictorial territory. The subject matter of pictures such as *Still Life with Glass and Deck of Cards* is, however, far from arbitrary. The ace of clubs, which occurs frequently in Picasso's work at this time, has a number of traditional and symbolic meanings, and the printed leaflet used here is an unusually direct reference to one of the artist's closest friends. The leaflet announces a recent publication by Max Jacob, the poet who may have been the subject of Picasso's *Sailor rolling a Cigarette* (Cat. no. 31) and whose work the artist had illustrated on more than one occasion. Even the central wineglass, one of the simplest, most ubiquitous and apparently neutral objects in Picasso's world, is not without significance. The repeated inclusion of glasses, bottles, cigarettes and loaves of bread in Cubist pictures was partly an assertion of a status and a way of life; such unpretentious objects celebrated bohemian existence and insisted on the possibility of art made from the humblest materials.

Still Life with Glass and Deck of Cards summarises much of Picasso's repertoire at the high point of Synthetic Cubism. On a pale surface, several sheets of cut-out paper have been superimposed and pasted down, while a number of drawn lines indicate a table and the profiles of a still-life group. Some of these lines suggest shadow, both of real objects, such as the leaflet, and of contrived forms, such as the wineglass. Paint has then been applied, transforming one area of pasted paper into a playing card and another into a riot of pointillist colour spots. Behind the wineglass, part of the surface has been painted to look like a strip of simulated moulding, of the kind used by interior decorators and sometimes pasted by Picasso onto his collages, but here achieving the status of an illusion of a simulation. Such shifts between artifice and actuality, between areas of paint and paper that represent themselves and similar areas that represent glass, space and shadow, are handled with a lightness of touch that contrasts sharply with the more lugubrious phases of early Cubism.

PROVENANCE: Galerie Kahnweiler, Paris (inv. no. 2138); Kahnweiler sale, Paris 1923 (?) (see below); André Weil, Paris; Emile E. Wolf, New York (1962); Christophe Janet, New York.

EXHIBITIONS: New York 1962 (Knoedler & Co.); Saidenberg Gallery, no. 23, ill.; Rhode Island 1984, no. 37, ill. p. 89; Tübingen-Düsseldorf 1986, no. 85; Geneva 1988, no. 72, ill. p. 185; New York 1989–90, ill. p. 325.

LITERATURE: 4th Kahnweiler sale, Paris, Hôtel Drouot, 7–8 May 1923 (?); *Burlington Magazine*, May 1962, pp. 224–5, ill. p. 225; Daix-Rosselet 1979, no. 696, p. 322.

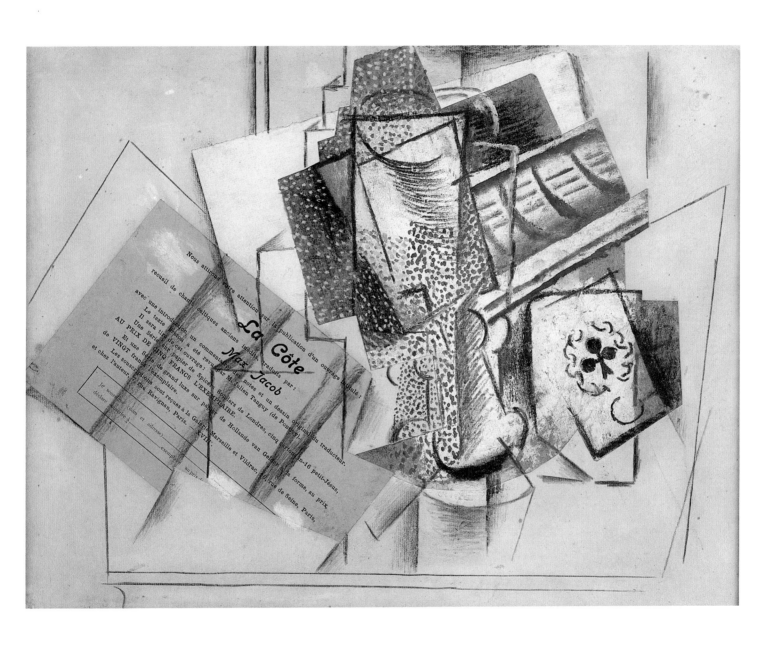

Pablo Picasso

38 Glass and Dice
1914

Graphite, gouache and papier collé on paper, 23.5 × 14.5 cm. Signed on verso: *Picasso*

With the development of collage and papier collé, Braque and Picasso had transformed the possibilities for the making of a work of art. Pictures could now be constructed, built up from disparate fragments and materials and even initiated by randomly discovered forms. In *Glass and Dice* Picasso's characteristic way of arriving at such an image can be reconstructed. Like so many of his papiers collés, the picture began as a drawing, in which the principal forms were defined and the locations of the paper elements determined in advance. At this stage, a thick wad of newspaper was stuck down to form the bowl of the wineglass, while an intricately cut fragment of speckled paper was used to suggest its stem and base. Working on these surfaces with paint and pencil, Picasso then accentuated the roundness of bowl, stem and base, hinting at the transparency of the glass and allowing the speckled paper to suggest the drink inside. The result is a playful conjunction of the random and the controlled, a mixture of high and low viewpoints, of flat shapes that link with spaces and modelled forms that toy with illusion.

The wineglass is one of two objects (the other being the guitar) which dominate Picasso's still-life repertoire. Both glass and guitar are instantly recognisable forms whose identities are not easily lost in the process of visual transformation. Both also consist of an outer shell that encloses an empty space, and in each case there is a visible and functional link between outer and inner forms. With the invention of collage, it was only a matter of time before the principle of construction was applied to such three-dimensional objects. As early as 1912 Picasso had made the first of a series of sculptures based on the guitar, followed in 1914 by a group of variations on the wineglass (Fig. 27). Using cardboard, string and roughly carved pieces of wood, he was able to combine the familiar external forms of these objects with a representation of their interior surfaces. Just as the collage techniques of *Glass and Dice* had reversed many of the conventions of drawing and painting, so these new structures appeared to destroy the notion of sculpture as a solid and impenetrable mass. With a characteristic leap of the imagination, Picasso projected the planes and volumes of his two-dimensional compositions back into space, adding yet another twist to his already convoluted games with representation.

PROVENANCE: Galerie Kahnweiler, Paris (inv. no. 2161, photo no. 384); Kahnweiler sale, Paris 1923 (see below); Vicomtesse Marie-Laure de Noailles; Jacques Goldschmidt, Paris.

EXHIBITIONS: London 1960, no. 76, p. 32, pl. 16, i; Frankfurt-Hamburg 1965, no. 50, ill.; London 1967, no. 243, ill.; Paris 1973, no. 14, cat. no. 45, ill.; Bielefeld 1979, no. 109, ill.; Tübingen-Düsseldorf 1986, no. 83 (see Spies 1986, below); Geneva 1988, no. 73, ill. p. 187.

LITERATURE: Zervos 1949–86, vol. II, no. 501, pl. 230; 4th Kahnweiler sale, Paris, Hôtel Drouot, 7 May 1923, no. 85; Daix-Rosselet 1979, no. 689, p. 321, ill.; Spies 1986, no. 83, ill.

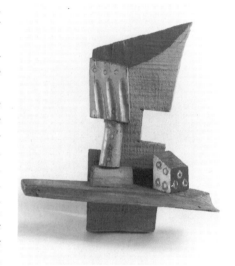

Fig. 27 Picasso, *Glass and Dice*, 1914. Painted wood, 17 × 16.2 × 5.5 cm. Musée Picasso, Paris.

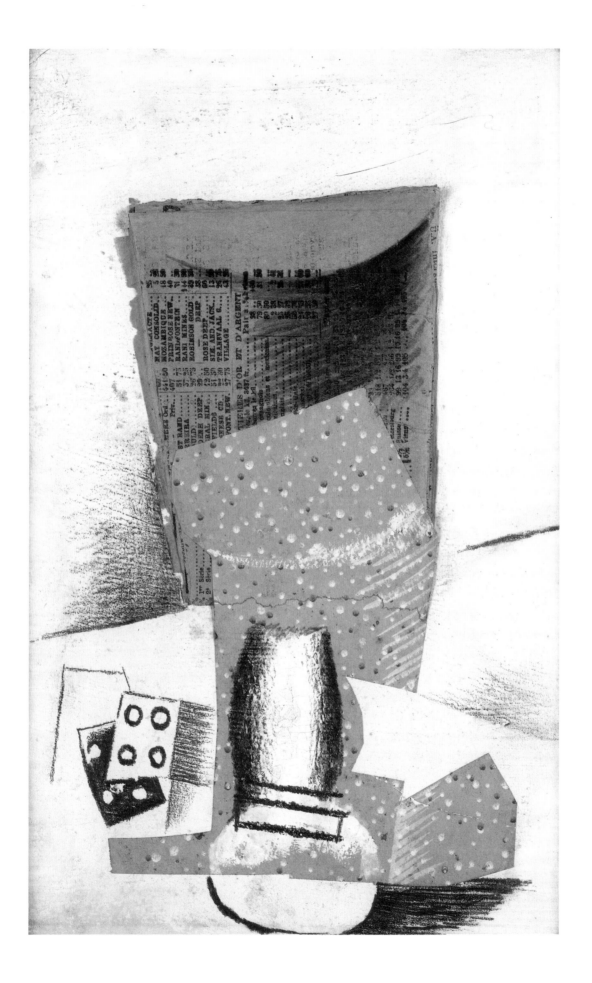

Pablo Picasso

39 Still Life with a Bunch of Grapes
1914

Oil and sawdust on board, 26.7 × 25 cm. Signed on verso: *Picasso*

This small but finely resolved painting is a virtual primer of Picasso's Synthetic Cubism. Using his favourite starting point of a still-life group, the artist has contrived a series of pictorial conundrums and visual counterpoints, playful in their appearance but challenging in their consequences. At first sight the picture is a deftly arranged pattern of contrasting colours, forms and surface incident: black is set against grey and white, sharp angles against curves and ellipses, and areas of stippled red and blue paint against the improbable texture of sawdust. Many of these features echo the flatness of the picture surface, recalling Picasso's papiers collés and even simulating the collage elements in works such as *Glass and Dice* (Cat. no. 38). Here, however, Picasso seems to invert or even satirise his own techniques, constructing the fragment of newspaper from brushmarks and supplying a fanciful line of shadow for the immaterial bunch of grapes. The same elements are also used, paradoxically, to challenge the insistent flatness of the image. The diagonal line of the newspaper carries the eye into a fictitious space, suggesting the tilted table-top on which the objects are arranged, and describing the recessional nature of the still-life group. Grapes, wineglass and distant bottle (the red diamond derives from the trademark of Bass beer, apparently a favoured drink in Picasso's circle at this time) pointedly overlap each other, while a long clay pipe obscurely but significantly links fore-ground and background.

Still Life with a Bunch of Grapes also illustrates the interconnections and dia-logues within Picasso's imagery. A number of drawings, collages, paintings and sculptures executed in the same year, including several examples in the Berg-gruen Collection, are effectively variations on the same group of objects or visual conceits. Stippling, simulated collage and bizarre textural effects, incorporating sawdust, sand or even glass beads, are found in a number of related works, while the eponymous bunch of grapes reappears in a variety of guises. The image of the wineglass is subject to endless reworking and restatement, at times opening out into the picture plane and at others, as in the present case, adopting an almost diagrammatic transparency. Here Picasso offers both plan and eleva-tion, adding a bold diagonal that recalls the precariously balanced spoon in the bronze sculpture *The Absinthe Glass* (Cat. no. 40). By invoking his own sculpture in a painting, and by translating the speckled colours of the picture back onto the bronze, Picasso added further convolutions to his already gymnastic display. His delight in turning solid objects into flat planes, in conflating areas of paint and elements of collage, and in making grapes out of sawdust, is barely concealed.

PROVENANCE: Galerie Kahnweiler, Paris; 291 Modern Gallery, New York; Lydia Lane, Los Angeles; Earl Stendahl Gallery, Hollywood.

EXHIBITIONS: Los Angeles 1961, no. 8.

LITERATURE: Zervos 1949–86, vol. XXIX, no. 43; Daix-Rosselet 1979, no. 729.

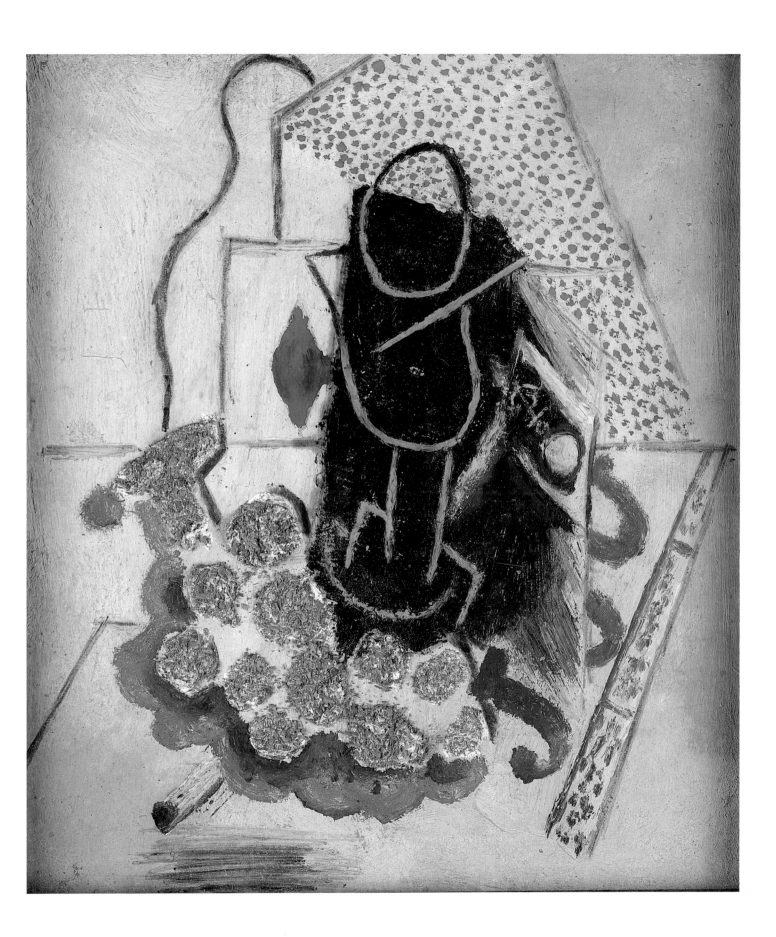

Pablo Picasso

40 The Absinthe Glass
1914

Painted bronze and silver-plated spoon, height 22 cm. In hollow of base, in relief: *VHK*

It is a sign of the importance that Picasso attached to his sculpture, and of his status among dealers and collectors, that this tiny object was cast in an edition of six bronzes almost as soon as it was completed. Most of his other Cubist sculptures were assembled from waste materials and have only survived because Picasso himself stored them away with care. Paradoxically, *The Absinthe Glass* – often seen as one of Picasso's most innovative works in the medium – was produced by a process that dates back to the Renaissance and beyond. Modelled by the artist in wax, the sculpture was then handed over to a craftsman to be cast in bronze, the casts being returned to Picasso for final treatment. The extent to which Picasso modified and adorned the set of casts is, however, entirely unorthodox. Each version has been painted with a different combination of colours, stipples and curving lines; one was entirely coated in sand; and all were provided with a real metal spoon which supports a simulated lump of sugar.

Like the 1909 *Head of a Woman* (Cat. no. 34), which was also promptly cast in bronze, *The Absinthe Glass* is a summary of many of the challenges and preoccupations of a particular moment in Picasso's career. Unlike the earlier sculpture, however, *The Absinthe Glass* overturns at least three of the most revered conventions of the medium. Firstly, by choosing as his subject an ordinary wineglass Picasso gave a commonplace and valueless object a prominence normally associated with the human figure. Secondly, while there are precedents for the use of colour in sculpture, the fanciful and almost frivolous way in which Picasso decorated his bronzes appears to contradict the solemnity of the medium. Finally, by representing a solid form as a series of curving planes, and by breaking into its surface to reveal the forms inside, Picasso disrupted the formal integrity of the sculptural mass. Where sculpture had been opaque, Picasso has begun to make it transparent; where it was once discrete, it now extends into its surroundings – in this case through a series of extruded planes or spatial links; above all, where sculpture had been dignified, it has become mischievous.

The Absinthe Glass belongs to an extended family of drawings, collages and relief sculptures that occupied Picasso in the months preceding the outbreak of the First World War. The gradual dematerialisation of the wineglass can be seen in paintings such as *Still Life on a Piano* (Cat. no. 36) and in a papier collé such as *Still Life with Glass and Deck of Cards* (Cat. no. 37), while it emerges into three dimensions in a series of wooden wall-sculptures (see Fig. 27). By painting the bronze casts, and by using the stippling and textural techniques of his two-dimensional work, Picasso established an unusual continuity between these various media. Even the collage principle has been applied to a three-dimensional context by the addition of the authentic absinthe spoon to the alarmingly tilted mouth of the sculpted glass.

EDITIONS: 6 casts, variously painted, of which one at the Musée National d'Art Moderne, Paris (Spies, 36a), one at the Museum of Modern Art, New York (Spies, 36d), and one at the Philadelphia Museum of Art (Spies, 36e).

PROVENANCE: Galerie Kahnweiler, Paris; Kahnweiler sale, Paris 1921 (see below); Léonce Rosenberg, Paris; Paul Rosenberg, Paris; Alexandre Rosenberg, New York; Otto Gerson, New York.

EXHIBITIONS: Paris 1936 (unnumbered); Paris 1966–7², cat. no. 219, ill.; Paris 1973, no. 15, ill.; London 1983, no. 193, ill. p. 367; Berlin-Düsseldorf 1983, no. 19 (Spies 1983, below); New York 1985, p. 110, ill. p. 120; Geneva 1988, no. 74, ill. p. 189.

LITERATURE: Zervos 1949–86, vol. II, no. 581, pl. 268; 1st Kahnweiler sale, Paris, Hôtel Drouot, 14 June 1921, lot no. 139 (5 casts); Kahnweiler 1948, no. 12 (different cast); Penrose 1961, pl. 8, no. 5, ill.; Leymarie 1971, p. 229; Spies 1971, pp. 48–51, no. 36, ill. p. 49; Minervino-Cachin 1977, no. 780, ill. p. 124; Daix-Rosselet 1979, no. 755, p. 332, ill.; Spies 1983, no. 36c, p. 328, ill. p. 73; Hohl 1986, p. 142, ill. p. 143.

Pablo Picasso

41 Ma Jolie
1914

Oil on canvas, 45 × 41 cm. Signed on verso: *Picasso*

In a much quoted letter to his dealer Kahnweiler, Picasso wrote of his current companion Eva Gouel: 'I love her very much and I shall write her name on my pictures.' Beginning in the winter of 1912, Picasso painted or stencilled the words *Ma Jolie* onto a number of his major canvases, referring both to his nickname for Eva and to the words of the popular song from which it was derived. The earliest of these canvases (Fig. 28) belongs to the most sombre and rectilinear phase of Cubism, and seems somewhat at odds with the exuberant nature of Picasso's inscribed message. By the time *Ma Jolie* was painted, however, Picasso's art had become more expansive and accessible, depicting commonplace objects in an almost fanciful manner and delighting in the juxtaposition of colour, ornament and topical allusion. After the rigours of early Cubism, a number of younger artists associated with the movement, among them Léger, Delaunay and Gris, had begun to introduce brighter colours into their paintings. At the same time, both Picasso and Braque had found a new confidence in their use of collage, papier collé and sculpture, producing an exhilarating series of works that have been referred to as Rococo Cubism. Dots and stipples of vivid colour – derived irreverently from the pointillism of Seurat and Signac – vie with flat areas of primary hue, while a rich repertoire of brushed, abraded and marbled textures, some with sand added to the paint, animates the canvas surface.

Picasso's choice of objects within his still-life groups has been much analysed. On first encounter, an arrangement such as that of *Ma Jolie* seems almost haphazard, a casual collection of items that might be found on any café table or in the corner of an artist's studio. It is Picasso himself who seems to disallow such a reading, using lettering or brand names to make puns and contemporary references and often including objects with highly charged associations. Dice or playing cards, which are traditionally related to chance, fate or even death, occur frequently in the work of this period (Cat. nos. 37 and 38), while the inclusion of the words *Ma Jolie* gives the pictures an explicitly autobiographical character. Here the word BASS refers to a bottle of English beer, but also has musical connotations appropriate to the adjacent guitar and the printed score in the background. The still life thus becomes a modern equivalent of the traditional *vanitas* image, a celebration of the delights of music, love and alcohol, with a solemn reminder of mortality.

PROVENANCE: Galerie Kahnweiler, Paris (inv. no. 2111, photo no. 368); Kahnweiler sale, Paris, 1923 (?) (see below); Léonce Rosenberg, Paris; Lee A. Ault, New York (1962); André Lefèvre, Paris.

EXHIBITIONS: Paris 1937, no. 26; Paris 1952, no. 120; New York 1962 (Saidenberg Gallery), no. 21, ill.; Paris 1964, no. 222; Basle 1976, p. 76, no. 35, ill. p. 77; New York 1980, p. 182; Geneva 1988, no. 75, ill. p. 191; New York 1989–90, ill. p. 321.

LITERATURE: Zervos 1949–86, vol. II, no. 525, pl. 241; 4th Kahnweiler sale, Paris, Hôtel Drouot, 7 May 1923, (probably no. 345, with the title *Le Violon*); Raynal 1922, p. 49; Stein 1938, p. 107, ill.; Tzara 1948, no. 9; Raynal 1953, p. 60; Raynal 1958, pl. 171; Lefèvre sale, Paris, Musée Galliéra, 25 November 1965, no. 75, ill.; Leymarie 1971, p. 40, ill.; Daix-Rosselet 1979, no. 742, p. 329, pl. XLVI; Minervino-Cachin 1977, no. 775, ill. p. 123, pl. LIII.

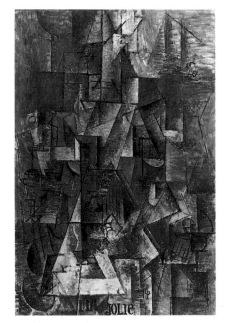

Fig. 28 Picasso, '*Ma Jolie*', 1911–12. Oil on canvas, 100 × 65.4 cm. The Museum of Modern Art, New York.

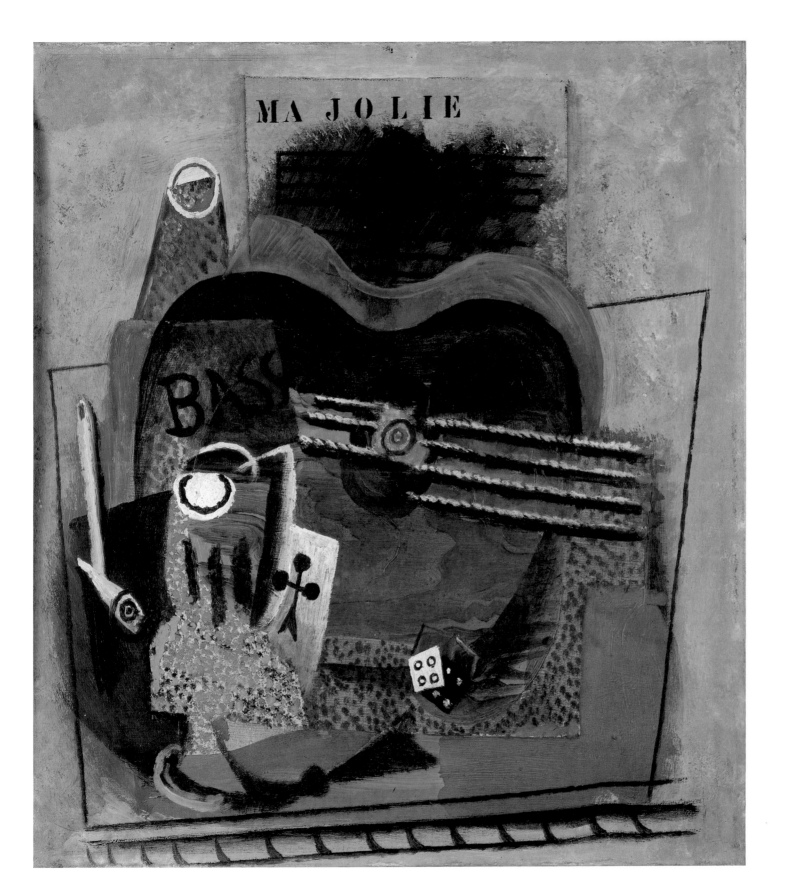

Pablo Picasso

42 Guitar and Newspaper
1916

Oil and sand on canvas, 101 × 66 cm. Signed and dated upper right: *Picasso/1916*; on verso, inscribed (partially obscured): *Picasso – 22 rue Victor-Hugo, Montrouge-sur-Seine*

A number of events in 1914 and 1915 were to transform Picasso's personal and artistic circumstances. As a Spaniard he was not involved in the call to arms in 1914, but found himself isolated in Paris while many of his painter friends went to the front. Some of the dealers with whom he had been associated – notably Daniel-Henry Kahnweiler – were of German origin and thus obliged to leave the country and in many cases to abandon their collections. The health of Picasso's mistress Eva Gouel, whom he had celebrated as *Ma Jolie* in a series of paintings (Cat. no. 41), had been deteriorating for some time and in December 1915 she died. Picasso's isolation and the sobriety of the times had an immediate impact on his art. The severe linearity and cool colours of *Guitar and Newspaper* are characteristic of a group of Cubist compositions dating from late 1915 and 1916, and are in sharp contrast to the almost frivolous 'Rococo' manner of previous months. Though the whimsical stippling or pointillism of the earlier 'Rococo' pictures has survived the transition, here it has been formalised and regimented, just as the playfully ambiguous spaces of *Ma Jolie* have now become more rectilinear. Even the use of sand in certain areas of the composition lacks the allusive wit of earlier collages, adding a further gravity to an already imposing canvas.

The severity and near-abstraction of *Guitar and Newspaper* was only one facet of Picasso's rapidly changing art. As early as 1914 he had embarked on a canvas depicting *The Painter and his Model* (Musée Picasso, Paris), using a stylised but essentially realistic mode of representation. This was followed by a series of precise and disciplined drawings of still-life groups and portraits of his friends, often recalling the precocious draughtsmanship of his youth and the studies of the nineteenth-century masters. Whether such works represent a critique of his own Cubist imagery or a return to his naturalistic roots, this alternative language persisted throughout the war years and blossomed into a remarkable group of classically inspired portraits and figure compositions (Cat. no. 49). While *Guitar and Newspaper* represents the culmination of a particularly monumental strand of Cubism, it was produced alongside more decorative and representational works; like every other picture by this most self-conscious of artists it was also a deliberate exercise in style, technique and visual syntax.

A curious, and previously unremarked, feature of this canvas is its conjunction of stylistic devices from two separate phases of Picasso's Cubism. Many areas show signs of reworking (drawn lines are visible under all the blocks of colour, and lilac paint beneath the corner areas), while certain passages of paint, notably the thinly brushed, monochromatic forms above and below the centre of the composition, appear to survive from an earlier stage in its production. These monochrome areas, with their block-like, tessellated brushstrokes, recall the techniques used by Picasso and Braque between 1911 and 1913 (Cat. nos. 36 and 27) and suggest that the canvas was begun at that time. Probably returning to the canvas in 1916, Picasso appears to have superimposed the dense passages of colour, sand and ornamentation that dominate the canvas today, transforming it from a muted exercise in form to a full-blooded example of high Cubism.

PROVENANCE: Myriam Hopkins, Los Angeles; Curt Valentin, New York; Sidney Brody, Los Angeles; Frank Perls, New York.

EXHIBITIONS: Los Angeles 1961, no. 11; Paris 1973, ill. no. 19; London 1983, no. 147; Geneva 1988, no. 76, ill. p. 193.

LITERATURE: Zervos 1949–86, vol. II, no. 539, pl. 250; vol. VI, no. 1296; Minervino-Cachin 1977, no. 820, ill. p. 125; Daix-Rosselet 1979, no. 809, p. 342, ill. pl. L; McEwen 1983, p. 35, ill.

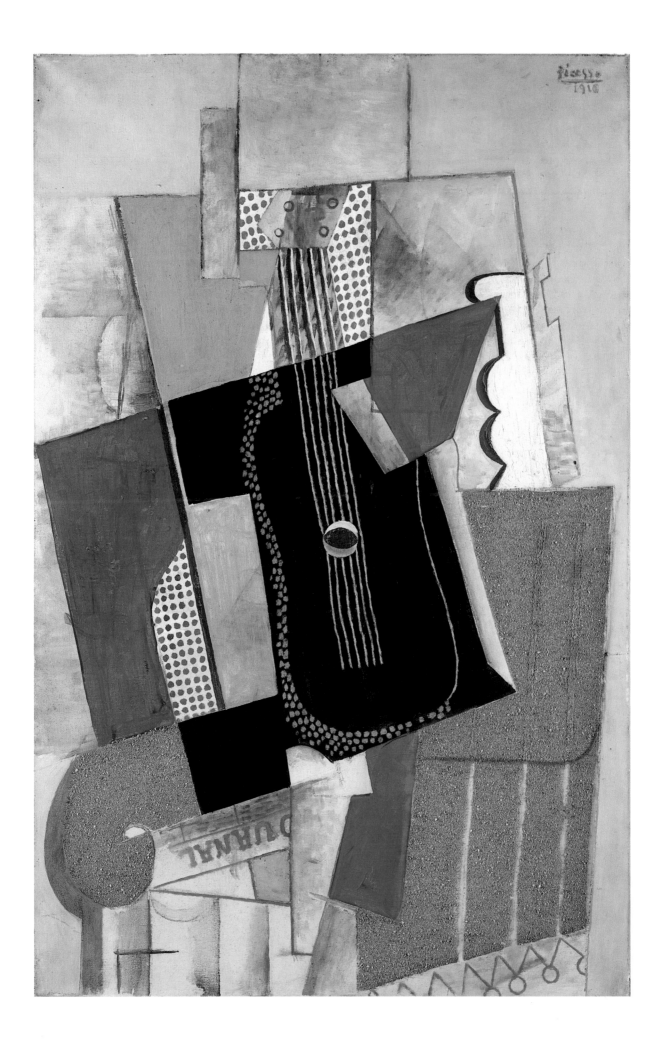

Pablo Picasso

43 Playing Card, Glass and Bottle on a Guéridon
1916

Tempera and sand on panel, 27 × 36 cm

In comparison with the many still-lifes from the earlier years of Picasso's Cubism, *Playing Card, Glass and Bottle on a Guéridon* is an exceptionally lucid, polished and accessible image. The forms of the still-life objects are crisply and unambiguously defined, while certain items, such as the playing card and wineglass, are rendered in an almost naturalistic manner. Bright colours and richly varied textures contribute to the decorative appeal of the picture, and finely controlled brushwork draws attention to Picasso's traditional skills (the painting is executed in the ancient medium of tempera on a prepared wooden panel). Where the mechanisms and transformations of Cubism are invoked, they are invoked in an unusually transparent fashion. Both front and side edges of the *guéridon*, or one-legged table, are shown; the wooden surface of the table is tilted up into the plane of the canvas; profile and elevated views of the bottle are linked together; and shadows and intervals between objects become as substantial as the objects themselves. Unlike previous phases of Cubism, all traces of the fabrication and adjustment of forms on the surface of the picture have been effaced, as if to signal a new era of technical and stylistic mastery.

Produced in Paris during the war years, this painting belongs to a group of compositions whose severity is in sharp contrast to the decorative and lyrical manner of Picasso's pre-war work. Many of his friends and colleagues, among them Braque, Léger and the poet Apollinaire, had been called to the front, but Picasso was able to continue his personal and artistic association with his fellow Spaniard Juan Gris. Gris had already made his mark on the evolution of Cubism, contributing a distinctive and formally rigorous approach to composition that was undoubtedly to influence Picasso's own work. Stressing the imperatives of pictorial organisation and the need to establish a dominant structure within each painting, Gris subordinated his subject matter to the demands of geometry and rhythm. Ever responsive to events around him, during these years Picasso often found himself in step with, or in advance of, a number of such developments within and beyond Cubism. The brightly coloured near-abstractions of Delaunay, the mechanistic constructions of Léger, and even the fractured forms of the Italian Futurists all contributed to the rich language of late Cubism from which *Playing Card, Glass and Bottle on a Guéridon* was created.

PROVENANCE: Léonce Rosenberg, Paris (inv. no. 5301); André Lefèvre, Paris, Lefèvre sale, Paris, 1967.

EXHIBITIONS: Paris 1964, no. 246; London 1983, no. 150, p. 310, ill. p. 311; Geneva 1988, no. 77, ill. p. 195.

LITERATURE: Zervos 1949–86, vol. II, no. 571, pl. 264; Raynal 1921, p. 23; Lefèvre sale, Paris, Hôtel Drouot, 24 November 1967, no. 122; Minervino-Cachin 1977, no. 873, ill. p. 126; sale, Sotheby's, London, 1 July 1980, no. 10.

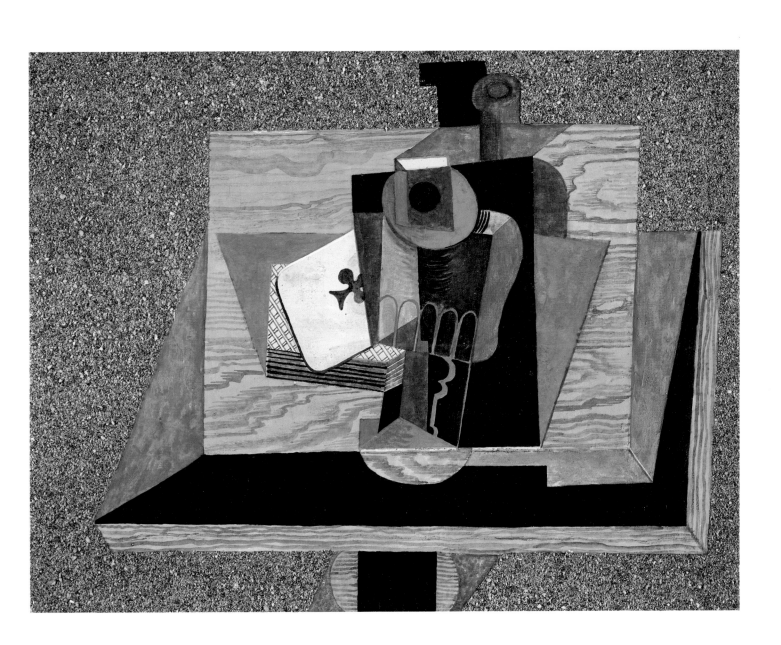

Pablo Picasso

44 Man seated at a Table
1916

Gouache on paper, 27.5 × 21.7 cm. Signed and dated upper right: *Picasso/1916*

A series of drawings begun in Avignon in 1914 charts the evolution of this small but majestic study, itself part of a major group of images made by Picasso during the war years. Paradoxically, the almost indecipherable subject of the picture first appeared at a time of unexpected naturalism in Picasso's art. Beginning with a detailed and largely realistic pencil drawing, Picasso studied the clothing and pose of a young man seated on a simple wooden chair, one arm resting on a table and the other supporting his slightly inclined head. In subsequent drawings the man's rounded forms gradually gave way to the angled structures of Cubism, though certain features, such as the horizontal arm and hand (which sometimes holds a pipe), the tilted head, and the turned leg of the chair, persist (Fig. 29). Returning to the motif in 1916, Picasso continued this process of transformation in a sequence of fully developed paintings, ranging from the miniature scale of the present work to the larger-than-life-size canvas of *Man leaning on a Table* (private collection). In these works a largely rectilinear geometry dominates the picture, while patches of bright colour and schematic ornament further stress the flatness of the composition. In *Man seated at a Table* the widespread use of black paint might suggest areas of shadow and recession, though these dark forms also join in the surface vitality of their more colourful neighbours.

For Picasso the subject of this painting had both personal and historical significance. The most naturalistic drawings done at Avignon were also related to an unfinished canvas, *The Painter and his Model* (Musée Picasso, Paris), in which the figure of the seated painter may represent Picasso himself. In their turn, these images of a man leaning against a chair or table are undoubtedly derived from a group of pictures by Cézanne, a number of which passed through the hands of the dealer Ambroise Vollard, who had represented both Cézanne and Picasso. In making reference to Cézanne's subject matter, and in identifying himself with the figure portrayed, Picasso was doing more than acknowledging his debt to the past. It is difficult not to see this appropriation of the seated figure, and its translation into the terms of Cubism and then near-abstraction, as a self-consciously historical manoeuvre. Implicitly, Picasso seems to take on the mantle of Cézanne and to suggest that works like *Man seated at a Table* are the culmination of his great predecessor's art.

Painted in water-based paint on paper, this work is also a reminder of the importance of Picasso's sketchbooks and sequences of preparatory studies. Many of his most ambitious images were conceived and nurtured on such a scale. Here a mixture of translucent washes and opaque areas has been used (some white paint at the left has partially oxidised and darkened), hinting at the decorative qualities soon to be associated with his designs for Diaghilev's Ballets Russes (the picture was first owned by the dancer and choreographer Léonide Massine).

PROVENANCE: Léonide Massine, Paris; Mrs Mack, San Francisco; Jacques Lindon, Paris.

EXHIBITIONS: Los Angeles-New York 1970–1, no. 274, ill.; Paris 1973, cat. no. 20, ill.; Tübingen-Düsseldorf 1986, no. 92 (see Spies 1986, below); Geneva 1988, no. 78, ill. p. 197.

LITERATURE: Zervos 1949–86, vol. XXIX, no. 212, ill. p. 89; New York 1958; Cooper 1970–1, pl. 251; Minervino-Cachin 1977, no. 871, ill. p. 126; Daix-Rosselet 1979, no. 888, p. 355, ill.; Spies 1986, no. 92, ill.

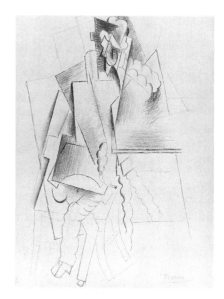

Fig. 29 Picasso, *Smoker sitting at a Table*, 1914. Graphite, 32.4 × 24.6 cm. Musée Picasso, Paris.

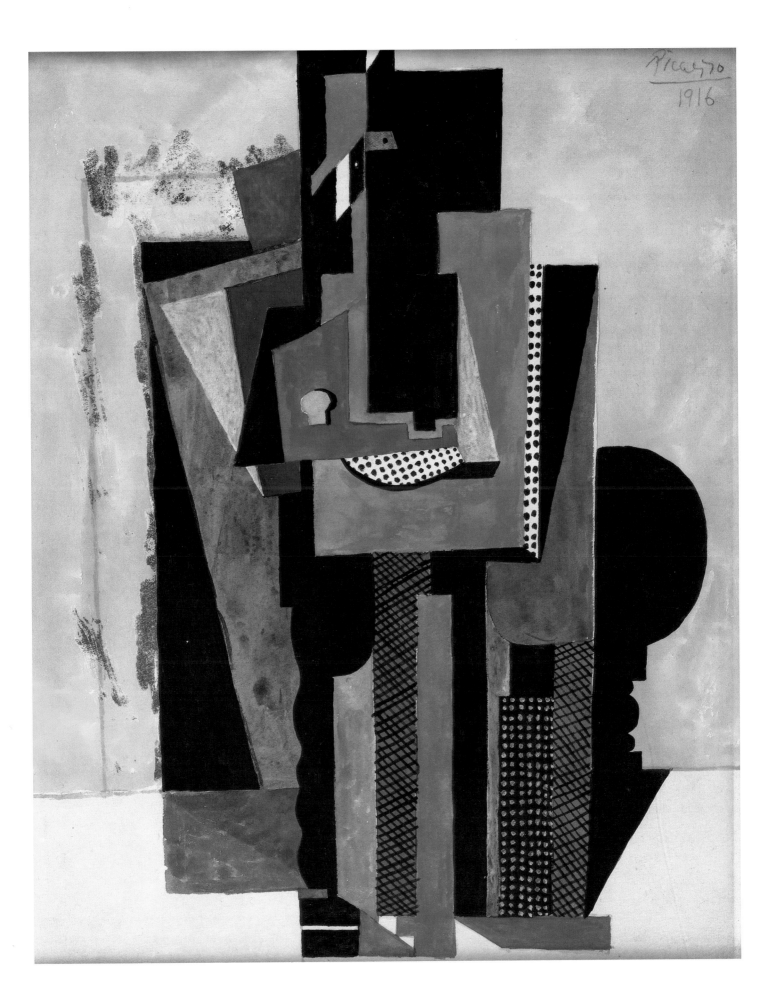

Pablo Picasso

45 Harlequin with Guitar
1918

Oil on panel, 35 × 27 cm. Signed and dated lower right: *Picasso/1918*

The naturalistic studies begun by Picasso in 1914 were continued into the early years of the war, gradually gathering momentum until they seemed to threaten the achievements of a decade of Cubism. To the dismay of many of his colleagues, Picasso showed that he could detach himself from the direction of his earlier work, producing pictures in a realistic, sentimental or openly frivolous manner. To add to their confusion, Picasso now chose to work in several different styles at the same time, creating variants on a single theme in a number of techniques and manners. Within months of painting *Harlequin with Guitar*, he had completed *Harlequin with Violin ('Si tu veux')* (Fig. 30), a radical, late-Cubist treatment of virtually the same subject which comes close to the brink of abstraction. This stylistic pluralism, and a refusal to accept the logical progression from Cubism into pure abstraction, are among the most distinctive and contentious features of Picasso's later career. His apparent change of heart cannot be simply explained, and the artist himself always insisted that early Cubism was just one phase among many in his long working life.

Harlequin with Guitar encapsulates one of the crucial transitions in Picasso's style and subject matter during the war years. As early as 1916, Picasso had been invited to work on his first theatrical production, designing sets and costumes for *Parade*, the celebrated collaboration between Jean Cocteau, Erik Satie and Diaghilev's Ballets Russes. To the surprise of his closest friends, Picasso threw himself into the project, beginning an important period of association with the theatre that coincided with, and perhaps reinforced, his move towards the decorative and the popularly accessible.

Parade itself became a very public display of Picasso's new stylistic diversity. While the costumes were based on an irreverent but geometric Cubism, the drop-curtain depicted an essentially realistic scene of harlequins, dancers and theatrical scenery, including a guitar-playing figure set against curtains and marble columns which is strongly reminiscent of *Harlequin with Guitar*. The clash of styles fascinated and alarmed the first-night audience, though in retrospect it is possible to see continuities in Picasso's work. In *Harlequin with Guitar* the exaggerated hatching, insistent surface textures and simulated marbling all have precedents in pre-war Cubism, while the stylisation of the harlequin, and even his knowing glance, all remind us of the game of representation that is being acted out.

PROVENANCE: Léon Bollag, Zurich.

EXHIBITIONS: Zurich 1932, no. 99; Marseille 1959, no. 28; London 1960, no. 88, p. 35, pl. 17g; Toulouse 1965, no. 21; Paris 1966–7[1], no. 106; Basle 1976, no. 40, ill. p. 85; Geneva 1988, no. 80, ill. p. 201.

LITERATURE: Zervos 1949–86, vol. III, no. 158, pl. 57; *Picasso* 1967, p. 125, ill.; *XXe siècle, Cahiers d'art*, Noël 1960, no. 15, p. 121, ill.

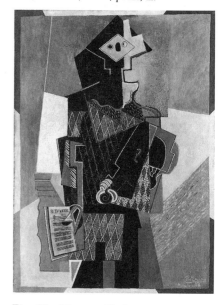

Fig. 30 Picasso, *Harlequin with Violin ('Si tu veux')*, 1918. Oil on canvas, 142 × 100.3 cm. Cleveland Museum of Art.

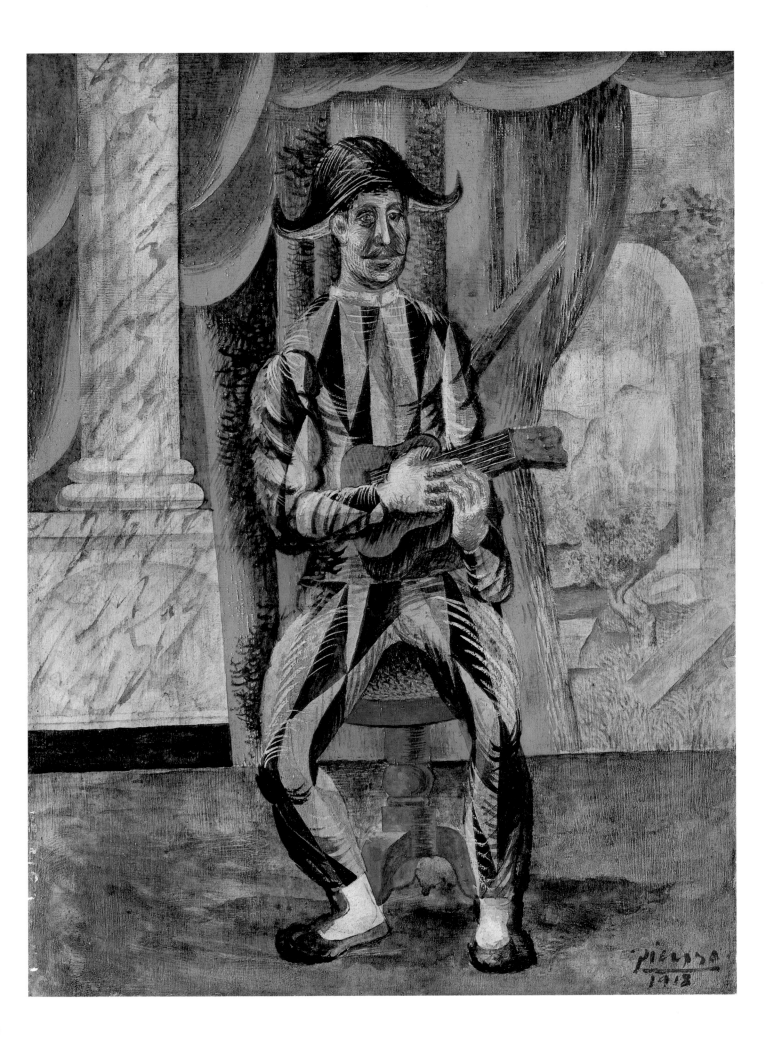

Pablo Picasso

46 The Sisley Family
1919

Graphite on paper, 30.5 × 22.5 cm. Signed lower left: *Picasso*

This emphatic but economical pencil drawing is one of a group of similar works produced in 1919, many of which were based on photographs or reproductions of works of art. The present drawing is a free transcription of a painting by Renoir, *The Sisley Family* (Fig. 31), that formed the basis of at least two further studies by Picasso. While following the principal elements of the composition and even such details as Sisley's cravat and the lace trimming of his companion's gown, Picasso has allowed himself considerable liberties with the original image. Both figures have been significantly amplified, the man developing a massive pair of shoulders and the woman a proportionately larger head and fleshy neck and hands. In contrast to earlier series of drawings, such as those for *Man seated at a Table* (see Fig. 29), these modifications accentuate the physicality of the two models, rather than suppressing and rationalising it into the flat patterns of Cubism. Though such drawings were produced alongside major Cubist canvases, they can only be seen as a re-exploration of more traditional qualities, such as narrative, illusionism and the interplay of volumes. Characteristically, Picasso chose drawing to prepare the way for this partial return to figuration. Drawing was always fundamental to his art and the bold, almost effortless line used in *The Sisley Family* reminds us of his legendary command of the medium.

Like *The Sisley Family*, several of the studies that Picasso made at this time represent couples either embracing or arranged in formal conjunction. There is good reason to relate these studies to Picasso's own marriage in July 1918 to Olga Koklova, a young dancer from the Ballets Russes. Another contemporary series of drawings in the same linear manner, again largely based on photographs, shows groups of ballerinas pirouetting on stage or striking poses for the camera. Olga herself appears in some of them, as she was increasingly to appear in Picasso's more naturalistic portraiture for several years. Picasso's marriage to Olga, his association with the glamorous Ballets Russes and the substantial income from the sales of his work all marked a new phase of social respectability and international renown in his career. The elegance of a drawing such as *The Sisley Family*, and the adoption of a more representational manner, has sometimes been linked to this change in his circumstances, and it is instructive to note Picasso's choice of Renoir, arguably the least demanding of the Impressionists, as his current model. After the rigours of his encounter with Cézanne, Picasso has perhaps reasserted his right to delight, dazzle and amuse.

PROVENANCE: John Becker, Chicago; James Goodman, New York.

EXHIBITIONS: Tübingen-Düsseldorf 1986, no. 98 (see Spies 1986, below); Geneva 1988, no. 81, ill. p. 203.

LITERATURE: Zervos 1949–86, vol. III, no. 429, p. 143; Spies 1986, no. 98, ill.

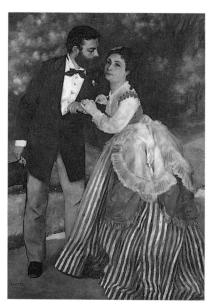

Fig. 31 Renoir, *The Sisley Family*, 1868. Oil on canvas, 106 × 74 cm. Wallraf-Richartz-Museum, Cologne.

Pablo Picasso

47 Still Life in front of a Window, Saint-Raphaël
1919

Gouache and graphite on paper, 35.5 × 25 cm. Signed and dated lower left: *Picasso/19*

Many of the familiar accessories of pre-war Cubism, such as the draped table and the paraphernalia of music-making, are present in this picture, yet they are given a pointedly different role. In his papiers collés and associated paintings, Picasso had brought his subject matter to the surface of the canvas, stressing the interplay of flat shapes and the fictional nature of their painted relationships. While some of these devices are still in evidence, he has here pushed his forms and structures back into space, using conventional perspective to lead our gaze across the room, through the open window and out into the distant seascape. In this new context the still life and its supporting table demand to be seen as free-standing objects, each occupying space and casting a shadow like the other structures in the room. With a little imagination the entire composition could be reconstructed as a three-dimensional tableau, using the painting as a blueprint or as a stage designer's model, and translating the forms into planes of cardboard or folded paper.

Still Life in front of a Window, Saint-Raphaël is one of an important group of variants of this motif, apparently begun in Picasso's Paris apartment and developed during a stay by the Mediterranean in the summer of 1919. The motif of the open window is rich in allusion and historical precedent, and had more recently been taken up by artists as varied as Matisse, Delaunay, Gris and Braque. Though Picasso was no longer as close to Braque as he had been in the early years of Cubism, an exhibition of Braque's recent work in Paris in 1918 may well have suggested both the subject matter and the starting point of this new series. Some of the pictures in the group, such as *Table, Guitar and Bottle* (Smith College Museum of Art, Northampton, Massachusetts), continue the flat, collage-like manner of late Cubism, while the present painting moves boldly in another direction, fusing elements of the Cubist repertoire with Picasso's new exploration of naturalism. The crisp, almost metallic description of form recalls the artifice of Cubism, while the deep space and the play of light and shadow belong to the conventions of illusionism. Passages of geometric severity alternate with areas of finely observed detail (such as the moulding and handle of the right-hand door and the billowing curtain beside it), and establish an unusual dialogue between alternative pictorial languages.

Some of the studies related to this picture indicate further complexities in Picasso's visual thinking. A watercolour study for the guitar and still-life group (Fig. 32) looks more like a design for a sculpture than a painting, and some surviving constructions in card, including one entitled *Table and Guitar in front of a Window* (Musée Picasso, Paris), suggest that he thought of these pictures in essentially structural terms. Similarly, the repeated depiction of open windows and curtains, and even the use of pale-toned and matt paints, hints at a theatrical association, a reminiscence perhaps of his recent work on Diaghilev's ballet *Tricorne*.

PROVENANCE: Paul Rosenberg, Paris; Rosenberg family, Paris-New York.

EXHIBITIONS: New York et al. 1939–40, no. 145, p. 101, ill.; New York 1962 (Paul Rosenberg & Co.), no. 9, ill.; Los Angeles-New York 1970–1, no. 276, pl. 260; Cambridge et al. 1981, no. 63 (see Tinterow 1981, below); Tübingen-Düsseldorf 1986, no. 95 (see Spies 1986, below); Geneva 1988, no. 82, ill. p. 205.

LITERATURE: Zervos 1949–86, vol. III, no. 396, p. 133; Cassou 1940, ill.; Barr 1946, p. 112, ill.; Elgar-Maillard 1955, p. 98, ill.; Runnqvist 1959, pp. 68, 189, ill. no. 74; Champris 1960, no. 94; Diehl 1960, pl. 33 (incorrectly described); Cooper 1970–1, pl. 260; Baumann 1976, ill. p. 96, no. 166; Rosenblum 1976, no. 58, ill.; Arnason 1977, no. 525, ill.; Cachin-Minervino 1977, no. 933; Rosenberg sale, London, Sotheby's, 3 July 1979, no. 10, ill.; Tinterow 1981, no. 63, ill. pp. 19, 159; Spies 1986, no. 95, ill.

Fig. 32 Picasso, *Still Life*, 1919. Gouache, 10.5 × 18.5 cm. Musée Picasso, Paris.

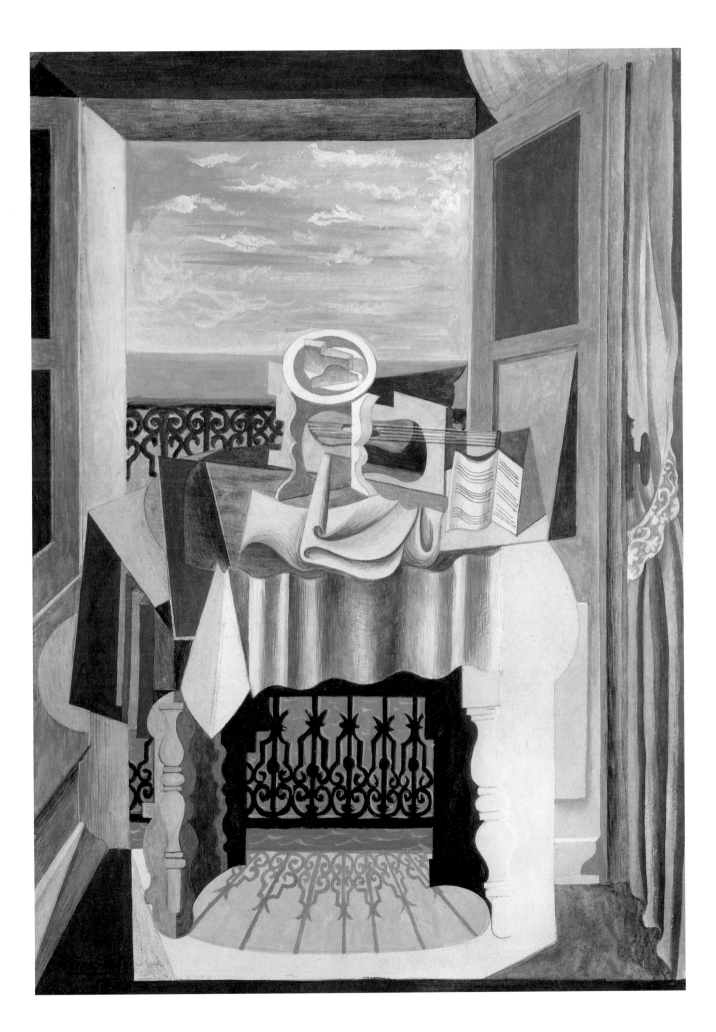

Pablo Picasso

48 Two Women on the Beach
1920

Graphite on paper, 26.5 × 42 cm. Signed and dated lower right: *Picasso 23.6.20*

Though many artists had tackled the subject before, it was surely Picasso who made the modern beach scene his own. By now able to spend several months each summer in the resorts of the Mediterranean, Picasso delighted in the open-air life and in the subjects and symbols he found there. Roland Penrose, who later recorded his summer visits to the artist and his entourage, described how 'The small, neat, well-built physique of Picasso was at home in these surroundings. His well-bronzed skin, his agile controlled movement, his athletic figure and small shapely hands and feet seemed to belong to the Mediterranean scene as though he were the reincarnation of the hero of an ancient myth.' Using his hotel as a studio, Picasso produced drawings and paintings based on his daily encounters, as well as working on parallel series of pictures of unrelated subjects and in quite different idioms. The beach setting allowed him exceptional freedom with the great subject of his career, the human body: it could be depicted in contemporary guise, dressed in discreet swimwear (Cat. no. 50) or self-consciously soaking up the sun, as in *Two Women on the Beach*; it could be stripped of local significance and transformed into an emblem of another age (Cat. no. 49); or it could become the vehicle for his boisterous and sinister imagination (Cat. nos. 54 and 56).

Two Women on the Beach was drawn in 1920 during a long summer sojourn at Juan-les-Pins. The scale of the drawing and the directness of its execution suggest that it may have been a page from a sketchbook, perhaps used on the beach. As in the study of *The Sisley Family* (Cat. no. 46), a strong pencil outline describes the figures, and the artist's first vigorous strokes have not been erased or developed. The rudimentary indication of sea and beach, and the slack, unusually amorphous body of the reclining figure, point to a rapidly executed study, though the deftly drawn head of this same figure and the marvellously disentangled legs and fingers of her companion were surely observed with great care. Between 1918 and 1920 Picasso had made a series of drawings of naked women beside the sea, ranging in style from the refinement of *Bathers* (Fogg Museum, Cambridge, Massachusetts) to the deliberate awkwardness of *Two Bathers* (Musée Picasso, Paris). *Two Women on the Beach* falls halfway between these two extremes, combining an expressive, even lyrical line with an acute sense of the models' particularity. Though the drawing is not listed in the Zervos catalogue of Picasso's work, its 'sense of graphic mastery' has been identified by Pierre Daix with a number of studies from this period.

PROVENANCE: Valentine Dudansing, New York; Maxwell Davidson, New York.

138

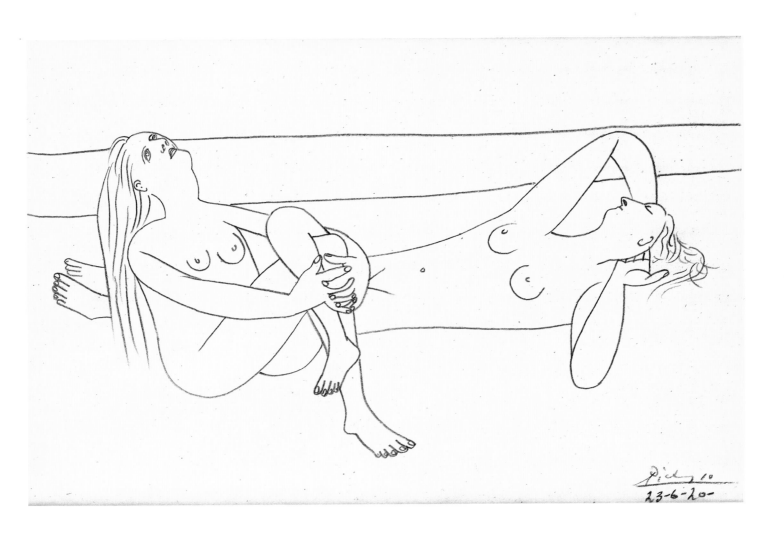

Pablo Picasso

49 Seated Nude drying her Foot
1921

Pastel on paper, 66 × 50.8 cm. Signed and dated lower right: *Picasso/21*

Picasso's renewed interest in naturalistic modes of representation showed itself at first in his drawings and small-scale studies, and in works associated with the theatre. Gaining in ambition and perhaps in conviction, he soon began to plan a group of major figurative compositions, as large and unequivocal as anything from his earlier Cubist phase. Many of these scenes, like *Seated Nude drying her Foot*, show bathers and male or female figures posed in states of reflective lassitude, at the opposite extreme to the abrasive subject matter of his pre-war work. So extreme was this shift that were it not for his simultaneous preoccupation with a number of large canvases in a Cubist idiom – such as *The Three Musicians* (Philadelphia Museum of Art) – it would be tempting to see it as a systematic repudiation of his earlier manner. In *Seated Nude drying her Foot* the identity of the subject is immediately apparent, forms and spaces are conventionally described, and the setting is as remote from the cafés and studios of Paris as the imagination allows.

Many features of this pastel, as well as the evidence of other pictures in the series, leave us in no doubt that Picasso had a classical context in mind. In 1917, while working for Diaghilev and the Ballets Russes, he had visited Rome and Pompeii, initiating an interest in antique sculpture, wall-painting and draughtsmanship that was to dominate his work in the subsequent decade. Among the frescoes at Pompeii are a number of idealised and generously proportioned female figures which seem to have suggested this new point of departure. In this pastel, the artist also echoes the celebrated classical sculpture of the *Spinario* (a seated figure extracting a thorn from his raised foot), as well as emphasising the gravity and three-dimensional complexity of the model's pose. Deep shadows and pronounced highlights are combined to amplify each form, while the interplay of volumes and tones aspires to the equilibrium of the classical tradition.

In his new concern for the art of the past, Picasso found himself caught up in a more general revival of classicism among the artists of post-war Europe. A search for stability and continuity, which appeared to some to threaten the achievements of the pre-war avant-garde, made itself evident in art forms as various as music and architecture, design and painting. *Seated Nude drying her Foot* is a powerful and historically resonant image in which Picasso self-consciously returns to the challenges of the European tradition. Even the technique of pastel, which Picasso unexpectedly chose for several pictures in this series, is laden with such associations; his use of dark, textured paper and his careful blending of adjacent colours all derive from conventional, even academic, practice. It is a mistake, however, to oversimplify Picasso's revivalism. Many of the characteristics of this image, such as the discontinuous horizon, the combination of frontal and profile features and the model's massively tactile fingers, remind us of the artist's earlier and continuing Cubist concerns.

PROVENANCE: Paul Rosenberg, Paris; Rosenberg family, Paris-New York.

EXHIBITIONS: Limoges 1923, no. 370; Munich 1922, no. 31, ill. no. 35 (with wrong medium); New York 1962 (Duveen Brothers Inc.), no. 27, ill.; Tübingen-Düsseldorf 1986, no. 111 (see Spies 1986, below); Paris 1988, p. 10; Geneva 1988, no. 85, ill. p. 211.

LITERATURE: Zervos 1949–86, vol. IV, no. 330, ill. p. 125; Rosenberg sale, London, Sotheby's, 3 July 1979, no. 24, ill.; Hoog 1984, p. 166; Spies 1986, no. 111.

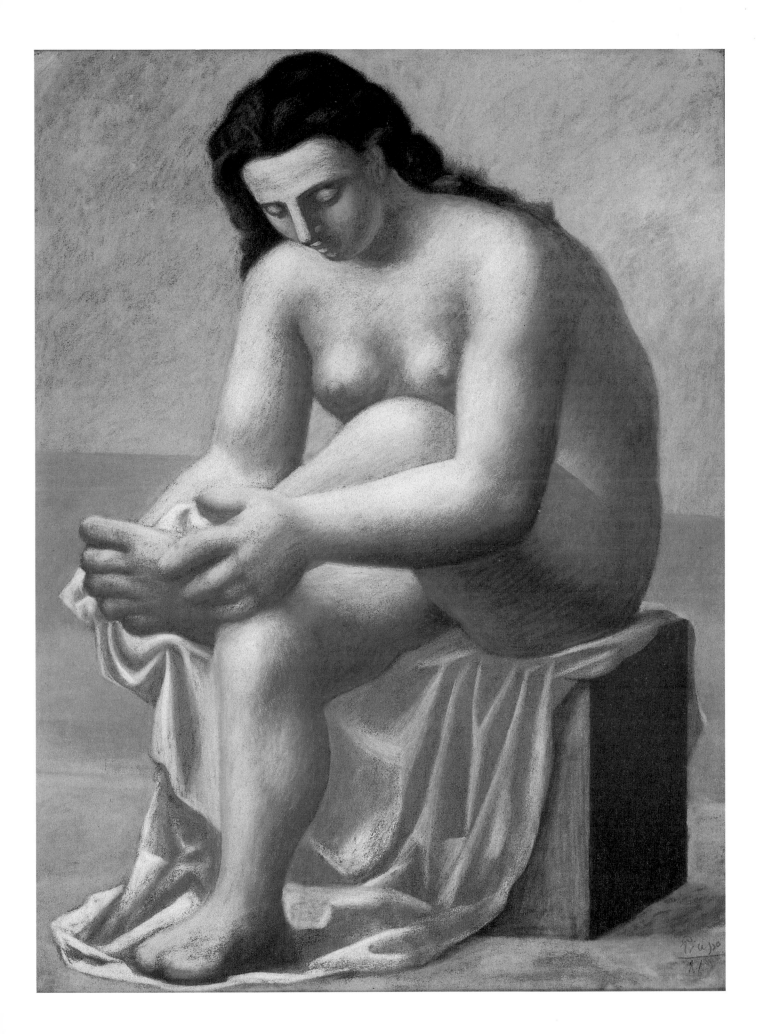

Pablo Picasso

50 Two Bathers
1921

Graphite on paper, 24.5 × 30.5 cm. Signed and dated upper left: *Picasso 8.3.21*

Many of the works in Picasso's newly adopted classical manner have an unmistakeable affinity with sculpture. *Seated Nude drying her Foot* (Cat. no. 49) refers to one of the most famous statues of antiquity; *Three Women at the Spring*, 1921 (Museum of Modern Art, New York) resembles a classical relief; while *Two Bathers* seems like a study for a stone carving yet to be made. Paradoxically, this was a period when Picasso made few works in three dimensions, as if the strongly modelled forms of his drawings and paintings temporarily satisfied his sculptural concerns. In *Two Bathers* each element is carefully hatched or modelled, recalling the action of the sculptor's chisel or the engraver's burin. Legs, arms and torsos are lucidly arranged in space, with overlapping features and intervening spaces precisely accounted for. As in a number of his earlier pictures, such as *At the Café-Concert* (Cat. no. 28), a profile is combined with a three-quarter view, supplying the viewer with an extended awareness of a single form. Even the faces of the figures, which may well reflect Picasso's original models, also suggest the timeless proportions of the classical portrait.

While the majority of Picasso's beach scenes show the female figure, and are often erotic or predatory in character, a parallel series depicts athletic and classically inspired male subjects. This series was also the product of Picasso's summer visits to the Mediterranean, where he claimed that the figures of classical mythology came vividly alive for him. In this context, the two bathers seem more like Roman gods or resting heroes, an allusion made explicit in a monumental painting of two male figures, *The Pipes of Pan*, 1923 (Musée Picasso, Paris). Such classical figures could also make the transition into Picasso's Cubist canvases, notably as fragments of sculpture in a series of still-life paintings and in the 1925 *Studio with Plaster Head* (Museum of Modern Art, New York).

PROVENANCE: Sotheby's sale, London 1990 (see below).

LITERATURE: Zervos 1949–86, vol. IV, no. 263, ill; sale, Sotheby's London, 4 April 1990, no. 141, ill.

Pablo Picasso

51 Seated Nude
1922–3

Black ink on paper, 26 × 35 cm. Signed lower right: *Picasso*

In comparison with the elegant draughtsmanship of *The Sisley Family* and the disciplined line of *Two Bathers* (Cat. nos. 46 and 50), this drawing seems almost wilfully unconstrained. Here Picasso has built up his forms with dense areas of texture and rapid, nervous strokes of the pen. Vigorous crosshatching animates the surface of the paper, while improvised and meandering lines hint at drapery or the play of shadow. Once again we are reminded of the action of the sculptor's chisel, though here the reclining figure might be roughly blocked out, or perhaps eroded by the elements. At a number of points in his career Picasso seems to have needed to challenge his own facility, to disrupt the natural control and delicacy of his line and to reassert his instinctive vitality. His studies for *Les Demoiselles d'Avignon* (Cat. no. 32) and some of the paintings and drawings of the Cubist period were made in defiance of his technical adroitness, rather than in celebration of it. As with *Seated Nude*, many of these works coincided with a period of stylistic self-examination, resulting in images of unusual directness and intensity.

The subject of this drawing is a long-limbed figure who strikes a pose of considerable historical significance. Whether or not he used a model for the drawing, Picasso has chosen to evoke one of the most familiar of classical themes – the recumbent male river god or his female counterpart, *La Source*. Both figures traditionally support an urn or water jar, absent in *Seated Nude* though conspicuously evident in a large contemporary work by Picasso, *La Source* (Fig. 33). In invoking the classical tradition, while adopting an abrasive and anti-classical manner, Picasso displays his Mediterranean credentials and once again asserts his right to plunder the ancient and the modern for artistic purposes. As he said in an interview at about the time *Seated Nude* was executed: 'When I have found something to express, I have done it without thinking of the past or the future. I do not believe I have used radically different elements in the different manners I have used in painting. If the subjects I have wanted to express have suggested different ways of expression I have never hesitated to adopt them.'

PROVENANCE: John S. Newburry, Detroit; E. V. Thaw, New York.

EXHIBITIONS: New York 1952, no. 39, ill.; New York 1959, no. 149, ill.; Frankfurt-Hamburg 1965, no. 67, ill.; Tübingen-Düsseldorf 1986, no. 122 (see Spies 1986, below); Geneva 1988, no. 86, ill. p. 213.

LITERATURE: Zervos 1949–86, vol. VI, no. 1440, p. 172, ill.; Jardot 1959, p. 59, ill.; Spies 1986, no. 122, ill.

Fig. 33 Picasso, *La Source*, 1921. Wax crayon on canvas, 100 × 200 cm. Musée Picasso, Paris.

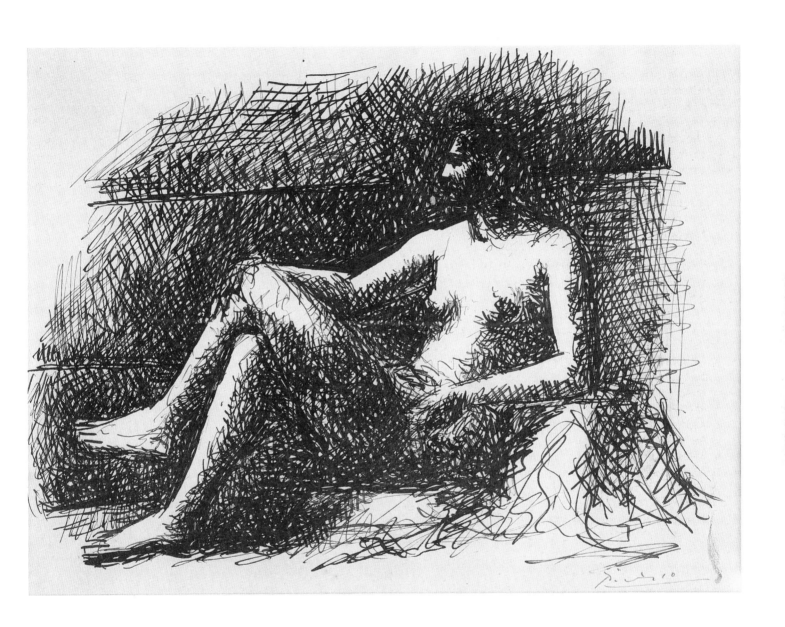

Pablo Picasso

52 Bullfight
1923

Ink and pencil on paper, 35 × 25 cm. Signed upper left: *Picasso*

The theme of the bullfight had disappeared from Picasso's art for almost two decades, but in the inter-war years it was to take on a persistent, almost obsessive significance. As a young man at the turn of the century he had painted a number of brightly coloured scenes of the corrida, combining documentary accuracy with spirited late-Impressionist brushwork. In the *Bullfight* Picasso returns to the subject a changed artist, veteran of several stylistic excursions and master of a new diversity of means. Choosing a similar incisive and controlled line to that used in *The Sisley Family* and *Two Bathers* (Cat. nos. 46 and 50), Picasso appears to distance himself from the very violence that he depicts. While adopting a viewpoint much closer to the incident in the bullring than any real spectator would have – and perhaps by implication casting himself as the toreador – Picasso contains the scene within a precise and symmetrical structure. The horse and bull – who here represent not only the bullfight but a ritual that has gone out of control – are posed at the centre of the composition, frozen in mid-movement as if in a tableau or relief carving. The sense of unreality, or of time suspended, is continued into the sparse audience, here dressed in generalised costumes and barely engaged in the desperate struggle below.

It was part of Picasso's new stylistic virtuosity that a subject such as that of *Bullfight* might reappear in a series of parallel variations, involving changes of scale, technique and dramatis personae. One such drawing shows the two animals alone, while a small oil painting depicts an almost identical audience watching a solitary white horse. More remarkable are a drawing and an associated painting (Fig. 34) which include the figure of a bullfighter draped across the back of the bull and apparently dead. For Picasso such scenes had irresistably symbolic overtones associated with his Spanish upbringing, his view of nature and even his own creativity and sexuality. In less than a decade he was to turn again to the same motif, fusing the figure of the bull with that of a minotaur, introducing a female bullfighter, and exploring a ferocious visual vocabulary that is far removed from the cool restraint of the *Bullfight*.

PROVENANCE: Etienne de Beaumont.

EXHIBITIONS: Geneva 1988, no. 87, ill. p. 215.

LITERATURE: Zervos 1949–86, vol. V, no. 146, p. 73; Goeppert 1987, ill. p. 18.

Fig. 34 Picasso, *Bullfight*, 1922. Oil on canvas, 13.6 × 19 cm. Musée Picasso, Paris.

Pablo Picasso

53 Still Life with Blue Guitar
1924

Oil on canvas, 100 × 81 cm. Signed and dated upper left: *Picasso 24*

In the 1920s Picasso found himself at the centre of an extraordinarily diverse and often combative artistic milieu. The Cubism pioneered by himself, Braque and Gris had spawned a variety of offspring, some perpetuating the mannerisms of their forebears, others advancing into pure abstraction. Dadaism and the newly emergent Surrealism had claimed the attention of many of Picasso's colleagues, while new advances in sculpture, photography, design and film-making were being pressed into service. Picasso's own art, already remarkable for its technical and idiomatic versatility, was able to accommodate and even to become instrumental in many of these developments, though the artist himself remained unattached to their proliferating factions and ideologies. However, his continuing awareness of the work of Matisse, Miró, Braque and others, as well as his broad alignment with the revival of classicism, are immediately evident in the varied pictorial output of this decade.

Still Life with Blue Guitar is one of a group of large, often intensively worked exercises in late Cubism produced in the mid-1920s, and including such works as *The Bird Cage* of 1923 (private collection, New York) and the *Three Dancers* of 1925 (Tate Gallery, London). Even while his art was dominated by naturalistic concerns, Picasso turned again to some of the great themes and unresolved challenges of his pre-war career. Still life, which had formed the bedrock of much of his Cubist experimentation, was given a new lease of life in canvases that range from the decorative to the fantastic. Here the forms of the still-life objects have been reduced to extreme simplicity, an austere interplay of tones and colours against a grid-like background of blue and pink. While each object retains its identity, they have all become interdependent within the drama of the picture – a gentle curve echoing the form of its neighbour or an area of warm colour setting off a cooler shadow. At the heart of the composition is Picasso's preoccupation with line and form, here expressed as an incised outline which both contains and describes the painted elements. Close examination of the canvas shows how this line has been repeatedly effaced and redrawn, while several passages of colour have also been repainted in the ensuing pictorial dialogue. The deceptive sobriety of the final image hides a taut, hard-won structure, at once classical in its stillness and lyrical in its colouring.

PROVENANCE: Galerie Simon, Paris; Alphonse Kann, St Germain-en-Laye; Galerie Beyeler, Basle.

EXHIBITIONS: Paris 1932, no. 142; Basle 1957, no. 43; Cologne 1964, no. 83; Humlebaek 1968, no. 116.

LITERATURE: Zervos 1949–86, vol. V, no. 280; Daix 1977, p. 198.

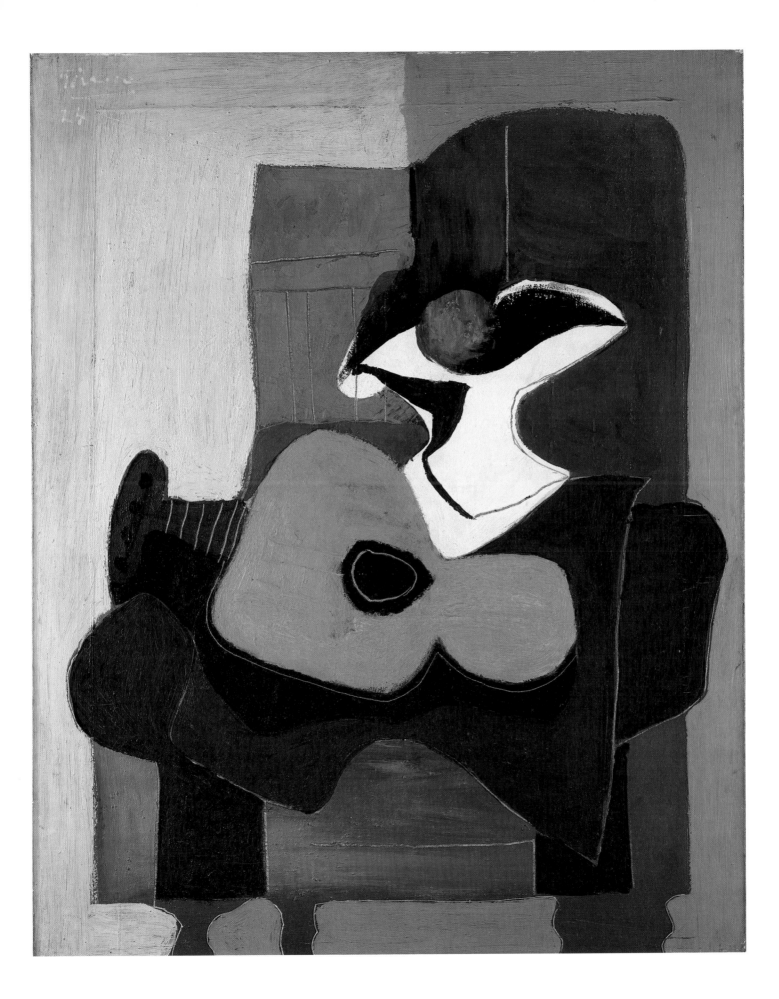

Pablo Picasso

54 Silenus in Dancing Company
1933

Black ink and gouache on paper, 34 × 45 cm. Signed and dated lower right: *Picasso/Cannes 6 Juillet XXXIII*

The year 1933, when *Silenus in Dancing Company* and *The Sculptor and his Statue* (Cat. no. 55) were executed, was a time of personal stress and compromise for Picasso. His marriage to Olga had come under considerable strain and was soon to end in a formal separation, while his young mistress, Marie-Thérèse Walter, increasingly dominated both his life and his art. The evidence of Picasso's work, however, shows that it was also a period of extraordinary creativity. Not only did he produce a large number of drawings, etchings and paintings during the year, but even by Picasso's standards they were spectacular in their diversity. In February and March he made some drawings for what appear to be whimsical, semi-abstract sculptures; the following month a group of sexually explicit studies in a deliberately childlike manner; by early June more than 50 etchings for the classically inspired Vollard Suite; and in the summer and autumn a series of variations on his most violent theme, the bullfight. The extent to which these pictures reflect the tensions of Picasso's private life must remain a matter of conjecture, but there can be little doubt that the artist identified with many of the characters and dramas in his own imagery.

Silenus in Dancing Company was completed in the middle of this turbulent year, following an intensive period of work on the plates of the Vollard Suite (see Fig. 35). Though the painting has an emphatic unity, it also represents a virtual catalogue of Picasso's current visual and thematic concerns. The classical subject continues a theme established more than a decade before, though here, as so often in the artist's recent printmaking, it becomes the pretext for a sexual fantasy. Male and female figures embrace and intermingle, while a slightly sinister urgency pervades the scene. Most strikingly, and perhaps significantly, Silenus and his male companions are rendered in a sculptural idiom, while their female consorts are two-dimensional, almost wraith-like presences. This stylistic disjunction, with its echoes of the artist's personal predicament, is reiterated in the contrast between the deep, illusionistic landscape and the shallow foreground tableau. Picasso's success in containing and resolving these divergent qualities is a tribute to his visual persuasiveness, though he makes no attempt to disguise a fundamental tension, both private and artistic, at the heart of the work.

PROVENANCE: Philippe Dotremont, Brussels.

EXHIBITIONS: Amsterdam-Eindhoven 1954, no. 62; Arles 1957, no. 46, pl. 19; London 1960, no. 132, p. 43, pl. 32 i; Frankfurt-Hamburg 1965, no. 75, ill.; Fort Worth 1967, no. 189, ill. p. 60; New York 1980, p. 313, ill.; Tübingen-Düsseldorf 1986, no. 142 (see Spies 1986, below); Geneva 1988, no. 88, ill. p. 217.

LITERATURE: *Picasso* 1967, p. 136, ill.; Spies 1986, no. 142, ill.

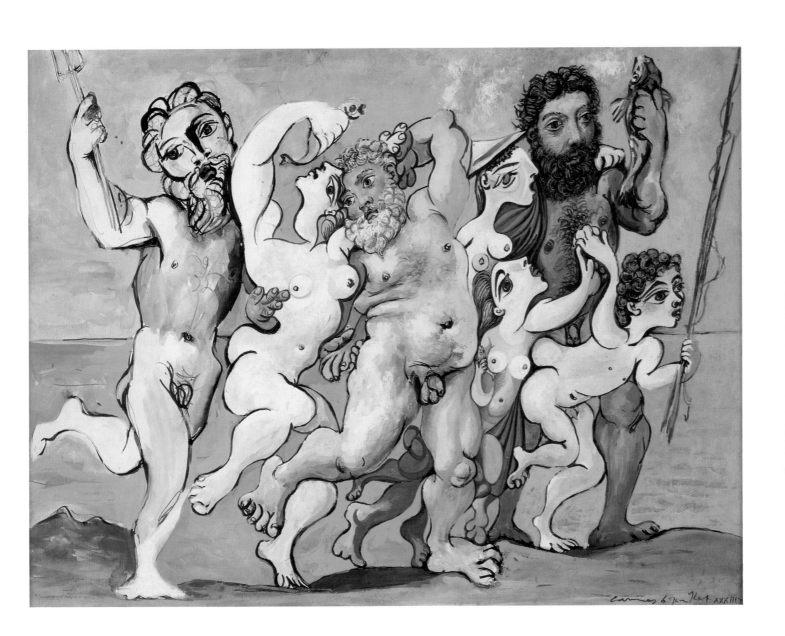

Pablo Picasso

55 The Sculptor and his Statue
1933

Ink, watercolour and gouache on paper, 39.5 × 50 cm. Signed and dated upper left: *Cannes 20 juillet XXXIII/Picasso*

The setting for *The Sculptor and his Statue* is a timeless and fanciful Mediterranean world, where artists work in the nude and beautiful models pose tirelessly. In a number of earlier drawings and paintings Picasso had begun his lifelong fascination with images of the painter and his subject, most notably in the severely geometric *Painter and Model* of 1928 (Museum of Modern Art, New York). Many of the etchings in the Vollard Suite (Fig. 35) take up this theme, proposing a variety of wistful, witty and occasionally violent permutations on an age-old relationship. In some images, as in *The Sculptor and his Statue*, the artist is pensive, reflecting on his recent work or perhaps on the nature of his own creativity. Frequently, the model herself intervenes, joining in the artist's gaze and sometimes appearing perplexed by his depiction of her features. Other variants allow Picasso to mock his own stylistic diversity, to explore the sexual tensions of the studio and even to invoke such subjects as the minotaur and the harem. As in so much of Picasso's work of this period, the challenges of style, subject matter and autobiography are recurrent concerns, allowing the artist to reflect on the paradoxes of his life and the nature of his vocation.

The techniques used by Picasso in *The Sculptor and his Statue* are typically unorthodox and allusive. Using a mixture of pen, ink, watercolour and gouache, the artist has created a dense interplay of forms and colours, contrasting the energetic lines of the sculptor with the delicate tints of the sky behind him, or the near-monochromatic statue with the adjacent red draperies. Many of the forms are modelled with linear crosshatching, a procedure that strongly recalls the etched lines of the Vollard Suite. As in a number of the etchings, *The Sculptor and his Statue* extends this technical virtuosity into a consideration of the paradoxes of art and the ambiguities of pictorial language. Here Picasso has depicted a fellow artist in his studio, surrounded by the products of his own invention but distinguished from them by the conventions of his craft. The sculptor's casual pose and linear vitality express the animation of the living figure, while the compact forms of the female statue suggest another order of reality. Between the two, the large male head appears to question both conventions, its massively sculpted features evoking the processes of sculpture, while its colouring and expression hint at the vital world of the sculptor himself.

PROVENANCE: Paul Rosenberg, Paris; Rosenberg family, Paris-New York.

EXHIBITIONS: New York et al. 1939–40, no. 260, ill. p. 162; New York-Chicago 1957, p. 70, ill.; Philadelphia 1958, no. 132, ill.; New York 1962 (The New Gallery), no. 31, ill.; New York 1980, p. 313, ill.; Cambridge et al. 1981, no. 78 (see Tinterow 1981, below); Tübingen-Düsseldorf 1986, no. 141 (see Spies 1986, below); Geneva 1988, no. 89, ill. p. 219.

LITERATURE: Zervos 1949–86, vol. VIII, no. 120, ill. p. 50; Barr 1946, p. 185, ill.; Diehl 1960, p. 32, ill.; Richardson 1964, no. 22, ill.; Leymarie 1967, pp. 58–9, ill.; Rosenberg sale, London, Sotheby's, 3 July 1979, no. 35, ill.; Tinterow 1981, no. 78, p. 186, ill. p. 187, ill. p. 21; Spies 1986, no. 141, ill.; Goeppert 1987, p. 88, ill.

Fig. 35 Picasso, *Sculptor and Model with Sculpture*, 1933. Etching, 267 × 194 cm. Musée Picasso, Paris.

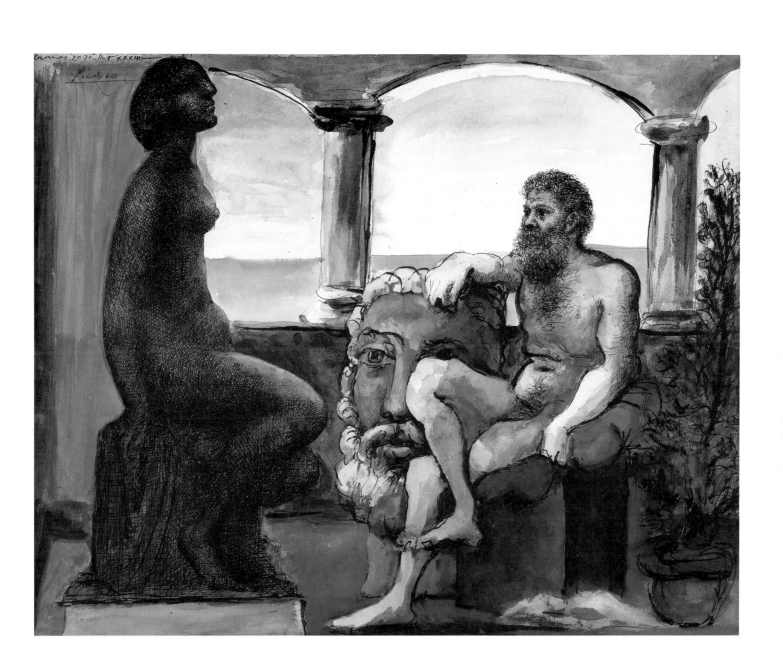

Pablo Picasso

56 Minotauromachy

1935

Etching, 49.6 × 69.3 cm.
Inscribed (spring 1971), lower left: *Pour mon ami Bergruen* [sic] / *Picasso*

Much of Picasso's most experimental and confessional work in the mid-1930s was executed on paper, either as drawings, etchings or combinations of pen and ink, gouache and pastel. The smaller scale of such works and the immediacy of many of the techniques corresponded to a new urgency in his art, while the possibilities for revision and enrichment of the picture surface were seized upon eagerly. *Minotauromachy* is arguably the grandest of the works of this period, as well as being an important milestone in the evolution of Picasso's imagery. Many of the elements in the composition are familiar from earlier paintings and drawings, though here they are combined in a suggestive and non-naturalistic manner that is close to contemporary Surrealism (Picasso designed the cover for the Surrealist magazine *Minotaur* in 1935). The site of their confrontation is a beach or harbour, previously the setting for some of Picasso's most tranquil imagery but here rendered sinister by the darkening sky and encroaching buildings. At the left a number of spectators represent the more innocent element of the narrative, gazing impassively at the horrors unfolding before them. Towards the centre a disembowelled horse, which derives from Picasso's studies of the bullfight, moves into a new register of angularity and violence, and now supports the broken figure of a female toreador. Towering above the other protagonists, a gigantic minotaur completes the nightmarish ritual, spelling out the fantastic nature of the scene and introducing a final touch of savagery.

The subject matter, scale and finished appearance of *Minotauromachy* all suggest an unusually intense statement of Picasso's concerns. Larger than any of the plates in the contemporary Vollard Suite (see Fig. 35), this etching was developed through a number of stages and enriched with an exceptional variety of surface textures. Despite the clarity of Picasso's intentions – the first states of the print (Fig. 36) vary from the final image principally in tone and surface incident – the significance of the composition has never been fully identified. Characteristically, Picasso himself was silent on the subject, though the image has been associated with the events of his private life, the political developments in pre-war Europe, and the artist's view of the human condition. As in *Silenus in Dancing Company* (Cat. no. 54), it is difficult to study Picasso's representation of women at this period without reference to his own compromised relationships, and the female figures in the present etching, from the wide-eyed child to the violated bullfighter, may well be concerned with his own roles as father, husband and lover. The minotaur itself, half instinctive animal and half rational man, had already been adopted by Picasso in the Vollard Suite and elsewhere as an occasional alter ego, a personification of his divided passions and the paradoxes of his creativity. Locked together in terrible proximity, these bizarre dramatis personae are part of a desperate and perhaps doomed search for a new vocabulary of representation, a collusion of the public and private with the classical and the contemporary that would soon find its most celebrated expression in the painting *Guernica* (Museo del Prado, Madrid).

EDITIONS: Probably 50 numbered proofs and a certain number of artist proofs, printed by Roger Lacourière.

EXHIBITIONS: Geneva-Paris 1987–8, no. 234, ill. p. 26; Geneva 1988, no. 90, ill. p. 221.

LITERATURE: Baer 1986, no. 573, p. 26; Goeppert 1987, p. 116 (includes detailed bibliography).

Fig. 36 Picasso, *Minotauromachy*, 1935. Etching (first state), 49.6 × 69.3 cm. Musée Picasso, Paris.

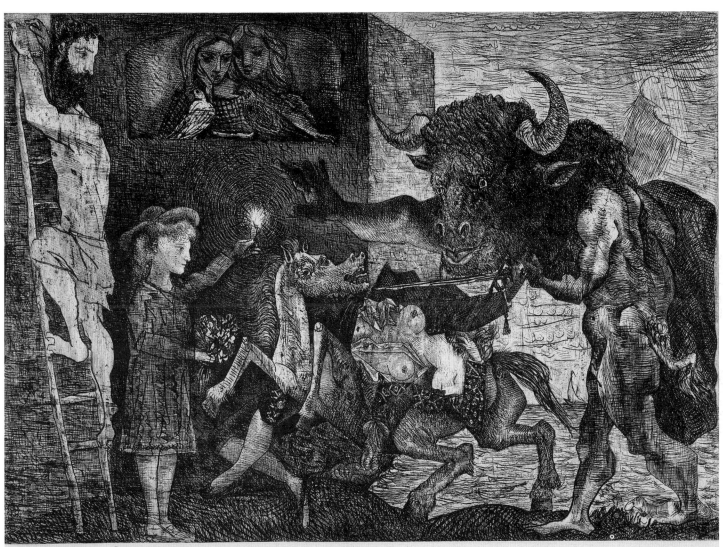

pour mon ami Bergruen
Picasso

Pablo Picasso

57 Head of a Faun
1937

Ink and wax crayon on paper, 27 × 21 cm. Signed and dated lower left: *Picasso/37*

Drawn with a broad and almost casual pen line, *Head of a Faun* is a defiant and disconcerting image. After the finesse of the Vollard Suite and its related studies (see Fig. 35; Cat. no. 55), and the expressive nuances of the recent *Minotauromachy* (Cat. no. 56), this drawing offers little comfort to conventional sensibilities. Even the colour, which appears to have been chosen from every point in the spectrum, is more aggressive than descriptive or ornamental, and the unorthodox medium of wax crayon adds further to its abrasiveness. It is only by relating *Head of a Faun* to other pictures from the same period, such as *Guernica* and *Weeping Woman*, that Picasso's intentions become clear. In the oil painting *Weeping Woman* (Tate Gallery, London) the same arbitrary and violent colours are made to disrupt the grieving woman's face, while in the depicted carnage of *Guernica* linear distortion becomes part of a more general disfigurement. In all three pictures the fragmented language of Cubism enjoys a late revival, though here put to more sinister use.

The faun is one of a number of figures from the classical repertoire which Picasso appropriated and perhaps identified with, using it to personify mischief, lust or licence. In his etching *Faun unveiling a Woman* of 1936, the artist chose a more poised and elegant version of the creature, shown as it disturbs the sleep of a voluptuous female nude. In other scenes of the same period distinctions between the faun and the minotaur become blurred (see Fig. 37), and the implicit threat of the mythological character, which also lurks behind *Head of a Faun*, is spelt out.

PROVENANCE: Jean Paterno, Paris; Jean Planque, Morges.

EXHIBITIONS: Frankfurt-Hamburg 1965, no. 79, ill.; Tübingen-Düsseldorf 1986, no. 164 (see Spies 1986, below); Geneva 1988, no. 91, ill. p. 223.

LITERATURE: Spies 1986, no. 164, ill.

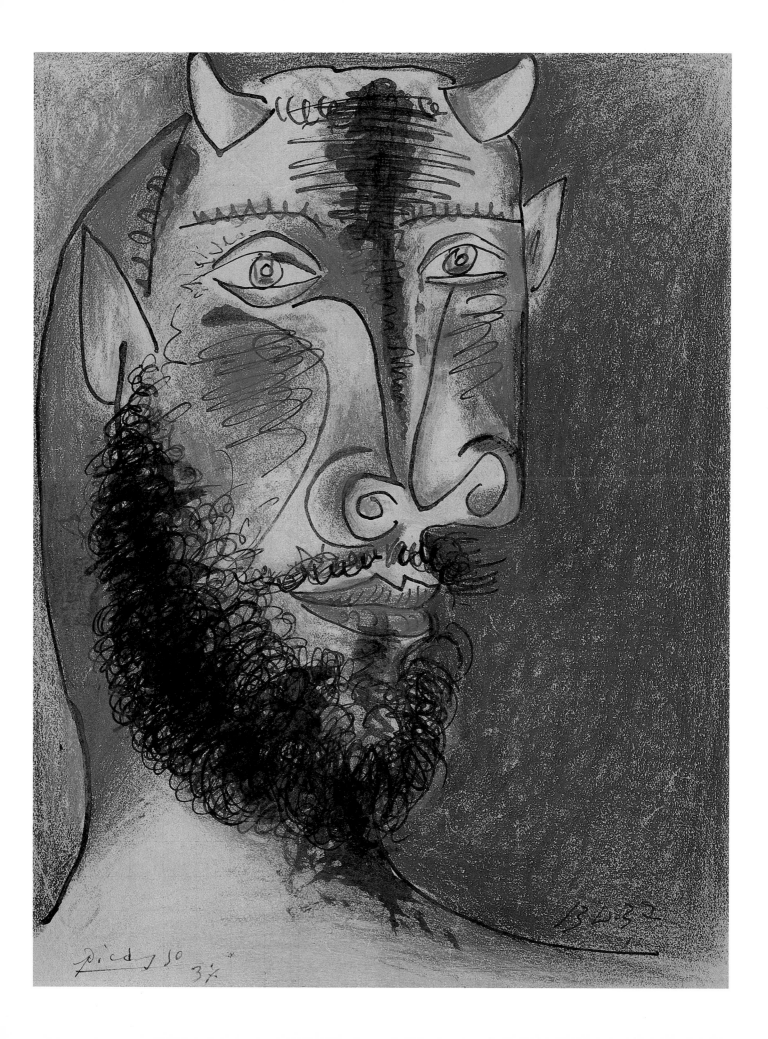

Picasso 50
3/5

Pablo Picasso

58 The Circus Horse
1937

Black ink and pastel on paper, 29 × 43 cm. Signed and dated lower left: *Picasso/23 octobre/37*; dated upper right: *octobre 37*

By June 1937 Picasso had completed his massive painting *Guernica*, which was prompted by the aerial bombardment of the Spanish town of Guernica by pro-Franco forces. In this celebrated picture the artist attempted to give a larger and more public meaning to some of the emblems from his private vocabulary, such as the stricken child, the eviscerated horse and the bellowing bull. In this sense at least the painting was a conflation of the personal and the political, a howl of outrage at the human condition as well as an urgent response to his own times. From the early 1930s Picasso had increasingly explored the darker side of his experience and his imagination, making sombre variations on new subjects, such as the Crucifixion, and returning with unprecedented ferocity to certain earlier themes, such as the corrida. Where a study of the previous decade, such as *Bullfight* (Cat. no. 52), might be almost clinical in its depiction of violence, the new paintings and drawings were often dramatically coloured, impatiently rendered and explicit in their savagery. *The Circus Horse*, though ostensibly concerned with a more innocent subject, is closely related to the subject of the bullring, and certainly conforms to such studies in execution and emphasis.

The Circus Horse has an unusually rich surface which tells us much about its evolution as an image. Reversing his normal sequence of operations, Picasso appears to have begun by laying down hazily defined areas of colour, using patches of blue and red pastel to indicate the horse and its keeper. Working over these areas, pen and ink were then used to draw in the outlines and features, and to elaborate the modelling on the horse's body. Finally, modifications to the position of the horse's head were reinforced with swathes of black ink, encouraging Picasso to strengthen other forms in the composition and even to obliterate earlier features (an overpainted head is visible to the left of the horse). The assertiveness of Picasso's line is reminiscent of his printmaking activity earlier in the decade, and certain techniques, such as crosshatching, seem to have been borrowed directly from that medium. The exuberant calligraphy which describes the horse, however, has a life of its own. In a number of contemporary works Picasso used penstrokes in an ornamental and fantastic fashion, suggesting a mannered revival of the Cubist vocabulary (Fig. 37).

PROVENANCE: Paul Rosenberg, New York.

EXHIBITIONS: Paris 1956, pl. 14; Arles 1957, no. 53; Kassel 1964, no. 5, p. 187, ill.; Frankfurt-Hamburg 1965, no. 81, ill.; Fort Worth 1967, no. 194; New York 1980, p. 332, ill.; Tübingen-Düsseldorf 1986, no. 168 (see Spies 1986, below); Geneva 1988, no. 92, ill. p. 225.

LITERATURE: Zervos 1949, no. 136; Zervos 1949–86, vol. IX, no. 83, ill. pp. 34, 102; Sabartés 1957, pp. 38–9, ill.; Jardot 1959, ill. p. 88; Spies 1986, no. 168, ill.

Fig. 37 Picasso, *Minotaur, Horse and Bird*, 1936. Gouache, watercolour and ink, 44.3 × 54.2 cm. Musée Picasso, Paris.

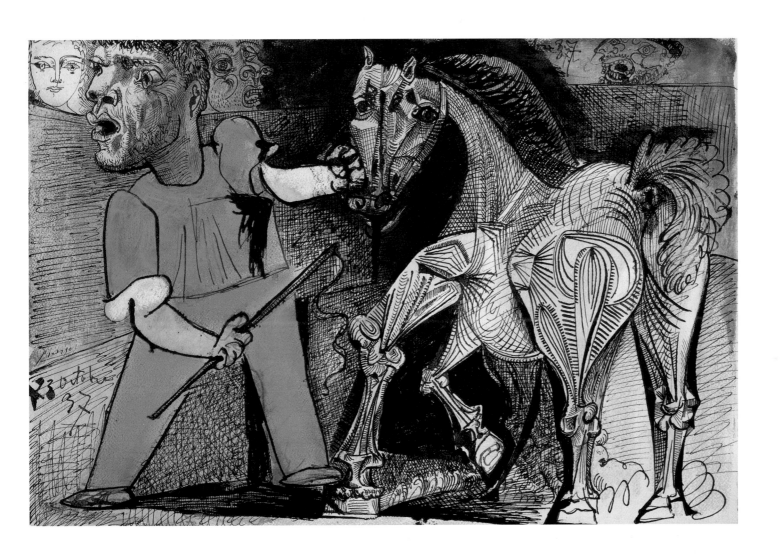

Pablo Picasso

59 Portrait of Nusch
1937

Oil on canvas, 55 × 46 cm. Signed and dated lower left: *Picasso 37*

Nusch Eluard and her husband Paul were among Picasso's closest friends in the later part of his career. They met in the mid-1930s, at a time when Picasso was closely involved with the Surrealist poets and had himself written and illustrated a number of inventive texts. In 1936 Picasso made a series of etchings to accompany two books of Paul Eluard's poetry, *La Barre d'appui* and *Les Yeux Fertiles*, in some cases intertwining his own designs with the handwritten words of the poem – by implication expressing an unusual sympathy between artist and writer. One of Picasso's illustrations also included a portrait of Nusch, whose alert, bird-like features had fascinated him from the beginning of their friendship. Famously beautiful, Nusch was the subject of several portraits by Picasso, often recognisable by her dark, tightly curled hair, her delicate neck and an assortment of curious and sometimes comical hats.

In the summer of 1937 Nusch and Paul Eluard joined Picasso and his new companion Dora Maar for an extended stay at Mougins, near Cannes. Other visitors came and went, and have described the events that took place, the discussions of recent developments in the Spanish Civil War, the open-air lunches at which Picasso and Eluard clowned and entertained the company, and the solitary painting routine adopted by Picasso. Roland Penrose remembers how the artist would emerge from his makeshift studio announcing that he had painted a portrait of one of the company – it might be yet another study of Dora Maar, Eluard depicted as a peasant, or a canvas such as *Portrait of Nusch*. Behind many of these portraits lay what Penrose called a 'diabolical playfulness' – a juxtaposition of the tension and outrage that had recently found expression in *Guernica* with Picasso's irrepressible delight in the paradoxes of resemblance.

Painted from memory, *Portrait of Nusch* shows evidence of the pictorial improvisation and almost violent handling that typify Picasso's canvases at this period. The background was originally dark brown, while the face appears to have been outlined in scarlet; working over these areas in thick white and blue paint, Picasso transformed the composition, allowing dribbles and smears of colour to add to the surface vitality. With his characteristic blend of wit and subtle observation, Picasso then summarised the sitter's face in a few bold lines, combining shadows, dislocated features and entirely arbitrary colours in an image that is both irreverent and endearing.

PROVENANCE: Paul Eluard, Paris; Paul Kantor, Beverly Hills, California.

EXHIBITIONS: London 1960, no. 150, p. 48, pl. 33g; Paris 1982–3 (unnumbered); Geneva 1988, no. 93, ill. p. 227.

LITERATURE: Fierens 1959, ill. p. 49; Penrose 1961, ill. p. 19; Greenspan 1985, ill. p. 111.

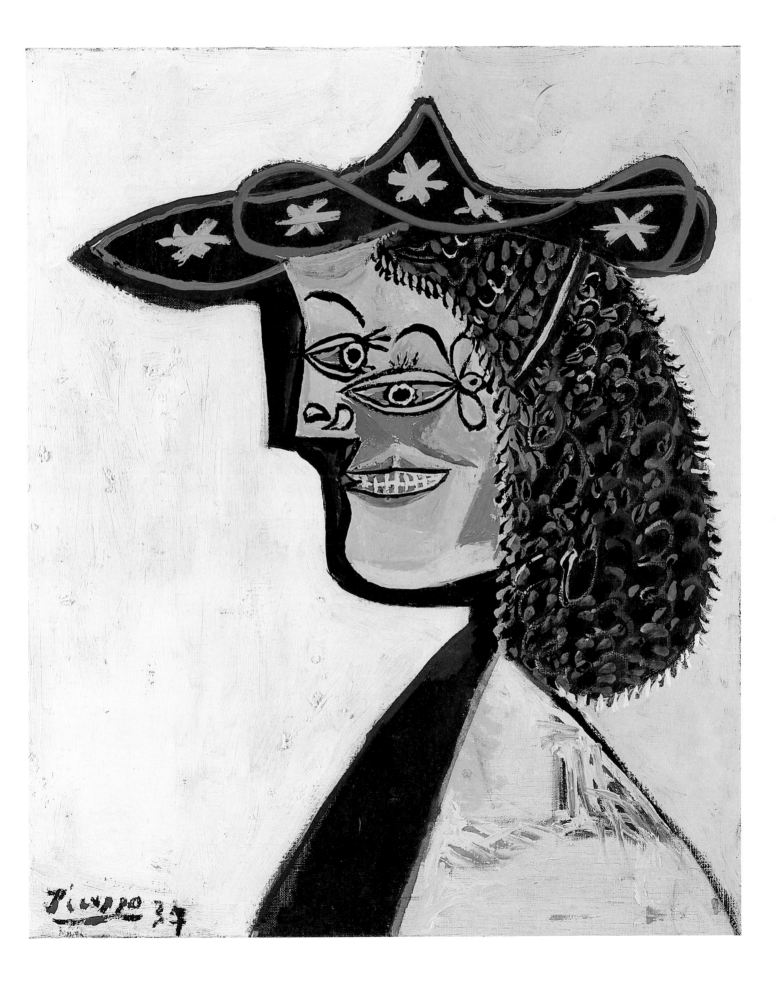

Pablo Picasso

60 Woman with a Hat
1938

Pastel, charcoal and Indian ink on paper, 76.5 × 56.2 cm. Dated lower left: *28.4.38*

The date in the lower left-hand corner of this drawing links it with a wider group of studies, many of them based on Picasso's mistress Dora Maar, and many involving similar technical experiments. The day before he finished the picture, Picasso signed and dated another portrait of a woman, similarly crowned with an elaborate hat but rigidly posed against a wooden chair. In this earlier drawing, which is also executed in pen and pastel, decorative striations cover face, hair, torso and arms, and are even extended, cobweb-like, into the surrounding space. The day after completing *Woman with a Hat*, Picasso made a third image of his model, this time seen full length, almost engulfed by a richly patterned chair and an obsessively decorated picture surface. Together, this group of drawings shows the distinctive sequential working of Picasso's imagination, as well as the constructive relationship between his imagery and his chosen media. The incised, contour-like marks on the woman's face in the present drawing, which also occur in *The Circus Horse* of the previous year (Cat. no. 58), were soon to disappear from his repertoire, but not before he had shown the versatility of their application. In other contemporary works Picasso used these striations and basketwork textures for decorative, sculptural and even comic effect, in contrast to their unexpected elegance in an image such as *Woman with a Hat*.

The combination of indian ink and pastel is highly unconventional, not only in a historical sense but even among the notorious technical acrobatics of Picasso's later career. In this drawing most of the pen lines on face and hat were added at a late stage, over the layers of pastel and strokes of charcoal. The partial transparency of the pastel surface allows us to glimpse a previous stage in the image, in which earlier charcoal and pen lines described a necklace at the woman's throat, a fringe on her forehead and a number of variations in her features. Most surprising of all was the original hat, which was clearly rectilinear in structure and extended behind the present head before it was obliterated by its curvacious successor. Alternating line and colour, Picasso has built up a dense web of forms, textures and surface activity that is both independent and descriptive of the subject.

PROVENANCE: Morton D. May, St Louis; Mrs Willard Waldheim, St Louis; Knoedler and Co., New York; Marlborough-Gerson Gallery, New York; Mrs Martin Goodman, New York.

EXHIBITIONS: London 1962, no. 49.

LITERATURE: Zervos 1949–86, vol. IX, no. 143.

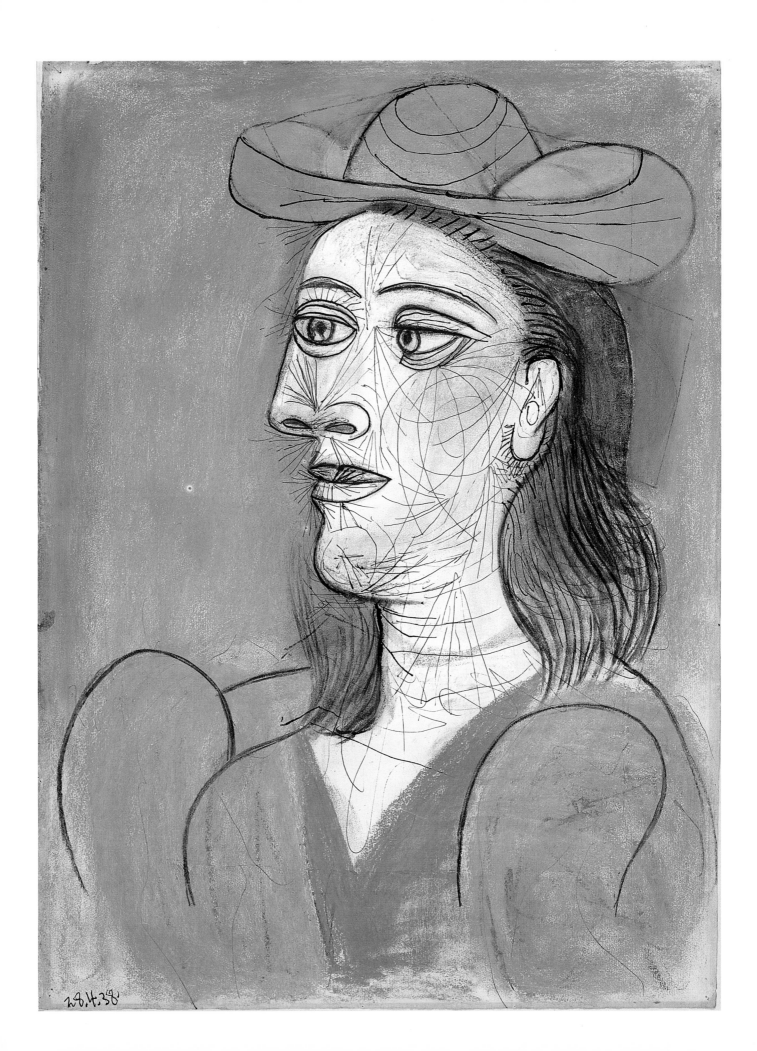

Pablo Picasso

61 Reclining Female Nude
1938

Black ink and gouache on paper, 26 × 34 cm. Signed and dated lower left: *Picasso/28.12.38*; on verso: *'Bouquet of Flowers'*; inscribed: *Pour Mary Callery/d'ici Paris 23 rue la Boétie/le 18 juin de l'an 1941/Avec les meilleurs souvenirs joints/Picasso*

A large proportion of Picasso's subject matter in the 1930s was devoted to the female figure, and often reflected the shifting and sometimes turbulent nature of his private life. A variety of attempts have been made to reconstruct the dependence of Picasso's art on his relationship with women, but all of them acknowledge that his pictures were used to dramatise, and perhaps exorcise, his current entanglements. Each of the women with whom Picasso was involved became the subject of portraits, nude studies and exercises in fantasy, and each acquired her own pictorial identity. The elegant but remote posture of his wife Olga was gradually replaced by the sensuous, oval-faced Marie-Thérèse, while in the late 1930s the appearance of a darker, more alert countenance marked the ascendancy of Dora Maar. Whether painting female companions or friends, figures seen on the beach or in his imagination, Picasso increasingly explored the extremes of sensation and style. His depicted women could be monumental, as in *The Sculptor and his Statue* (Cat. no. 55), or comical, as in *Portrait of Nusch* (Cat. no. 59), but they might also be anguished, grotesque and threatening.

Reclining Female Nude was begun as a pen drawing, the artist building up his composition with outline, crosshatching and washes of ink applied with a brush. White paint was then superimposed on much of this preliminary work, and some final strokes of the pen gave increased definition to the figure's breasts, arms and head. The choice of monochrome for this image relates it both to *Guernica*, painted in the previous year, and to a number of equally severe compositions of 1938 and 1939, while the subject of the reclining nude reflects an important preoccupation of this period. Working sometimes on a large scale, as in canvases such as *The Farmer's Wife* (Fig. 38), which is also effectively monochromatic, Picasso knowingly invoked one of the time-honoured themes of European painting. In both images Picasso arranged the model in the classic pose of enticement – arms raised behind the head and face angled towards the viewer. At the same time, the angular and unglamorous treatment of the women's bodies appears to mock this same tradition, and the introduction into the large canvas of hen, cockerel and chicks makes explicit its bawdy implications. No such explanation is offered in the case of *Reclining Female Nude*, however, and its suggestive and disconcerting imagery is left to speak for itself. It may also be significant, as Jean Marquis has pointed out, that Picasso himself was confined to bed with severe sciatica at the time this picture was painted.

PROVENANCE: Mary Callery, New York-Paris; Stephen Mazoh, New York.

EXHIBITIONS: Geneva 1988, no. 94, ill. p. 229.

Fig. 38 Picasso, *The Farmer's Wife*, 1938. Charcoal and oil on canvas, 120 × 235 cm. Musée Picasso, Paris.

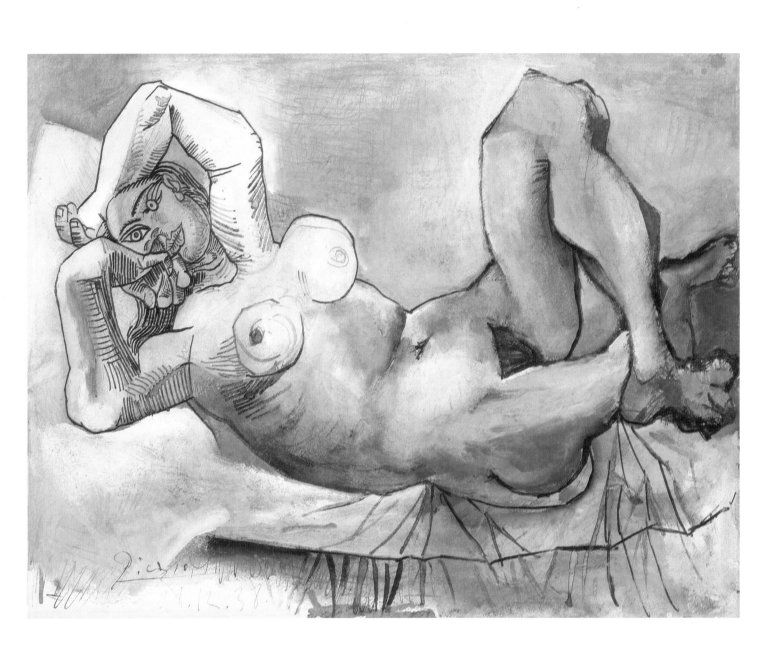

Pablo Picasso

62 The Sailor
1938

Oil on canvas, 60 × 50 cm. Signed and dated upper left: *Picasso/38*

This painting has a close and illuminating relationship with an unfinished work, *The Artist in front of his Canvas* (Fig. 39), that Picasso kept in his own possession. Both paintings show a heavy-jawed male figure whose face combines profile and frontal features, and both depend on extensive and pronounced use of black outline. Certain characteristics, such as the emphatic mouth and the striped sailor's shirt, are common to both, and close examination of *The Sailor* reveals a network of preparatory drawing which is also evident in the unfinished picture. However, while *The Artist in front of his Canvas* is manifestly a self portrait, the same assumption cannot be made of *The Sailor*. Painted at a time when Picasso's portraits were often based on memory, and on whimsical or mischievous references to his friends, *The Sailor* forms part of a sequence of pictures that ranges from the artist's own face to that of Paul Eluard, and from other sailor figures to some more bizarre variants, such as *Man with an Ice Cream Cone* (Musée Picasso, Paris).

The resemblance of *The Sailor* to *The Artist in front of his Canvas* provides an unusual insight into Picasso's working practices at this period. In the unfinished canvas, charcoal lines have been used to explore the position of the figure, leaving traces and shadows where earlier marks have been erased: major changes can be seen, for example, in the artist's collar and in the placing of his arm and palette. In *The Sailor* similar lines are visible under the striped shirt, here rendered in thin black oil paint but possibly begun in charcoal. Both pictures illustrate Picasso's subtle dialogue with the motif, his willingness to combine observation and memory with the structural demands of the picture and to improvise as the painting proceeded. As the artist said in 1935: 'A picture is not thought out and settled beforehand. While it is being done it changes as one's thoughts change. And when it is finished, it still goes on changing, according to the state of mind of whoever is looking at it.'

PROVENANCE: Leigh Block, Chicago; Acquavella Galleries, New York.

EXHIBITIONS: New York 1971, no. 54, p. 64; Washington-Los Angeles 1967, no. 40, ill.; New York 1980, p. 360, ill.; Geneva 1988, no. 95, ill. p. 231.

LITERATURE: Zervos 1949–86, vol. IX, no. 191, ill. p. 91; Sabartés 1946, ill.; Eluard 1944, p. 132, pl. 132.

Fig. 39 Picasso, *The Artist in front of his Canvas*, 1938. Charcoal on canvas, 130 × 94 cm. Musée Picasso, Paris.

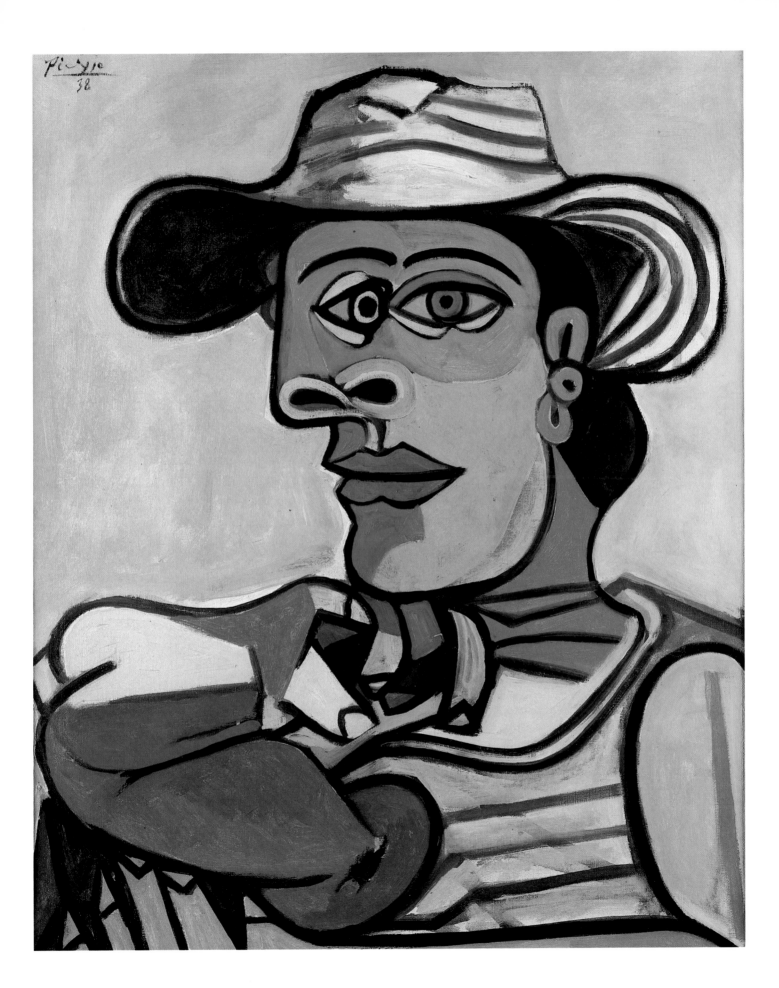

Pablo Picasso

63 The Yellow Sweater
1939

Oil on canvas, 81 × 65 cm.
Dated and signed upper left: *31.10.39/Picasso*; on verso: *Picasso/31.10.39*

During most of the Second World War Picasso continued to live in Paris, working in increasingly difficult conditions and eventually finding himself a symbol of the resilient spirit of the city. In the early months of the war he had attempted to establish himself at Royan, near Bordeaux, but by mid-1940 had returned to the capital and to his friends, pictures and studios. It was probably during one of his visits to Royan that *The Yellow Sweater* was painted, and it is difficult to separate this haunting, austere image from the circumstances of its production. Asked why he had not made paintings of the historic and violent events going on around him, Picasso pointed to canvases such as *The Yellow Sweater* and replied: 'The war is in these pictures.'

This portrait is one of a large number based on Picasso's companion of the war years, Dora Maar, a young Yugoslavian painter and photographer. Always recognisable by her sombre colouring and dark, waving hair, Dora Maar features in other studies in the Berggruen Collection (Cat. nos. 64 and 65). The tensions of this period were compounded for Picasso and his circle by the continued proximity of his former mistress Marie-Thérèse Walter and their daughter Maïa, and by his persistence in painting both Dora and Marie-Thérèse, sometimes within days or even hours of each other. At Royan Picasso had installed both women in the town, and, earlier in the same year, had made a separate picture of each figure, posed in an almost identical composition and painted on the same day. Like so many of Picasso's portraits, these pictures are fraught with private significance, a series of intense configurations of colour and form that document his personal and public allegiances.

The Yellow Sweater was developed from a group of small drawings in a sketchbook kept by Picasso at Royan. In one of these (Fig. 40), the chair-back, the treatment of the sweater and the characteristic rearrangements of the face are anticipated, though the symmetry of the final pose has yet to emerge. For almost two years Picasso had been experimenting with decorative 'basketwork' effects such as that applied to the model's sweater, sometimes extending the same texture to face, hands and background. Here it is used to create contrast, the yellow paint standing out against the cold blues and greys, while its dense texture relieves an otherwise austere and gaunt composition.

PROVENANCE: Paul Rosenberg, New York (inv. no. 23).

EXHIBITIONS: London 1960, no. 160, p. 49, pl. 42c; Vallauris 1961, no. 12; Paris 1966–7[1], no. 189, ill.; Amsterdam 1967, no. 88, ill.; Geneva 1988, no. 97, ill. p. 235.

LITERATURE: Allen 1967, no. 199, p. 90, ill.; *Hommage à Picasso* 1971, ill. p. 123.

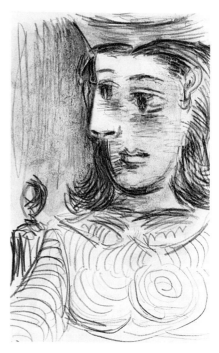

Fig. 40 Picasso, *Study of Dora Maar*, 1939. Graphite, 17 × 11 cm. Musée Picasso, Paris.

Pablo Picasso

64 Woman Seated
1940

Oil, card and wood on cardboard box, 15.5 × 11.5 cm. Dated lower right: *3.2.40*; on verso inscription by Paul Eluard:
Ce bas-relief peint est bien de la main de Pablo Picasso/Paul Eluard/12.1.52

Even in Picasso's most challenging and rigorous work an element of playfulness, whether macabre or childlike, is rarely absent. His sense of humour was legendary, ranging from verbal and visual puns to caricature, disguise and mimicry. Beach parties would often involve games and fancy dress, while meal times would be enlivened with figures and animals improvised from the materials at hand. Much of this activity has left no trace, though a number of the artist's friends took pains to preserve the decorated matchboxes, paper sculptures and ornamented napkins that survived the dining process. In their turn, these ephemeral objects appear to have fired Picasso's imagination, leading him to more substantial, but no less improvised, works on a larger scale and in more durable materials.

Woman Seated seems to fall halfway between these two extremes. Constructed on the base of a cardboard box, whose inscription tells us that it once contained a hundred cigarettes (Picasso was an inveterate smoker), this small relief sculpture was conjured up from pieces of card and a length of wood, possibly from a paintbrush handle. By sticking some of these elements to the box, and by folding and overlapping the card, Picasso has described the principal forms of woman and chair, while his painted additions echo and complement the constructed elements. The wit and ingenuity of the work are self-evident, but the paradoxical seriousness with which Picasso approached it is visible in a number of adjustments to the painted surface and several changes in colour (some of the white areas, for example, were originally green). The artist pursued the same motif in three further variations, made from similar materials on successive days in early February 1940. Preserved today in the Musée Picasso, Paris, these miniature reliefs of string, cardboard and paint continue his investigations into one of the most persistent themes of the period. Like *The Yellow Sweater* and *Portrait of a Woman* (Cat. nos. 63 and 65), *Woman Seated* was one of a series of female portraits painted at Royan during the early months of the war. It may have been based on Dora Maar, his companion at Royan, or on Nusch Eluard, whose husband Paul became its first owner.

PROVENANCE: Paul Eluard, Paris; Pierre Lundholm, Stockholm.

EXHIBITIONS: Humlebaek 1968, no. 49; Geneva 1988, no. 98, ill. p. 237.

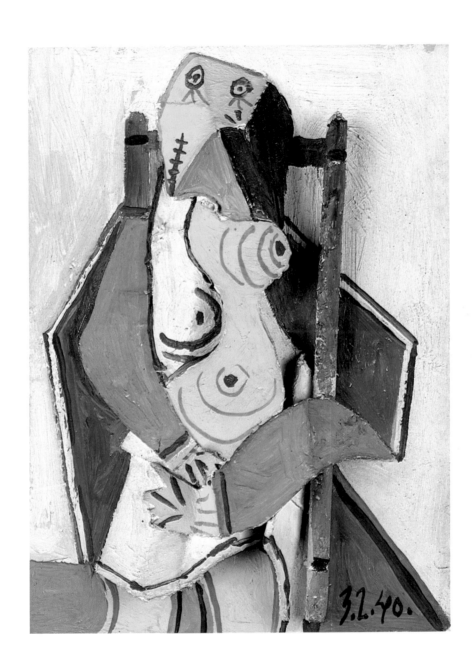

Pablo Picasso

65 Portrait of a Woman
1940

Oil on paper, laid on canvas, 64 × 46 cm. Signed and dated upper left: *Picasso 11.6.40*

One of Picasso's most familiar, but still disconcerting, strategies of representation was to combine the acutely observed with the utterly fantastic. In *Portrait of a Woman* the distinctively dark hair of his mistress Dora Maar is rendered with extraordinary fidelity as it rises from her scalp, curves away from her forehead and falls elegantly to her shoulders. The woman's hands and arms, though more rudimentary in execution, are also essentially plausible, and the general disposition of light and colour is that of the traditional portrait. But at the centre of his picture Picasso has suddenly taken leave of these same traditions, opening out the model's face as if it were hinged and turning profile and nose in opposite directions. With a licence that ultimately derives from Cubism, the artist has rearranged the evidence of his senses and his memory, though here in a selective fashion. While the systematic incorporation of different viewpoints in early Cubism has been much overstated, in *Portrait of a Woman* there is no such pretension. In this picture the vestiges of Cubist language have been used for expressive effect, confronting the viewer with both visual deformity and pictorial illusion. As Picasso himself said: 'We all know that art is not truth. Art is a lie that makes us realise truth.'

Picasso's habit of dating most of his drawings, paintings and sketchbooks enables us to reconstruct with unusual precision the sequences and patterns of his work. Completed on 11 June 1940, *Portrait of a Woman* forms part of a small group of studies of identical size, painted on successive days at Royan, near Bordeaux. A portrait of the same model, her face grimacing wildly and flattened into an angular pattern, is dated 10 June, and on the same day that he painted *Portrait of a Woman* Picasso made a third study of this subject, now twisted into the grotesque form of a skull. Of the group, *Portrait of a Woman* is the least distorted, though its subtle dialogue with realism may ultimately make it the most disturbing. The picture appears to have been painted directly and rapidly, and was originally executed in oil paint on paper, and only later attached to canvas.

PROVENANCE: Frank Morini, New York.

LITERATURE: Zervos 1949–86, vol. X, no. 176.

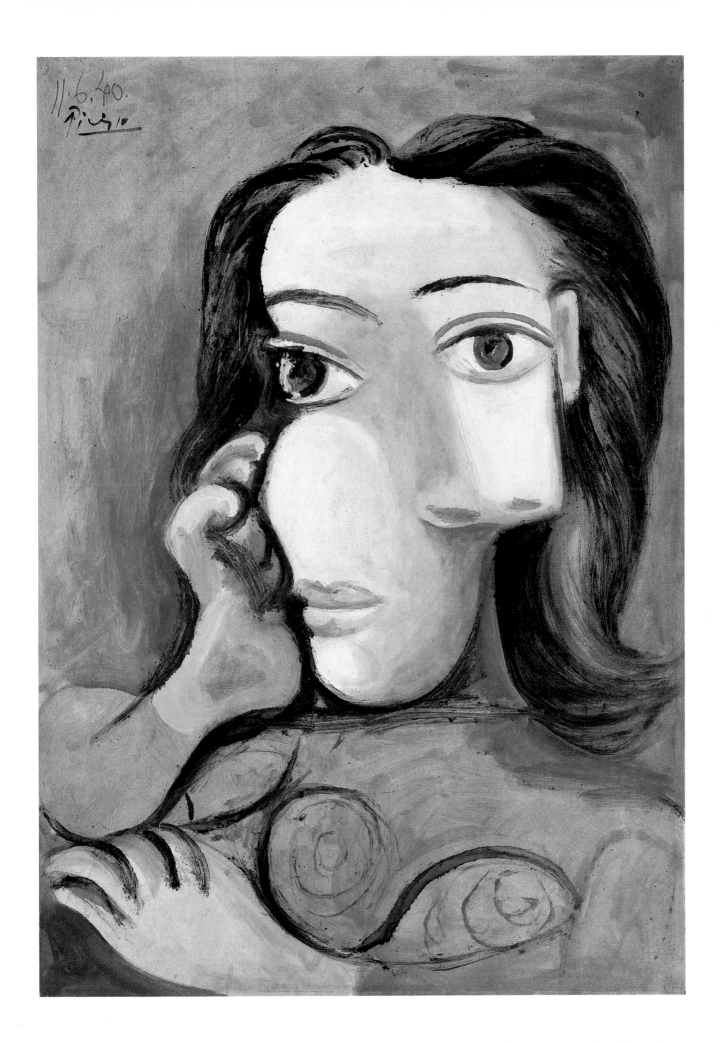

Pablo Picasso

66 Man Sleeping
1942

Black ink and wash on paper, 50 × 65 cm. Signed and dated lower right: *Picasso/13.D.42*

The subject of the sleeping figure watched over by his or her companion is a recurrent theme in Picasso's mid-career. In the early 1920s a group of studies with marked similarities to *Man Sleeping* shows a recumbent male figure and a clothed woman on the beach, at times joined by a child who may well represent Picasso's young son Paolo. Subsequent variations reversed the roles of man and woman, and explored a number of real and imaginary implications in their juxtaposition. A decade later Picasso used several plates in the Vollard Suite to develop the theme, often defining the male figure as an artist and his companion as a lover, model or muse. Despite differences in the features of the protagonists, there can be little doubt that Picasso identified himself with the depicted artist and saw the series as an extended reflection on sexuality and its relation to his own creativity. In *Man Sleeping*, for example, the woman's features are reminiscent of those of his mistress Dora Maar, while the dormant male is marked out by his beard as the stereotypical artist, and therefore as Picasso himself. By now in his early sixties, Picasso would represent himself in a variety of guises, sometimes as a gnarled and lecherous sculptor of antiquity and occasionally even as a monkey. Here, however, he has become the ageless embodiment of creativity, dependent upon and perhaps emasculated by his muse.

During the war years Picasso produced an unusually large number of works in monochrome or subdued colour. Following the shocking greys and blacks of *Guernica*, the cold palette of a work like *Reclining Female Nude* (Cat. no. 61), and even the metallic flesh tones of *The Yellow Sweater* (Cat. no. 63) mark a phase of exceptional austerity in his art. *Man Sleeping* is a virtuoso exercise in this manner, using all the resources of line, tone and texture to indicate the softness of flesh, the play of light and shadow, and the coarser surfaces of wall and bed covering. In certain passages, such as the woman's profile, the delicacy of Picasso's line recalls his own classical phase, while in other areas a gestural, almost casual technique exploits the roughness of the paper and the chance encounters of ink and wash. As so often in Picasso's work, this is not an isolated image but one of a group of variations, all made within a few days of each other and variously exploring nuances of composition and style.

PROVENANCE: Paul Eluard.

EXHIBITIONS: Paris 1956, pl. 19; Hamburg 1959, no. 249, pl. 27; Stuttgart 1960, no. 120, pl. 15; Frankfurt-Hamburg 1965, no. 95, ill; Geneva 1988, no. 99, ill. p. 239.

LITERATURE: Zervos 1949–86, vol. XII, no. 185, p. 94, ill.; Eluard 1944, pl. 104; Jardot 1959, pl. 110; Leymarie 1971, p. 9, ill.; Gateau 1983, pp. 76, 344.

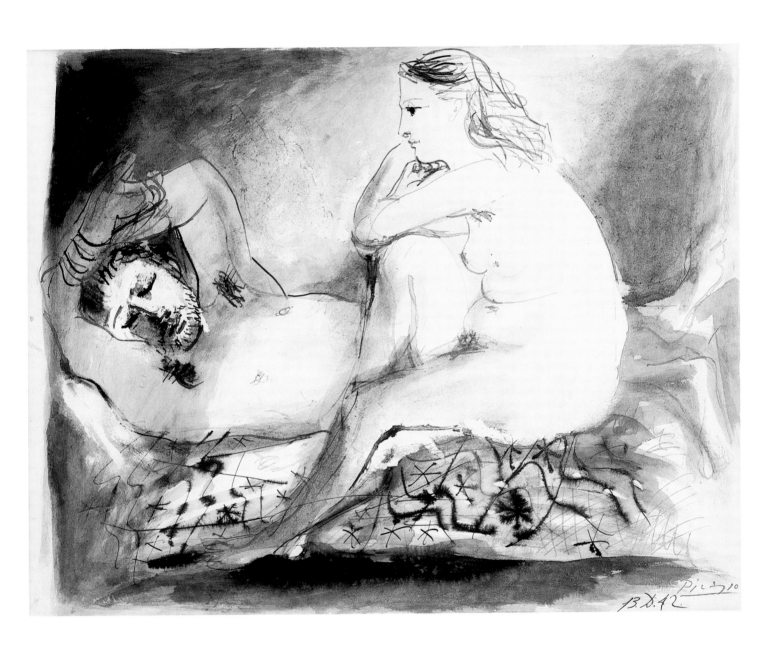

Pablo Picasso

67 The Crane
1952

Painted bronze, height 75 cm, base 43 × 29 cm. Seal: *Cire perdue C. Valsuani*

The Crane belongs to a large group of sculptures made by Picasso in the years following the war, in a new studio at Vallauris, near Antibes. Working with clay, plaster, wood and found objects, the artist conjured up a private menagerie of probable and improbable creatures, including goats and monkeys, birds and bulls, children and centaurs. Some were constructed from conventional materials such as clay and plaster, and subsequently cast into bronze, while others were improvised from locally made ceramics. Most famously, it was at this period that Picasso perfected another technique, that of using domestic objects in unexpected juxtapositions to suggest witty variations of figures and animals. During the war, he had joined together a bicycle saddle and handlebars to make his celebrated *Bull's Head*, and just before he executed *The Crane* he used a similar conceit in *Goat Skull and Bottle* (Fig. 41), here adding a cluster of nails to evoke the light of a candle. In *The Crane* an exceptionally fine equilibrium is achieved between the subject depicted and the objects used in its construction. The shovel that forms the wings is self-evidently a shovel, while precisely describing the plumage of the bird; similarly, the foot is both fork and claw, while the wickerwork neck supports a conjunction of tap, nuts and spike, which is also a perfectly bird-like head.

From the earliest years of Cubism, Picasso had delighted in confrontations between the real and the fictitious, introducing commonplace objects into his painted collages and even into certain sculptures (Cat. no. 40). At times this playfulness became both convoluted and disconcerting, as in his transformation of a metal sheet into the crumpled-looking *Packet of Tobacco* (Musée Picasso, Paris) and his later reworking of a cigarette box into a sculptured figure (Cat. no. 64). While humour is an undervalued feature of many of these works, it is often combined with an abrasive and imaginative challenge to the nature of perception. In *The Crane* this challenge has itself been transformed: now it is the acute realism of the final image that engages us, as the bizarre collection of abandoned metal so accurately mirrors the awkward elegance of this bird. Despite their light-heartedness, Picasso took some pains with these sculptures. The original, which was kept by the artist, is ingeniously held together with wire and plaster, and was subsequently made into an edition of four bronze casts, each of which was painted in a different combination of bars and stripes.

EDITIONS: 4 casts, variously painted.

PROVENANCE: Harold Diamond, New York.

EXHIBITIONS: London 1967, no. 119; Berlin-Düsseldorf 1983–4, no. 461c (see Spies 1983, below); Geneva 1988, no. 101, ill. p. 243.

LITERATURE: Spies 1983, no. 461c, p. 355, ill.

Fig. 41 Picasso, *Goat Skull and Bottle*, 1951–4. Painted bronze, 78.8 × 95.3 × 54.5 cm. The Museum of Modern Art, New York.

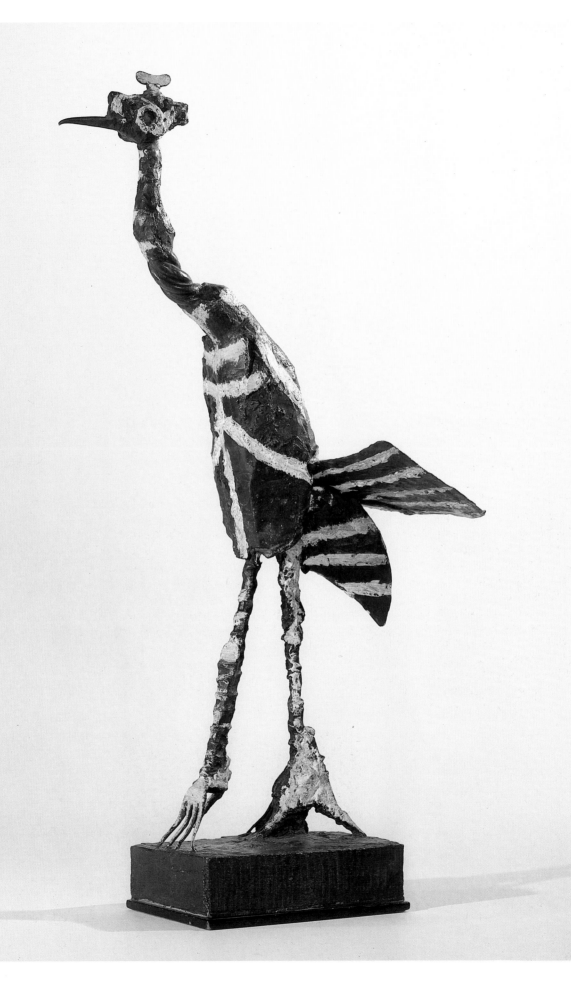

Pablo Picasso

68 Reclining Nude
1969

Black chalk on paper, 65.5 × 50.5 cm. Signed and dated upper left: *Picasso 11.7.69*

This drawing was made when Picasso was 87 years of age and represents one of the most familiar subjects of his last years. The reclining, naked and flagrantly displayed female figure appears in hundreds of drawings and paintings and in a variety of suggestive contexts, ranging from the harem to the painter's studio, and from the erotic fantasy to the Old Master transcription. Though Picasso had been preoccupied with the female form throughout his career and had produced explicitly sexual studies as a young man, little in his earlier imagery approaches the uninhibited and cheerful abandon of these late works. Not only does all sense of propriety disappear, but the means by which the images are made become as sensuous and unconstrained as their subject matter. Paint is allowed to splatter and dribble, colour glows with a luminous brightness and lines and curves perform indulgent arabesques. Whether wish fulfilment or nostalgic reminiscence, these final statements on a lifelong theme are characteristically defiant.

Reclining Nude is executed in dense black chalk on a softly textured paper, the artist using his fingers to soften the outlines and model the forms. Like many of Picasso's later works it was drawn with exceptional directness and without underdrawing or later alterations to the composition. Despite its size and the addition of tonal modelling, it is an emphatically linear image which can be associated with a series of contemporary etchings and line drawings of similar subjects. Many of these are overtly erotic, and a number take the form of inventive and irreverent variations on the art of the past. In later life Picasso produced many hundreds of reworkings of pictures by Poussin, Manet, Velázquez and others, often projecting his own fantasies onto their works or making improvisations on a single figure that had captured his imagination. *Reclining Nude* relates to a group of brothel scenes derived from Degas, to etchings based on Ingres and Rembrandt, and to a pose taken from Delacroix's *Women of Algiers*, 1834 (Musée du Louvre, Paris). In a typical sequence of permutations, Picasso divested the woman of her clothes, twisted her body into new and almost unrecognisable configurations, and finally translated her into a familiar and domestic context. At the end of his long career, Picasso had returned to one of the definitive subjects of the Western tradition, his draughtsmanship, his wit and his passion undiminished by a lifetime's iconoclasm.

PROVENANCE: Galerie Leiris, Paris; Norman Granz.

EXHIBITIONS: Avignon 1970.

LITERATURE: Zervos 1949–86, vol. XXXI, no. 311.

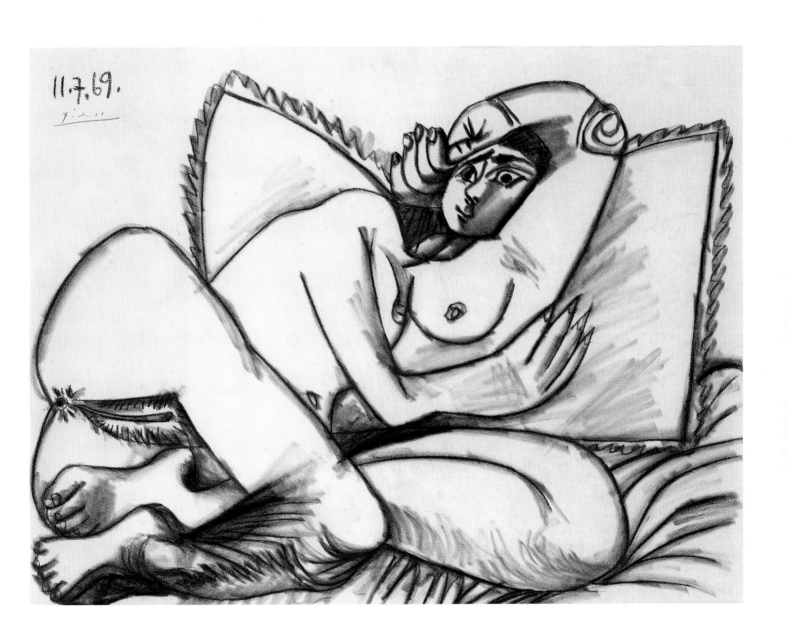

Joan Miró

1893–1983

Joan Miró

69 Dialogue of Insects
1924–5

Oil on canvas, 74 × 93 cm. Signed and dated lower right: *Miró./1924–25*; on verso: *Joan Miró/Dialogue d'Insectes/1924–25*

In 1919 Joan Miró left his native Catalonia and made his first visit to Paris. His earlier work had shown a familiarity with Cubism, with the bright colours and decorative forms of Matisse, and with the primitive traditions of his own region, but he was soon to join the circle of poets and painters in the Dada, and later Surrealist movements. Miró also met and befriended Picasso, and undoubtedly became involved in a mutual exchange of imagery and procedures with his fellow Spaniard. During these years Miró's own work underwent the most radical transformation of his career, from the representational manner of his youthful canvases to the diagrammatic, almost abstract pictographs of his maturity. A picture such as *The Farm*, 1921–2 (private collection, New York), which was begun in 1921 in Spain and finished in Paris the following year, was a stylised but entirely recognisable scene of animals, buildings and imaginative foliage set against a clear and uninterrupted blue sky. Within a year, *The Tilled Field*, 1923–4 (private collection, Pennsylvania), and *Catalan Landscape (the Hunter)* 1923–4 (The Museum of Modern Art, New York) advanced into more equivocal territory, where imaginary creatures and geometric forms shared a new vestigial landscape. As this process continued the orthodox perspective of Miró's earlier pictures gave way to a flat, insistent background of colour, at times still suggestive of an expanse of sky such as that in *The Farm*, but as often a non-naturalistic yellow, green or red.

Dialogue of Insects was painted at a time when the principal elements of Miró's mature art were already in evidence. Here, the simple division of the canvas into two bands of colour still recalls the landscape format, but the flatness of these areas denies the possibility of recession or illusion. Against this background simple lines and curving forms suggest the flora and fauna of an alternative universe, not wholly unrelated to our own but neither familiar enough to be named. Some of these forms, such as the tapering black triangle that culminates in an ear of wheat, and the white, moon-like shape above it, are modified survivors of Miró's earlier imagery, while others point to the graphic inventiveness of his later years. As in the work of a number of artists associated with Surrealism, many of these forms seem spontaneously or arbitrarily fashioned, the product of free invention on the canvas or of improvised drawing procedures. On the other hand, there is no doubt that the creatures in Miró's visual menagerie had a private significance for him, and it is noticeable that in other pictures of this period, such as *Dog barking at the Moon*, 1926 (Philadelphia Museum of Art), several of the elements in *Dialogue of Insects* make a reappearance.

PROVENANCE: Mme Pierre Loeb, Paris.

EXHIBITIONS: Paris 1925; London-Zurich 1964, no. 40, pl. 8 b; Tokyo-Kyoto 1966, no. 24, ill. p. 43; Saint-Paul-de-Vence 1971, no. 641, ill.; Paris 1974, no. 20, p. 13, ill. pp. 41, 115; Geneva 1988, no. 60, ill. p. 159.

LITERATURE: Prévert-Ribemont-Dessaignes 1956, ill. p. 117; Dupin 1961, no. 102, pp. 144–5, ill. p. 493; Penrose 1970, p. 36, ill.; *Miró* 1974, p. 2, ill.; Greenspan 1985, p. 115, ill.

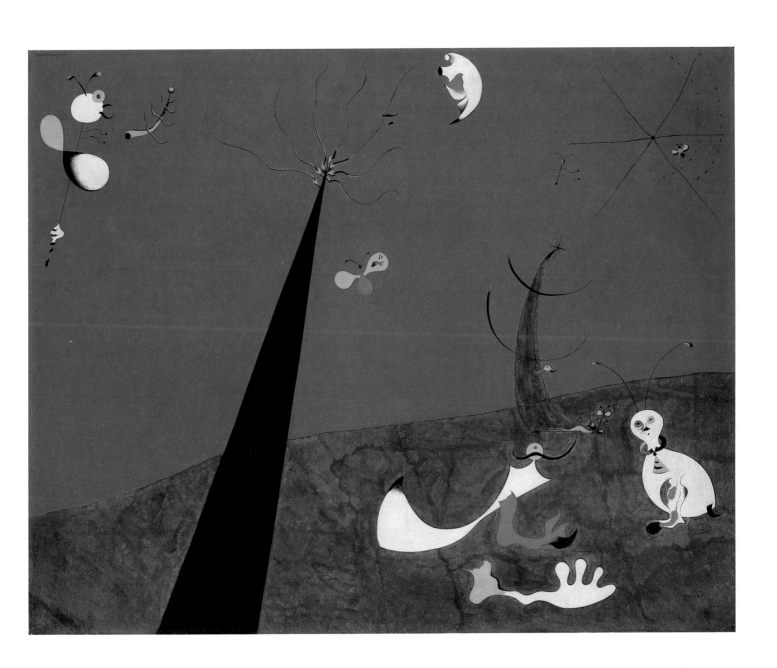

African Art

African Art

70 Bas-relief, Benin

Nigeria, Kingdom of Benin, *c*. 1600. Bronze, height 50 cm

The bronze sculptures of the city of Benin are among the best known and most celebrated works of art from Africa. In 1897, when a British punitive expedition finally subjugated this ancient city state, thousands of objects and sculptures were removed and found their way into museums and collections around the world. However, the compelling blend of naturalistic and stylised motifs in Benin art had long fascinated European traders and missionaries. This relief was one of many plaques attached as decoration to columns in the royal palace. These extraordinary pieces were observed by a Dutch traveller in 1686: '. . . the Palace of the King [of Benin] is a complex of buildings which occupies as much space as the city of Harlem [sic] and is closed up by walls. There are various apartments for ministers of the Prince and beautiful galleries, of which the major part are as large as those of the Exchange in Amsterdam. They are upheld by wooden columns embedded in copper, in which their victories are engraved.'

The panel, which is bronze not copper, was cast using the 'lost wax' technique. The relief – including all the fine detail of the design – would have been modelled in wax, which was then covered with a thick layer of clay. Once dry, the clay mould was heated to melt the wax in the centre. Molten metal was poured into the space left by the 'lost' wax and allowed to cool. Finally the clay mould would have been broken away, leaving the bronze cast.

This piece is of exceptional quality and its patina is beautifully preserved. It appears to represent a ruler, on the left, with two of his servants.

J.P.B.

PROVENANCE: William F. Kaiser, Berkeley (California); Pace Gallery (Bryce Holcombe), New York.

EXHIBITIONS: Berkeley 1967, no. 100, p. 44; Geneva 1988, no. 103, ill. p. 249.

LITERATURE: Bascom 1973, pl. 56, p. 94.

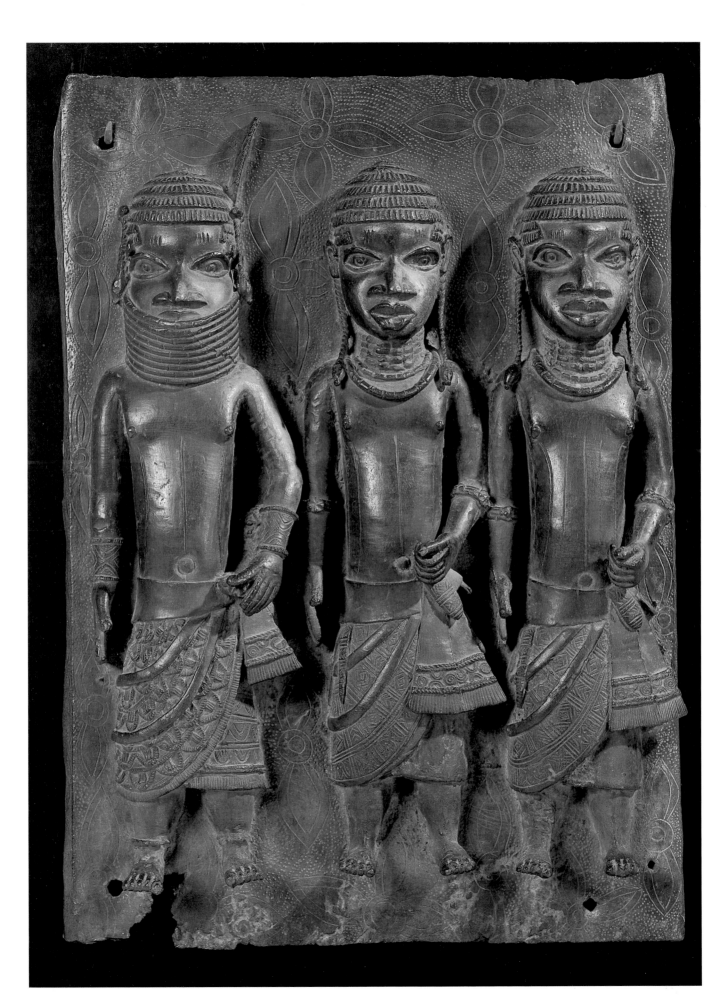

African Art

71 Large Kalao-Pogada Bird

Ivory Coast, Korhogo region, Senufo art. Wood, height 149 cm

This large bird is a kalao (type of hornbill) of the savannas. In the mythology of the Senufo peoples the hornbill is a sacred creature believed to be one of the first inhabitants of the earth. The sculpted image of this bird is a symbol of fertility, and in this case the rounded belly would appear to be an allusion to maternity whereas the exaggeratedly large beak would perhaps suggest a phallic connotation. This ambivalence is intended to express the totality of humanity by way of the fusion of female and male characteristics.

Such sculptures were painted with lozenge and square motifs representing the plumage, but often, as has happened here, the colours have faded or disappeared. The base of the sculpture was sometimes hollowed out so that it could be placed over the head of a dancer and worn during important ceremonies. Smaller birds would probably have been tied to the sculpture by the holes still visible in the wings, their movement enhancing the dramatic impact of the piece as the wearer swayed to the rhythms of a dance.

Large Senufo birds of this type are rare. This one undoubtedly belongs to the small surviving group of old sculptures – which are now often copied by nontraditional Senufo sculptors who produce large quantities of pieces that are artificially aged and sold as 'antiques'.

<div align="right">J.P.B.</div>

PROVENANCE: Pierre Loeb, Paris.

EXHIBITIONS: Paris 1977; Brussels 1979, no. 215, ill.; Geneva 1988, no. 104, ill. p. 251.

LITERATURE: Sale 'Arts primitifs', Paris, Palais d'Orsay, 3 December 1977, no. 12, ill.

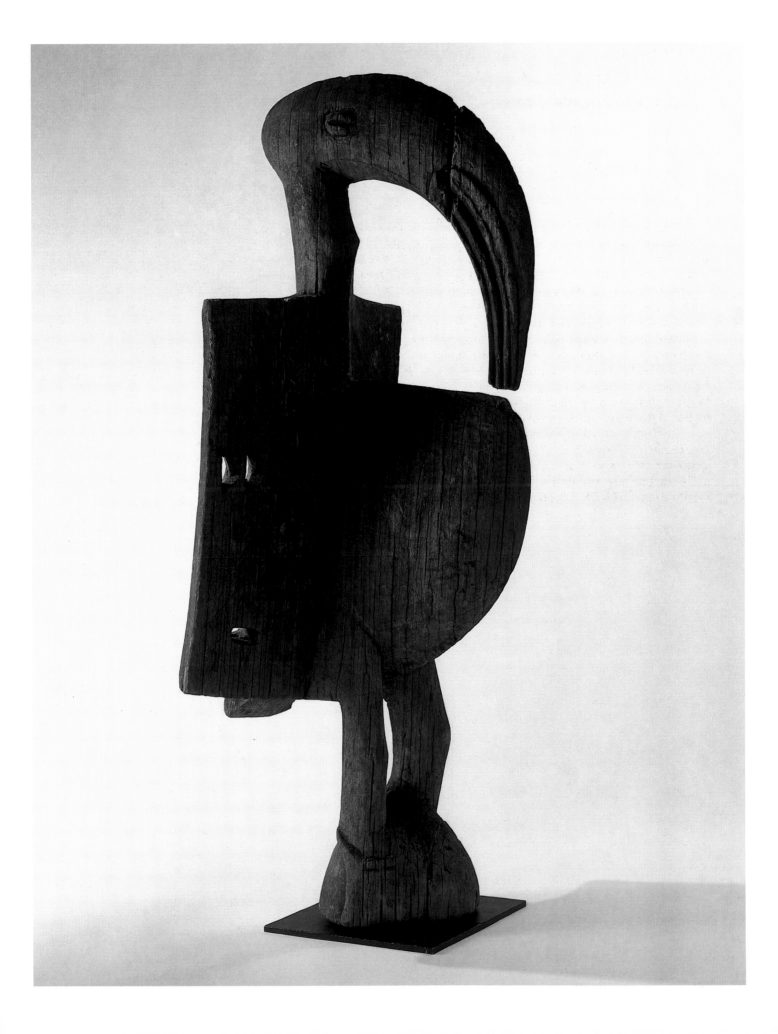

African Art

72 Ancestor Cult Reliquary Figure, Kota

South Kota. Wood laminated with copper, iron and brass, height 75 cm

The Kota peoples inhabit the region of the Ogowe River in the Congo. They have long practised a family ancestor cult, characterised by the conservation of the skulls of the dead of important lineage, by propitiatory sacrifices or reconciliation, and by exhibiting the content of reliquary chests to neophytes during initiation ceremonies. Sculptured figures – simple commemorative effigies – had the role of guardians and of symbolic evocation, and were often placed over the chests containing the treasured relics. These extraordinary reliquary figures were carved in wood which was then covered with brass and copper sheets to form an abstract, two-dimensional image with a highly reflective surface.

The stylistic forms varied depending on the ethnic group, the village and, sometimes, on the artist. It has thus been possible to trace their evolution, even if the 'antiquity' of these objects is somewhat relative: few of such reliquary figures can be dated to before the first half of the nineteenth century.

This figure comes from a southern Kota sub-style in which the convex volume of the face – rounded forehead, double-arched eyebrows, realistic nose and mouth, and contoured cheeks decorated with oblique scars – is contrasted by a flat, very classical 'hairstyle', consisting of a crescent shape beneath which are broad side 'wings' and four ringlets.

L.P.

PROVENANCE: Charles Ratton, Paris; Maurice Pinto, Geneva.

EXHIBITIONS: New York et al. 1984, ill. p. 270; Geneva 1988, no. 205, ill. p. 253.

LITERATURE: Perrois 1979, no. 186.

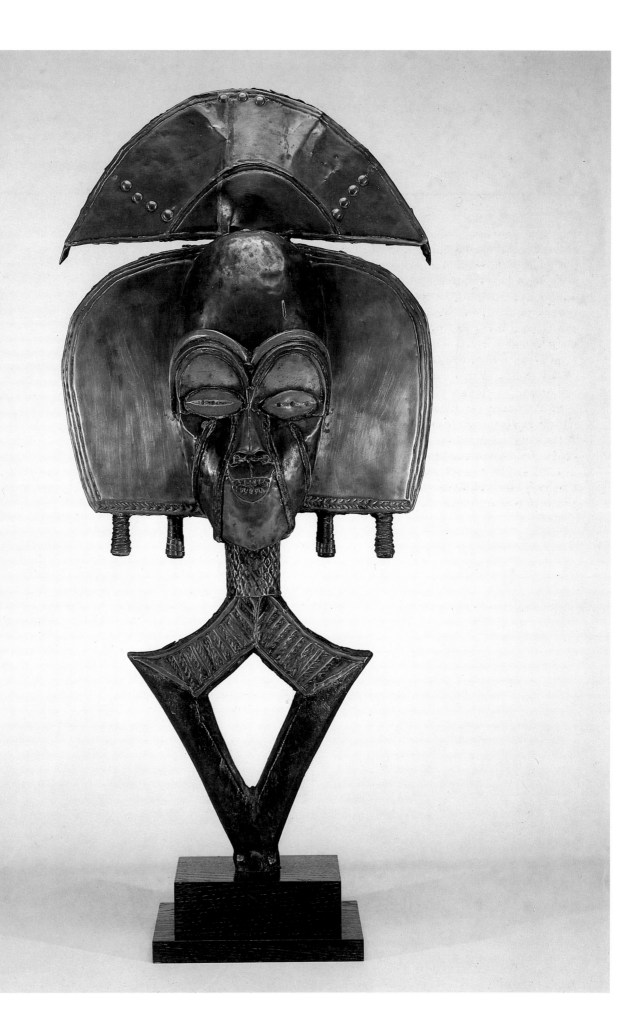

African Art

73 Ijo Spirit Figure

Western Ijo. Wood, height 67.5 cm

Ijo peoples of the Niger Delta sculpt images of ancestors, culture heroes, and water and forest spirits. Such sculpture constitutes the 'seat' or the 'name' of the spiritual entity, allowing humans to 'fix' a supernatural entity in a place and contact its guiding spirit or *teme*.

This piece probably comes from the central or western Ijo and may depict a forest spirit or hero. It incorporates several important Ijo icons: the janus or multi-faced image that evokes the extraordinary, all-seeing qualities of spirits; the medicine gourds suspended around the neck and attached to the arms and torso which convey the spirit's *teme*; and the liquor bottle used in ritual libations.

The strong, angular qualities of Ijo sculpture derive from the human skeleton – the Ijo have a history of warfare and head-taking. Ijo artists explain that the spirits, because of their power and personalities, should be represented in bold forms. Teeth are a prominent motif in Ijo art. Their appearance during childhood is regarded as an auspicious event and their depiction in the sculpting process marks the moment when the spirit enters its representation.

H.J.D.

EXHIBITIONS: Geneva 1988, no. 105, ill. p. 253.

LITERATURE: Horton 1965; Anderson 1983.

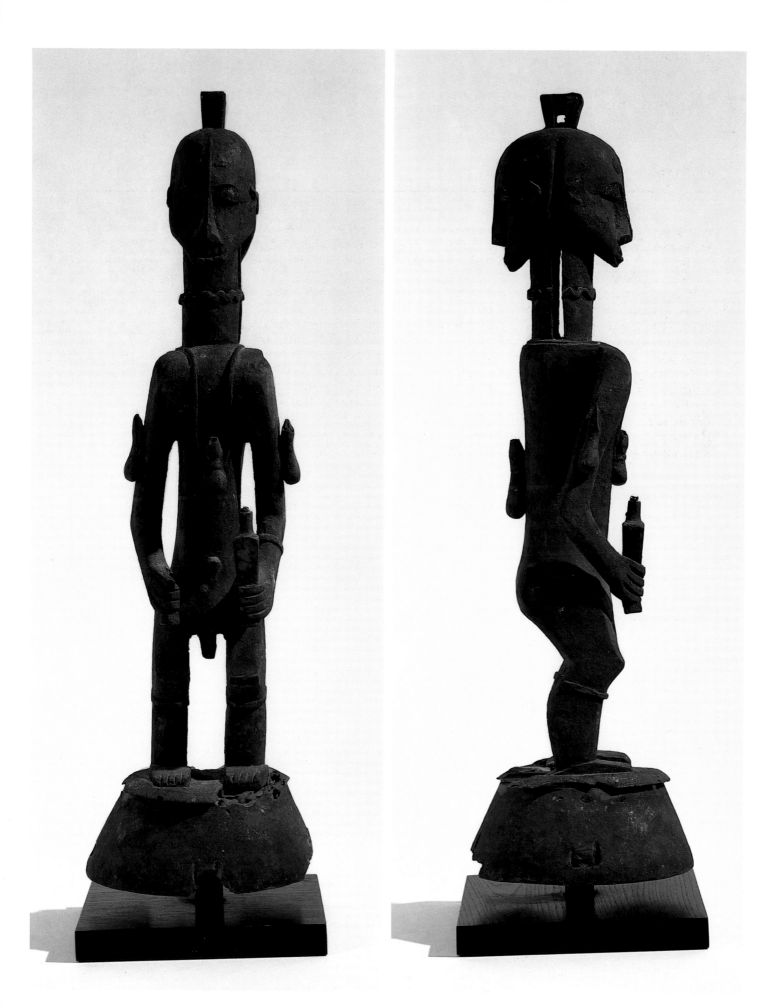

Heinz Berggruen: A Personal View

Camilla Cazalet

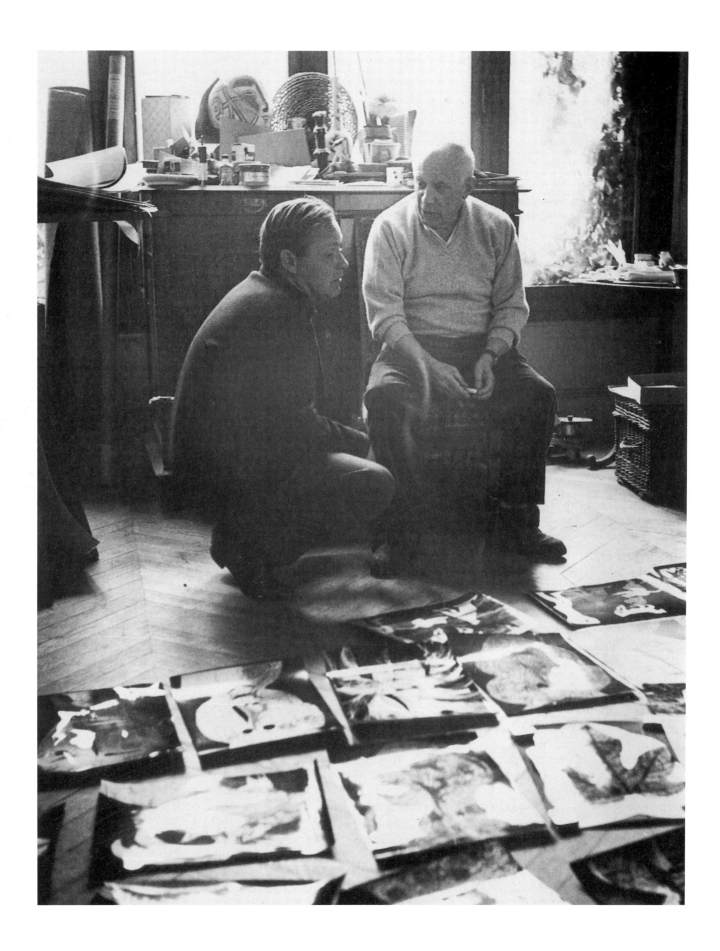

Heinz Berggruen: A Personal View
Camilla Cazalet

Heinz Berggruen is a private, unassuming man of great intelligence and impeccable taste. His perception of quality in every aspect of art and its presentation is refined and discerning, and he is widely regarded as one of the most distinguished dealers and collectors of the post-war years.

A few words on his background. Berggruen was born in Berlin in 1914 where, in the period between the two world wars, he was to experience all the excitement that characterised Berlin's cultural life before the rise of Nazism. After the completion of his school years at the Goethe Gymnasium in Berlin, he went on to study medieval art at the University of Toulouse, obtained a *Licence ès lettres* and returned to his home town to become a correspondent for the prestigious *Frankfurter Zeitung*. A scholarship allowed him to leave for California, where he became a staff member of the *San Francisco Chronicle* and, soon after, Assistant to the Director of the San Francisco Museum of Art. He married and had two children – a son, John (now a successful dealer in San Francisco), and a daughter, Helen. War came and Berggruen, by now an American citizen, joined the US army and served in the States and in Europe. After the collapse of Germany he decided to stay in Europe and moved to Paris to join UNESCO in the Arts Department. This job did not suit him: 'It was most tedious and all we did was write memoranda from one office to another – a horrible bore!' He left, and relinquished financial security for the uncertain fortunes of the art world.

In 1947, aged thirty-three, Berggruen embarked on his new career as a dealer specialising in rare books and portfolios of prints, with no capital, and working from a tiny space at the back of a bookdealer's store in the Place Dauphine. His first transaction was the purchase of a portfolio of Toulouse-Lautrec lithographs, the famous album *Elles*, for the equivalent then of a thousand pounds. Within six months he had been offered double that amount by the great Lautrec collector Ludwig Charell. From that moment his dealing activities escalated. Through the Surrealist poets Eluard, Breton, Aragon and Tristan Tzara he met artists whose works he could buy to sell, and later buy to collect.

In 1950 Berggruen sold his shop in the Place Dauphine to his neighbours Simone Signoret and Yves Montand (who turned it into their kitchen) and bought the gallery at 70 rue de l'Université. He was to remain there for thirty years until his retirement in 1980, when he handed the gallery over to his assistant Antoine Mendiharat. Caroline Annesley, who worked as Berggruen's assistant from 1963 to 1966, recalls the 'attractiveness and charm' of the gallery: 'It was behind an inconspicuous door with only a small *vitrine* on the wall outside in an elegant but not grand street in the 7th arrondissement of Paris. The décor was modern without being hard or severe. A shifting mix of paintings, drawings and prints hung on the walls and in a showcase were some ceramics – mainly by Picasso – and assorted illustrated books.'

In the new gallery the emphasis gradually shifted from rare books to prints, mainly by the masters of the School of Paris: Braque, Chagall, Kandinsky, Laurens, Léger, Matisse, Miró, Picasso – but above all Klee, an exhibition of whose prints were shown in the new gallery in 1952. This was the first exhibition of Klee prints to be held in Paris. From 1952 onwards Berggruen presented three or four exhibitions annually, each accompanied by a catalogue – in a distinctive

Fig. 42 *Above* The young Heinz Berggruen photographed through a windowpane, San Francisco 1939, by John Gutmann.

Fig. 43 *Opposite* Heinz Berggruen in Picasso's atelier at Cannes on the occasion of the publication of *Diurnes*, 1962. Photograph by André Villers.

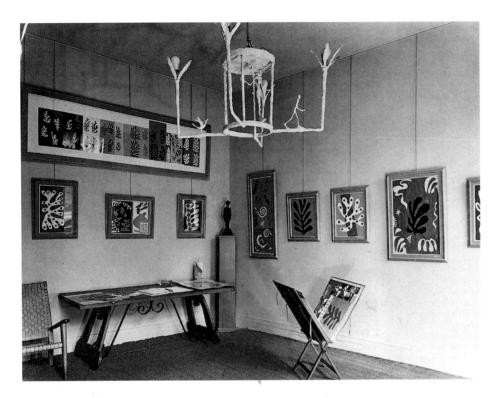

Fig. 44 The Berggruen Gallery, Paris, in 1953, showing the first exhibition of *papiers découpés* by Matisse. The chandelier is by Alberto Giacometti.

narrow format – his now famous *plaquettes*. Chagall, Miró, Picasso and a host of other artists created original lithographs for the covers of these, and the texts were written by prominent art historians, poets and artists. Sixty-six *plaquettes* were published between 1952 and 1979. In 1951 Berggruen planned to present a book of poems by Tristan Tzara, *De mémoire d'homme*, with illustrations by Picasso. Tzara and Berggruen had been friends for some time and the poet had decided that Berggruen's new gallery would be the ideal place in which to display his book, but he needed Picasso's agreement. He therefore arranged a meeting between Picasso and Berggruen; Picasso took to the young dealer at once, and so began a close association that ended only with Picasso's death in 1973.

Berggruen says he owes much to the generosity of his mentor, the distinguished dealer Daniel-Henry Kahnweiler (whom he nicknamed the *comptable du Cubisme* (book-keeper of Cubism), because of his fastidiously analytical approach to art). Also from a German Jewish background, Kahnweiler had set up shop thirty years earlier and had become one of the most distinguished dealers of his day. In the early years of the Galerie Berggruen, Kahnweiler participated in the purchase from Alice B. Toklas of a group of Picasso drawings – of his Blue and Pink Periods – which had originally been owned by Gertrude Stein. The exhibition of this collection was highly prestigious for the Galerie Berggruen. Kahnweiler wrote the introduction to the catalogue; 'everyone' came to see it, including Alfred Barr (the Director of the Museum of Modern Art in New York) and Nelson Rockefeller; and all the works were sold.

Though Berggruen himself bought and sold important drawings, watercolours and paintings, his gallery always specialised in prints. As Gary Tinterow (Curator at the Metropolitan Museum of Art in New York) describes, 'publishing was the gallery's forte, from the lithographs of Chagall, Miró and Picasso and the superb facsimiles of notebooks by Picasso and Cézanne in the 1950s, to the monumental catalogue raisonné of the work of Juan Gris (written by Douglas Cooper) that appeared in 1977.'

According to Caroline Annesley, Berggruen enjoyed the contact with his varied clientele: 'He didn't mind whether the client was rich or not as long as he displayed a serious interest in what he saw. It was interesting to me that he clearly derived as much pleasure in concluding a deal for a 10 franc poster as for a 10,000 franc lithograph or an important painting.'

When Berggruen started out as a dealer he had no idea that he would ever have the ambition or the means to build his own collection. Both developed gradually. From the beginning he never saw the point of collecting 'just a group of pictures by great names – what the New York newspapers call a "Park Avenue" collection. It had to be something exceptional, very special and close to my taste.' During the first ten years he could rarely afford to buy to keep, though he did manage to retain a few works by Klee and some by Picasso – which were to form the basis of one of the most important collections of these artists' works in private ownership.

His first marriage had ended in divorce, and in 1960 he married Bettina Moissi. With the arrival of two sons, Nicolas and Olivier, and the financial demands made by a young family, Berggruen's personal art buying was still restricted. The collection of works by Klee was refined and redefined during this period; also in 1962 he bought the wonderful portrait of Cézanne's wife (Cat. no. 17), then two drawings by Seurat (Cat. nos. 4 and 5), in 1965 two important Cubist Picassos (Cat. nos. 36 and 41), in 1969 the Blue Period pastel of a café scene (Cat. no. 28), in 1973 *Les Poseuses* by Seurat (Cat. no. 15) – 'the jewel of my collection' – not however without the sacrifice of two Cubist paintings by Picasso and a van Gogh drawing.

The collection now on loan to the National Gallery consists essentially of five artists – Cézanne, van Gogh, Seurat, Braque and Picasso. These are the artists to whom he is constantly drawn: 'Cézanne, Seurat, van Gogh – they are the ones who opened the gates to twentieth-century painting. Cézanne, as we all know, leads right into Cubism. The extreme modernism of Seurat is to be very much related to all that came afterwards, including the *raffinement* in the work of an artist like Klee; and van Gogh obviously leads the way to Fauvism and Expressionism. . . . Picasso is always exciting. He towers above all other artists of this

Fig. 45 *Above* A photograph of Picasso taken by Jacqueline Roque, with a dedication to Berggruen, 1965.

Fig. 46 *Left* Picasso and friends at Mougins in 1960. From left to right: a *banderillero*, Claude Picasso, M. Giron (a *torero*), Lionel Prejger, Pablo Picasso, Paulo Picasso, Paco Munoz ('*impresario*' *de corrida*), Paloma Picasso, César Giron (a *torero*), Heinz Berggruen.

century. He is more inventive, more creative, so the accent in my collection is of course on him – numerically more than half the works shown here are by him. I like the idea of collecting in depth to enrich what is already there, and I have concentrated on creating as intense a collection of Picasso's work as possible.'

Although his gallery dealt mostly in prints Berggruen did not collect in this area; he was daunted by the 'infinite' possibilities of print collecting. The one example on show here, perhaps the greatest etching of this century, Picasso's *Minotauromachy* (Cat. no. 56), was a gift from Picasso and bears a dedication: *Pour mon ami Bergruen* [sic]. Though his gallery never dealt in the works of Seurat, van Gogh or Cézanne, Berggruen says it was a great advantage for him as a collector to have an active gallery because it often gave him access before others to many works of art. He was his own best client, a fact that some people resented: 'For no good reason that I can see they seemed to assume that a dealer has no right to keep anything. However the justification for doing so is evident here, I think, in that my collection is now at the disposal of a vast public of art lovers. This makes me very happy.'

In 1984 Berggruen donated his entire collection of ninety works by Klee to the Metropolitan Museum in New York. (He had already given thirteen to the Musée National d'Art Moderne, in Paris). Klee, together with Picasso, remains his greatest love: 'I cannot stop buying Klee – it is an addiction. It is a love affair that began in San Francisco and is with me to this day.' It was a great delight to him that Picasso should share his admiration. He writes, 'It gave me great joy that the living artist whom I most admired shared my love for Klee. . . . I always had the idea – the non-French reader will forgive me – to organise an exhibition called *Les Klee du Paradis* (The Keys to Paradise). I never did that show. I must have been waiting for the Metropolitan Museum of Art to open the doors of the new wing to let us all enjoy *Les Klee du Paradis*.'

The Metropolitan is resplendent with the Berggruen Klees, and now, for a minimum of five years, the National Gallery is enriched by a large part of Berggruen's remarkable collection: two Cubist Braques, eight very fine Cézannes, two van Goghs, fourteen rare Seurats and no less than forty-one Picassos. It is a great honour that Heinz Berggruen has chosen to exhibit these major works in London. Art lovers in this country are deeply indebted to him.

Bibliography

Bibliography

Vincent van Gogh

EXHIBITIONS

Amsterdam 1905
Vincent van Gogh, Amsterdam, Stedelijk Museum, July–August 1905.

Amsterdam 1930
Vincent van Gogh en zijn tijdgenooten, Amsterdam, Stedelijk Museum, September–November 1930.

Basle 1924
Vincent van Gogh, Basle, Kunsthalle, March–April 1924.

Basle 1943
Werken des 19 Jahrhunderts aus Basler Privatbesitz, Basle, Kunsthalle, May–June 1943.

Basle 1945
Vincent van Gogh 25 Werke, Hollandhilfe, Basle, Galerie Schulthess, June–August 1945.

Basle 1947
Vincent van Gogh, Basle, Kunsthalle, October–November 1947.

Berlin 1907
Berliner Sezession, Berlin, December 1907.

Berlin 1913
Sechste Austellung, Berlin, Paul Cassirer, March 1913.

Berlin 1914
Vincent van Gogh, Berlin, Paul Cassirer, May–June 1914.

Berlin 1921
Van Gogh–Matisse, Berlin, Kronprinzenpalais, Nationalgalerie, 1921.

Berlin – Vienna – Hanover 1927–8
Vincent van Gogh, Berlin, Otto Wacker Galerie; Vienna, Neue Galerie; Hanover, Kestner Gesellschaft; December 1927–April 1928.

London 1979–80
Post-Impressionism, London, Royal Academy of Arts, November 1979–March 1980.

London 1987
19th and 20th Century Masters and selected Old Masters, London, Thomas Gibson Fine Art, June–July 1987.

Munich 1909
Vincent van Gogh, Munich, Brakl, October–December 1909.

LITERATURE

Bonafoux 1987
P. Bonafoux, *Van Gogh, le soleil en face*, Paris 1987.

Dorn 1988
R. Dorn, 'Vincent Van Gogh's Concept of Decoration', in *Van Gogh International Symposium*, Tokyo 1988.

De la Faille 1928
J-B. de la Faille, *L'oeuvre de Vincent van Gogh*, Paris 1928.

De la Faille 1939
J-B. de la Faille, *Vincent van Gogh*, Paris 1939.

De la Faille 1970
J-B. de la Faille, *The Works of Vincent van Gogh*, London 1970.

Feilchenfeldt 1988
W. Feilchenfeldt, *Vincent van Gogh and Paul Cassirer, Berlin*, Amsterdam 1988.

Hulsker 1974
J. Hulsker, 'The Poet's Garden', in *Vincent*, vol. 3, 1974.

Hulsker 1980
J. Hulsker, *The Complete Vincent van Gogh, Paintings, Drawings, Sketches*, New York 1980.

Lecaldano 1971
P. Lecaldano, *Tout l'oeuvre peint de van Gogh*, Paris 1971.

Pickvance 1984
R. Pickvance, *Van Gogh in Arles*, exhibition catalogue, New York 1984.

Von Marées-Gesellschaft 1928
Hans von Marées-Gesellschaft, *Vincent Van Gogh, facsimiles from his drawings and watercolours*, Munich 1928.

Sherjon – de Gruyter 1937
W. Sherjon and W. de Gruyter, *Vincent van Gogh's Great Period, Arles, St. Remy and Auvers-sur-Oise*, Amsterdam 1937.

Thomson 1983
B. Thomson, *The Post-Impressionists*, Oxford 1983.

Walker 1981
J.A. Walker, *Van Gogh Studies*, London 1981

Walther – Metzger 1990
Ingo F. Walther, Rainer Metzger, *Vincent van Gogh. L'oeuvre complète. Peinture*, Cologne 1990.

Wentinck – Clergue 1989
C. Wentinck and L. Clergue, *Arles van Gogh*, Arles 1989.

Van der Wolk – Pickvance 1990
J. van der Wolk, R. Pickvance, *Vincent van Gogh, Drawings*, exhibition catalogue, Amsterdam–Otterlo 1990.

Georges Seurat

EXHIBITIONS

Amsterdam 1931
E.J. van Wisselingh & Co., *La Peinture Française aux XIXe et XXe siècles*, Amsterdam, April–May 1931.

Amsterdam – Otterlo 1953
Van Gogh's Grote Tijdgenooten, Amsterdam, Stedelijk Museum, summer; Otterlo, Musée Kröller-Müller, summer 1953.

Baltimore 1940
Exhibition of Modern Painting, Baltimore, Museum of Art, January–February 1940.

Bielefeld et al. 1983–4
Erich Franz, Bernd Growe, *Georges Seurat. Zeichnungen*, Bielefeld, Kunsthalle, October–December 1983; Baden-Baden, Staatliche Kunsthalle, January–March 1984; Zurich, Kunsthaus, March–May 1984.

Brussels 1891
VIIIe Exposition des XX, Brussels, Musée d'Art Moderne, February–March 1891.

Brussels 1892
IXe Exposition des XX (Georges Seurat retrospective), Brussels, Musée Royal de Peinture, October 1892.

Cambridge 1936
French Artists of the 18th and 19th Centuries, Cambridge, 1936.

Chicago – Boston 1913
International Exhibition of Modern Art, Chicago, The Art Institute, March–April; Boston, Copley Hall, April–May 1913.

Chicago 1935
Twenty-four Paintings and Drawings by Georges-Pierre Seurat, Chicago, The Renaissance Society of the University of Chicago, February 1935.

Chicago – New York 1958
Seurat, Paintings and Drawings, Chicago, The Art Institute, January–March; New York, The Museum of Modern Art, March–May 1958.

Copenhagen 1914
Fransk Malerkunst fra det 19nde Aarkundrede, Copenhagen, Royal Museum, June 1914.

Detroit 1940
The Age of Impressionism and Objective Realism, Detroit, The Institute of Arts, May–June 1940.

Geneva 1988
Berggruen Collection, Geneva, Musée d'art et d'histoire, June–October 1988.

Indianapolis 1990
Seurat at Gravelines: The Last Landscapes, Indianapolis, Indianapolis Museum of Art, October–November 1990.

London 1926
Pictures and Drawings by Georges Seurat, London, Reid & Lefèvre Gallery, April–May 1926.

London 1932
Exhibition of French Art, London, Burlington House, Royal Academy of Arts, 1932.

London 1936
Masters of French Nineteenth Century Paintings, London, New Burlington Galleries, October 1936.

London 1937
Seurat and his Contemporaries, London, Wildenstein Galleries, January–February 1937.

London 1948
Samuel Courtauld Memorial Exhibition, London, Tate Gallery, May 1948.

London 1949–50
Landscape in French Art, London, Royal Academy of Arts, December 1949–March 1950.

London 1957
XIX and XX Century French Painting, London, Lefèvre Gallery, March–April 1957.

London 1978[1]
Nineteenth Century French Drawings, London, Hazlitt, June–July 1978.

London 1978[2]
Seurat, Paintings and Drawings, London, David Carritt Ltd., November–December 1978.

London 1979–80
Post-Impressionism, London, Royal Academy of Arts, November 1979–March 1980.

Los Angeles 1941
Painting of France since the French Revolution, Los Angeles, County Museum, June–July 1941.

Newark 1961
Nineteenth Century Master Drawings, Newark, Newark Museum, March 1961.

New York 1885
Works in Oil and Pastel by the Impressionists of Paris, New York, Durand-Ruel Gallery, March–May 1885.

New York et al. 1913
International Exhibition of Modern Art, Armory Show, New York, February–March; Chicago, The Art Institute, March–April; Boston, Copley Hall, April–May 1913.

New York 1924
Paintings and Drawings by Georges Seurat, New York, Joseph Brummer Gallery, December 1924.

New York 1929
Cézanne, Gauguin, Seurat, Van Gogh, New York, The Museum of Modern Art, 1929.

New York 1939
Art in our Time (10th Anniversary Exhibition), New York, The Museum of Modern Art, May–October 1939.

New York 1940
The Post-Impressionists, New York, Bignou Gallery, October–November 1940.

New York 1942
A Selection of 19th Century French Paintings, New York, Bignou Gallery, 1942.

New York 1947
Seurat, his Drawings, New York, Buchholz Gallery, March 1947.

New York 1948
A Loan Exhibition of Six Masters of Post-Impressionism, New York, Wildenstein Galleries, April–May 1948.

New York 1949
Seurat 1859–1891: Paintings and

Drawings, New York, Knoedler Galleries, April–May 1949.

New York 1958
Seurat, Paintings and Drawings, New York, The Museum of Modern Art, March–May 1958.

New York 1963
The Armory Show, 50th Anniversary, New York, Armory Show, 1963.

New York 1977
Seurat Drawings and Oil Sketches from New York Collections, New York, The Metropolitan Museum of Art, September–November 1977.

Paris 1886
VIIIe Exposition de Peintures Impressionnistes, Paris, Maison Dorée, May–June 1886.

Paris 1887
IIIe Salon des Artistes Indépendants, Paris, Pavillon de la Ville de Paris, March–May 1887.

Paris 1891
VIIe Salon des Artistes Indépendants, Paris, Pavillon de la Ville de Paris, March–April 1891.

Paris 1892
VIIIe Salon des Artistes Indépendants, (Seurat commemorative exhibition), Paris, Pavillon de la Ville de Paris, March–April 1892.

Paris 1900
Seurat – La Revue Blanche, Paris, March–April 1900.

Paris 1905
XXIe Salon des Artistes Indépendants, Paris, Grandes Serres de la Ville de Paris, March–April 1905.

Paris 1908–9
Rétrospective Georges Seurat, Paris, Galerie Bernheim-Jeune, December 1908–January 1909.

Paris 1910
Nus, Paris, Galerie Bernheim-Jeune, May 1910.

Paris 1919–20
XXXIe Salon des Artistes Indépendants, Paris, December 1919–January 1920.

Paris 1920
Georges Seurat, Paris, Galerie Bernheim-Jeune, January 1920.

Paris 1922
Georges Seurat, Paris, Galerie Devambez, October 1922.

Paris 1926
Les Dessins de Seurat, Paris, Galerie Bernheim-Jeune, November–December 1926.

Paris 1933–4
Seurat et ses Amis, la Suite de l'Impressionnisme, Paris, Gazette des Beaux-Arts, December 1933–January 1934.

Paris 1936[1]
Le Grand Siècle, Paris, Galerie Paul Rosenberg, June–July 1936.

Paris 1936[2]
Georges Seurat, Paris, Galerie Paul Rosenberg, February 1936.

Paris 1937
Chefs-d'œuvre de l'Art Français, Paris, Exposition Internationale, Palais National des Arts, 1937.

Paris 1938
Quelques œuvres échangées entre..., Paris, Galerie Jacques Rodrigues-Henriques, 1938.

Paris 1942
Paysages français de Corot à nos jours, Paris, Galerie Charpentier, June 1942.

Paris 1942–3
Le Néo-Impressionnisme, Paris, Galerie de France, December 1942–January 1943.

Paris 1946
Michel Florisoone, *Les Chefs-d'œuvre des Collections françaises retrouvés en Allemagne par la Commission de Récupération artistique et les Services alliés*, Paris, Orangerie des Tuileries, June–August 1946.

Paris 1954
Le dessin de Toulouse-Lautrec aux Cubistes, Paris, Musée d'Art Moderne, 1954.

Paris 1955[1]
De David à Toulouse-Lautrec; chefs-d'œuvre des collections américaines, Paris, Musée de l'Orangerie, April–July 1955.

Paris 1955[2]
Impressionnistes de la collection Courtauld de Londres, Paris, Musée de l'Orangerie, summer 1955.

Paris 1957
Seurat, Paris, Musée Jacquemart-André, November–December 1957.

Paris 1960–1
Les sources du XXe siècle, Paris, Musée de la Ville de Paris, November 1960–January 1961.

Philadelphia 1937
French Artists of the 18th and 19th Centuries, Philadelphia 1937.

Philadelphia 1947
Masterpieces of Philadelphia Private Collections, Philadelphia, Museum of Art, 1947.

Philadelphia 1949
The Henry P. McIlhenny Collection, Philadelphia, Museum of Art, 1949.

Philadelphia 1950–1
Masterpieces of Painting, Diamond Jubilee Exhibition, Philadelphia, Museum of Art, November 1950–February 1951.

Rome 1950
Disegni di Georges Seurat, Rome, Galleria dell'Obelisco, 1950.

San Francisco 1962
The Henry P. McIlhenny Collection, San Francisco, The California Palace of the Legion of Honor, 1962.

Venice 1950
Disegni di Georges Seurat, Venice, XXV Biennale di Venezia, 1950.

Venice 1952
Il Divisionismo, Venice, XXVI Biennale di Venezia, 1952.

Washington – San Francisco 1986
The New Painting: Impressionism 1874–1886, Washington, National Gallery of Art, January–April; San Francisco, The Fine Arts Museum, April–July 1986.

Worcester 1941
The Art of the Third Republic, Worcester (Mass.), Art Museum, February–March 1941.

LITERATURE

Anon 1926
John Anon, *The John Quinn Collection of Paintings, Watercolors, Drawings and Sculpture*, New York 1926.

Apollonio 1945
Umbro Apollonio, *Disegni di Seurat*, Venice 1945.

Bernier 1957
Rosamond Bernier, 'Le musée privé d'un conservateur', in *L'Œil*, March 1957.

Broude 1978
Norma Broude (ed.), *Seurat in Perspective*, Englewood Cliffs (New Jersey) 1978.

Brown 1963
Milton W. Brown, *The Story of the Armory Show*, New York 1963.

Canaday 1959
John Canaday, *Mainstreams of Modern Art*, New York 1959.

Chastel 1973
André Chastel, Fiorella Minervino, *Tout l'œuvre peint de Seurat*, Paris 1973.

Clayson 1989
S.H. Clayson, 'The Family and the Father: The *Grande Jatte* and its Absences', in *The Art Institute of Chicago Museum Studies*, vol. 14, no. 2, 1989.

Cogniat 1951
Raymond Cogniat, *Seurat*, Paris 1951.

Cogniat 1959
Raymond Cogniat, *Le siècle des Impressionnistes*, Paris 1959.

Cooper 1946
Douglas Cooper, *Georges Seurat: Une baignade à Asnières*, London 1946.

Cooper 1954
Douglas Cooper, *The Courtauld Collection*, London 1954.

Coquiot 1924
Gustave Coquiot, *Georges Seurat*, Paris 1924.

Courthion 1969
Pierre Courthion, *Georges Seurat*, Paris 1969.

Courthion 1988
Pierre Courthion, *Seurat*, Paris 1988.

Cousturier 1921
Lucie Cousturier, *Seurat*, Paris 1921.

Cousturier 1926
Lucie Cousturier, *Georges Seurat*, Paris 1926.

Dorra – Rewald 1959
Henri Dorra, John Rewald, *Seurat*, Paris 1959.

Edouard-Joseph 1934
Edouard-Joseph, *Dictionnaire biographique des artistes contemporains 1910–1930*, Paris 1934.

Frost 1942
Rosamund Frost, *Contemporary Art: The March of Art from Cézanne until now*, New York 1942.

Fry 1939
Roger Fry, *Last Lectures*, London 1939.

Geffroy 1886
Gustave Geffroy, 'Salon de 1886: VIII Hors du Salon, Les Impressionnistes', in *La Justice*, 26 May 1886.

Georgel – Lecoq 1982
Pierre Georgel, Anne-Marie Lecoq, *La peinture dans la peinture*, Dijon 1982.

Goldwater 1941
Robert J. Goldwater, 'Some Aspects of the Development of Seurat's Style', in *The Art Bulletin*, New York, June 1941.

Greenspan 1985
Stuart Greenspan, 'Berggruen's Picassos', in *Art & Auction*, vol. VII, no. 9, April 1985.

Haacke 1975
Hans Haacke, *Seurat's Les Poseuses (Small version)*, New York 1975.

De Hauke 1961
César M. de Hauke, *Seurat et son œuvre*, vol. I (Peintures), vol. II (Catalogue des Dessins), Paris 1961.

Hautecœur 1974
Louis Hautecœur, *Les Impressionnistes, Seurat*, Milan 1974.

Herbert 1958
Robert L. Herbert, 'Seurat in Chicago and New York', in *Burlington Magazine*, May 1958.

Herbert 1960
Robert L. Herbert, 'A Rediscovered Drawing for Seurat's Baignade', in *Burlington Magazine*, August 1960.

Herbert 1962
Robert L. Herbert, *Seurat's Drawings*, New York 1962.

Hope Johnstone 1932
John Hope Johnstone, 'La collection Stoop', in *L'Amour de l'Art*, no. 6, June 1932.

House 1979
J. House, 'The legacy of Impressionism in France', in *Post-Impressionism*, exhibition catalogue, London 1979.

House 1980
J. House, 'Meaning in Seurat's Figure Paintings', in *Art History*, vol. 3, no. 3, September 1980.

Huyghe 1947
René Huyghe, 'Trois Poseuses de Seurat', in *Bulletin des Musées de France*, 1947.

Kahn 1928
Gustave Kahn, *Les Dessins de Georges Seurat*, 2 vols., Paris 1928.

Langaard 1921
J.H. Langaard, 'Georges Seurat', in *Kunst og Kultur*, 1921.

Laprade 1945
Jacques de Laprade, *Georges Seurat*, Monaco 1945.

Lee 1983
Ellen Wardwell Lee, *The Art of Neo-Impressionism: The W.J. Holliday Collection*, Indianapolis, 1983.

Lhote 1922
André Lhote, 'Georges Seurat', in *Valori Plastici*, collection Les Artistes Nouveaux, Rome 1922.

Mabille 1938
Pierre Mabille, 'Dessins inédits de Seurat', in *Le Minotaure*, no. 11, 15 May 1938.

Madeleine–Perdrillet 1990
Alain Madeleine–Perdrillet, *Georges Seurat*, Geneva 1990.

Nicolson 1941
Benedict Nicolson, 'Seurat's La Baignade', in *Burlington Magazine*, November 1941.

Nochlin 1989
L. Nochlin, 'Seurat's *Grande Jatte*: An Anti-Utopian Allegory', in *The Art Institute of Chicago Museum Studies*, vol. 14, no. 2, 1989.

Pach 1923[1]
Walter Pach, *Georges Seurat*, New York 1923.

Pach 1923[2]
Walter Pach, 'Seurat', in *The Arts*, March 1923.

Rasponi 1989
S. Rasponi, *Seurat*, Paris 1989.

Reid 1968
B.L. Reid, *The Man from New York; John Quinn and his Friends*, New York 1968.

Renard 1938
Marie Renard, 'Au temps des Poseuses', in *Verve*, vol. IV, 1938.

Rewald 1943
John Rewald, *Georges Seurat*, New York 1943.

Rewald 1948
John Rewald, *Georges Seurat*, Paris 1948.

Rewald 1952
John Rewald, 'Extraits du Journal inédit de Paul Signac', in *Gazette des Beaux-Arts*, 1952.

Rewald 1956
John Rewald, *Post-Impressionism. From Van Gogh to Gauguin*, New York 1956.

Rewald 1990
John Rewald, *Seurat*, London 1990.

Rey 1931
Robert Rey, *La renaissance du sentiment classique dans la peinture française à la fin du XIXe siècle*, Paris 1931.

Rich 1935
Daniel Catton Rich, *Seurat and the Evolution of La Grande Jatte*, Chicago 1935.

Richardson 1979
John Richardson, *The Collection of Germain Seligman*, New York 1979.

Roger-Marx 1931
Claude Roger-Marx, *Seurat*, Paris 1931.

Russell 1965
John Russell, *Seurat*, London 1965.

Russell 1969–70
John Russell, 'Seurat's Les Poseuses', in *Christie's Review of the Year*, London 1969–70.

Schapiro 1958
Meyer Schapiro, 'New Light on Seurat', in *Art News*, no. 57, 1958.

Seligman 1947
Germain Seligman, *The Drawings of Georges Seurat*, New York 1947.

Sérullaz 1968
Maurice Sérullaz, *Great Drawings of the Louvre Museum (French Drawings)*, New York 1968.

Sitwell 1926
Osbert Sitwell, 'Les Poseuses', in *Apollo*, June 1926.

Sutter 1970
Jean Sutter, *Les Néo-Impressionnistes*, Neuchâtel 1970.

Thomson 1985
Richard Thomson, *Seurat*, Oxford 1985.

Ventes 1988
Le grand livre des ventes aux enchères, Paris 1988.

Venturi 1953
Lionello Venturi, *De Manet à Lautrec*, Paris 1953.

Wilenski 1951
R.H. Wilenski, *Georges Seurat*, London 1951.

Wotte 1988
Herbert Wotte, *Georges Seurat*, Dresden 1988.

Zervos 1928
Christian Zervos, 'Un dimanche à la Grande Jatte et la technique de Seurat', in *Cahiers d'Art*, no. 9, 1928, p. 361 ff.

Paul Cézanne

EXHIBITIONS

Aix-en-Provence 1961
Exposition Cézanne, Tableaux – Aquarelles – Dessins, Aix-en-Provence, Pavillon de Vendôme, July–August 1961.

Amsterdam 1911
Moderne Kunst Kring, Amsterdam, Stedelijk Museum, 1911.

Chicago – New York 1952
Cézanne, Paintings, Watercolours and Drawings, Chicago, The Art Institute, February–March; New York, The Metropolitan Museum of Art, April–May 1952.

Dayton 1960
French Paintings 1789–1929 from the Collection of Walter P. Chrysler Jr., The Dayton Art Institute, March–May 1960.

Detroit 1954
Two Sides of the Medal, The Detroit Institute of Arts, 1954.

Geneva 1988
Berggruen Collection, Geneva, Musée d'art et d'histoire, June–October 1988.

Kassel 1964
Documenta III Internationale Ausstellung (Handzeichnungen), Kassel, Museum Fridericianum, June–October 1964.

Liège – Aix-en-Provence 1982
Cézanne, Liège, Musée Saint-Georges, March–May; Aix-en-Provence, Musée Granet, June–August 1982.

London 1924
Important Pictures by 19th Century French Masters, London, Reid & Lefèvre Gallery, 1924.

London 1939
Homage to Paul Cézanne, London, Wildenstein Galleries, July 1939.

London 1942
Nineteenth Century French Painting, London, National Gallery, 1942.

London 1979
Important XIX and XX Century Paintings, London, Lefèvre Gallery, November–December 1979.

Montreal 1933
The Sir William van Horne Collection, Montreal, Art Association, 1933.

Newcastle – London 1973
Watercolour and Pencil Drawings by Cézanne, Newcastle, Laing Art Gallery, September–November; London, Hayward Gallery, November–December 1973.

New York et al. 1913
International Exhibition of Modern Art, Armory Show, New York, February–March; Chicago, The Art Institute, March–April; Boston, Copley Hall, April–May 1913.

New York 1942
Paintings by Cézanne, New York, Paul Rosenberg Gallery, 1942.

New York 1947
Cézanne, New York, Wildenstein Galleries, March–April 1947.

New York 1952
Cézanne, Rarely Shown Works, New York, Fine Arts Associates (Otto Gerson), November 1952.

New York 1963
Cézanne Watercolours, New York, Knoedler Galleries, April 1963.

New York – Houston 1977–8
Cézanne. The Late Work, New York, The Museum of Modern Art, October 1977–January 1978; Houston, The Museum of Fine Arts, January–March 1978.

Oslo 1918
Den franske Utstilling, Christiania (Oslo), Kunstnerforbundet, January–February 1918.

Ottawa 1950
Paintings from the Vollard Collection, Ottawa, National Gallery of Canada, 1950.

Paris 1895
Paul Cézanne, Paris, Galerie Vollard, November–December 1895.

Paris 1929
Cézanne 1839–1906, Paris, Galerie Pigalle, December (?) 1929.

Paris 1936
Cézanne, Paris, Musée de l'Orangerie, May–October 1936.

Paris 1971
Aquarelles de Cézanne, Paris, Galerie Bernheim-Jeune, January–March 1971.

Portland 1956
Paintings from the Collection of Walter P. Chrysler Jr., Portland (Oregon), The Art Museum, 1956.

Saint-Paul-de-Vence 1989
L'œuvre ultime de Cézanne à Dubuffet, Saint-Paul-de-Vence, Fondation Maeght, July–October 1989.

San Francisco 1937
Cézanne, San Francisco, Museum of Art, September–October 1937.

Tokyo et al. 1974
Paul Cézanne, Tokyo, National Museum of Western Art, March–May; Kyoto, Municipal Museum, June–July; Fukuoka, Cultural Center, July–August 1974.

Tübingen – Zurich 1982
Götz Adriani, *Paul Cézanne Aquarelle*, Tübingen, Kunsthalle, January–March; Zurich, Kunsthaus, April–May 1982.

Vienna 1961
Paul Cézanne, 1839–1906, Vienna, Österreichische Galerie im Oberen Belvedere, April–June 1961.

Washington – Chicago et al. 1971
Cézanne, an Exhibition in Honor of the Fiftieth Anniversary of the Phillips Collection, Washington, The Phillips Collection, February–March; Chicago, The Art Institute, April–May; Boston, The Museum of Fine Arts, June–July 1971.

Zurich 1917
Französische Kunst des XIX. und XX. Jahrhunderts, Zurich, Kunsthaus, October–November 1917.

Zurich 1956
Paul Cézanne, Zurich, Kunsthaus, August–October 1956.

LITERATURE

Arishima 1926
Ikouma Arishima, 'Cézanne', in *Ars*, XIV, 1926.

Art News 1946
'Buddy de Sylva: Gift to Hollywood', in *Art News*, September 1946.

Barnes – De Mazia 1939
Albert C. Barnes, Violetta de Mazia, *The Art of Cézanne*, New York 1939.

Bernard 1926
Emile Bernard, *Souvenirs sur Paul Cézanne. Une conversation avec Cézanne. La méthode de Cézanne*, Paris 1926.

Bertram 1929
Anthony Bertram, *Cézanne*, London 1929.

Bourges 1984
M. Bourges, *Le Jardin de Cézanne*, Paris 1984.

Van Buren 1966
Anne H. van Buren, 'Madame Cézanne's Fashions and the Dates of her Portraits', in *Art Quarterly*, 1966.

Burmann 1922
G. Burmann, *Jahrbuch der Jugendkunst*, Leipzig 1922.

Bye 1921
A. Bye, *Pots and Pans or Studies in Still Life Painting*, Princeton 1921.

Chappuis 1973
Adrien Chappuis, *The Drawings of Paul Cézanne, A Catalogue Raisonné*, vols. I–II, London 1973.

Cogniat 1939
Raymond Cogniat, *Cézanne*, Paris 1939.

Coutagne 1990
D. Coutagne, *Sainte-Victoire Cézanne 1990*, Aix-en-Provence 1990.

Du 1989
Das Tor zur Moderne. Paul Cézanne in schweizer Sammlungen, in *Du*, no. 9, September 1989.

Elderfield 1971
John Elderfield, 'Drawing in Cézanne', in *Art Forum*, June 1971.

Elgar 1975
Frank Elgar, *Cézanne*, New York 1975.

Fontainas – Vauxcelles 1922
André Fontainas, Louis Vauxcelles, *Histoire générale de l'art français de la Révolution à nos jours*, Paris 1922.

Frost 1942
Rosamund Frost, *Contemporary Art – The March of Art from Cézanne until now*, New York 1942.

Fry 1917
Roger Fry, 'Compte-rendu de l'ouvrage d'Ambroise Vollard sur Paul Cézanne', in *Burlington Magazine*, August 1917.

Gaunt 1938
William Gaunt, 'Paul Cézanne, an Essay in Valuation', in *Studio*, March 1938.

Gimpel 1963
René Gimpel, *Journal d'un collectionneur marchand de tableaux*, Paris 1963.

Goldwater 1938
Robert J. Goldwater, 'Cézanne in America', in *Art News*, March 1938.

Guerry 1966
Liliane Guerry, *Cézanne et l'expression de l'espace*, (2nd edition) Paris 1966.

Hoog 1971
Michel Hoog, *L'univers de Cézanne*, Paris 1971.

Jedlicka 1948
Gotthard Jedlicka, *Cézanne*, Berne 1948.

Jewell 1944
Edward Alden Jewell, *Paul Cézanne*, New York 1944.

Lindsay 1969
Jack Lindsay, *Cézanne, his Life and Art*, New York 1969.

Loran 1943
Erle Loran, *Cézanne's Composition*, Berkeley 1943.

Mack 1935
Gerstle Mack, *Paul Cézanne*, New York
1935.

Mauny 1927
J. Mauny, 'Cézanne: The Old Master',
in *Drawing and Design*, 1927.

Neumeyer 1958
Alfred Neumeyer, *Cézanne Drawings*,
New York 1958.

Orienti 1972
S. Orienti, *The Complete Paintings of
Cézanne*, London 1972.

Pfister 1927
Kurt Pfister, *Cézanne, Gestalt, Werk,
Mythos*, Potsdam 1927.

Ramuz 1968
Charles Ferdinand Ramuz, *Cézanne
Formes*, Lausanne 1968.

Raynal 1936
Maurice Raynal, *Cézanne*, Paris 1936.

Reff 1977–8
Theodore Franklin Reff, *Painting and
Theory in the Final Decade*, in *Cézanne:
The Late Work*, exhibition catalogue,
New York – Houston 1977–8.

Rewald 1937
John Rewald, *Paul Cézanne.
Correspondance*, Paris 1937.

Rewald 1948
John Rewald, *Paul Cézanne, A
Biography*, New York 1948.

Rewald 1978
John Rewald, *Paul Cézanne.
Correspondance*, Paris 1978.

Rewald 1984
John Rewald, *Les aquarelles de Cézanne*,
catalogue raisonné, Paris 1984.

Rewald 1986
John Rewald, *Cézanne, A Biography*,
New York 1986.

Rivière 1923
Georges Rivière, *Le maître Paul
Cézanne*, Paris 1923.

Rubin 1977–8
William S. Rubin, *Cézannisme and the
Beginnings of Cubism*, in *Cézanne: The
Late Work*, exhibition catalogue, New
York–Houston 1977–8.

Sérullaz 1971
Maurice Sérullaz, *Cézanne – Quinze
aquarelles reproduites en fac-similé* (album
Jacomet), Paris 1971.

Siblik 1972
Jiri Siblik, *Paul Cézanne, Dessins*, Paris
1972.

Sutton 1974
Denys Sutton, 'The Paradoxes of
Cézanne', in *Apollo*, no. 150, August
1974.

Taillandier 1979
Yvon Taillandier, *Paul Cézanne*, Paris
1979.

Tatlock 1924
A. Tatlock, 'Lefèvre Gallery – Works
by French Masters', in *Daily Telegraph*,
22 June 1924.

Venturi 1936
Lionello Venturi, *Cézanne, son art – son
œuvre*, 2 vols., Paris 1936.

Venturi 1942
Lionello Venturi, 'Cézanne Fighter for
Freedom', in *Art News*, 15 November
1942.

Venturi 1943
Lionello Venturi, *Paul Cézanne
Watercolours*, Oxford 1943.

Vollard 1914
Ambroise Vollard, *Paul Cézanne*, Paris
1914.

Wadley 1975
Nicholas Wadley, *Cézanne and his Art*,
London 1975.

Von Wedderkop 1922[1]
Hans von Wedderkop, 'Paul Cézanne'
in *Cicerone*, 16 August 1922.

Von Wedderkop 1922[2]
Hans von Wedderkop, *Paul Cézanne*,
Leipzig 1922.

Georges Braque

EXHIBITIONS

Edinburgh – London 1956
Georges Braque, Edinburgh, The Royal
Scottish Academy (International
Festival), August–September; London,
Tate Gallery, September–November
1956.

Geneva 1988
Berggruen Collection, Geneva, Musée
d'art et d'histoire, June–October 1988.

London 1983
Douglas Cooper, Gary Tinterow, *The
Essential Cubism 1907–1920. Braque,
Picasso and their Friends*, London, Tate
Gallery, April–July 1983.

Los Angeles – New York 1970–1
Douglas Cooper, *The Cubist Epoch*, Los
Angeles, County Museum of Art,
December 1970–February 1971; New
York, The Metropolitan Museum of
Art, April–June 1971.

Munich 1963
Georges Braque, Munich, Haus der
Kunst, October–December 1963.

New York 1981
XIX & XX Century Master Paintings,
New York, Acquavella Galleries,
May–June 1981.

New York 1985
*Les Cafés, Paris Cafés, Their Role in the
Birth of Modern Art*, New York,
Wildenstein Galleries,
November–December 1985.

New York – Basle 1989–90
Picasso and Braque, Pioneering Cubism,
New York, Museum of Modern Art;
Basle, Kunstmuseum.

Paris – Washington 1982–3
Georges Braque – Les papiers collés, Paris,
Musée National d'Art Moderne,
Centre Georges Pompidou,
June–September 1982; Washington,
National Gallery of Art, October
1982–January 1983.

LITERATURE

Caizergues 1981
Pierre Caizergues, 'Guillaume
Apollinaire', in *Cahiers du musée
national d'art moderne*, no. 6, 1981.

Descargues – Ponge – Malraux 1971
Pierre Descargues, Francis Ponge,
André Malraux, *Georges Braque*, Paris
1971.

Descargues – Carrà 1973
Pierre Descargues, Massimo Carrà,
Tout l'œuvre peint de Braque 1908–1929,
Paris 1973.

Hermann 1980
Frank Hermann, *Selected Paintings at
The Norton Simon Museum, Pasadena,
California*, London 1980.

Isarlov 1932
Georges Isarlov, *Georges Braque*, Paris
1932.

Krauss 1971
Rosalind Krauss, 'The Cubist Epoch',
in *Art Forum*, vol. IX, no. 6, February
1971.

Pouillon – Monod 1982
Nadine Pouillon, Isabelle Monod,
Œuvres de Georges Braque (1882–1963),
catalogue des collections du Musée
National d'Art Moderne, Paris 1982.

Richardson 1955
John Richardson, 'Au Château des
Cubistes', in *L'Œil*, no. 4, 15 April
1955.

Steadman 1976
David W. Steadman, 'Painting in
France 1860–1940', in *The Connoisseur*,
vol. 193, November 1976.

Worms de Romilly – Laude 1982
Nicole Worms de Romilly, Jean Laude,
Braque, le cubisme, fin 1907–1914, Paris
1982.

Pablo Picasso

EXHIBITIONS

Amsterdam – Eindhoven 1954
Collection Philippe Dotremont,
Amsterdam, Stedelijk Museum;
Eindhoven, Stedelijk van
Abbemuseum, 1954.

Amsterdam 1967
Picasso, Amsterdam, Stedelijk
Museum, March–April 1967.

Arles 1957
*Picasso, Dessins, gouaches, aquarelles,
1898–1957*, Arles, Musée Réattu,
July–September 1957.

Avignon 1970
Pablo Picasso 1969–70, Avignon, Palais
des Papes, 1970.

Basle 1957
Maîtres de l'Art Moderne, Basle, Galerie
Beyeler, October–November 1957.

Basle 1966–7
Picasso, Basle, Galerie Beyeler,
November 1966–May 1967.

Basle 1976
Picasso, Basle, Kunstmuseum,
June–September 1976.

Berlin 1974
Hommage à Schönberg, Berlin,
Nationalgalerie, 1974.

Berlin – Düsseldorf 1983–4
Werner Spies, *Picasso. Das plastische
Werk*, Berlin, Nationalgalerie,
October–November 1983; Düsseldorf,
Kunsthalle, December 1983–January
1984.

Bielefeld 1979
Zeichnungen und Collagen des Kubismus,
Bielefeld, Kunsthalle, March–April 1979.

Cambridge et al. 1981
Gary Tinterow, *Master Drawings by
Picasso*, Cambridge (Mass.), Fogg Art
Museum, February–April; Chicago,
The Art Institute, April–June;
Philadelphia, Museum of Art,
July–August 1981.

Cologne 1964
*Kunst der 20 Jahrhunderts in Kölner
Privatbesitz*, Cologne, Kölnischer
Kunstverein, November–December 1964.

Fort Worth 1967
Picasso, Fort Worth (Texas), Art Center
Museum, February–March 1967.

Frankfurt – Hamburg 1965
Ewald Rathke, Sylvia Rathkeköl,
*Picasso, 150 Handzeichnungen aus sieben
Jahrzehnten*, Frankfurt, Kunstverein,
Steinernes Haus, May–July; Hamburg,
Kunstverein, summer 1965.

Geneva – Paris 1987–8
*Regards sur Minotaure, la revue à tête de
bête*, Geneva, Musée Rath, October
1987–January 1988; Paris, Musée d'Art
Moderne de la Ville de Paris,
March–May 1988.

Geneva 1988
Berggruen Collection, Geneva, Museé
d'art et d'histoire, June–October 1988.

Hamburg 1959
*Französische Zeichnungen des 20.
Jahrhunderts*, Hamburg, Kunsthalle,
September–November 1959.

Humlebaek 1968
Pablo Picasso, Humlebaek, Louisiana
Museum, September–November 1968
(with a special issue of *Louisiana-Revy*,
no. 1–2).

Kassel 1964
Documenta III. Handzeichnungen, Kassel,
Alte Galerie, Museum Fridericianum,
June–October 1964.

Limoges 1923
Société des Amis des Arts, Limoges, Salle
des conférences, May–June 1923.

London 1960
Picasso Retrospective, London, Arts
Council of Great Britain, Tate Gallery,
July–September 1960.

London 1962
Aspects of Twentieth Century Art,
London, Marlborough Fine Arts,
1962.

London 1967
*Picasso. Sculpture, Ceramics, Graphic
Work*, London, Tate Gallery,
July–August 1967.

London 1983
Douglas Cooper, Gary Tinterow, *The
Essential Cubism 1907–1920. Braque,
Picasso and their Friends*. London, Tate
Gallery, April–July 1983.

Los Angeles 1961
Bonne Fête Monsieur Picasso, Los
Angeles, University of California Art
Galleries, October–November 1961.

Los Angeles – New York 1970–1
Douglas Cooper, *The Cubist Epoch*, Los
Angeles, County Museum of Art,
December 1970–February 1971; New
York, The Metropolitan Museum of
Art, April–June 1971.

Lugano 1988
Il Cubismo nella scultura, Lugano,
Galleria Pieter Coray, April–June 1988.

Madrid 1988
El Siglo de Picasso, Madrid, Centro de
Arte Reina Sofia, January–March 1988.

Marseille 1959
Douglas Cooper, *Picasso*, Marseille,
Musée Cantini, May–July 1959.

Milan 1953
Franco Russoli, *Picasso*, Milan, Palazzo
Reale, September–November 1953.

Munich 1922
Pablo Ruiz Picasso, Munich, Moderne
Galerie, Thannhaüser, June 1922.

New York 1936
Cubism and Abstract Art, New York,

The Museum of Modern Art, March–April 1936.

New York et al. 1939–40.
Picasso, Forty Years of his Art, New York, The Museum of Modern Art, November 1939–January 1940; Chicago, The Art Institute, February–March; San Francisco, Museum of Art, April–May 1940.

New York 1952
Pablo Picasso 1920–1925, New York, Curt Valentin Gallery, September–October 1952.

New York – Chicago 1957
Picasso, 75th Anniversary Exhibition, New York, The Museum of Modern Art, May–September; Chicago, The Art Institute, October–December 1957.

New York 1958
Pictures from a Private Collection (Mrs Mack), New York, Emmerich Gallery, 1958.

New York 1959
French Master Drawings – Renaissance to Modern, New York, Charles E. Slatkin Gallery, February–March 1959.

New York 1962.
John Richardson, *Picasso: An American Tribute*, New York, April–May 1962: *1895–1909*, Knoedler & Co.; *Cubism*, Saidenberg Gallery; *The Twenties*, Paul Rosenberg Gallery; *The Classic Phase*, Duveen Brothers, Inc.; *The Thirties*, Perls Galleries; *The Forties*, Staempfli Gallery; *The Fifties*, Cordier-Warren Gallery; *Drawings*, The New Gallery; *Sculpture*, Otto Gerson Gallery.

New York 1963[1]
Der blaue Reiter, New York, Leonard Hutton Galleries, February–March 1963.

New York 1963[2]
20th Century Masters from the Bragaline Collection, New York, Knoedler & Co., 1963.

New York 1968
Primitives to Picasso, New York, Knoedler & Co., December 1968.

New York 1971
Homage to Picasso for his 90th Birthday, New York, Saidenberg Gallery (years 1901–24); Marlborough Gallery, October 1971.

New York 1980
Pablo Picasso: A Retrospective, New York, The Museum of Modern Art, May–September 1980.

New York 1982
The Long Island Collections, A Century of Art: 1880–1980, New York, Nassau County Museum of Fine Arts, April–July 1982.

New York 1984[1]
XIX and XX Century Master Paintings, New York, Acquavella Galleries, November–December 1984.

New York 1984[2]
The Shock of Modernism in America, The Eight and Artists of the Armory Show, New York, Nassau County Museum of Fine Arts, April–July 1984.

New York et al. 1984
Primitivism in 20th Century Art, New York, The Museum of Modern Art; Detroit, The Institute of Art; Dallas, Museum of Art, 1984.

New York 1985
Les Cafés, Paris Cafés, their Role in the Birth of Modern Art, New York,

Wildenstein Galleries, November–December 1985.

New York – Basle 1989–90
Picasso and Braque, Pioneering Cubism, New York, Museum of Modern Art; Basle, Kunstmuseum.

Paris 1902
Exposition de peintures, pastels et dessins par MM. Girieud, Launay, Picasso et Pichot, Paris, Galerie Weill, November–December 1902.

Paris 1929
Collection de M. Paul Guillaume, Paris, Galerie Bernheim-Jeune, May–June 1929.

Paris 1932
Exposition Pablo Picasso, Paris, Galeries Georges Petit, June 1932.

Paris 1936
Exposition surréaliste d'objets, Paris, Galerie Charles Ratton, May 1936.

Paris 1937
Les Maîtres de l'Art Indépendant, 1895–1937, Paris, Musée du Petit Palais, June–October 1937.

Paris 1952
Nature morte de l'antiquité à nos jours, Paris, Orangerie des Tuileries, April–September 1952.

Paris 1955
Maurice Jardot, *Picasso, peintures 1900–1955*, Paris, Musée des Arts Décoratifs, June–October 1955.

Paris 1956
Picasso – Dessins d'un demi-siècle, Paris, Galerie Berggruen, May–July 1956.

Paris 1964
La collection André Lefèvre, Paris, Musée National d'Art Moderne, March–April 1964.

Paris 1966
Picasso, Dessins et aquarelles, 1899–1965, Paris, Galerie Knoedler, November–December 1966.

Paris 1966–7[1]
Hommage à Pablo Picasso. Peintures, Paris, Grand Palais, November 1966–February 1967.

Paris 1966–7[2]
Hommage à Pablo Picasso. Dessins, Sculptures, Céramiques, Paris, Musée du Petit Palais, November 1966–February 1967.

Paris 1973
Œuvres cubistes: Braque, Gris, Léger, Picasso, Paris, Galerie Berggruen, May–September 1973.

Paris 1975
Jeanine Warnod, *Le Bateau-Lavoir, berceau de l'art moderne*, Paris, Musée Jacquemart-André, autumn 1975.

Paris 1978
Il y a 70 ans le Cubisme, Paris, Grand Palais, March–April 1978 (exhibition organised within the 89th Salon des Artistes Indépendants).

Paris 1982–3
Paul Eluard et ses amis peintres, Paris, Musée National d'Art Moderne, Centre Georges Pompidou, November 1982–January 1983.

Paris 1987–8
Le siècle de Picasso, Paris, Musée d'Art Moderne de la Ville de Paris, October 1987–January 1988.

Paris 1988
Les Demoiselles d'Avignon, Paris, Musée Picasso, January–April 1988.

Philadelphia 1958
Picasso, A Loan Exhibition of his Paintings, Drawings, Sculpture, Ceramics, Prints and Illustrated Books, Philadelphia, Museum of Art, January–February 1958.

Princeton 1981
Works on Paper, Princeton (New Jersey), Princeton University Art Museum, April–June 1981.

Rhode Island 1984
From the Age of David to the Age of Picasso, Rhode Island, School of Design Museum of Art, 1984.

Stuttgart 1960
Robert Rosenblum, *Der Kubismus und die Kunst des 20. Jahrhunderts*, Stuttgart, 1960.

Tel Aviv – Jerusalem 1966
Picasso, Tel Aviv Museum, Helena Rubinstein Pavilion, January–May 1966; Jerusalem, Israël Museum (dates unknown).

Tokyo et al. 1977–8
Picasso Exhibition. Retrospective 1898–1970, Tokyo, Metropolitan Museum of Art, October–December 1977; Nagoya, Aichi Museum, December 1977; Fukuoka, Cultural Center, January 1978; Kyoto, National Museum of Modern Art, January–March 1978.

Toulouse 1965
Picasso et le théâtre, Toulouse, Musée des Augustins, June–September 1965.

Tübingen – Düsseldorf 1986
Werner Spies, *Picasso, Pastelle Zeichnungen Aquarelle*, Tübingen, Kunsthalle, April–May; Düsseldorf, Kunstsammlung Nordrhein-Westfalen, June–July 1986.

Vallauris 1961
Hommage à Picasso, Vallauris, October 1961.

Venice 1986
Pontus Hulten, *Futurismo & Futurismi*, Venice, Palazzo Grassi, summer 1986.

Washington – Los Angeles 1967
100 European Paintings and Drawings from the Collection of Mr and Mrs Leigh B. Bloch, Washington, National Gallery of Art, May–June; Los Angeles, County Museum of Art, September–November 1967.

Zurich 1932
Picasso, Zurich, Kunsthaus, September–November 1932.

LITERATURE

Allen 1967
Giles Allen, 'Americans in Europe. Heinz Berggruen', in *Réalités* (American edition), no. 199, June 1967.

Arnason 1977
Hjörvardur Harvard Arnason, *History of Modern Painting* (2nd edition), Englewood Cliffs (New Jersey); New York 1977.

Baer 1986
Brigitte Baer, *Picasso peintre graveur*, t. III, Berne 1986.

Barr 1946
Alfred Hamilton Barr, *Picasso, Fifty Years of his Art*, New York 1946.

Baumann 1976
F.A. Baumann, *Pablo Picasso, Leben und Werk*, Stuttgart 1976.

Blunt – Pool 1962
Sir Anthony Blunt, Phoebe Pool,

Picasso, the Formative Years. A Study of his Sources, London 1962.

Boeck – Sabartés 1955
Wilhelm Boeck, *Picasso*, preface by Jaime Sabartés, Stuttgart 1955.

Breerette 1988
Geneviève Breerette, 'La genèse d'un tableau', in *Le Monde*, 30 January 1988.

Brown 1963
Milton W. Brown, *The Story of the Armory Show*, New York, 1963.

Cassou 1940
Jean Cassou, *Picasso*, Paris 1940.

De Champris 1960
Pierre de Champris, *Picasso, ombre et soleil*, Paris 1960.

Cooper 1970
Douglas Cooper, *The Cubist Epoch*, Oxford 1970.

Courthion 1966
Pierre Courthion, 'Les grandes étapes de l'art contemporain 1907–1917', in *XXe siècle*, vol. 26, 1966, p. 75 ff.

Daix – Boudaille 1966
Pierre Daix, Georges Boudaille, *Picasso 1900–1906, catalogue raisonné de l'œuvre peint*, Neuchâtel 1966.

Daix 1977
Pierre Daix, *La vie de peintre de Pablo Picasso*, Paris 1977.

Daix – Rosselet 1979
Pierre Daix, Joan Rosselet, *Le cubisme de Picasso, catalogue raisonné de l'œuvre peint 1907–1916*, Neuchâtel 1979.

Descargues – Ponge – Malraux 1971
Pierre Descargues, Francis Ponge, André Malraux, *Georges Braque*, Paris 1971.

Diehl 1960
Gaston Diehl, *Picasso*, New York 1960.

Collection Philippe Dotremont 1954
Catalogue de la collection Philippe Dotremont, Amsterdam 1954.

Elgar – Maillard 1955
Frank Elgar, Robert Maillard, *Picasso*, Paris 1955.

Eluard 1944
Paul Eluard, *A Pablo Picasso*, Geneva 1944.

Fels 1950
Florent Fels, *L'Art vivant de 1900 à nos jours*, vol. I, Geneva 1950.

Fermigier 1969
André Fermigier, *Picasso*, Paris 1969

Fierens 1959
Paul Fierens, 'Picasso et la figure humaine', in *XXe siècle*, no 13, 1959, p. 45 ff.

Fisher 1966
Robert Fisher, *Picasso*, New York 1966

Gateau 1983
Jean-Charles Gateau, *Eluard, Picasso et la peinture*, Geneva 1983.

Geiser 1955
Bernhard Geiser, *L'œuvre gravé de Picasso*, Lausanne 1955.

Giraudy 1986
Danièle Giraudy, *Picasso*, Paris 1986.

Goeppert 1987
Sebastian Goeppert, Herma C. Goeppert-Frank, *La Minotauromachie de Pablo Picasso*, Geneva 1987.

Goldwater 1967
Robert Goldwater, *Primitivism in Modern Art*, New York 1967.

Greenspan 1985
Stuart Greenspan, 'Berggruen's
Picassos', in *Art & Auction*, vol. VII,
no. 9, April 1985.

Hohl 1986
Reinhold Hohl, *La Sculpture, l'aventure
de la sculpture moderne*, Geneva
1986.

Hommage à Picasso 1971
Hommage à Picasso, XXe siècle, special
issue, 1971.

Hoog 1984
Michel Hoog, *Catalogue de la collection
Jean Walter et Paul Guillaume, Musée de
l'Orangerie*, Paris 1984.

Hoog 1988
Michel Hoog, *Les Grandes Baigneuses de
Picasso*, Paris 1988.

Jardot 1959
Maurice Jardot, *Pablo Picasso, Dessins*,
Paris 1959.

Johnson 1976
Ron Johnson, *The Early Sculpture of
Picasso 1901–1914*, Berkeley 1976.

Kahnweiler 1948
Daniel-Henry Kahnweiler, *Les
sculptures de Picasso*, Paris 1948.

Krauss 1971
Rosalind Krauss, 'The Cubist Epoch',
in *Art Forum*, vol. IX, no. 6, February
1971, p. 32 ff.

Lecaldano – Daix 1980
Paolo Lecaldano, Pierre Daix, *Tout
l'œuvre peint de Picasso, périodes bleue et
rose*, Paris 1980.

Level 1928
André Level, *Picasso*, Paris 1928.

Leymarie 1967
Jean Leymarie, *Picasso, Dessins*,
Geneva 1967.

Leymarie 1971
Jean Leymarie, *Picasso. Métamorphoses
et unité*, Geneva 1971.

Martin 1982
Alvin Martin, 'Georges Braque et les
origines du langage du cubisme
synthétique', in *Georges Braque: Les
papiers collés*, Paris 1982.

McEwen 1983
John McEwen, 'Squaring an Old
Account', in *The Sunday Times
Magazine*, 24 April 1983.

Minervino – Cachin 1977
Fiorella Minervino, Françoise Cachin,
Tout l'œuvre peint de Picasso 1907–1916,
Paris 1977.

Nash 1974
J.M. Nash, *Cubism, Futurism and
Constructivism*, London 1974.

Palau i Fabre 1981
José Palau i Fabre, *Picasso vivant (1881–
1907)*, Paris 1981.

Penrose 1961
Roland Penrose, *La vie et l'œuvre de
Picasso*, Paris 1961.

Picasso 1967
Picasso, collection 'Génies et Réalités',
Paris 1967.

Raynal 1921
Maurice Raynal, *Les maîtres du cubisme:
Pablo Picasso*, Paris 1921.

Raynal 1922
Maurice Raynal, *Picasso*, Paris 1922.

Raynal 1953
Maurice Raynal, *Picasso, études
biographiques et critiques*, Geneva 1953.

Raynal 1958
Maurice Raynal, *Peinture moderne*,
Geneva 1958.

Richardson 1964
John Richardson, *Picasso, aquarelles et
gouaches*, Basle 1964.

Rosenberg 1975
Harold Rosenberg, *Art on the Edge:
Creators and Situations*, New York 1975.

Rosenblum 1960
Robert Rosenblum, *Cubism and
Twentieth-Century Art*, New York 1960.

Rubin 1984
William Rubin, *Picasso*, in *Primitivism
in 20th Century Art*, exhibition
catalogue, New York 1984.

Runnqvist 1959
Jan Runnqvist, *Minotauros – en Studie
i Forhallendet Mellan Ikonografi och Form
i Picassos Konst, 1900–1937*, Stockholm
1959.

Russell 1959
John Russell, *Georges Braque*, London
1959.

Sabartés 1946
Jaime Sabartés, *Picasso – Un portrait
intime*, Paris 1946.

Sabartés 1957
Jaime Sabartés, *Dans l'atelier de Picasso*,
Paris 1957.

Spies 1971
Werner Spies, *Les sculptures de Picasso*,
Lausanne 1971.

Spies 1983
Werner Spies, Catherine Piot, *Picasso,
das plastische Werk*, exhibition
catalogue, Berlin – Düsseldorf 1983.

Spies 1986
Werner Spies, *Picasso, pastels, dessins,
aquarelles*, exhibition catalogue, Paris
1986.

Stein 1938
Gertrude Stein, *Picasso*, Paris 1938.

Tinterow 1981
Gary Tinterow. *Master Drawings by
Picasso*, Cambridge (Mass.) 1981.

Tzara 1948
Tristan Tzara, *Pablo Picasso*, Geneva
1948.

Warnod 1975
Jeanine Warnod, *Le Bateau-Lavoir.
1892–1914*, Paris 1975.

Zervos 1949
Christian Zervos, *Dessins de Picasso,
1892–1948*, Paris 1949.

Zervos 1949–1986
Christian Zervos, *Pablo Picasso*, vols. I–
XXIX, Paris 1949–86.

Joan Miró

EXHIBITIONS

Geneva 1988
Berggruen Collection, Geneva, Musée
d'art et d'histoire, June–October 1988.

London – Zurich 1964
Roland Penrose, *Joan Miró*, London,
Arts Council of Great Britain, Tate
Gallery, August–October; Zurich,
Kunsthaus, October–December 1964.

Paris 1925
Joan Miró, Paris, Galerie Pierre, June
1925.

Paris 1957
Depuis Bonnard, Paris, Musée National
d'Art Moderne, 1957.

Paris 1974
Joan Miró, Paris, Grand Palais,
May–October 1974.

Saint-Paul-de-Vence 1971
Exposition René Char, Saint-Paul-de-
Vence, Fondation Maeght, summer
1971.

Tokyo – Kyoto 1966
Joan Miró, Tokyo, National Museum of
Modern Art, August–October; Kyoto,
National Museum of Modern Art,
October–November 1966.

LITERATURE

Dupin 1961
Jacques Dupin, *Miró*, Paris 1961.

Greenspan 1985
Stuart Greenspan, 'Berggruen's
Picassos', in *Art & Auction*, vol. VII,
no. 9, April 1985.

Miró 1974
Joan Miró, Le petit Journal des grandes
Expositions, n.s., no. 11, 1974.

Penrose 1970
Roland Penrose, *Miró*, London 1970.

Prévert – Ribemont-Dessaignes 1956
Jacques Prévert, Georges Ribemont-
Dessaignes, *Joan Miró*, Paris 1956.

Serra 1985
Pere A. Serra, *Miró et Mallorca*,
Barcelona 1985.

African Art

EXHIBITIONS

Berkeley 1967
William Bascom. *African Arts*,
Berkeley, Robert H. Lowie Museum of
Anthropology, 1967.

Brussels 1979
L'aventure de Pierre Loeb, Brussels,
Musée d'Ixelles, October–December
1979.

Geneva 1988
Berggruen Collection, Geneva, Musée
d'art et d'histoire, June–October 1988.

New York et al. 1984
Primitivism in 20th Century Art, New
York, The Museum of Modern Art;
Detroit, The Institute of Arts; Dallas,
Museum of Art, 1984.

Paris 1977
L'aventure de Pierre Loeb, Paris, Musée
d'Art Moderne de la Ville de Paris,
June–September 1977.

LITERATURE

Anderson 1983
M.G. Anderson, *Central Ijo Art: Shrines
and Spirit Images*, PhD. dissertation,
Bloomington, Indiana University,
1983.

Bascom 1973
William R. Bascom, *African Art in
Cultural Perspective*, New York –
London 1973.

Horton 1965
R. Horton, *Kalabari Sculpture*,
Department of Antiquities, Lagos
1965.

Perrois 1979
Louis Perrois, *Arts du Gabon*,
Arnouville 1979.

Illustration Acknowledgements